HENS, OHIO Morning still-life. A bowl of fruit, a copy
the *Columbus Dispatch*, and an empty chair in the cool
ite light of dawn await the start of a new day in the home
photographer Christina Paolucci. 📷 Christina Paolucci

GROTON POINT, CONNECTICUT Sky, water, and land. Lauren, 12, swings off her grandparents' porch in the sunset. Her grandfather, lobster fisherman George Main, spends mornings on the misty waters of the Atlantic working the pots, afternoons catching fish off the back of his boat, and evenings at his waterfront home preparing his gear for the next day. But Main and his wife, Mary, always have time to watch Lauren swing. 📷 Bradley E. Clift

Library of Congress Control Number: 2007941769
ISBN 9780-7624-3415-2

9 8 7 6 5 4 3 2 1
Digit on the right indicates the number of this printing
Printed in China

This book may be ordered by mail from the publisher.
Please include $2.50 for postage and handling.
But try your bookstore first!

Running Press Book Publishers
2300 Chestnut Street
Philadelphia, PA 19103-4371

Visit us on the web!
www.runningpress.com

AMERICA AT HOME

A CLOSE-UP LOOK AT HOW WE LIVE

CREATED BY RICK SMOLAN & JENNIFER ERWITT
AGAINST ALL ODDS PRODUCTIONS

RUNNING PRESS
PHILADELPHIA · LONDON

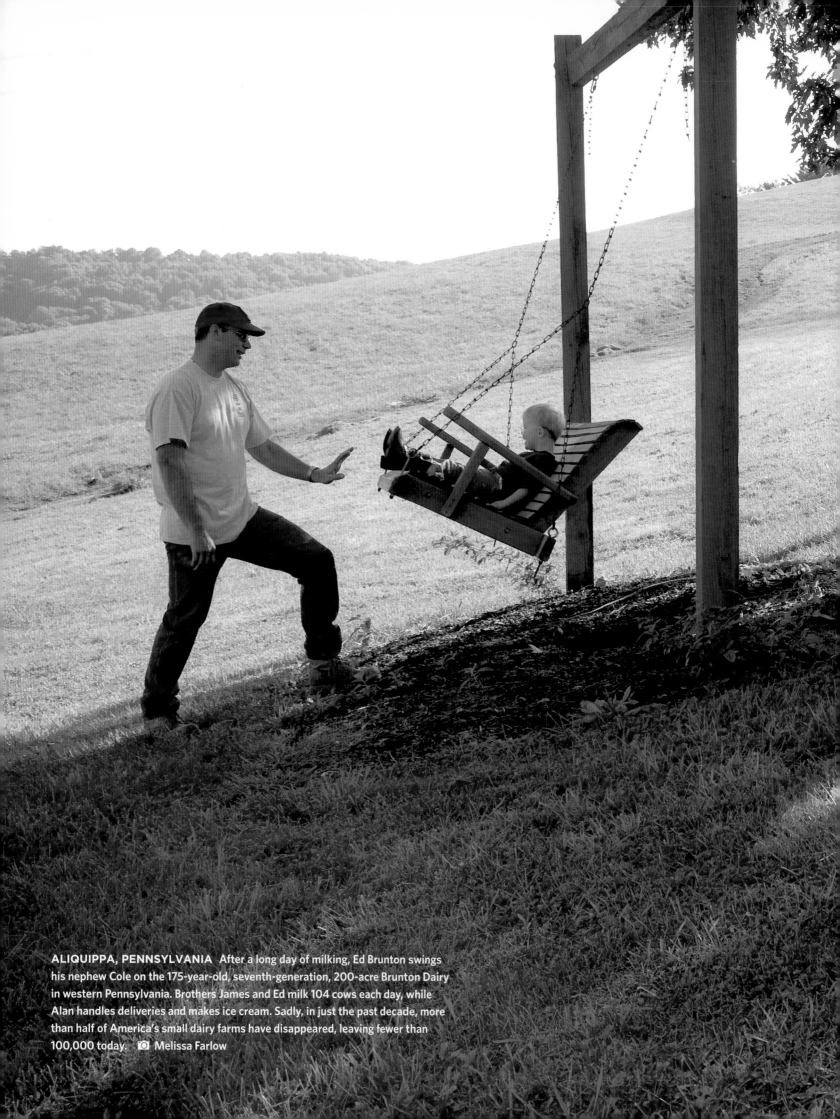

ALIQUIPPA, PENNSYLVANIA After a long day of milking, Ed Brunton swings his nephew Cole on the 175-year-old, seventh-generation, 200-acre Brunton Dairy in western Pennsylvania. Brothers James and Ed milk 104 cows each day, while Alan handles deliveries and makes ice cream. Sadly, in just the past decade, more than half of America's small dairy farms have disappeared, leaving fewer than 100,000 today. 📷 Melissa Farlow

INTRODUCTION

WE AMERICANS, whether we arrived here on the deck of the Mayflower or in the hold of the slave ship Wanderer, were already here by land bridge via Siberia, or are post-Bicentennial party-crashers, have a complex relationship with "home."

Home is that place where each of us began, be it a rickety swamp-shack with a leaky roof or a rambling suburban McMansion with a leaky roof. It is where we first define ourselves and our place in the larger world. And we carry that original image with us wherever we wander, and wherever we live, for the rest of our lives.

Home prepares us for the bigger world to come, but it is just as likely to handicap us when we get there. Untold numbers of men and women have accomplished great things in their lives because their childhood home life gave them the tools they needed. Others have overcome the psychopathology of their home life by tricking themselves into becoming so sane they don't know they're crazy. And then there are those of us squeezed in the middle, kinda functional and kinda loopy.

Twenty years ago, when I first thought up *The Simpsons*, I knew exactly where to look to find my characters: my own childhood home. It's no coincidence that the Springfield scamps bear the same names and street address as my own childhood Portland family. And though others have remarked that there's no way I could have come up with such annoying characters in a matter of minutes, they shouldn't be surprised. I'd been carrying the little ingrates in my heart all these years.

Each of us has just such an image of home—with its unique smells, shapes, breezes, and sounds, its unlikely assemblage of geezers and crackpots, and its tattered scrapbook of unforgettable dreams and nightmares—in our hearts. We spend the rest of our lives, sometimes in therapy, trying to re-create, or escape, that image. But for better or worse, none of us can erase that image, because it defines who we are. Without it, we would fade away.

In the pages that follow, you will see the extraordinary range of places, people, and patterns of living that define what home means in this frenetic and fluid society that is America at the beginning of the 21st century. It is a stunning reminder of just how diverse and different we Americans really are... and yet, when you study each of these images closely, it is impossible to escape the realization that when it comes to our weird, mysterious connection with home, we are one.

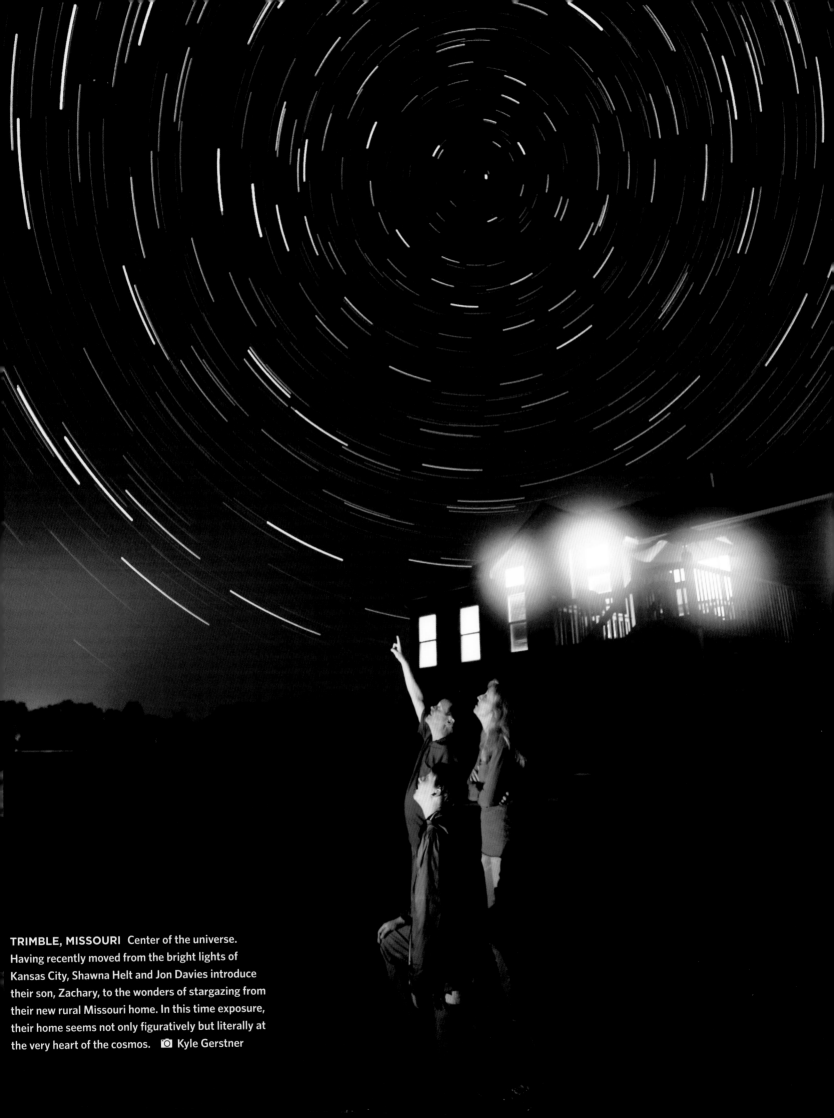

TRIMBLE, MISSOURI Center of the universe. Having recently moved from the bright lights of Kansas City, Shawna Helt and Jon Davies introduce their son, Zachary, to the wonders of stargazing from their new rural Missouri home. In this time exposure, their home seems not only figuratively but literally at the very heart of the cosmos. 📷 Kyle Gerstner

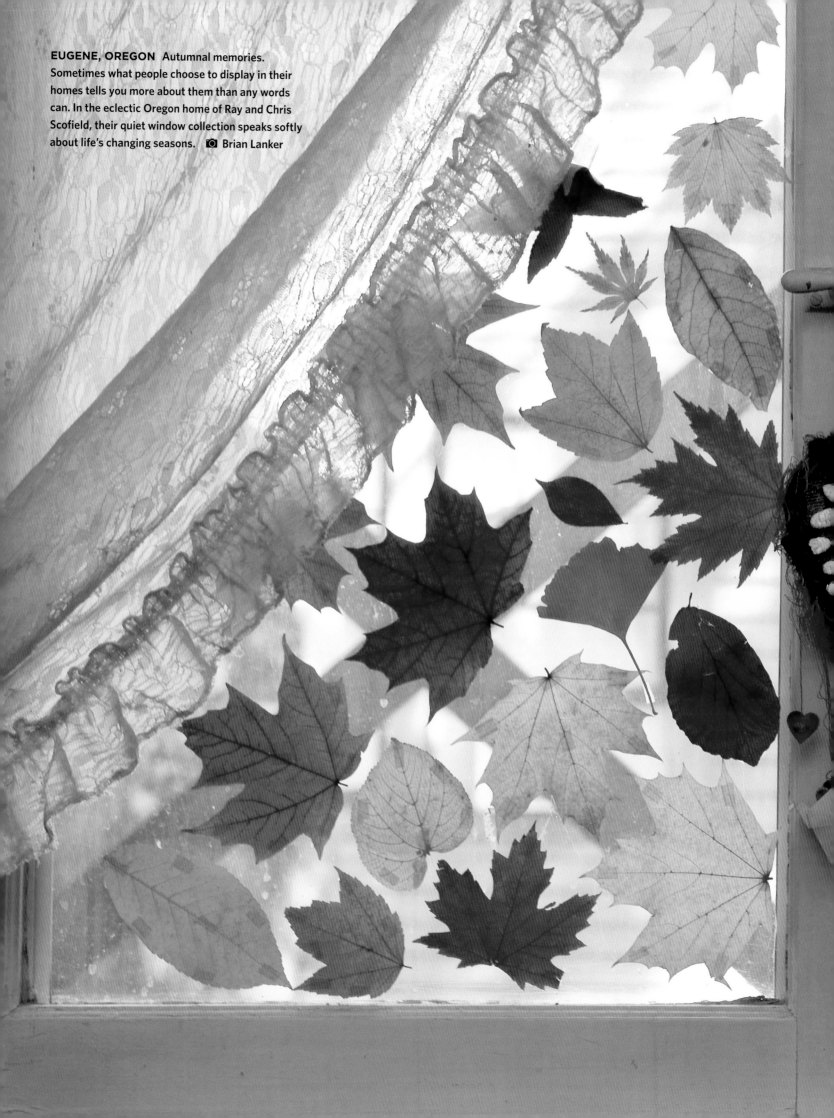

EUGENE, OREGON Autumnal memories. Sometimes what people choose to display in their homes tells you more about them than any words can. In the eclectic Oregon home of Ray and Chris Scofield, their quiet window collection speaks softly about life's changing seasons. 📷 Brian Lanker

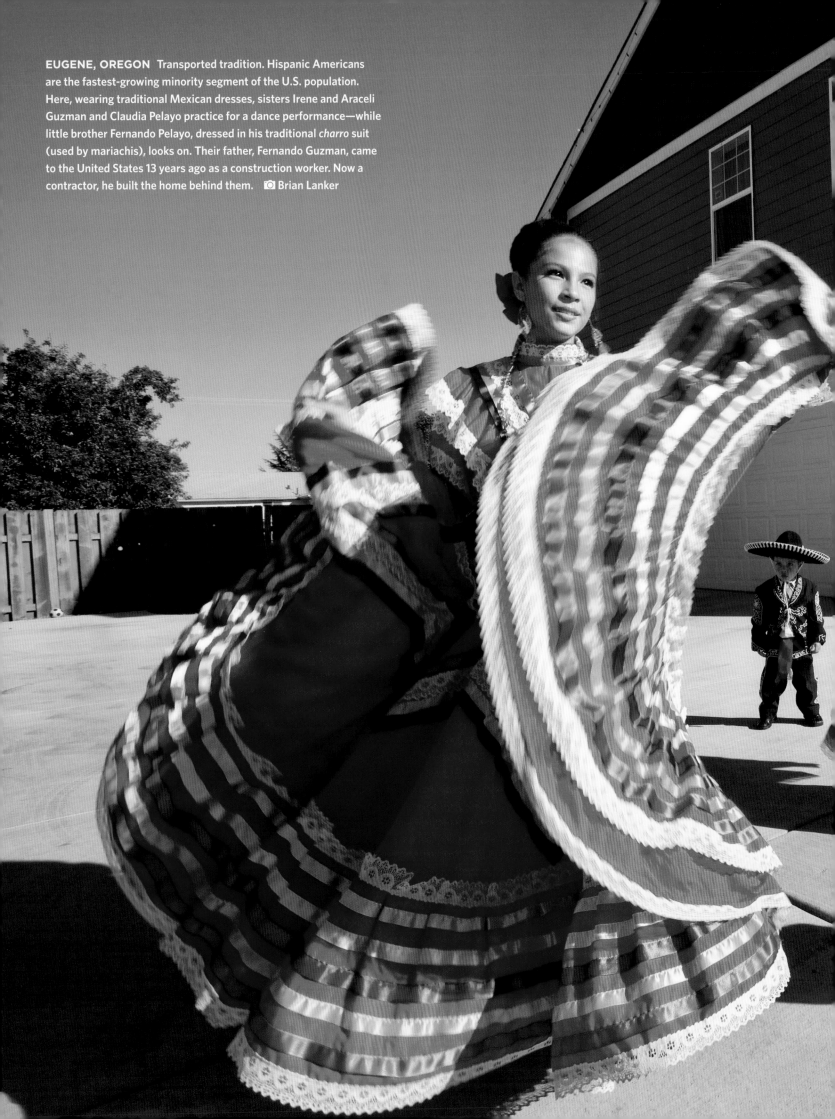

EUGENE, OREGON Transported tradition. Hispanic Americans are the fastest-growing minority segment of the U.S. population. Here, wearing traditional Mexican dresses, sisters Irene and Araceli Guzman and Claudia Pelayo practice for a dance performance—while little brother Fernando Pelayo, dressed in his traditional *charro* suit (used by mariachis), looks on. Their father, Fernando Guzman, came to the United States 13 years ago as a construction worker. Now a contractor, he built the home behind them. 📷 Brian Lanker

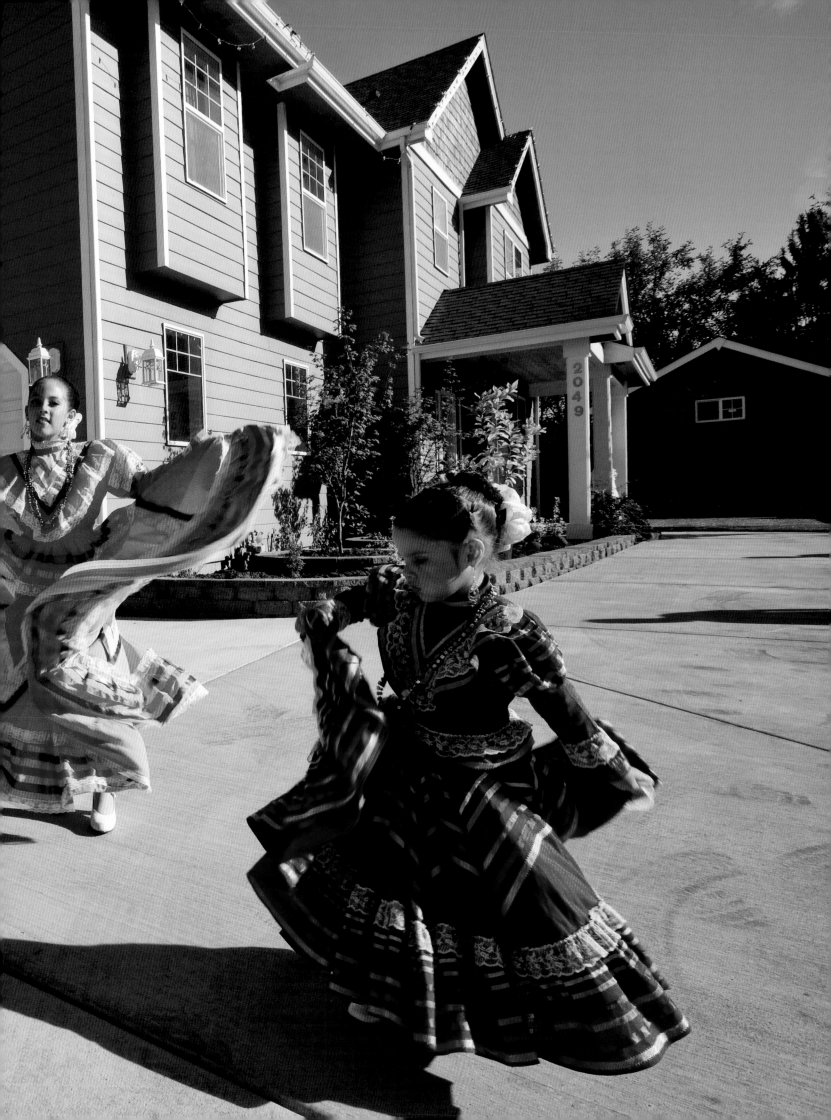

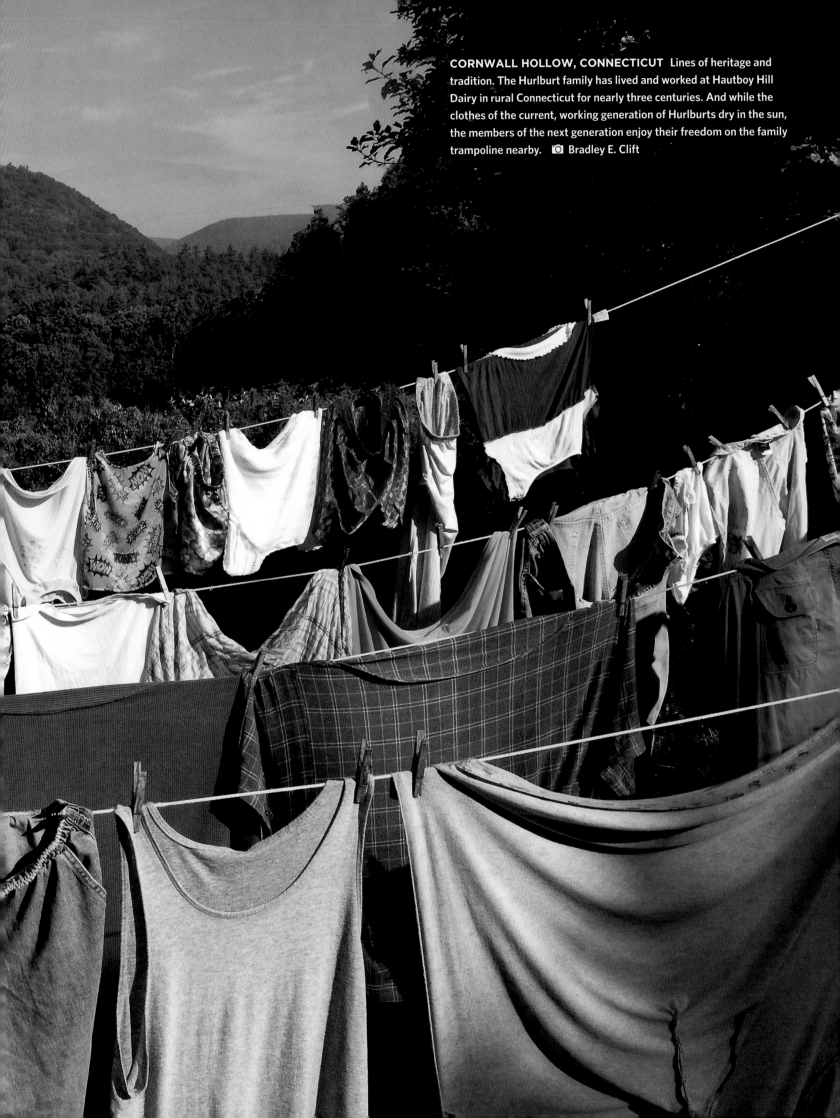

CORNWALL HOLLOW, CONNECTICUT Lines of heritage and tradition. The Hurlburt family has lived and worked at Hautboy Hill Dairy in rural Connecticut for nearly three centuries. And while the clothes of the current, working generation of Hurlburts dry in the sun, the members of the next generation enjoy their freedom on the family trampoline nearby. 📷 Bradley E. Clift

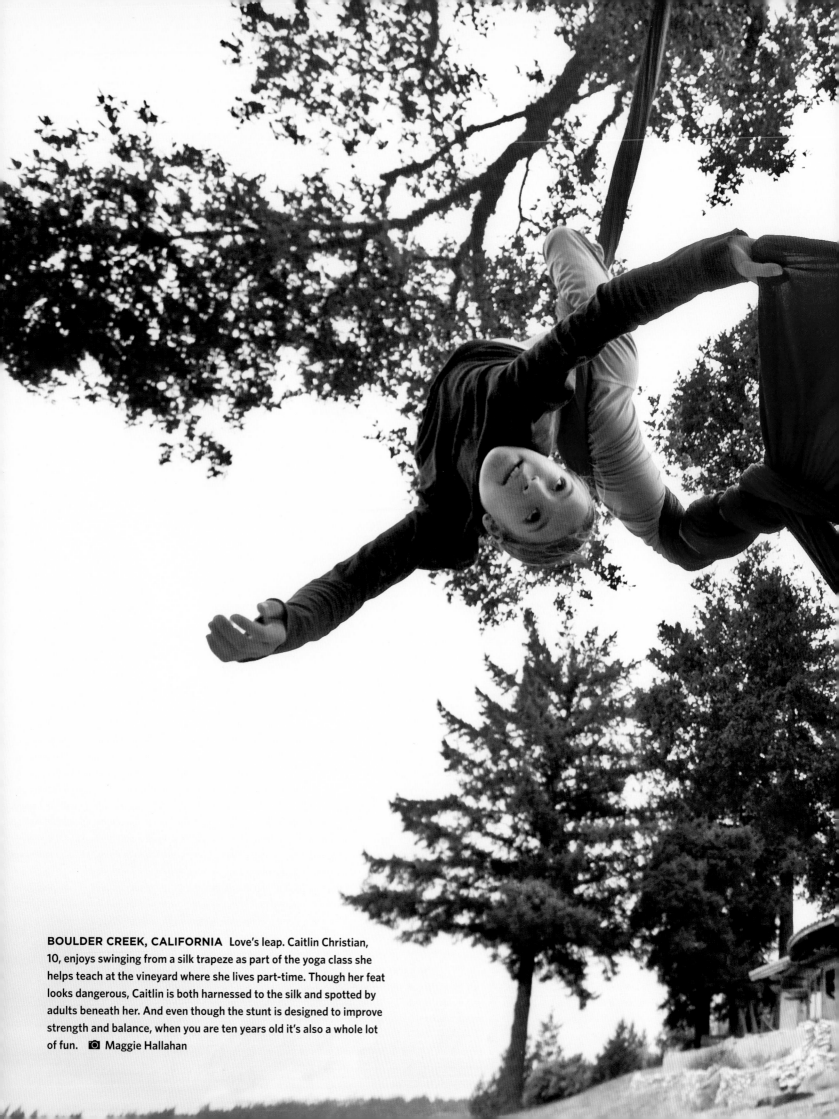

BOULDER CREEK, CALIFORNIA Love's leap. Caitlin Christian, 10, enjoys swinging from a silk trapeze as part of the yoga class she helps teach at the vineyard where she lives part-time. Though her feat looks dangerous, Caitlin is both harnessed to the silk and spotted by adults beneath her. And even though the stunt is designed to improve strength and balance, when you are ten years old it's also a whole lot of fun. 📷 Maggie Hallahan

DOMINIQUE BROWNING

HOME AS YOUR
SANCTUARY

I WAS PROBABLY AROUND EIGHT years old the first time I saw Dorothy in Oz, tapping the heels of her ruby red shoes together and chanting, "There's no place like home... There's no place like home." I burst into tears; her remorse at ever having wanted to run away in the first place, and her desperate hope to return, stirred my little being to its depths. Every morning I left home for school, and every morning, during that painful, bumpy journey on the bus full of loud, bouncing, manic children, I wanted nothing more than to be at home, in my own world of books and music and dolls, sunlight pouring in the picture window. I longed for the feel of my grandmother's lap, the sound of her strange accent, and the smell of my bed. It was years before I became accustomed to the dislocation.

Every day, each of us leaves our home and heads out into the world to work, to deliver children to school, to buy food. Every evening, we return home. This is an act so routine as to have become almost unthinking.

Sigmund Freud wrote about watching his grandson throw a little toy out of his crib and pull it back again by its string. He repeated this many times. The toy was thrown from the crib, and then the toy came back. Freud called this "the back-and-forth game." As he saw it, the child was learning that absent things will return. What is out of sight is not necessarily lost.

How often we are like those little toys, with strings attached to us to keep us returning home. Or, at the other end of the string, how often we are the ones at home tethered to those who leave, trusting that they will return. These are acts of daily life. When someone keeps the home fires burning, they do so in the hope and expectation that absent ones will return. And who doesn't want to go home? Home should be, after all, a sanctuary. A healing, protecting place. A sacred place, in which we can connect with the profound spiritual resources that animate our lives.

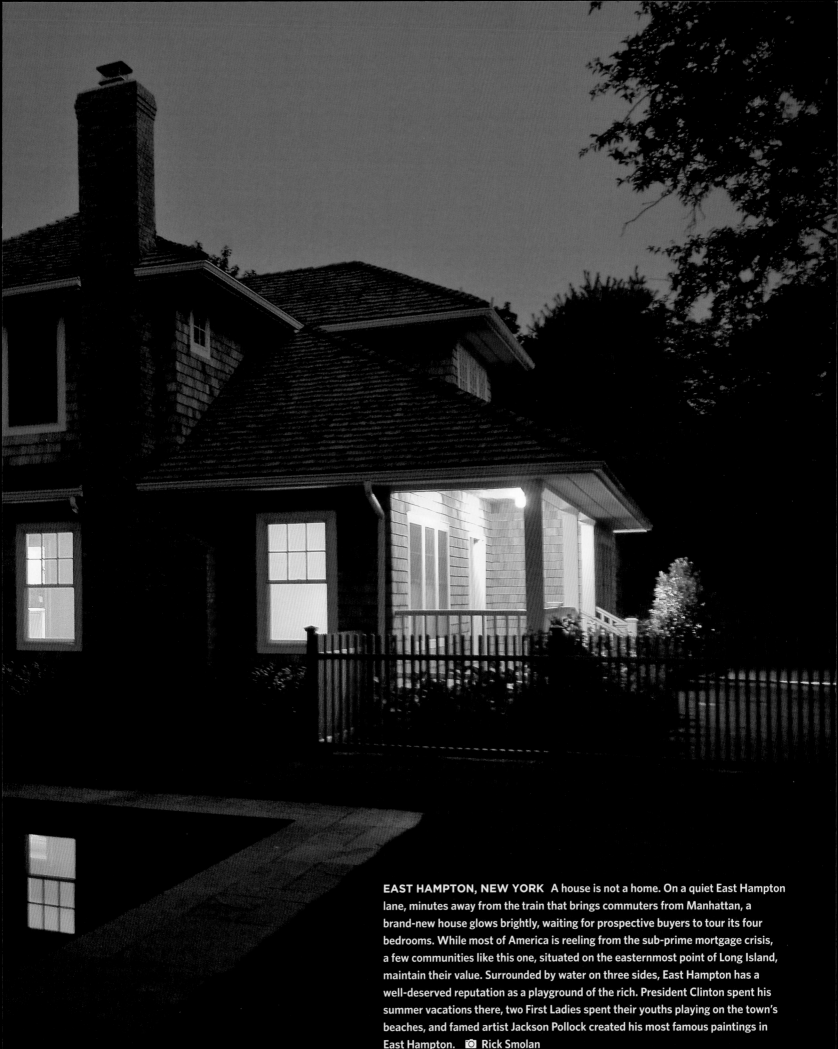

EAST HAMPTON, NEW YORK A house is not a home. On a quiet East Hampton lane, minutes away from the train that brings commuters from Manhattan, a brand-new house glows brightly, waiting for prospective buyers to tour its four bedrooms. While most of America is reeling from the sub-prime mortgage crisis, a few communities like this one, situated on the easternmost point of Long Island, maintain their value. Surrounded by water on three sides, East Hampton has a well-deserved reputation as a playground of the rich. President Clinton spent his summer vacations there, two First Ladies spent their youths playing on the town's beaches, and famed artist Jackson Pollock created his most famous paintings in East Hampton. ◎ Rick Smolan

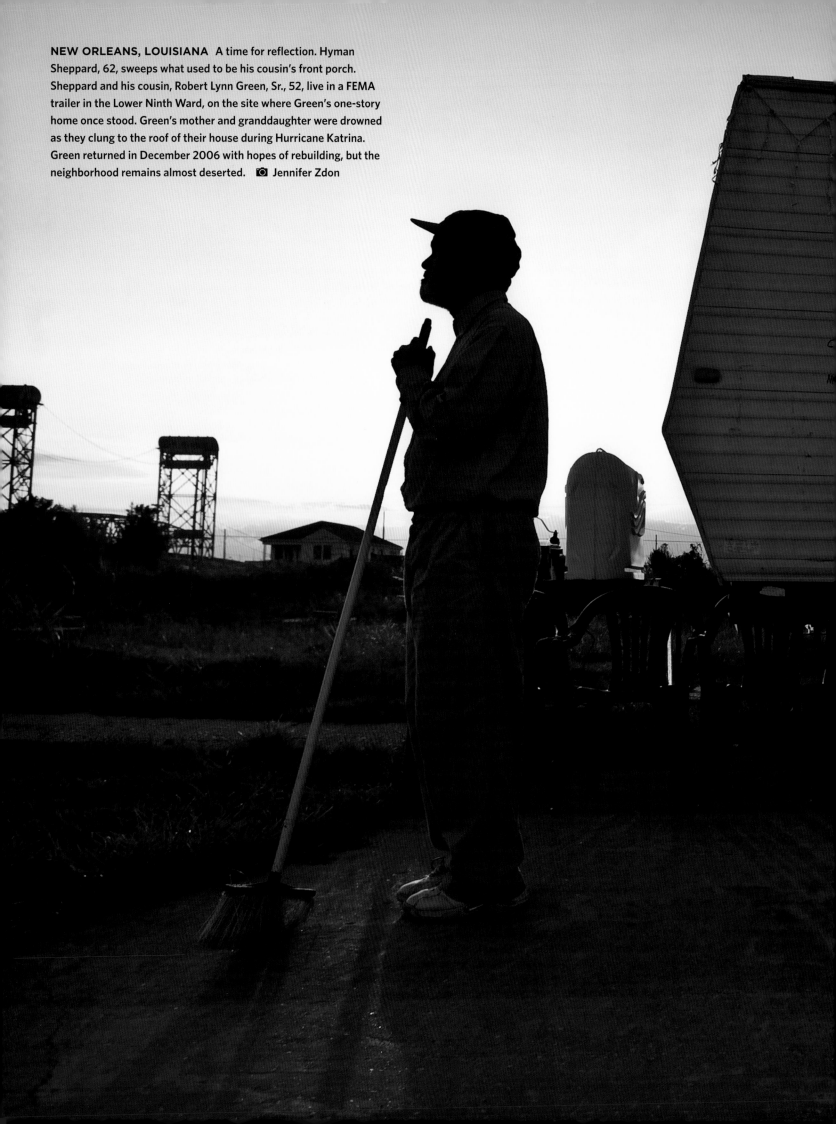

NEW ORLEANS, LOUISIANA A time for reflection. Hyman Sheppard, 62, sweeps what used to be his cousin's front porch. Sheppard and his cousin, Robert Lynn Green, Sr., 52, live in a FEMA trailer in the Lower Ninth Ward, on the site where Green's one-story home once stood. Green's mother and granddaughter were drowned as they clung to the roof of their house during Hurricane Katrina. Green returned in December 2006 with hopes of rebuilding, but the neighborhood remains almost deserted. 📷 Jennifer Zdon

It is fascinating to see the ways in which people turn their homes into sanctuaries. Some are quite literal about it: they create altars to their household gods, so that the soul is quieted and time slows down. For others, a sanctuary is a technological affair: it is a place where you can curl up, turn on the television, and let the world entertain you, or where you can watch horrific events unfold, participating in the human community from the safety of your den. For some, sanctuary is to be found in the garden, on a bench set among the roses, protected from wind by emerald-green hedges. And for some of us, sanctuary has to do with the rituals of nourishment: the evening meal is blessed, and the presiding spirits are thanked for bringing everyone together one more time. Many of us think of the tub as the heart of our sanctuaries: we draw the hot bath, turning on the taps, taking it for granted that the water is plentiful. As we sink into the bubbles, we feel caressed, regenerated, and, most of all, safe.

Safe. That feeling leads us to contemplate another dimension to the idea of home as a sanctuary, one that transcends cherished but commonplace activities in the kitchen, bedroom, living or dining room. The definition of sanctuary at its most profound, I am reminded by the dictionary, is "immunity offered by refuge in such a place." When you are in a sanctuary, you are out of reach of harm; you are offered protection from aggressors or escape from evil. This is an idea as old as humankind. As children, we rehearse this notion in so many of our games: we reach home plate; we are home free.

Until I started reading in the newspapers about the increasing roundup of immigrants in the United States without proper documentation, shipped away from the homes they have made here, I hadn't thought about Dorothy for years. I cannot imagine the pain and heartache of losing a home; it shocks—as it should. We must remind ourselves not to take our homes for granted, and contemplate, for a few moments, how fortunate we truly are when we are rooted to a spot—when home is a sanctuary, nurturing our souls and keeping us safe from harm.

There is no place like home.

Dominique Browning, the former editor in chief of House & Garden magazine, is the author of Around the House and in the Garden and Paths of Desire: The Passions of a Suburban Gardener.

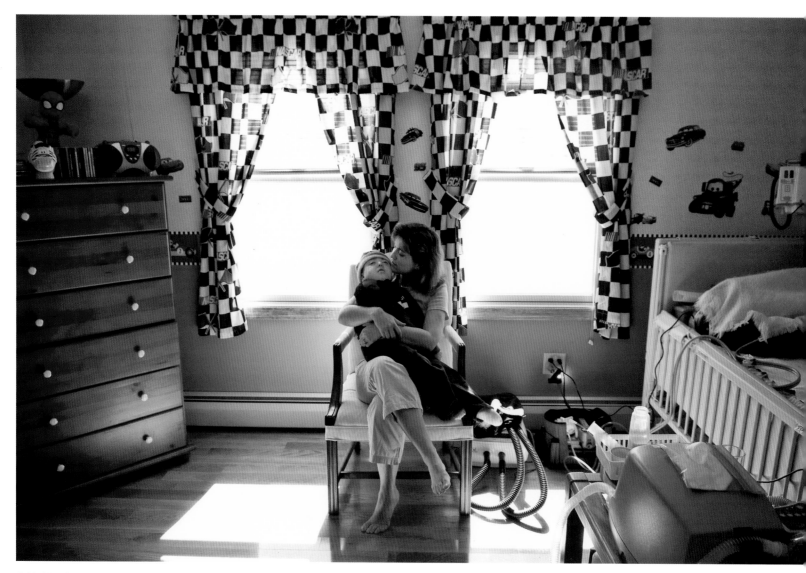

COLCHESTER, CONNECTICUT Two in a million. Pam Kristoff spends this day, as every day, feeding, bathing, and caressing the faces of her children Ryan and Alyssa, 6 and 3, both of whom suffer from early infantile Krabbe disease (her oldest child, Katie, 8, is unaffected). There are only 200 cases in the United States, and few children with the disease survive beyond age 2. Undaunted, Kristoff intends to beat those odds with the help of a $50,000 community donation for Ryan's room and five rotating nurses. But in the end it will come down to a mother's love. 📷 Bradley E. Clift

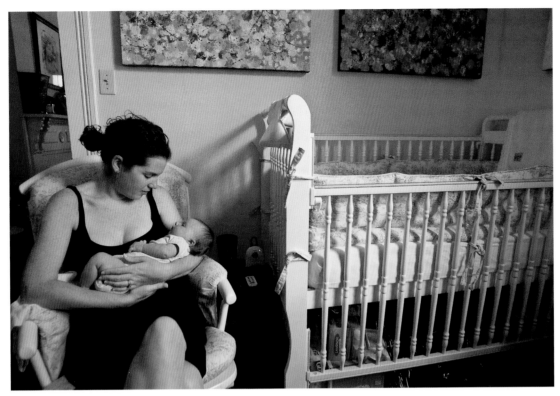

NEW ORLEANS, LOUISIANA Learning a different routine. Mary Giblin spends some quiet time with her baby girl, Sophie, at their New Orleans home. Just four weeks old, Sophie is already rewriting most of the daily schedule of mother Giblin and her husband, Keith Spera. The number of children who live with two married parents has fallen from 77 percent in 1980 to just 67 percent today. 📷 Jennifer Zdon

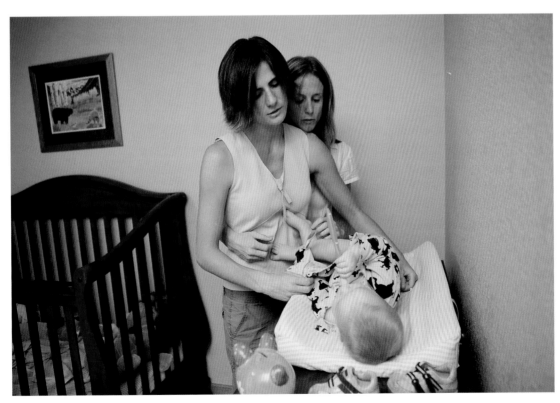

BOULDER, COLORADO Balancing act. Busy family physicians Dr. Marcie Lavigne and Dr. Michelle Drury juggle their schedules so that at least one partner is home with their two daughters, Rowan, 3, and Reese, 1, at all times. The doctors take time off during the week and never go on call at the same time. "This is what we do," says Lavigne. "We go to work, come home, and play with the girls." Only one state, Massachusetts, officially recognizes same-sex marriage; nine accept some form of civil unions. 📷 Joanna B. Pinneo

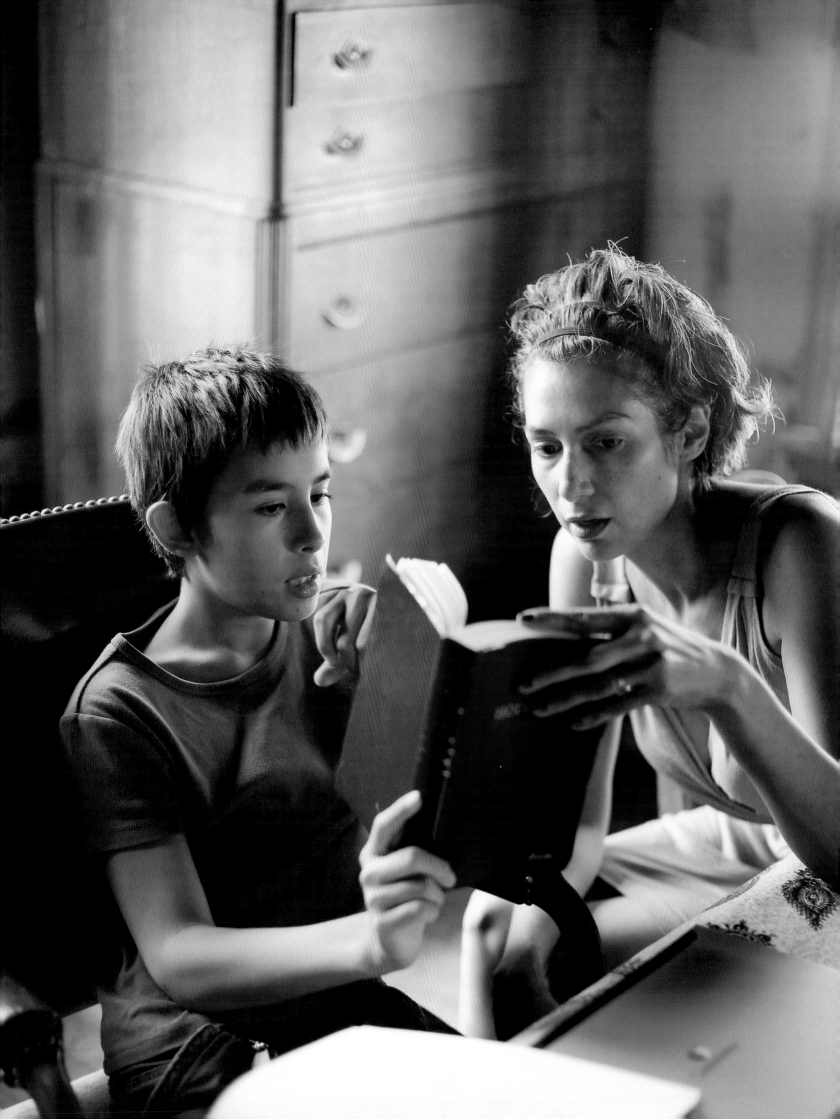

[Every morning American children head off to 124,110 schools.
The majority—86 percent—attend public school.]

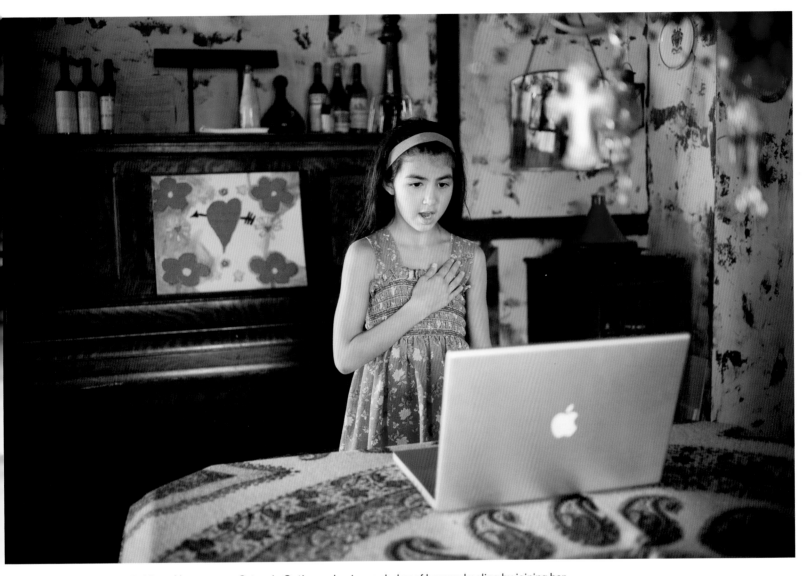

TINLEY PARK, ILLINOIS Virtual homeroom. Ortensia Ontiveros begins each day of homeschooling by joining her online classmates in the pledge of allegiance. Ortensia says her favorite part of the school day is learning about Jesus. Surveys of homeschooling families have found that more than a third do so for religious reasons. The most popular reason for homeschooling, at nearly 50 percent, is for better-quality education. 📷 Tim Klein

Tabletop schoolhouse. At the Ontiveros house, every room is a classroom. Chelo, a makeup artist, and Marco, a member of the Marine Special Forces, homeschool their two children using the educational program A Beka, which combines Christian teachings with traditional curriculum. According to the National Home Education Research Institute, more than two million American children are now being educated at home—more than double the number just three years ago. 📷 Tim Klein

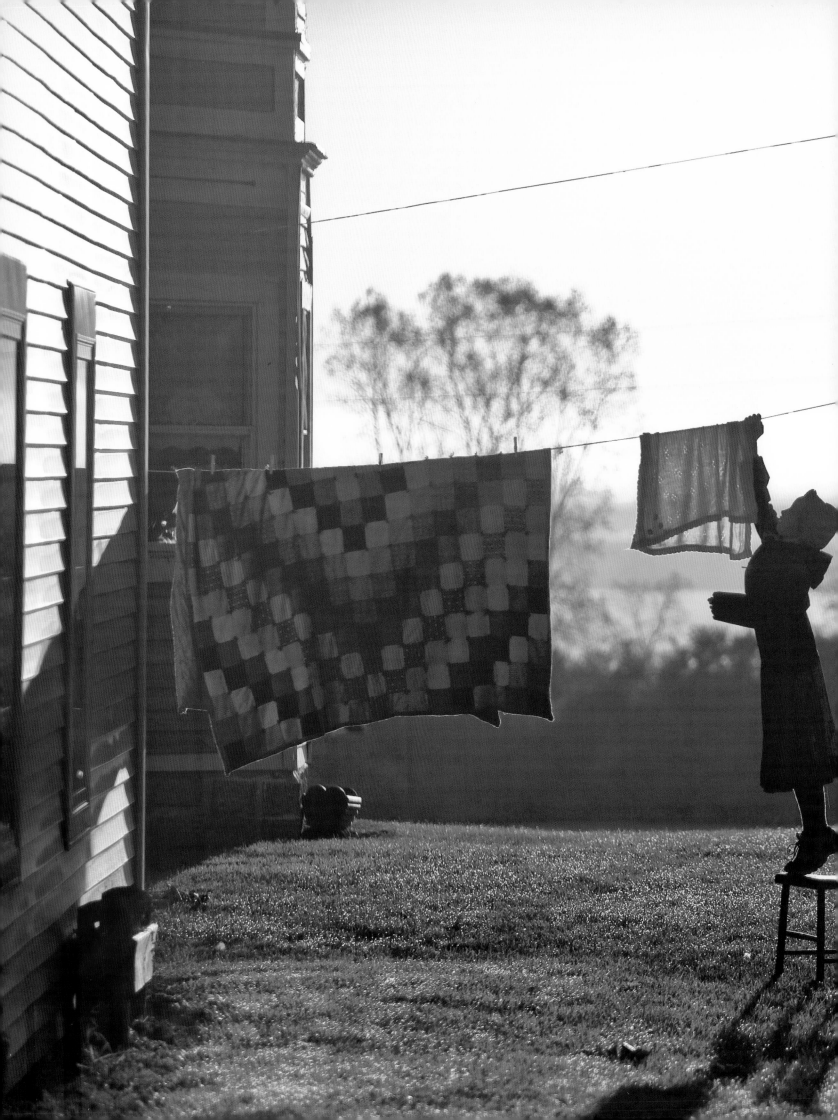

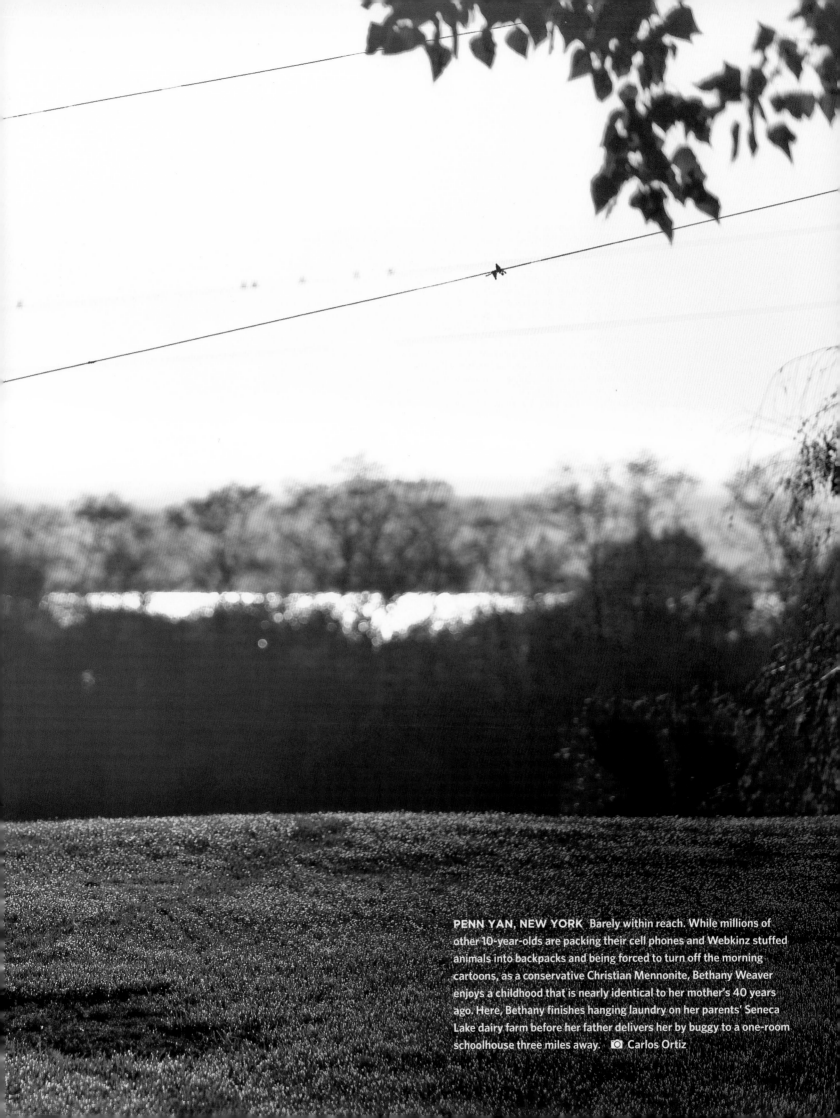

PENN YAN, NEW YORK Barely within reach. While millions of other 10-year-olds are packing their cell phones and Webkinz stuffed animals into backpacks and being forced to turn off the morning cartoons, as a conservative Christian Mennonite, Bethany Weaver enjoys a childhood that is nearly identical to her mother's 40 years ago. Here, Bethany finishes hanging laundry on her parents' Seneca Lake dairy farm before her father delivers her by buggy to a one-room schoolhouse three miles away. ⦿ Carlos Ortiz

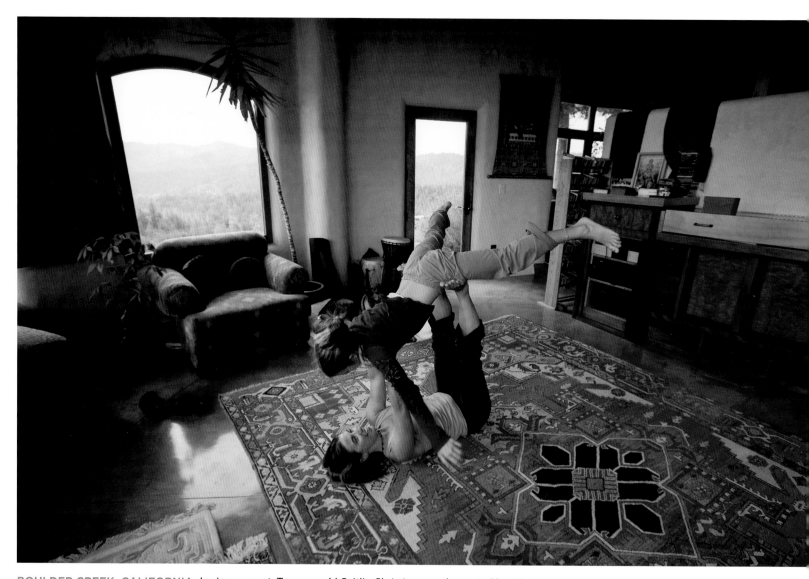

BOULDER CREEK, CALIFORNIA Loving support. Ten-year-old Caitlin Christian spends most of her time with her father in nearby Portola Valley, but weekends are typically spent with guardian Samantha Brown and her husband, Bradley, at their winery. There, Caitlin delights in playing with the surrogate mom who came into her life when she was just 3—and with whom, Samantha says, she had "an instant bond." 📷 Maggie Hallahan

STANLEY, IDAHO Making hay. Karen Day has spent most of her life as a journalist living out of a suitcase in third world countries—she's just returned from covering a story in Myanmar, for instance. Fred Crabtree is a native Idaho rancher and folk musician (not to mention master harmonica soloist). Together they have turned an old Pony Express bunk house into a bed-and-breakfast, to the delight of tourists attracted to fly-fishing the Salmon River and exploring the largest American wilderness outside of Alaska. 📷 Karen Kuehn

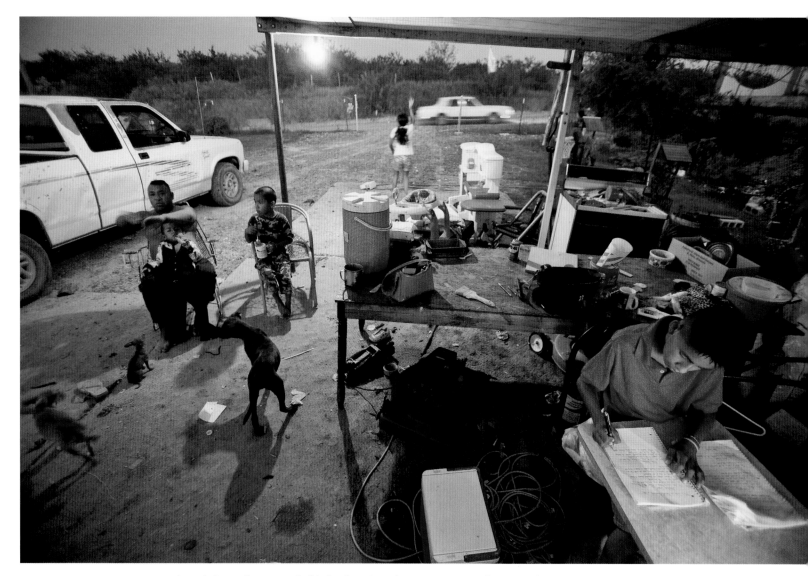

RIO GRANDE CITY, TEXAS A study in studiousness. As his family enjoys the evening air, Modesto Sanchez, 13, does his homework on the "porch" of his home in the Las Lomas *colonia* of Rio Grande City. The Sanchezes and their six children live in a makeshift house and trailer, borrowing water from their neighbor—a typical arrangement in this impoverished neighborhood. *Colonias* are suburbs that pop up in unincorporated areas around cities and towns and are defined by an absence of paved streets, numbered street addresses, sidewalks, storm drainage, sewers, electricity, potable water, or telephone services. Michael Stravato

FAIRFAX, CALIFORNIA Tuned out. Sam Worrin tries to focus on his homework and ignore the laughter and gossip coming from the next room, where his grandmother, Lucienne Matthews, is hosting her Wednesday night knitting group. While Grandma's socializing takes place in person, Sam often hangs out online with his friends at social networking sites such as MySpace and Facebook. 📷 Kim Komenich

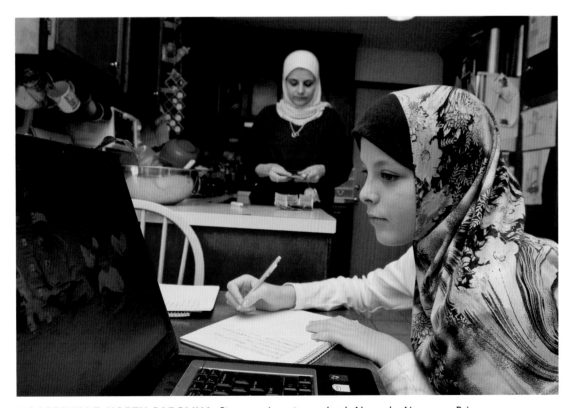

MOORESVILLE, NORTH CAROLINA Strangers in a strange land. Alexandra Noura von Briesen, a 13-year-old Muslim, borrows her brother's laptop to do her homework. She and her parents recently returned from Senegal, where all five von Briesen children attended Koran school. Despite fears about prejudice in post-9/11 America, the von Briesen family says they have been embraced by their new neighbors. An estimated 1 percent of all Americans are Muslim. 📷 Gayle Shomer Brezicki

[Not counting weddings and funerals, 38 percent of Americans
attend religious services at least once a week.]

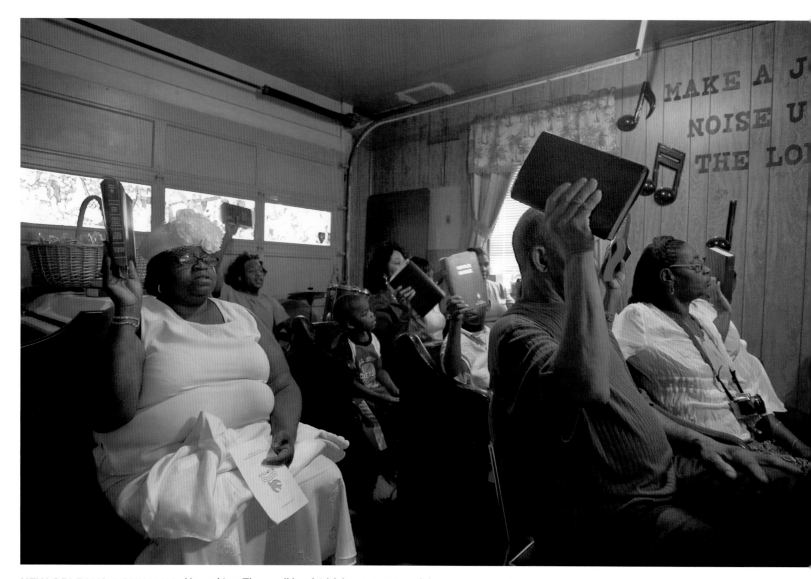

NEW ORLEANS, LOUISIANA No parking. The small but faithful congregation of the Jesus Outreach
Ministries and Fellowship gathers every Sunday in a tiny one-car garage attached to the home of the Rev. Billy
Zacharie, Sr., and his wife, Pamela. The couple has been holding services in their home garage every Sunday
since Hurricane Katrina destroyed their church in the Lower Ninth Ward. 📷 Jennifer Zdon

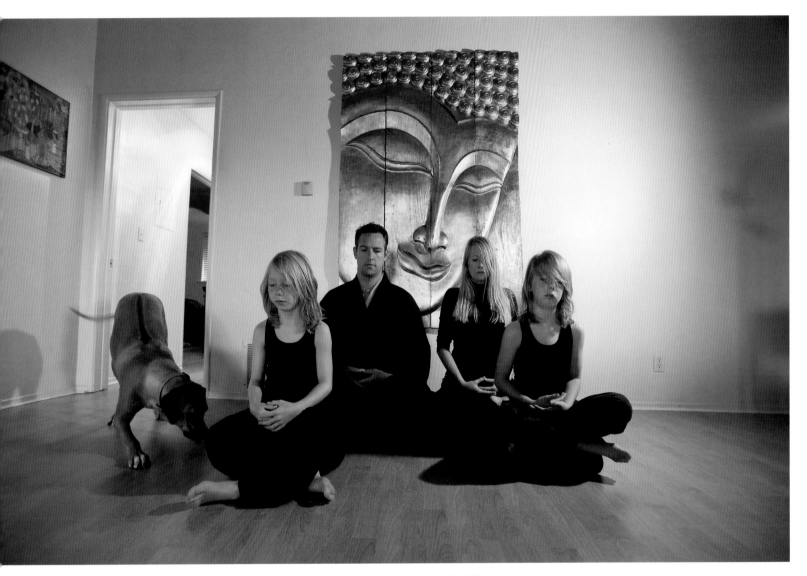

MALIBU, CALIFORNIA Family reflection. Shen Schulz uses his experience growing up in a Buddhist temple to teach his wife, Ema, and their 9-year-old twins, Bodhi (left) and Kai, to meditate. The twins, who have appeared in Oscar Mayer and McDonald's commercials and produce their own travel Web site for kids, are what is known as identical "mirror" twins: messy Bodhi is left-handed, while perfectionist Kai is right-handed. 📷 Dana Fineman

[60 percent of American teens eat dinner with their families at least five times a week
and 84 percent of teens prefer to have dinner with their families than to eat alone.]

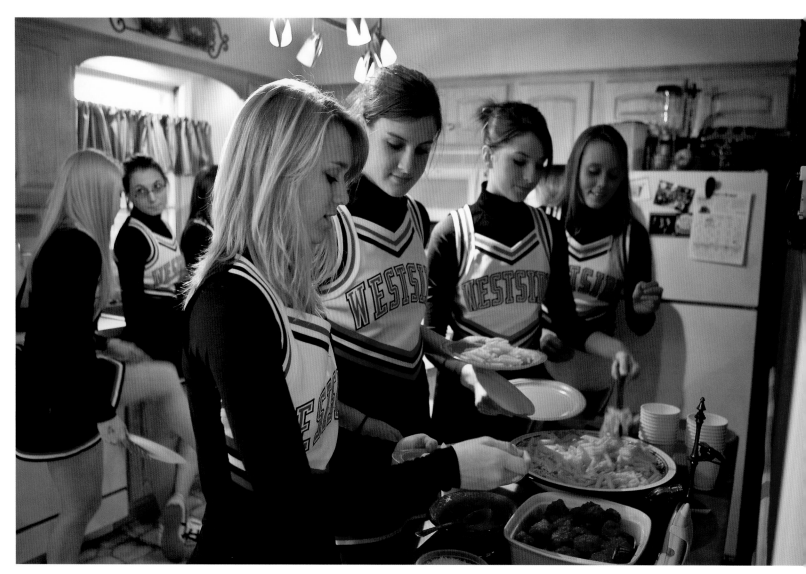

OMAHA, NEBRASKA Pre-game warm-up. At Omaha's Westside High School, it's a long-standing tradition for the
cheerleading squad to have dinner at one of the girls' homes before each Saturday night game. 📷 David Radler

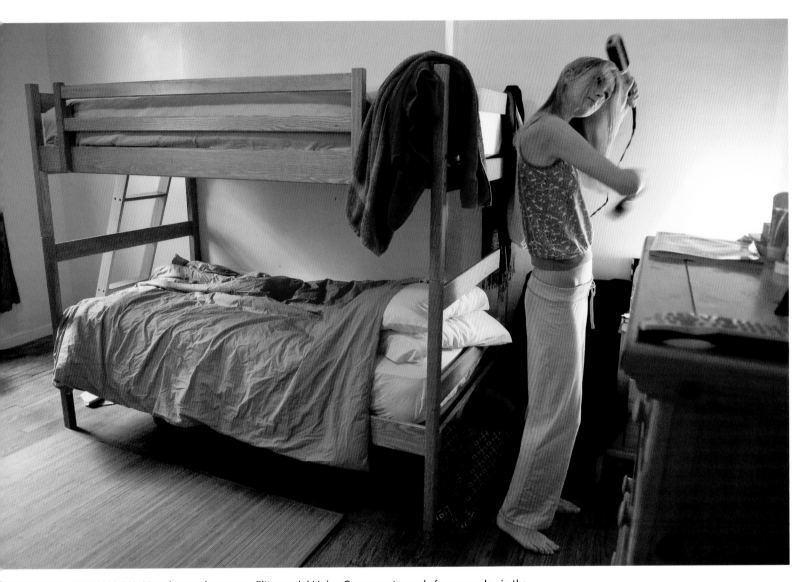

NEW YORK, NEW YORK Not always glamorous. Elite model Helen George gets ready for a new day in the Manhattan townhouse she shares with seven other aspiring young models. Even though the accommodations are cramped, she has no complaints. With a Japan gig in January and an upcoming Macy's holiday billboard, life is pretty good for a girl who grew up in a small fishing town in southern England. Jennifer S. Altman

[There are approximately 6,000 marriages every day, with more than half
of these couples living together before the Big Day.]

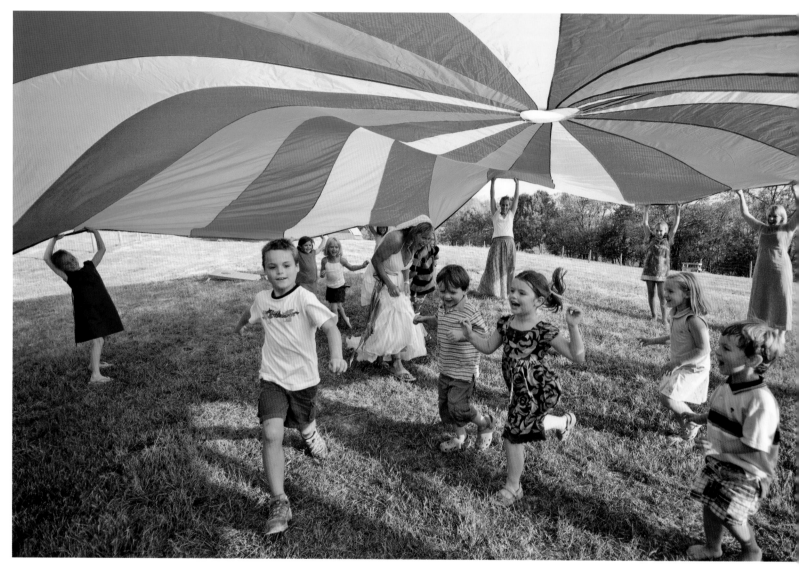

LOUISVILLE, KENTUCKY Child bride. Weasie Gaines adjusts her wedding dress as she plays
"parachute" with some of the children of her 200 guests. While Gaines is marrying for the first time
at age 37, most of her friends already have children of their own—but Gaines, says a friend, "is pretty
much a kid herself." ◎ Dan Dry

HARTFORD, CONNECTICUT Hoop dreams. They may live in the
poorest neighborhood of America's second-poorest city, but these
latchkey kids have found a home away from home at St. Brigid House,
run by Jackie Doucot and other social workers. There they can study,
play basketball, jump rope, and listen to music while they wait for their
parents to come home from work. ◎ Bradley E. Clift

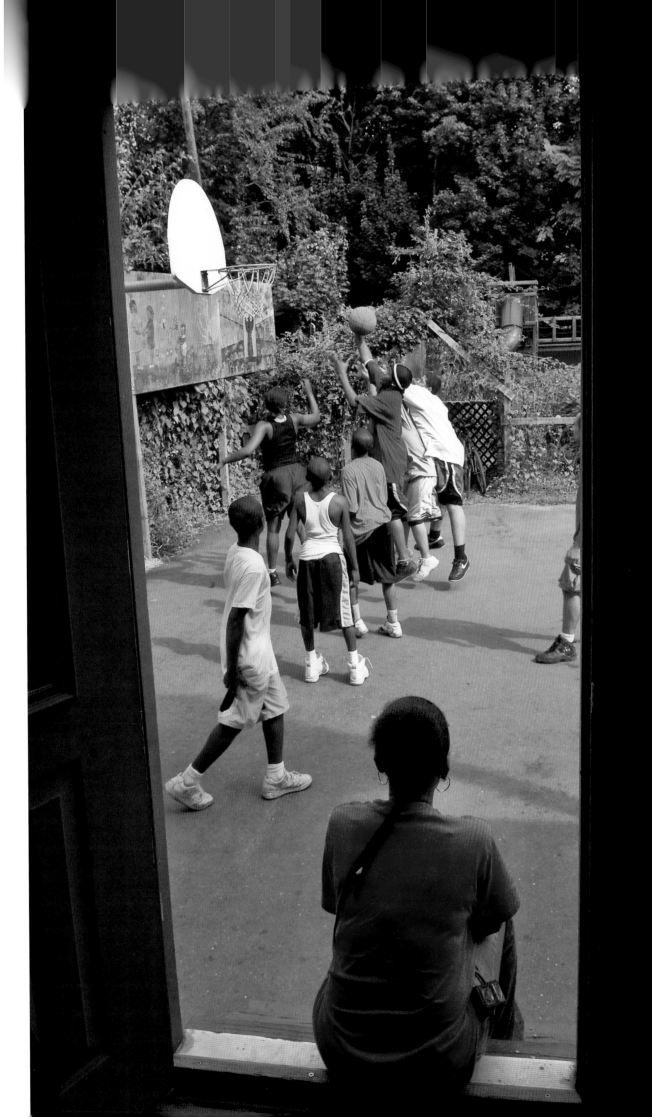

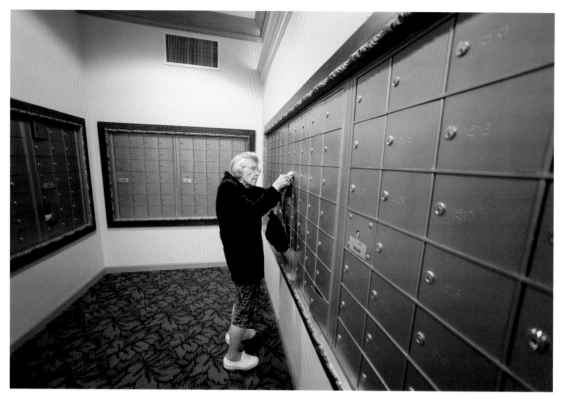

SEATTLE, WASHINGTON Indomitable. Van Shuler, 101, may be the oldest surviving Peace Corps volunteer, but that doesn't keep her from traveling the world, maintaining her own apartment, walking to appointments in downtown Seattle, or, in this case, checking her mail before heading off to a thrice-weekly ballroom dance. A widow now for 38 years, she credits her longevity to leading a serene life, avoiding alcohol and cigarettes, and being a great sleeper. 📷 Betty Udesen

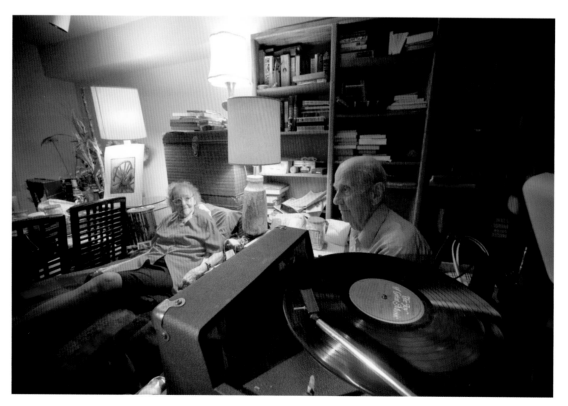

SEATTLE, WASHINGTON Melodic memories. Aino and John Katsos, 86 and 90, ask their friends not to call them between 6 and 8 in the evening. That's when they listen to their extensive record collection, reminisce, or talk about the world. She was a teacher; he was a seaman. On Friday nights, they add dinner and candlelight to the mix. 📷 Betty Udesen

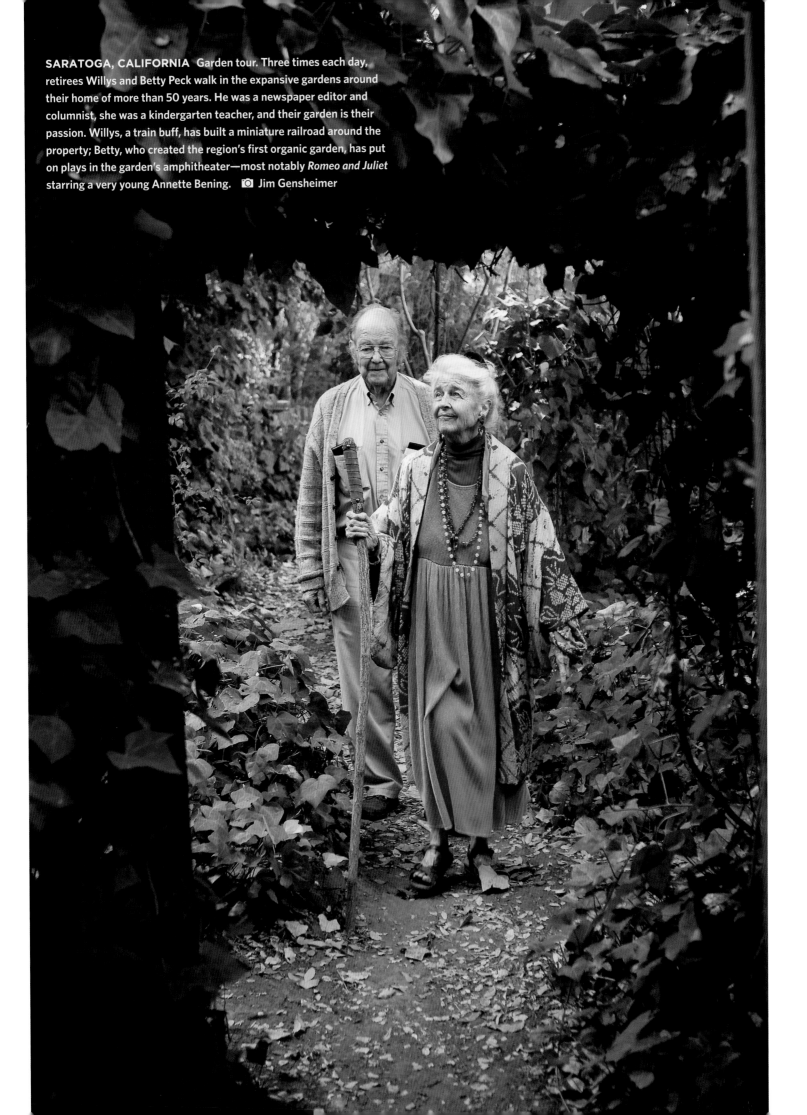

SARATOGA, CALIFORNIA Garden tour. Three times each day, retirees Willys and Betty Peck walk in the expansive gardens around their home of more than 50 years. He was a newspaper editor and columnist, she was a kindergarten teacher, and their garden is their passion. Willys, a train buff, has built a miniature railroad around the property; Betty, who created the region's first organic garden, has put on plays in the garden's amphitheater—most notably *Romeo and Juliet* starring a very young Annette Bening. 📷 Jim Gensheimer

BOSTON, MASSACHUSETTS Home base. David Arnold, 80, is one of the founders of Beacon Hill Village, a community program that enables seniors to remain in their homes as they age, while still receiving the services of traditional retirement homes. Today, more than 5 million Americans over age 65 are still working. A million more reside in assisted living facilities. ⓞ Bill Greene

OMAHA, NEBRASKA A quick dip. Bryce Boe dries off from a splash in his backyard pool. Boe, a retired civil engineer, and his wife, Willo, built the pool themselves more than 30 years ago, with the help of their children. ⓞ David Radler

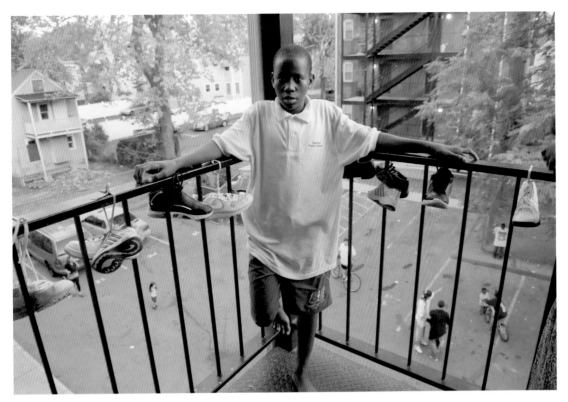

HARTFORD, CONNECTICUT Hanging up, hanging out. Back home in Somalia, Awise Issack, 14, usually ran around without shoes. Even in the United States, he still seems happiest when he can run footloose and free. Awise's family recently came to America from Somalia, and are among the few Muslim immigrants allowed into the country as political refugees. 📷 Bradley E. Clift

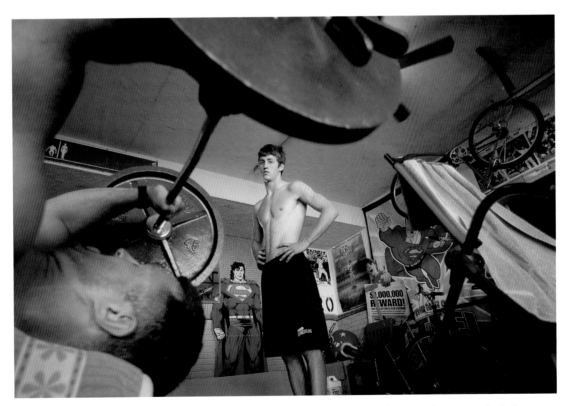

PEKIN, ILLINOIS Weighty matters. Boston Jacobs and his father, John, work out in a home gym in their converted garage. Boston wrestles, plays football, and runs track for local Pekin High. About 6 percent of high school football players go on to play NCAA college football—and of those, less than 2 percent make it to the pros. 📷 Fred Zwicky

NEW YORK, NEW YORK Seeing through the clutter. Though his landlord has tried to evict him many times over the past 40 years, Steve Fybish, 70, has endured in his Upper West Side apartment. A weather historian and substitute teacher, Fybish passes his time playing the violin and thinking of his late wife, whose ashes lie in an urn somewhere amid the books and papers. Each year the National Association of Professional Organizers receives an estimated 10,000 calls from clutter victims desperate for someone to help them create order out of chaos. 📷 Yoni Brook

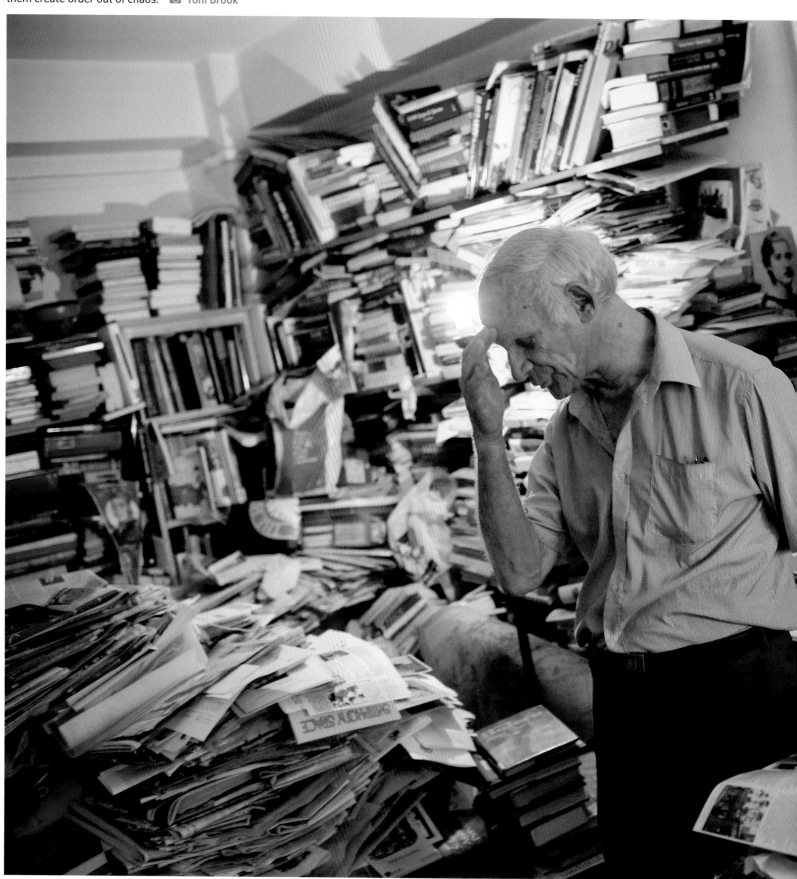

[Whether from a love of work or a need to work,
25 percent of Americans age 65-74 continue to work.]

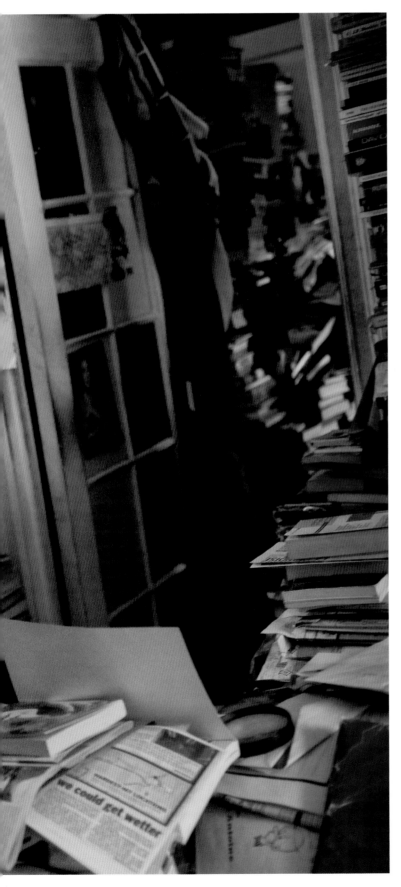

Rainy day reminder. Fybish maintains a meticulous daily weather log to help track the passage of time. Previous volumes are buried deep within the clutter, which leaves room for little more than a bed and a place to play his violin. Still, Fybish claims that the room is much neater now, after a general cleanup. 📷 Yoni Brook

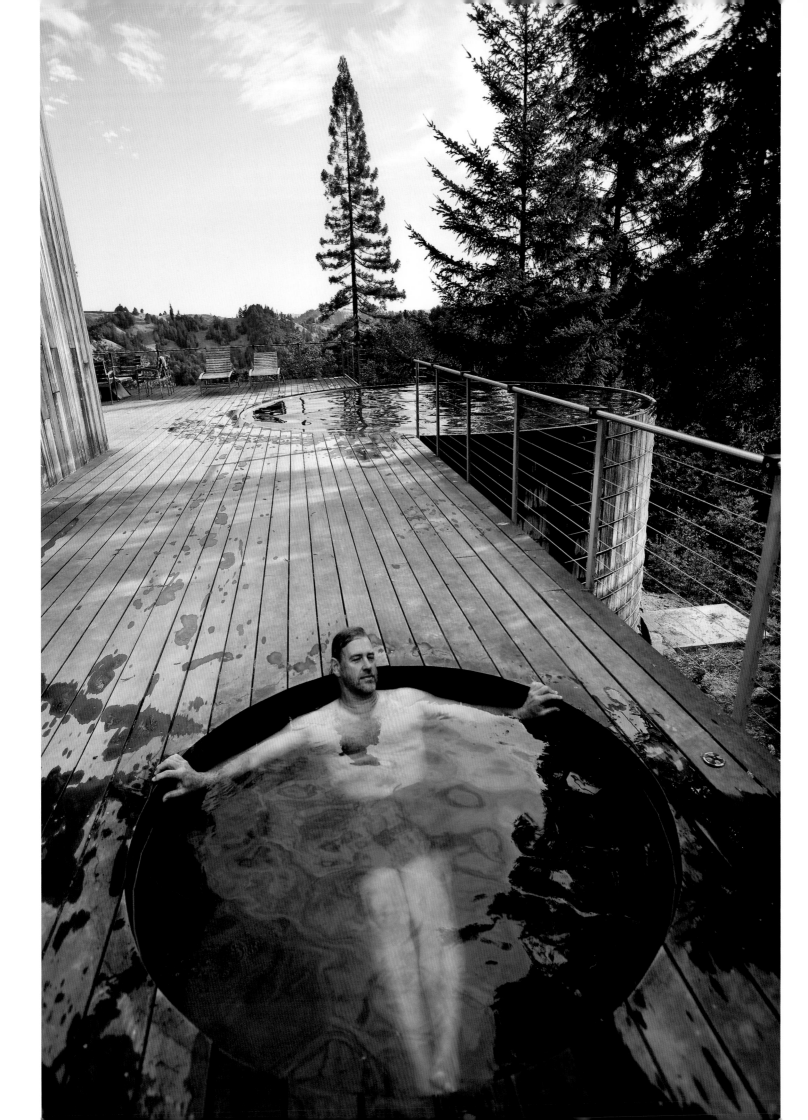

[Architects and physicians rank amongst
the people who are happiest with their jobs.]

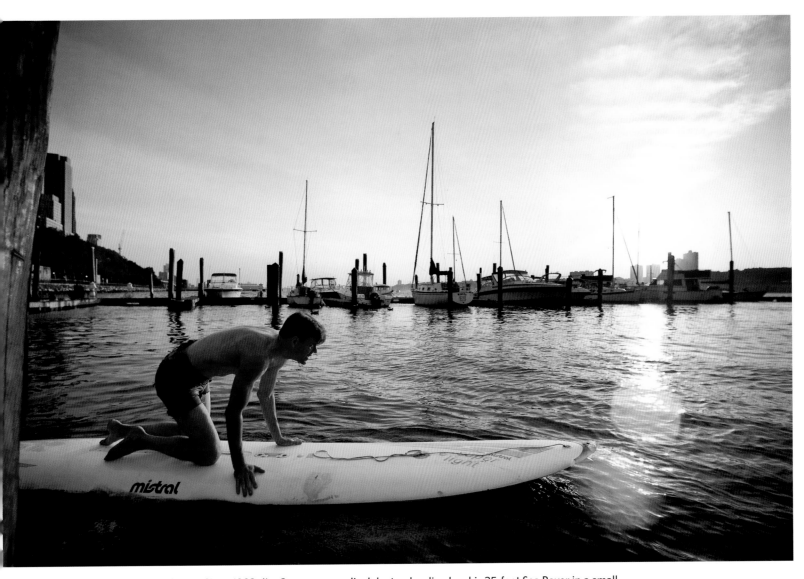

NEW YORK, NEW YORK Surf doctor. Since 1983, Jim Spencer, a medical doctor, has lived on his 35-foot Sea Rover in a small community of full-time residents at the 79th Street Boat Basin on the Upper West Side. Whenever the weather allows it, Spencer heads out onto the Hudson River to windsurf. Many of the homes at the basin are as eccentric (and unseaworthy) as their owners, and the city has given them two years to shape up or ship out. 📷 Ron Antonelli

TIMBER COVE, CALIFORNIA Big dipper. Architect and designer Olle Lundberg relaxes at the mountain home he and his wife Mary Breuer constructed from reclaimed materials salvaged from the shiny office buildings he designs for clients. The couple also live on a converted Icelandic car ferry berthed in San Francisco. Both homes are designed to have a low environmental impact. There are currently only about 8,000 Leadership in Energy and Environmental Design (LEED) certified homes in the United States. 📷 Kim Komenich

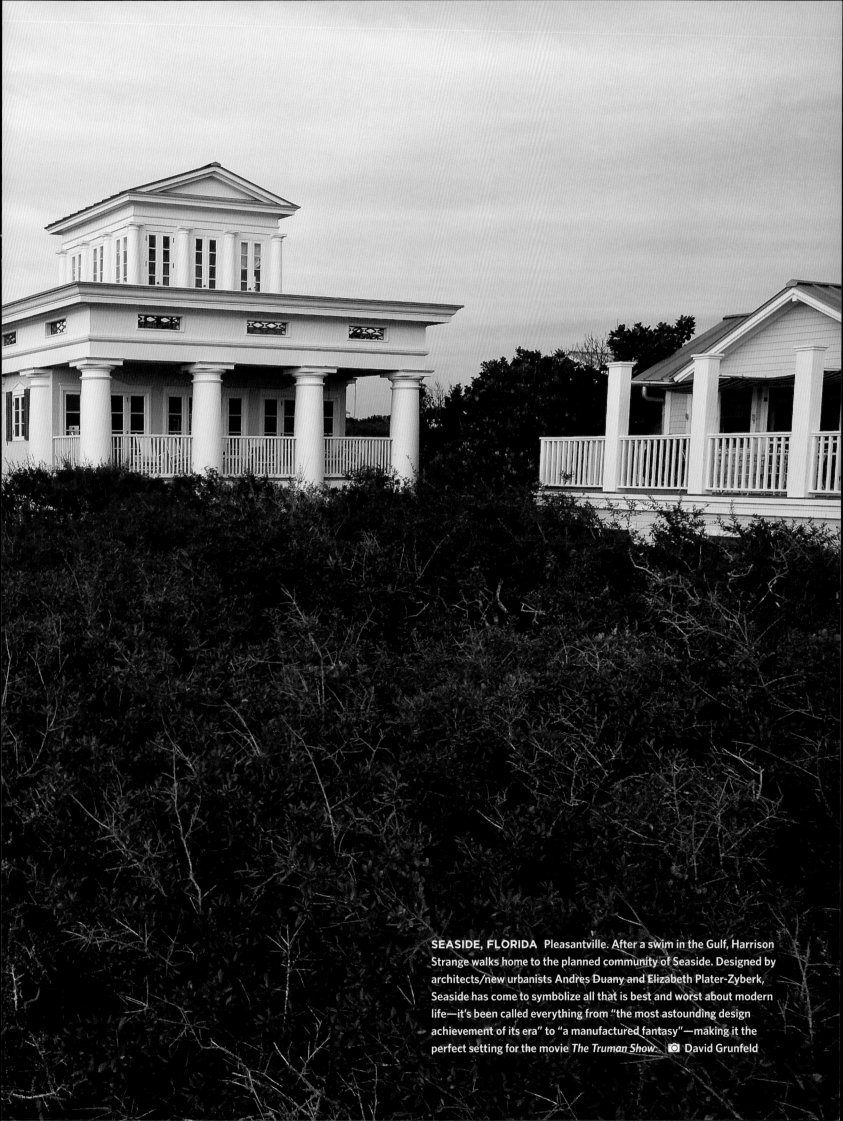

SEASIDE, FLORIDA Pleasantville. After a swim in the Gulf, Harrison Strange walks home to the planned community of Seaside. Designed by architects/new urbanists Andres Duany and Elizabeth Plater-Zyberk, Seaside has come to symbolize all that is best and worst about modern life—it's been called everything from "the most astounding design achievement of its era" to "a manufactured fantasy"—making it the perfect setting for the movie *The Truman Show.* ◎ David Grunfeld

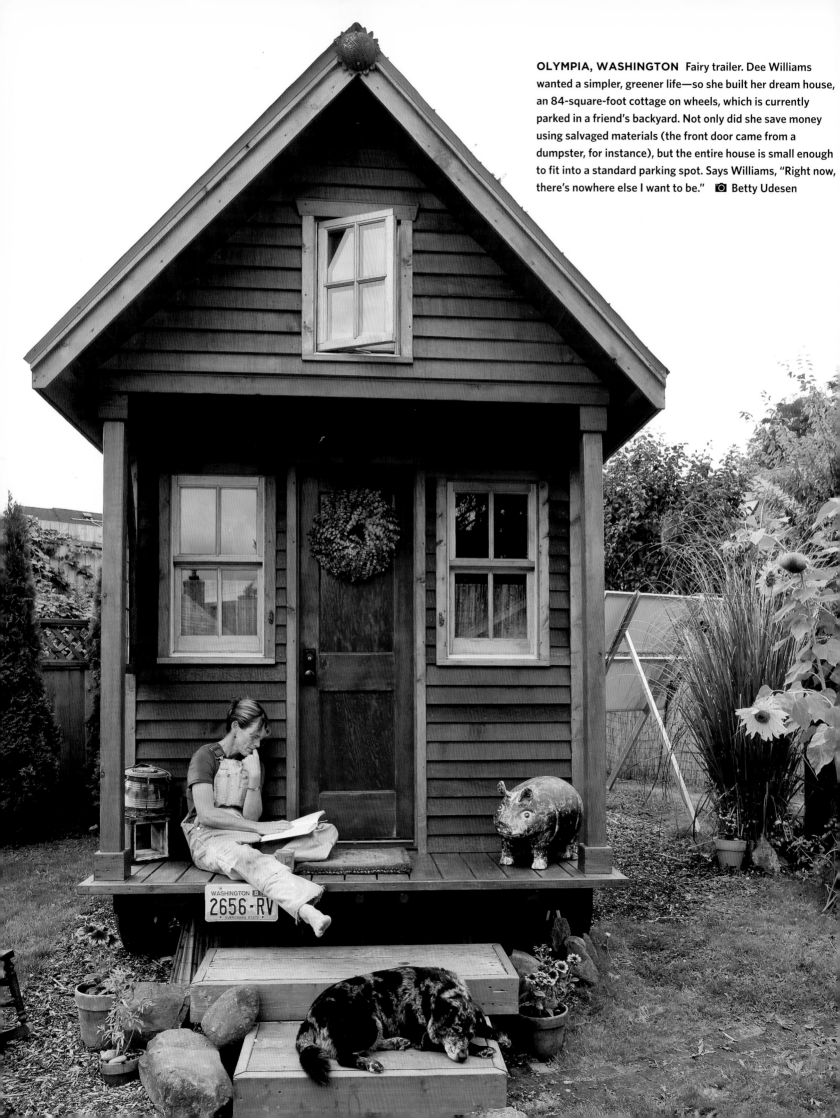

OLYMPIA, WASHINGTON Fairy trailer. Dee Williams wanted a simpler, greener life—so she built her dream house, an 84-square-foot cottage on wheels, which is currently parked in a friend's backyard. Not only did she save money using salvaged materials (the front door came from a dumpster, for instance), but the entire house is small enough to fit into a standard parking spot. Says Williams, "Right now, there's nowhere else I want to be." 📷 Betty Udesen

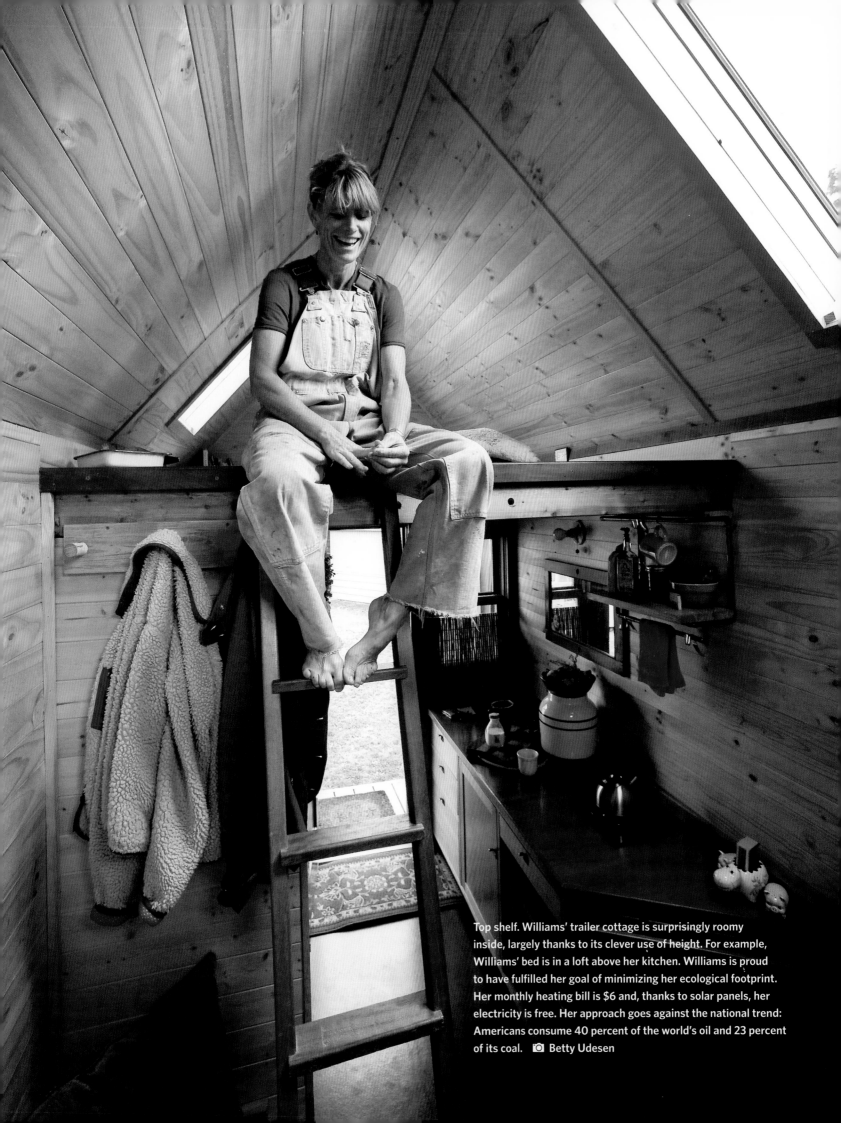

Top shelf. Williams' trailer cottage is surprisingly roomy inside, largely thanks to its clever use of height. For example, Williams' bed is in a loft above her kitchen. Williams is proud to have fulfilled her goal of minimizing her ecological footprint. Her monthly heating bill is $6 and, thanks to solar panels, her electricity is free. Her approach goes against the national trend: Americans consume 40 percent of the world's oil and 23 percent of its coal. 📷 Betty Udesen

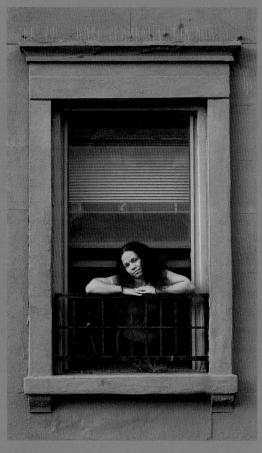

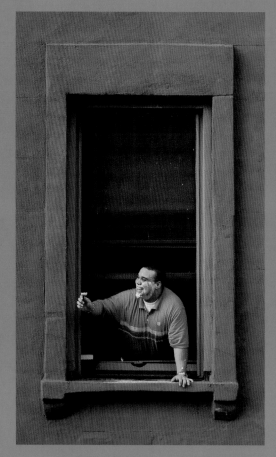

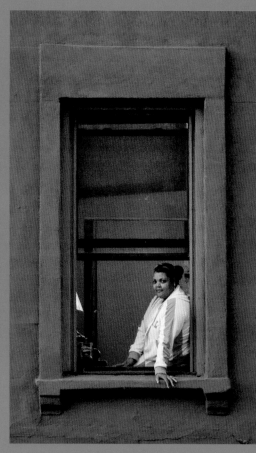

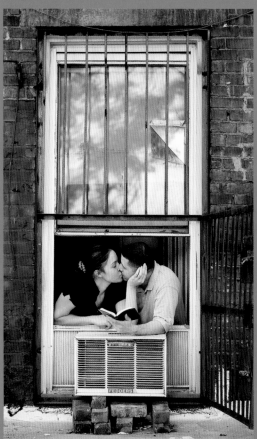

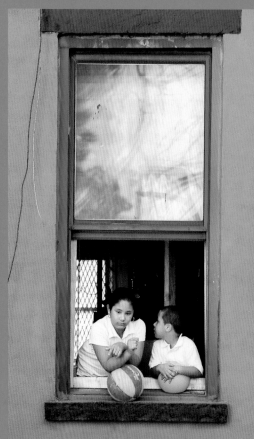

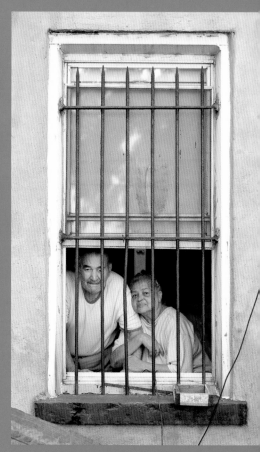

NEW YORK, NEW YORK Windows on a world. Residents of 116th Street in the Puerto Rican section of East Harlem are photographed in their windows. Daniel Batiz (seen shaving, top row, second from left) is a 22-year-old student; he has lived on this block all his life. So has Bilma Jimenez, 49 (top row, third from left), who is a cook. Members of the extended Morales family—grandparents, parents, and cousins—all live in this neighborhood, including Tanya, 26 (top row, far left), a bank supervisor, and Luis and Jennifer (bottom row, far left). Also pictured in the top row are Jose and Ines Palma (third

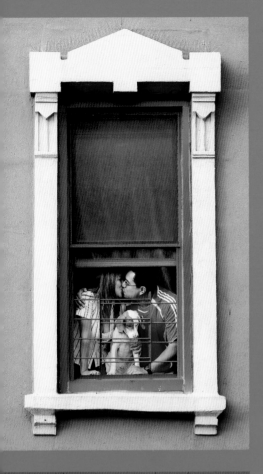

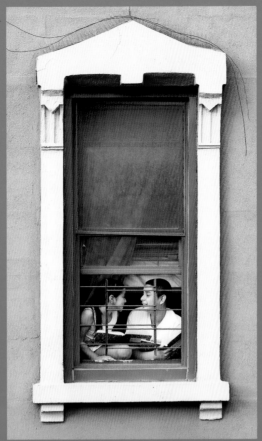

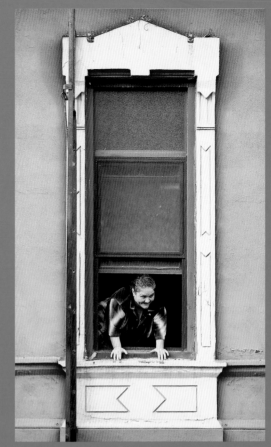

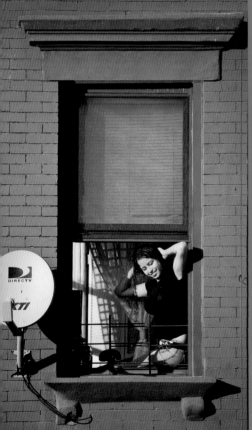

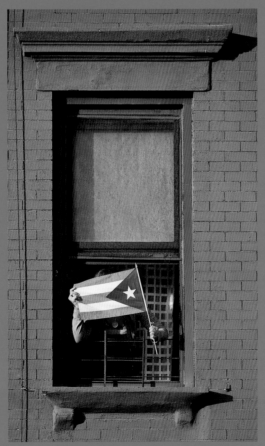

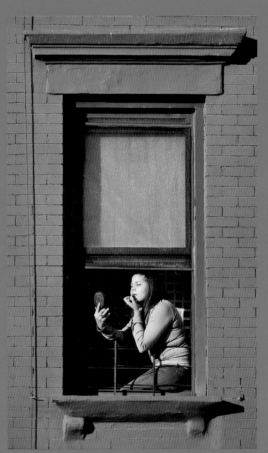

rom right) and their children, Andres and Kimberly (second from right), along with Ana Diaz (far ight). In the bottom row are Felix and Brianna Rivera (second from left), Ricardo and Virginia Viera third from left), Crystal Rivera (third from right), and Linabel Del Villal (far right). Says Tanya Morales, who was also born here, "It's the kind of neighborhood where we all look out for one nother. Even if we don't know other people's names, we know who they are, where they live, and heir kids. We all have each other's back." 📷 Julio Bittencourt

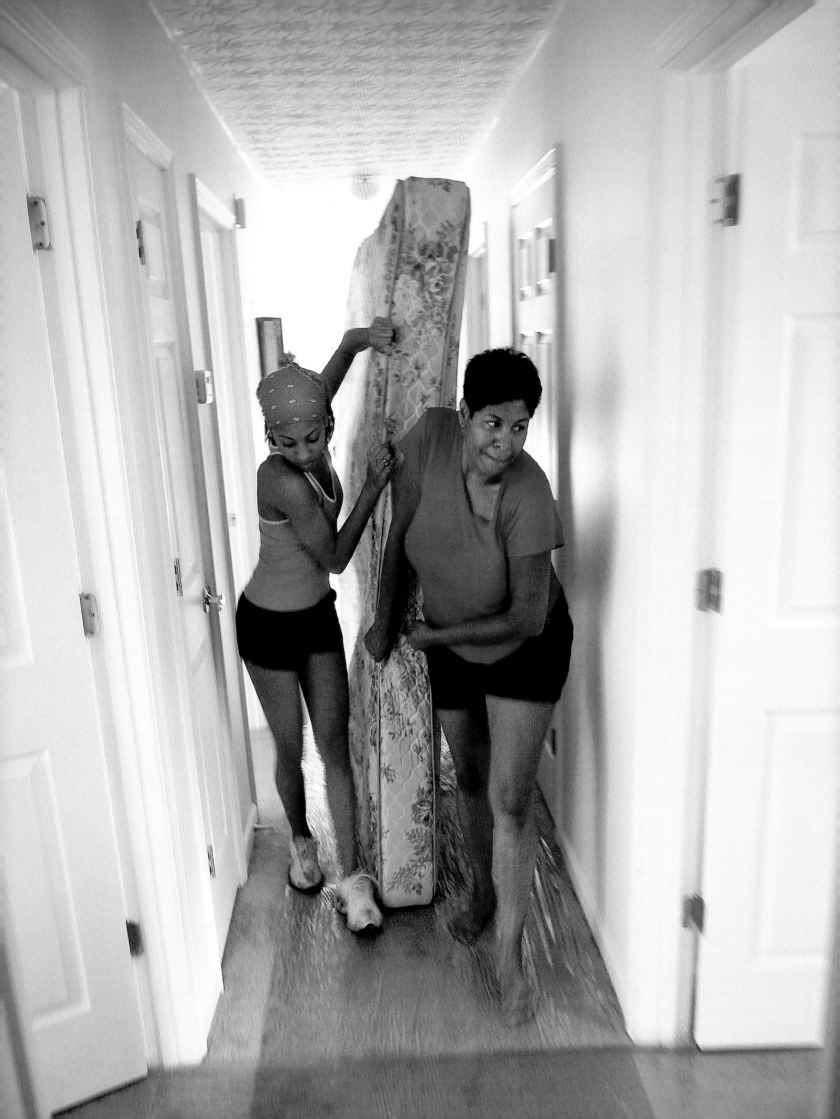

[American women average an hour less free time per day than men do.]

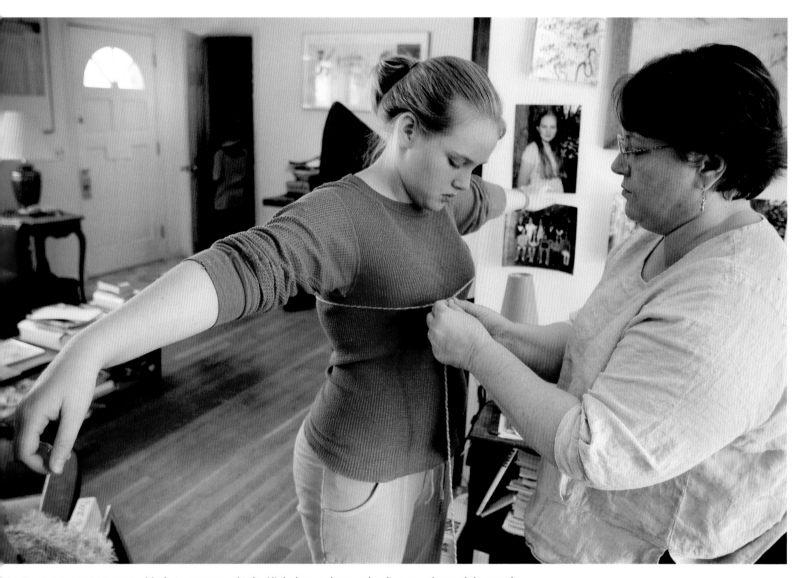

BALTIMORE, MARYLAND Made to measure. At the Kight house, homeschooling goes beyond the usual curriculum. Mother Kristen uses the Waldorf teaching method with Berit, 12, and the Jemicy and Calvert program with Dana, 9. She also instructs her daughters in practical skills like making a sweater. Fifteen percent of parents who homeschool say they do so to build their children's character. 📷 Susan Biddle

LUSTELL, GEORGIA Home sweet first home. Margot Corhern, 45, and er daughter Morgan, 19, move a mattress into their new home, provided y Habitat for Humanity. To earn the house, Margot put in more than 300 ours of work with Habitat (including 220 hours on her own future home). reviously the Corherns had rented apartments, moving every couple of ears. Founded in 1976, Habitat for Humanity has built 225,000 houses for e needy around the world. 📷 Erik S. Lesser

[As many as 3.5 million people experience homelessness
in a given year—one percent of the U.S. population.]

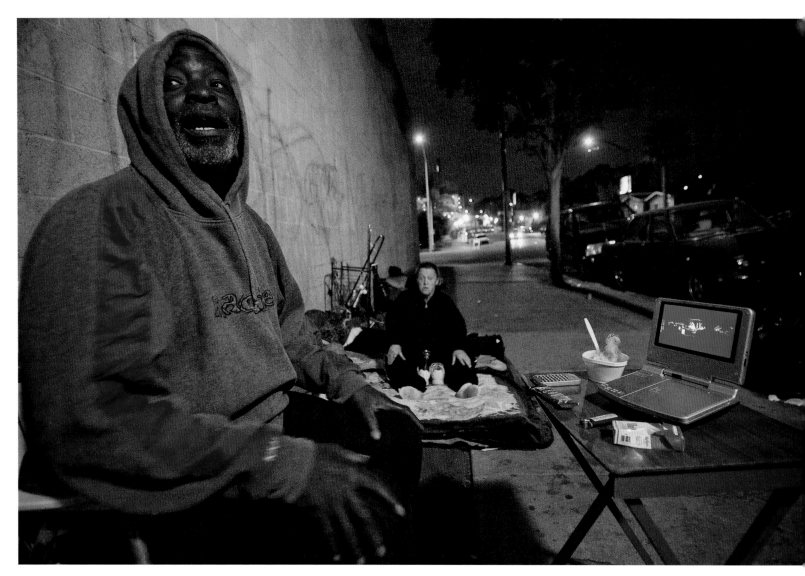

SAN DIEGO, CALIFORNIA Night moves. Anthony Robinson and Belinda Darby are from very different backgrounds: she comes from money and has a PhD in computer science; he was a poor kid from South Carolina who had trouble with the law. They found each other on the street, and now Darby is pregnant. Each night Robinson sets out their blankets and erects a shaky wooden table. And while Darby sleeps, Robinson gathers partially full cans from local dumpsters to keep them fed—then settles in to watch a DVD. 📷 Peggy Peattie

[American women with children under the age of 6 spend an average of 1½ hours a day watching television. Men without children spend an astounding 4½ hours per day.]

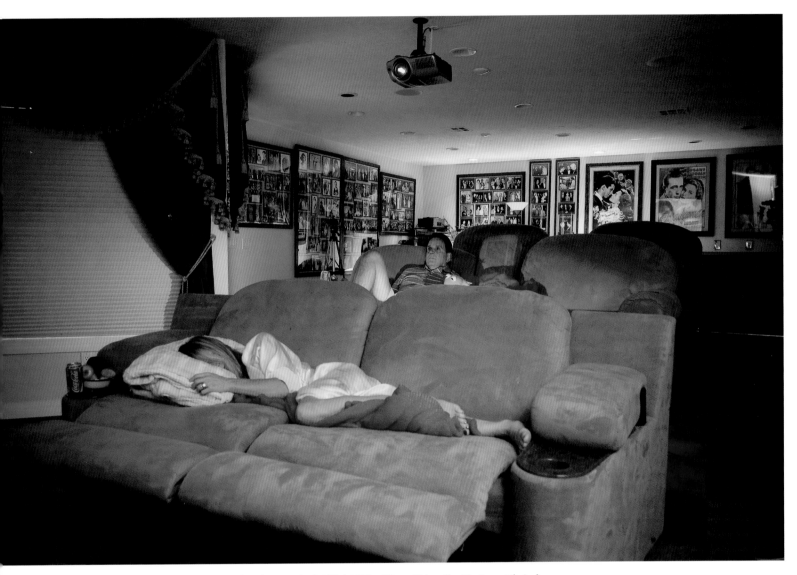

LAS VEGAS, NEVADA First impression. Legendary impressionist Rich Little, 69, and his wife, Marie, settle in for an afternoon watching old movies in their Las Vegas home theater. Marie likes to lie on the front-row couch, while Rich, an avowed movie buff, prefers to watch from his customary spot in the second row. The couple have been married for four years. 📷 Brad Zucroff

NEWPORT, RHODE ISLAND A gift from Grandma. Dollie Briggs has taken the last acre of what was once a mansion and eight-acre family estate and created a distinctive new home out of a tiny gardener's shed and four greenhouses. An avid gardener, Briggs still manages to keeps things green and blooming despite having 40 pets to care for. ◎ C.M. Glover

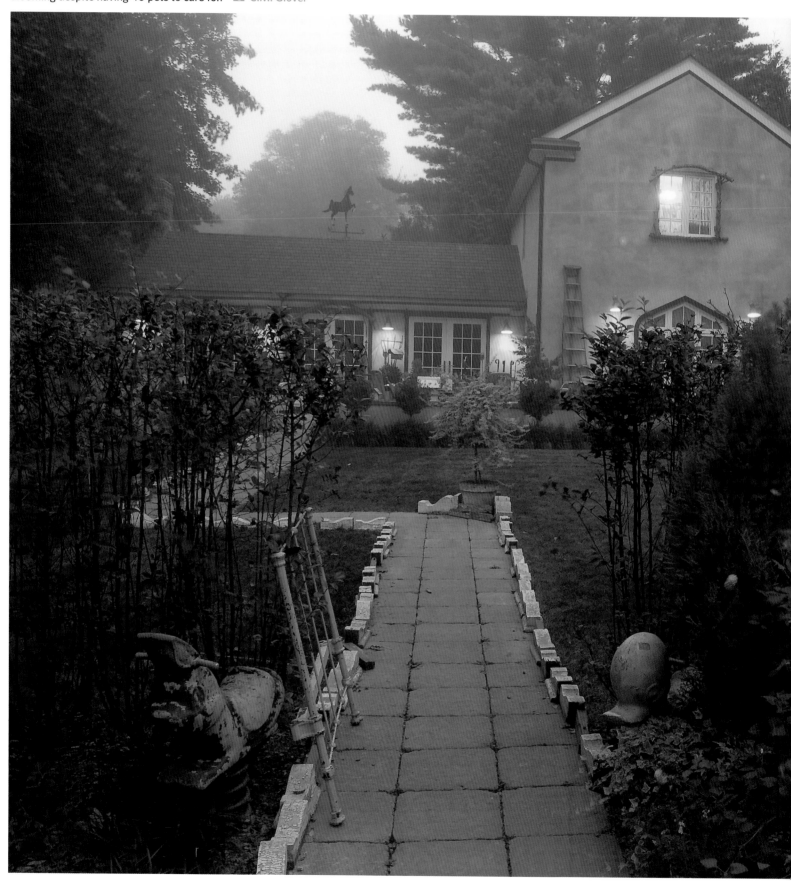

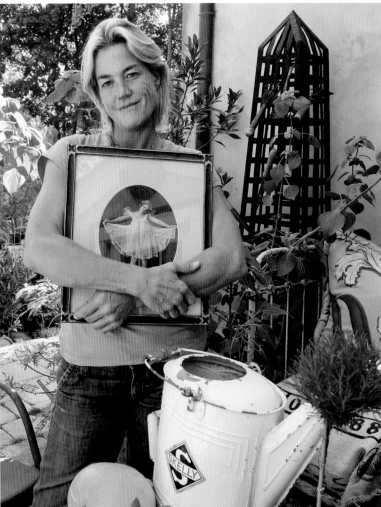

The treasures that remain. Standing on her kitchen terrace, Dollie Briggs holds a photo of her grandmother, Carolyn Skelly, who lived in the 36-room Bois Doré mansion next door. Skelly, once known as the number-one jewelry-robbery victim in America, lost more than $20 million worth of jewelry to theft. When she died at age 93, she left Dollie little more than the outbuildings and this cherished photograph. C.M. Glover

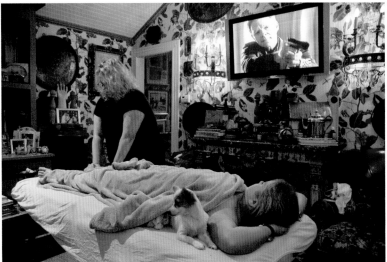

Hold it right there. Daisy Briggs gets a massage from family friend and jewelry designer Julie Basil Pierce as both watch *CSI Miami*. It's a weekly ritual for the pair, which they've dubbed "Murder and Massage." C.M. Glover

EUCLID, OHIO Out of time. Homeowner Laura Camp reluctantly surrenders her house keys to Deputy Bob Dvoroznak and his partner, Deputy Dave Rowe of the Cuyahoga County Sheriff's Department, as they arrive to officially evict her from her home on Ball Avenue in Euclid, Ohio. The house is nearly empty because Camp and her family have already moved their belongings outside. ◎ David Ahntholz

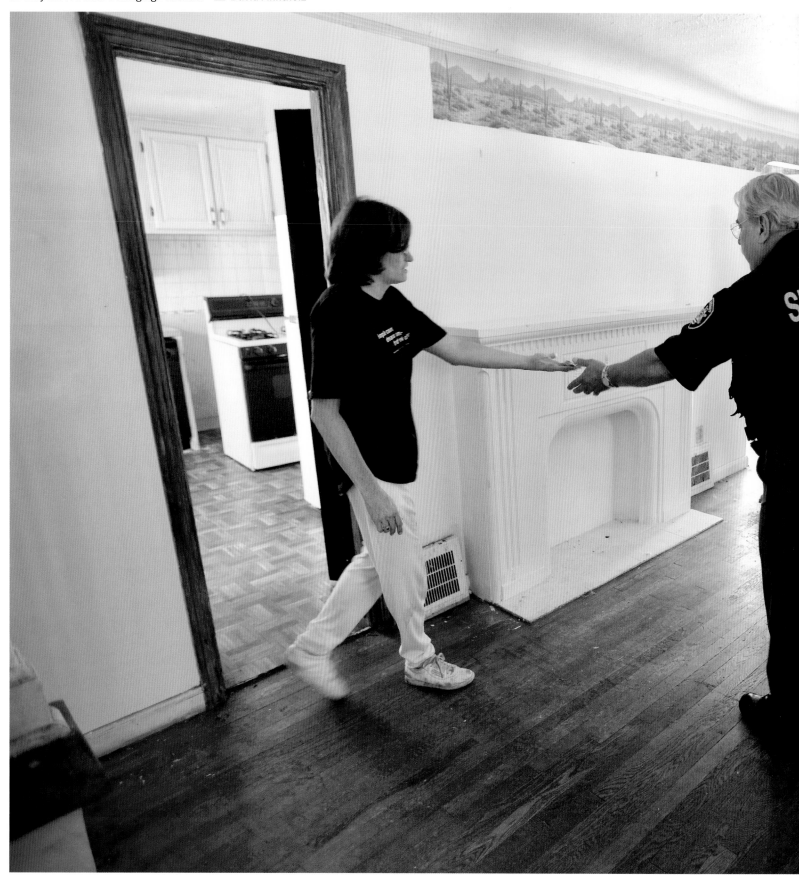

[More than two million families were evicted from their homes in the past 12 months as a direct result of the sub-prime mortgage crisis.]

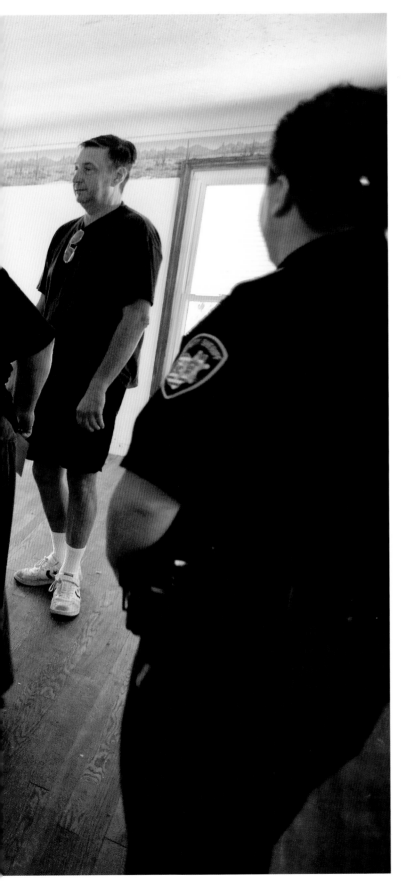

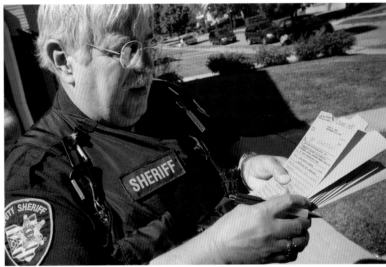

CLEVELAND HEIGHTS, OHIO A day's worth of bad news. Deputy Bob Dvoroznak goes through the stack of evictions on Desota Avenue for this shift. It currently takes about a year from the time homeowners start receiving notices to the day they are evicted from their homes. 📷 David Ahntholz

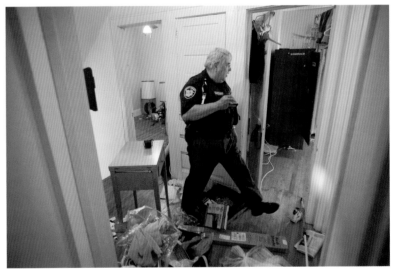

CLEVELAND HEIGHTS, OHIO All we leave behind. Deputy Bob Dvoroznak inspects a vacant house during his daily foreclosure eviction duties. A locksmith is also on hand to change the locks. An estimated 10,000 of Cleveland's 84,000 single-family homes are currently empty. In some parts of the surrounding county, where the foreclosure rate is the second highest in America, entire streets are being abandoned. 📷 David Ahntholz

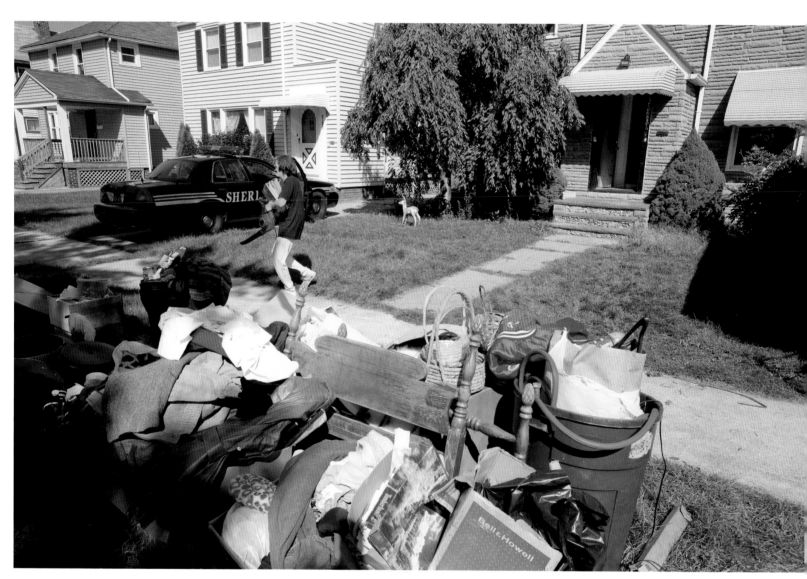

EUCLID, OHIO What you choose to save. Homeowner Laura Camp carries the last items out of her home, from which she has just been evicted. The lawn is covered with items destined for county-provided storage. Camp claims that her lawyer failed to file her bankruptcy paperwork. Now it's too late. Because so many empty houses quickly begin to deteriorate, some local cities mow the lawns every two weeks just to keep the street presentable. 📷 David Ahntholz

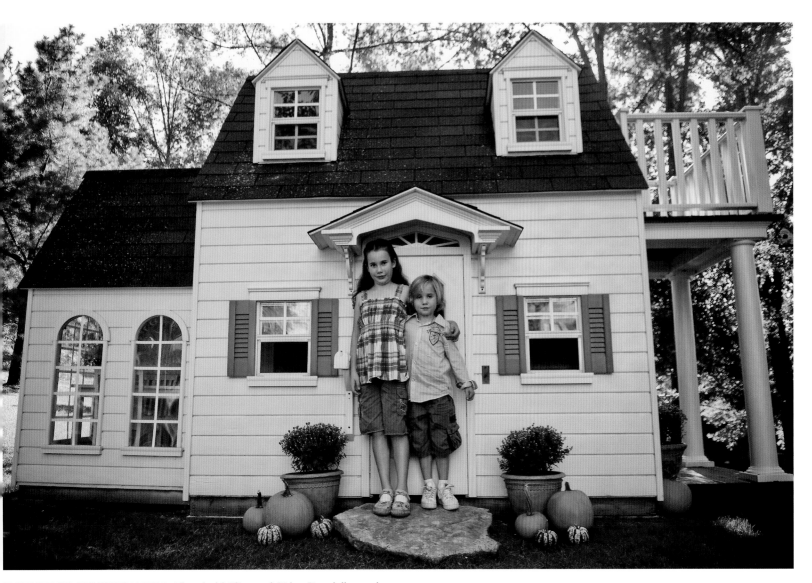

MCMURRAY, PENNSYLVANIA Threshold. Elise and Aidan Dowdall spend every summer moment in their backyard playhouse. The $10,000, 90-square-foot miniature manor has sponge-painted walls, simulated hardwood floors, electricity, and a sleeping loft. But when it gets dark, the siblings still prefer their own beds at home. 📷 Annie O'Neill

[Today, the average new single-family home is 2,349 square feet.

In 1950, it was just 983 square feet.]

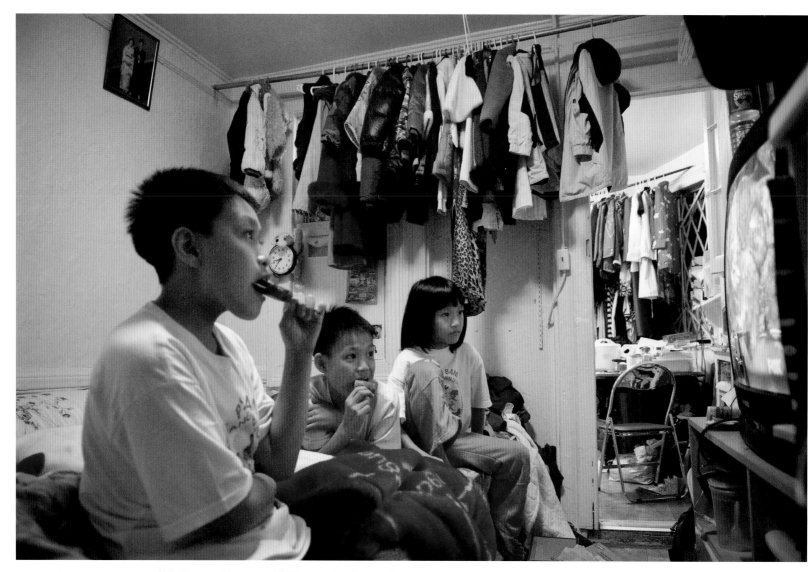

NEW YORK, NEW YORK Window to a bigger world. The Lam family crowds two Chinese-born parents and three American-born children into two tiny rooms. One serves as a combination kitchen, bathroom, living room, and dining room; the other holds four beds jammed together. Here, under the gaze of their parents' wedding photo, the Lam children watch TV. 📷 Thomas Holton

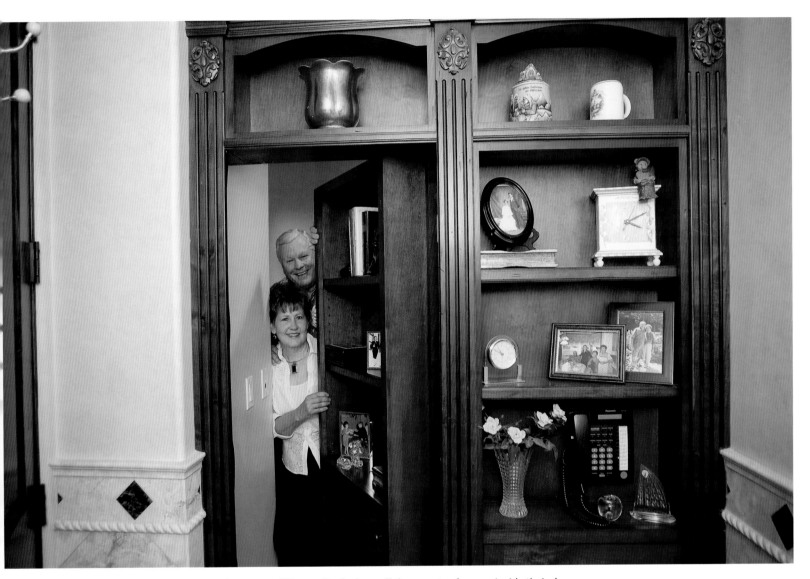

GOLD CANYON, ARIZONA Hide-and-seek. Anne and Harvey Cook show off the secret safe room inside their dream home in a gated community near the foothills of the Superstition Mountains. The room, located behind a bookcase in the master suite, has a hidden switch that quickly opens it in case of emergency or when the Cooks want to entertain any of their 13 grandchildren. An estimated 13 million thefts occur in the United States each year; nearly one-third net $50 or less. Safe rooms cost between $5,000 and $25,000. 📷 Michael Chow

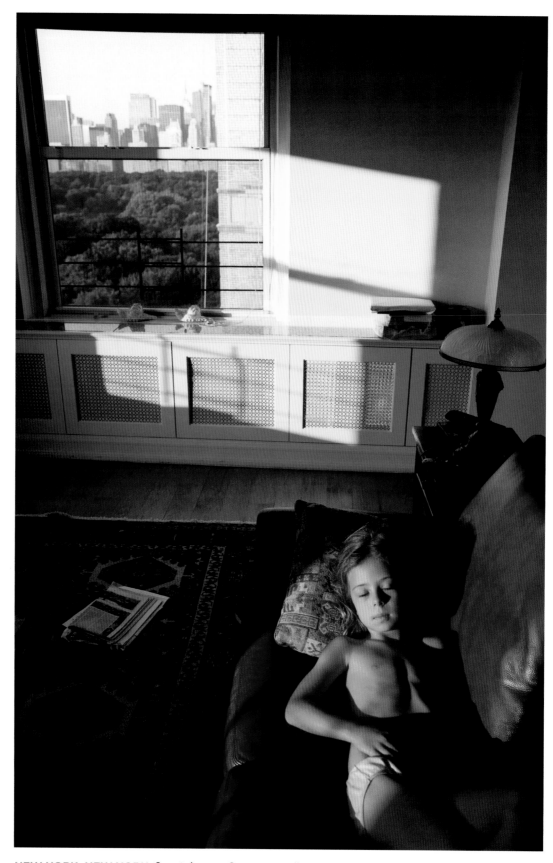

NEW YORK, NEW YORK Sweet dreams. On an unusually warm mid-September morning, Phoebe, a newly minted resident of the Upper West Side, catches a few more winks while her mother, Jennifer, prepares her favorite breakfast (oatmeal with a side order of crackers and sardines). Soon she and thousands of other second-graders will pour into buses, subways, sidewalks, taxis, and cars on their way to school. This year's main study focus: New York City. Rick Smolan

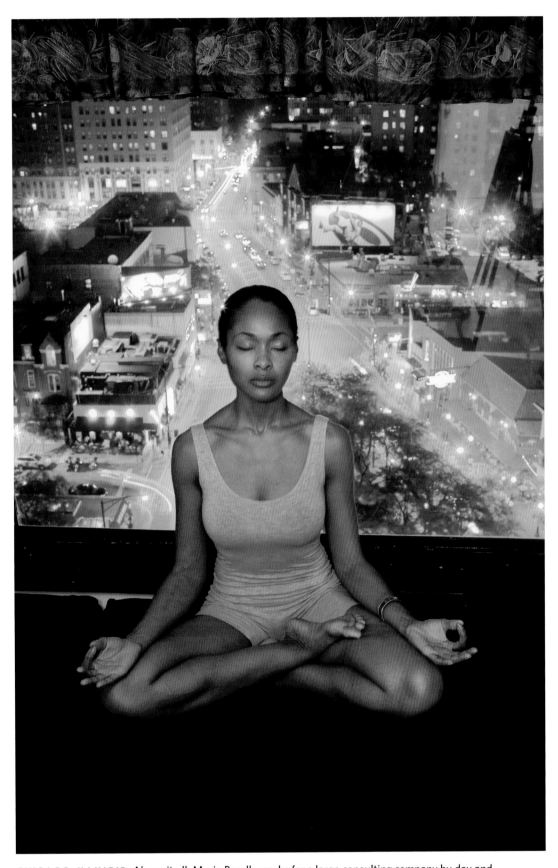

CHICAGO, ILLINOIS Above it all. Maria Barella works for a large consulting company by day and performs yoga in her downtown Chicago 19th-floor condo by night, where she has a unique view of the city that almost never sleeps. Up in her aerie, Barella finds that yoga relaxes, strengthens, and energizes her spirit. It also helps with her poetry, which she recites at open-mike events in Chicago's Gold Coast neighborhood. 📷 Mike Hettwer

HOME AND YOUR
OBSESSIONS

"SIMPLIFY, SIMPLIFY,"** Henry David Thoreau exhorted us in Walden, in which he tells how he spent two years living in a hand-built one-room shack so as to free himself from the shackles of stuff.

Me, I live in a small New York apartment whose walls are lined with eight hundred books, three thousand compact discs, and thirty-six lithographs, etchings, screenprints, woodcuts, and watercolors, and it's been five years since any of those numbers last trended downward.

Middle-class Manhattanites typically live in close quarters, and I'm no exception: I keep my saucepans in the oven and sleep in a loft. But that doesn't stop me from wedging more stuff into my Upper West Side home, whose neatness (for I am very neat) arises from the fact that my closets are so full that the only way I can cram something new into them is to throw out something old.

I am, in other words, a collector, and chances are that so are you. Most Americans are collectors, though some are more systematic about it than others. The works of modern American art that I own, for instance, are a collection in every sense of the word, so much so that a friend recently started referring to my apartment as "the Teachout Museum." Not that any of my pieces are priceless—I'm big on eBay—but they still amount to something more than a bunch of miscellaneous prints.

That's how you know you've amassed a collection: the whole is greater than the sum of its parts, which is a polite way of saying that you own too damn much of something for any immediately obvious purpose. My father collected mugs—but why? What did he get out of looking at the shelves on which dozens of dusty mugs were arranged as carefully and lovingly as I now hang the prints by John Marin, Milton Avery, Hans Hofmann, and Fairfield Porter that grace the walls of my living room? It never occurred to me to ask him. The mugs were as much a part of him as his deep voice, and that was that.

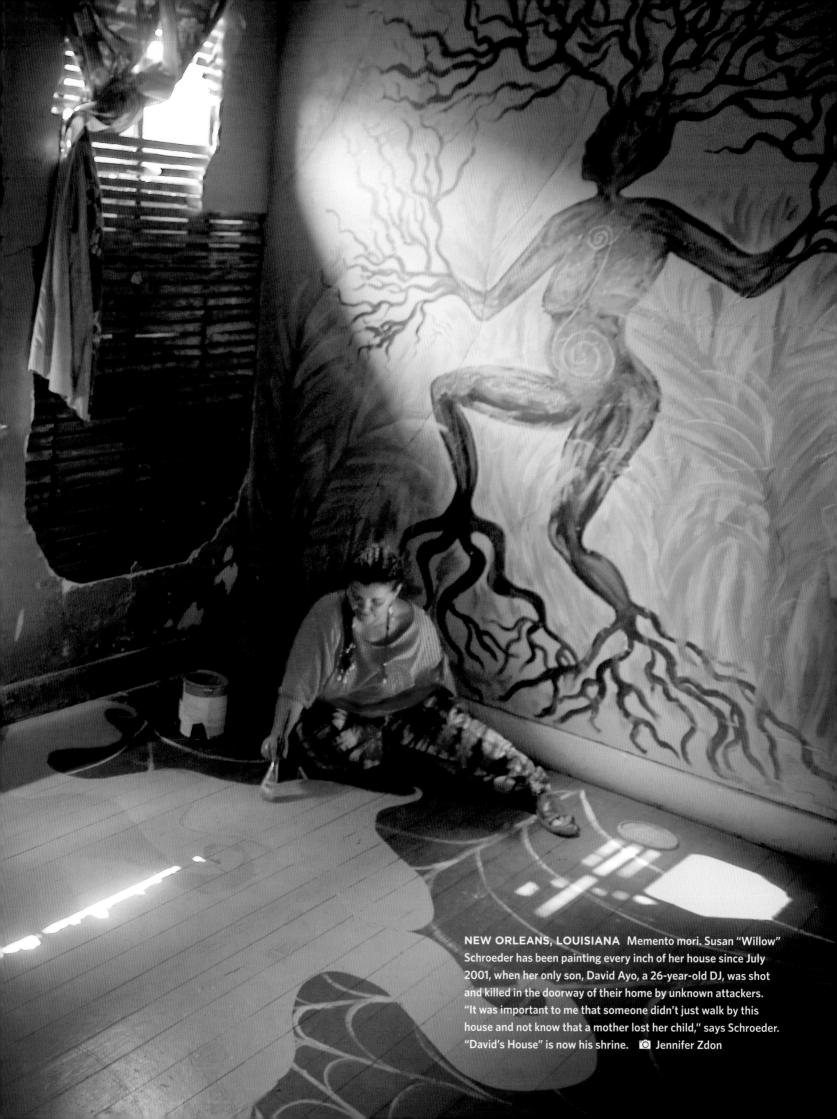

NEW ORLEANS, LOUISIANA Memento mori. Susan "Willow" Schroeder has been painting every inch of her house since July 2001, when her only son, David Ayo, a 26-year-old DJ, was shot and killed in the doorway of their home by unknown attackers. "It was important to me that someone didn't just walk by this house and not know that a mother lost her child," says Schroeder. "David's House" is now his shrine. 📷 Jennifer Zdon

RUTLAND, OHIO Half-pipe to heaven. Micah Friedman, founder of the immense Skatopia skating park, lives in a shack out back, which gives him 24/7 access to the facility, including the giant half-pipe he is using here. His 2-year-old daughter often joins him for a pre-bedtime loop in lieu of a bedtime story. Skatopia has the singular honor of being a level in "Tony Hawk's Underground 2," a hugely popular skateboarding video game. 📷 Christina Paolucci

Are we what we collect? Sometimes the answer is self-evident. Louis Armstrong and H. L. Mencken, who in every other way were utterly dissimilar, both preserved every scrap of personal memorabilia they could squeeze into their multistory homes. I once spent a rainy afternoon leafing through Mencken's old hospital bills. Both men, in essence, collected themselves, and with good reason, since they were great artists through whose self-collections scholars now rummage in search of insight. But even those of us who have no like claim on posterity seem no less compelled to collect something, be it mugs, lithographs, recipes, stamps, matchbooks, or plastic handbags. And while I know two collectors who have gone so far as to rent apartments devoted solely to the storage and display of their collections, it seems in the nature of most Americans to want to keep their stuff closer to home. Not a few of the finest museums in America began life as the private homes of wealthy art collectors.

Might it be that the presence of a collection, whether humble or haute, is part of what makes a house a home? If so, then it might also be that we are all self-collectors, and that our collections are, in Alec Wilder's phrase, clues to a life. Perhaps my father, who spent the middle part of his life as a traveling salesman, had a story to go with each of his mugs. I know that every one of the carefully framed family snapshots that hang on the walls of the house where he lived, and where my mother still lives, tells a little piece of the story of my family. They, too, are a collection, one of no value to anyone but my kinfolk, to whom they are as priceless as any of the Rembrandts hanging at the Met.

Needless to say, you can't take it with you, and so from time to time I make yet another virtuous but futile attempt to prune my shelves and clean out my closets. Frank Lloyd Wright, America's greatest domestic architect, was a passionate stuff-hater who actually went so far as to design houses that were intended to prevent their owners from piling up needless, life-complicating possessions. In my heart I know that he was right, and that the accumulation of too much stuff is a drag on the spirit. Yet I still can't help but smile wryly when I remember that Kentuck Knob, one of Wright's most beautiful residences, was later purchased by a British baron who collects... houses.

Terry Teachout is a blogger, a critic, and the biographer of George Balanchine and H. L. Mencken. He is at work on a biography of Louis Armstrong.

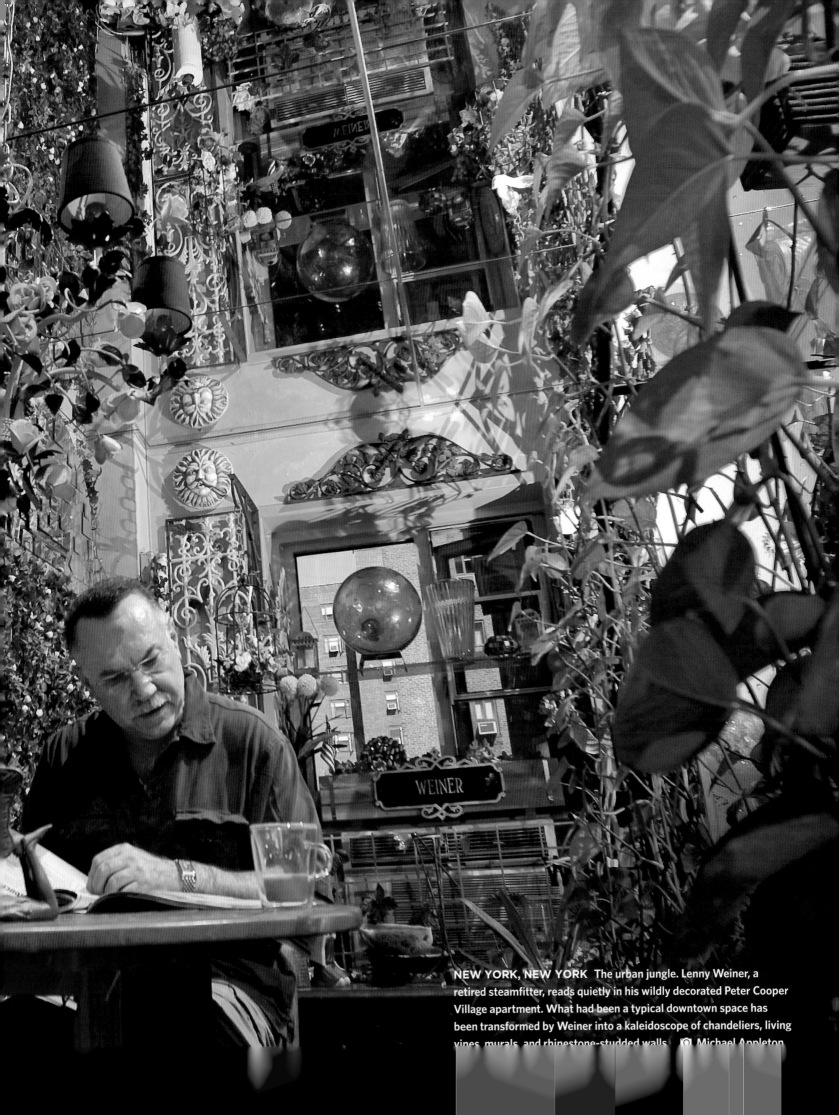

NEW YORK, NEW YORK The urban jungle. Lenny Weiner, a retired steamfitter, reads quietly in his wildly decorated Peter Cooper Village apartment. What had been a typical downtown space has been transformed by Weiner into a kaleidoscope of chandeliers, living vines, murals, and rhinestone-studded walls. © Michael Appleton

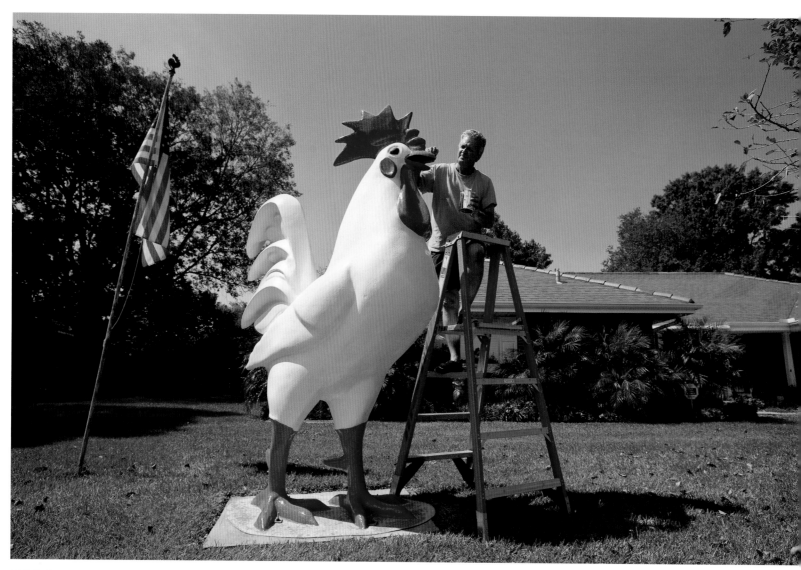

LULING, LOUISIANA Touch-up time. Roy Ledet Jr., 58, applies the annual fresh coat of paint to the beak of 12-foot Big Joe, the star of his wife Dianna's collection of thousands of chicken statues. Dianna purchased Big Joe as a birthday present for herself in 2003. "He is my pride and joy," she says. Neighborhood children love to get their picture taken atop him. But mischievous high schoolers beware: Big Joe is on camera 24/7. 📷 Jennifer Zdon

[Americans spent some $41 billion more than they earned last year, with an average of nearly 13 credit cards per household.]

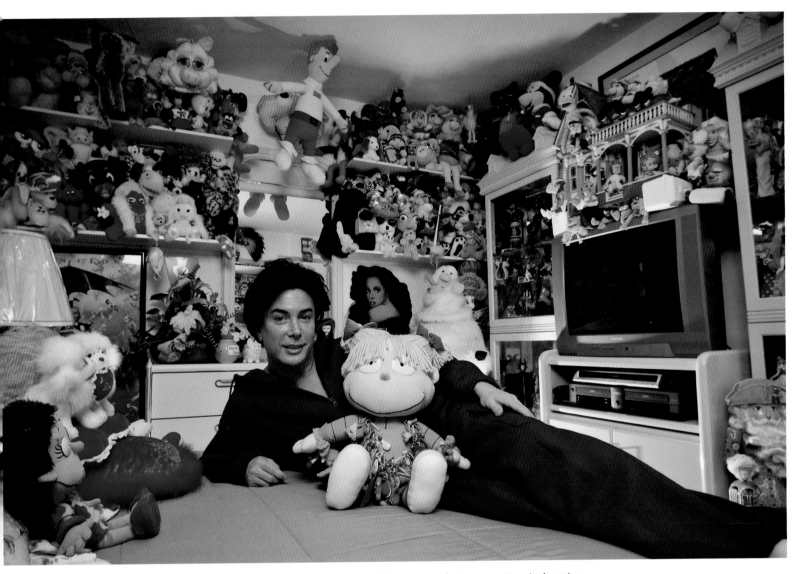

LAS VEGAS, NEVADA Character study. Frank Marino, 41, is one of the most famous female impersonators in America. The star of the *La Cage* show at the Riviera, he is best known for his impersonation of Joan Rivers. Offstage, Marino collects stuffed animals brought to the show for him by fans. When he runs out of room at home, he donates them to children's charities in the Las Vegas area. ◉ Brad Zucroff

SPRINGFIELD, PENNSYLVANIA Boys and their toys. Jeff Kimmel, Michael Panzer, and Erik and Kurt Kramer gather in Kimmel's basement to reenact the World War II battle of Arnheim. Kimmel's scale models are painted with such exacting detail that the others have dubbed the miniature village Kimmelsberg in his honor. ◎ Michael Bryant

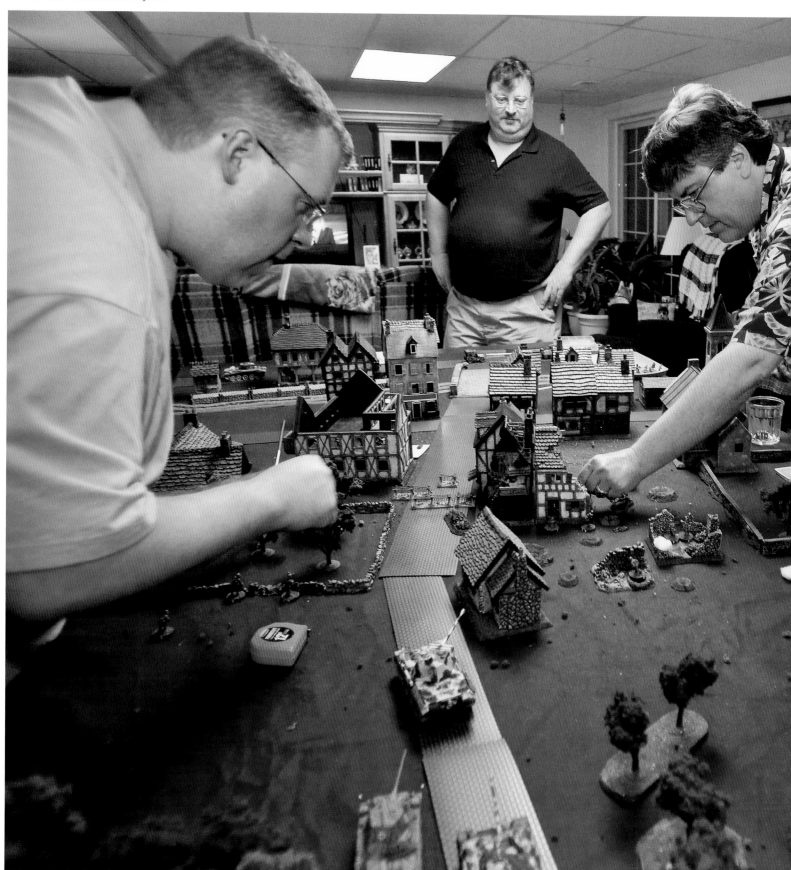

[Contrary to expectations, ordinary everyday Americans
live more than 13 years longer than most celebrities.]

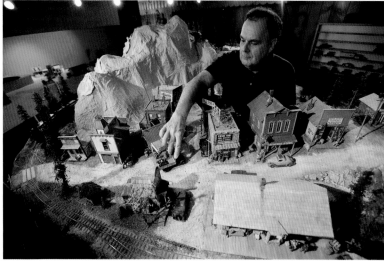

HENRIETTA, NEW YORK Master of all he surveys. Graphic designer
and illustrator David Rouse, 56, has spent 15 years constructing a basement
train set that is a near-perfect 1:43 re-creation of a 1930s Colorado mining
town. Rouse is so dedicated to the realism of his model that he uses dirt
actually brought back from abandoned mines in the Colorado Narrow Gauge
Circle. ◉ Carlos Ortiz

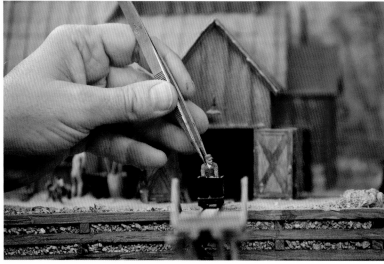

HENRIETTA, NEW YORK Precisely placed. Using tweezers, Rouse carefully
positions a figure pushing a mine car. Rouse's train set, complete with tracks,
mines, and mountains, covers more than 1,000 square feet of his basement,
almost the square footage of an average single-family home in the 1950s.
The National Model Railroad Association, founded in 1935, hosts an annual
convention that draws more than 20,000 enthusiasts. ◉ Carlos Ortiz

[When America was founded in 1776 life expectancy was 23.
By the end of this century the average American is expected to live to 100 years.]

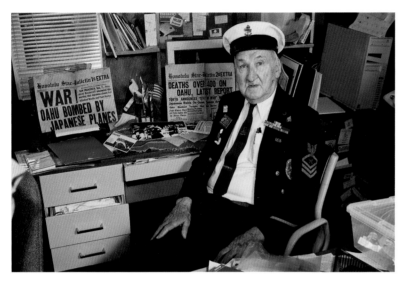

SOUTHAMPTON, MASSACHUSETTS Preserving infamy. In his home office, Edward Borucki, 86, wears his original Navy "blues," dating to his service on the USS *Helena*, docked at Pearl Harbor on December 7, 1941. Minutes after he raced to his battle station that day, the engine room where he'd been working was hit by a torpedo, killing 33 of his shipmates. Today he is one of 3 million remaining World War II veterans in the United States. 📷 Nancy Palmieri

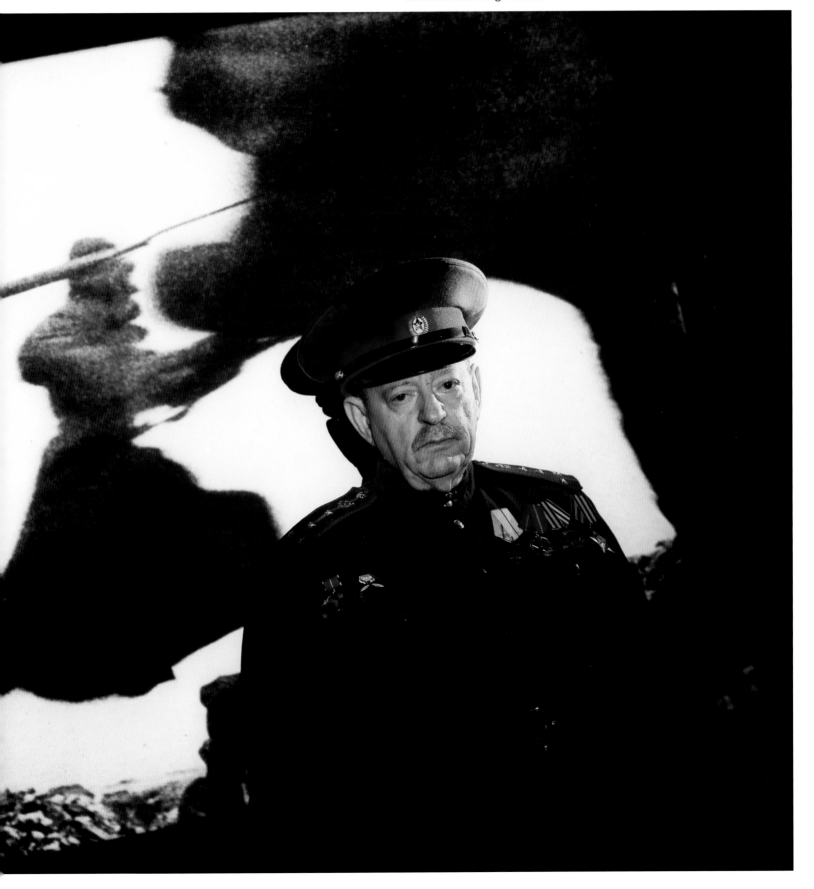

EUGENE, OREGON The face of battle. Nathan Fendrich, 73, has turned his garage into a theater for showing the 25,000 slides he has amassed on World War II and the Holocaust. For his lectures about battles on the Eastern Front—here, the Battle of Kursk—Fendrich likes to dress in a Russian general's uniform to add to the experience. The United States currently has an estimated 24 million surviving veterans. Brian Lanker

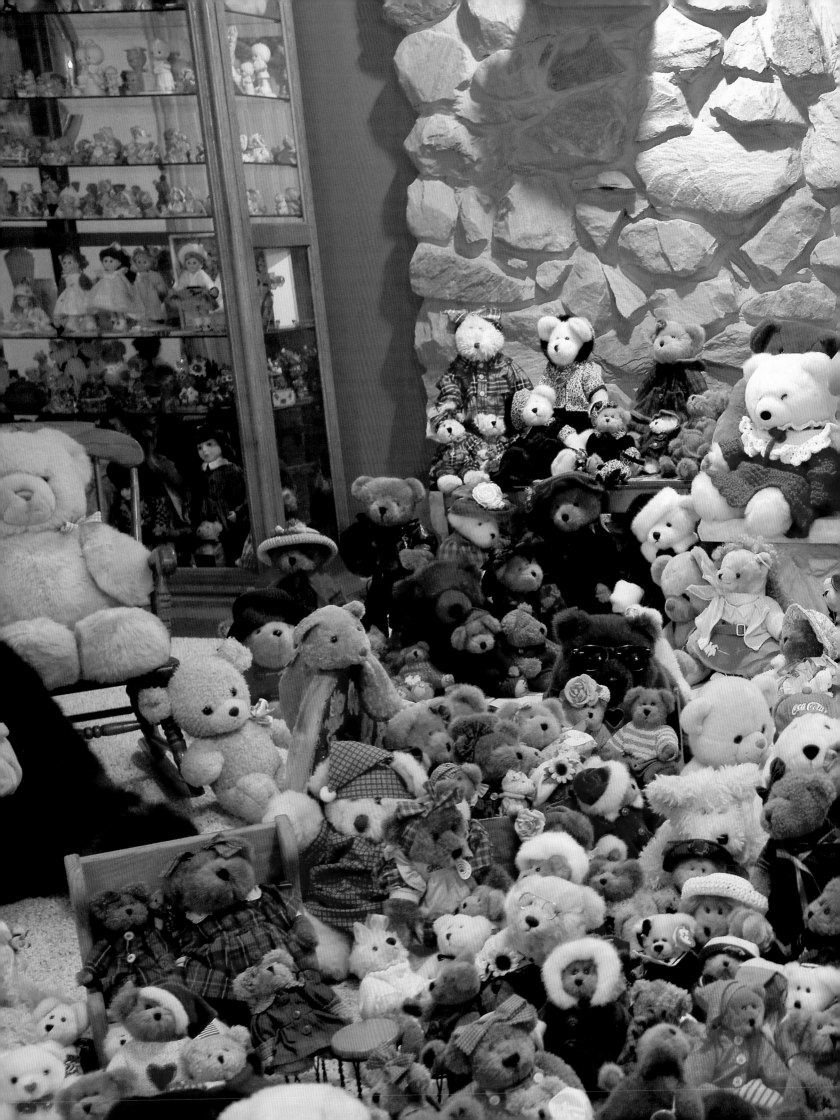

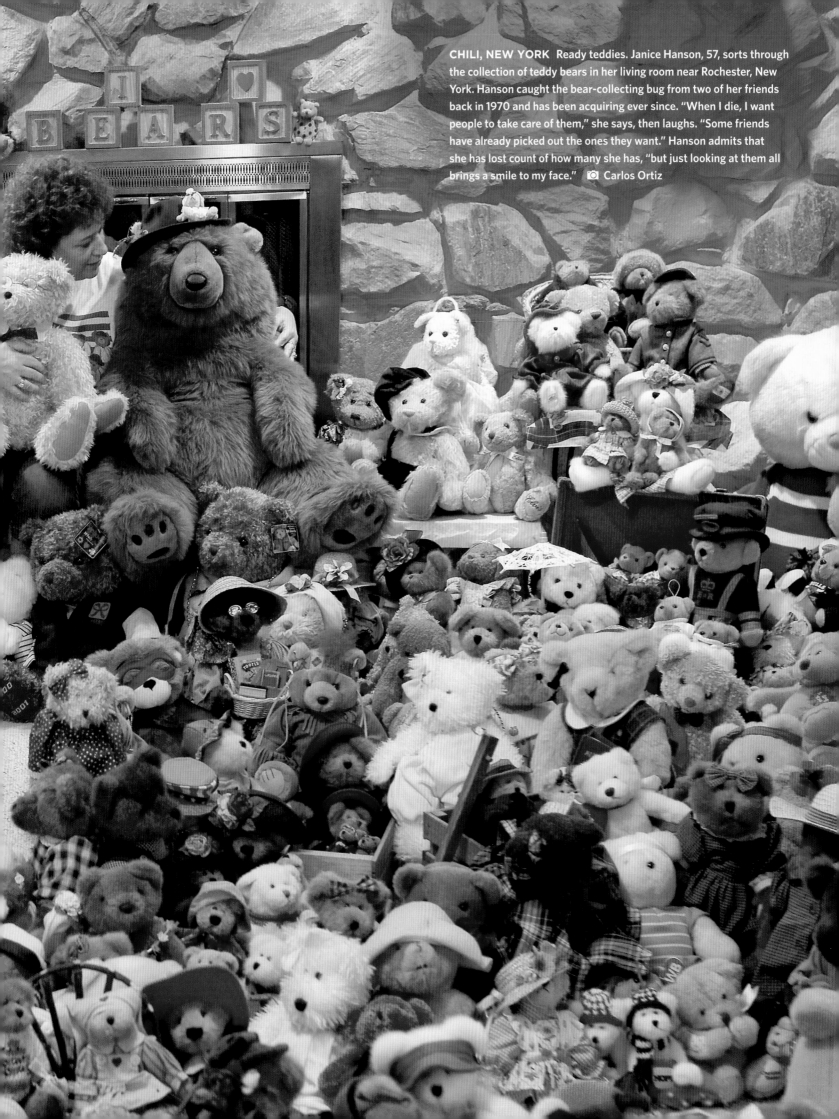

CHILI, NEW YORK Ready teddies. Janice Hanson, 57, sorts through the collection of teddy bears in her living room near Rochester, New York. Hanson caught the bear-collecting bug from two of her friends back in 1970 and has been acquiring ever since. "When I die, I want people to take care of them," she says, then laughs. "Some friends have already picked out the ones they want." Hanson admits that she has lost count of how many she has, "but just looking at them all brings a smile to my face." 📷 Carlos Ortiz

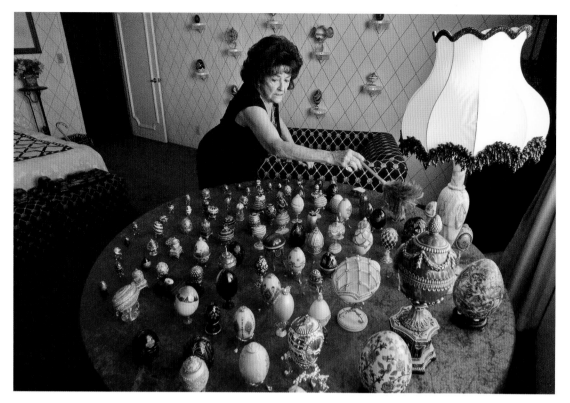

LAS VEGAS, NEVADA A light dusting. Longtime Vegas performer Toni Hart lives in Las Vegas's largest house, the 51-room Hartland Mansion, with her two sons. In addition to the eight bedrooms and 13 baths, the home has an Elvis Room where the singer would often stay, a swimming pool where Esther Williams used to practice, and the Egg Room, seen here, which houses her son Larry's jeweled egg collection. An ordained minister, Hart also performs weddings in the mansion. 📷 Brad Zucroff

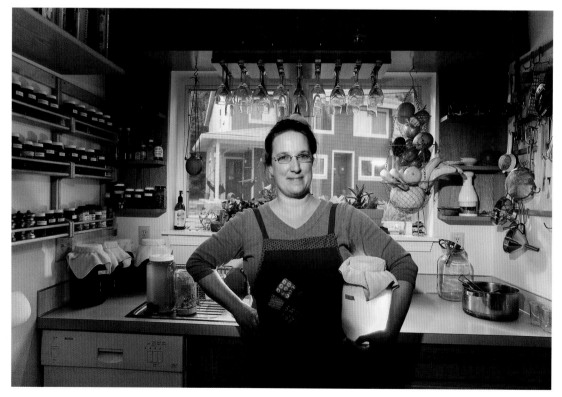

PORTLAND, OREGON Brewing ferment. Gretchen Westlight makes *kombucha*, an Asian sweetened tea fermented from a colony of bacteria and yeast cultures, in her kitchen. *Kombucha* has become hugely popular in recent years, and Westlight regularly distributes batches to neighbors. She produces *kombucha* on even-numbered days and Ethiopean wild honey wine and kefir on odd ones. 📷 Thomas Boyd

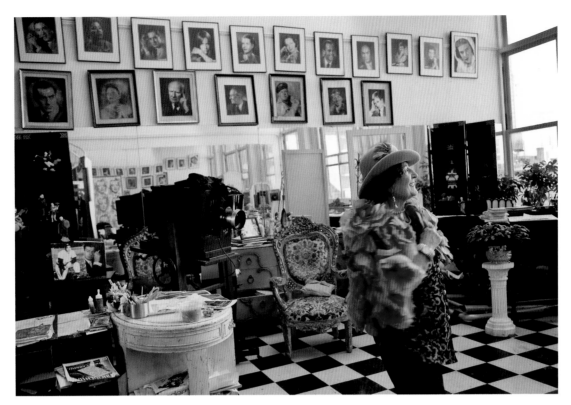

NEW YORK, NEW YORK Practice, practice. Entertainment photographer Editta Sherman stands in the pure northern light of her towering apartment/studio above Carnegie Hall. She is one of a group of longtime tenants, most of them artists, who have been fighting a long, and probably doomed, battle to keep their leases. Past tenants of these studios include Isadora Duncan, Marlon Brando, and Leonard Bernstein. 🄯 Zak Powers

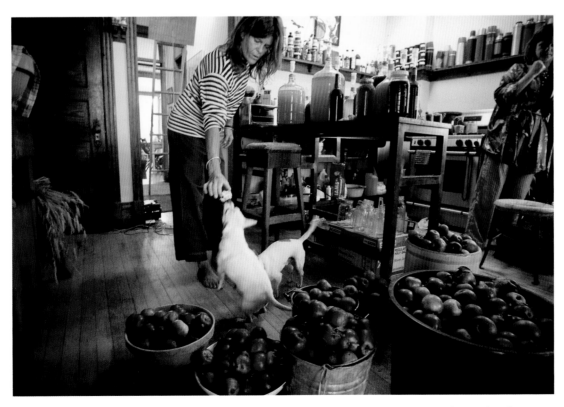

CHICAGO, ILLINOIS City country. Though she lives in the heart of Chicago's most densely populated neighborhood, Nance Klehm is dedicated to living an ecologically sound life connected to the land. To that end, she grows, composts, pickles, and ferments—and dries slices of the 300 pounds of apples that she has foraged from trees around the city. 🄯 Alex Garcia

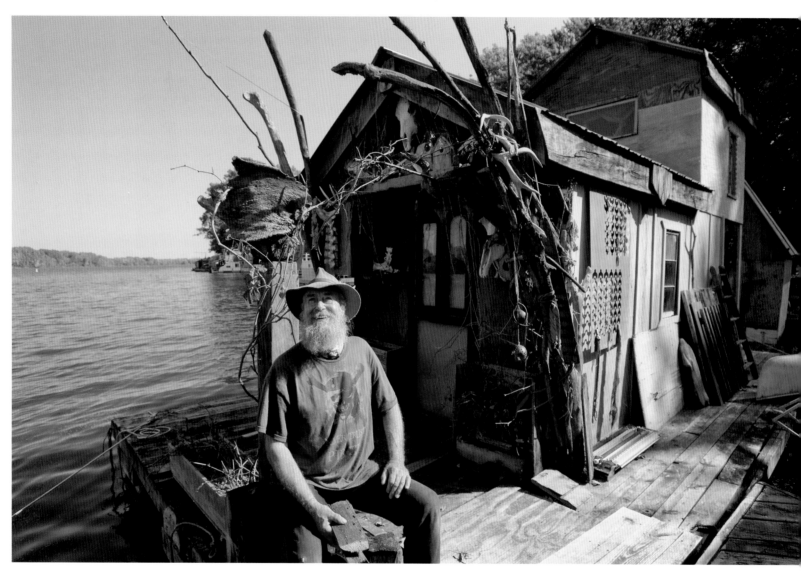

WINONA, MINNESOTA Big river. Artist Chris Parnell has lived for 23 years in a series of floating houses in the middle of the Mississippi River. Parnell owns three houseboats—one for living, one for storage, and one for the studio in which he paints and weaves. He keeps a few chickens and grows food in pots on the docks that connect the houses. But while he may have no electricity or running water, he does own a cell phone. 📷 Judy Griesedieck

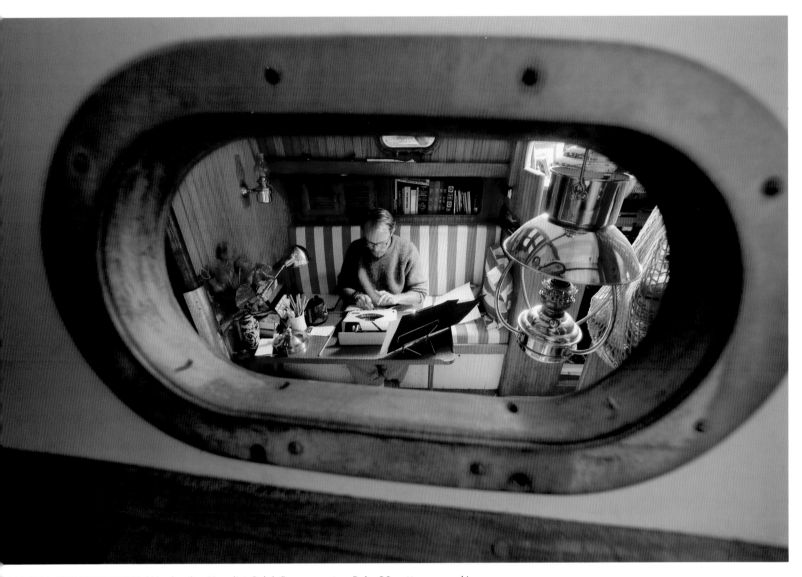

OLYMPIA, WASHINGTON Word sailor. Novelist Caleb Rogers rents a Baba 30 cutter moored in Olympia's West Bay Marina and finds the solitude perfect for his disciplined work schedule: "I write from 8:30 in the morning until 10 at night, with a break for tea and errands," he says. 📷 Betty Udesen

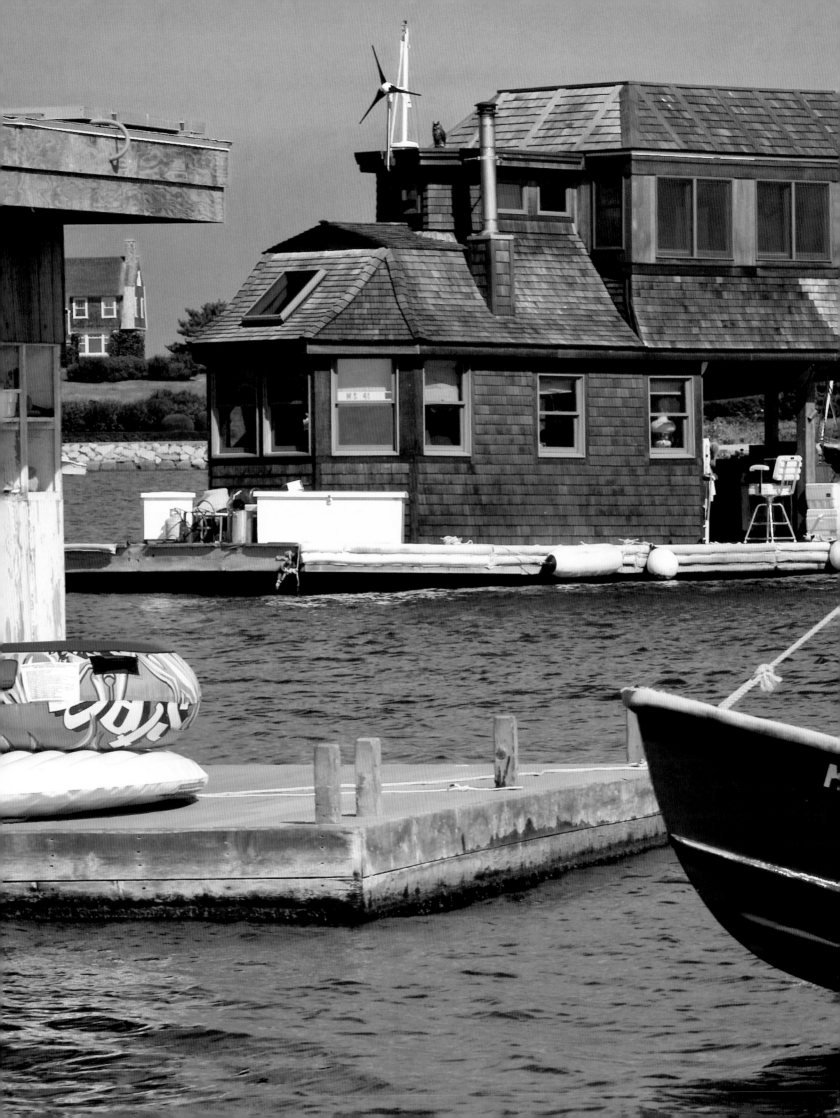

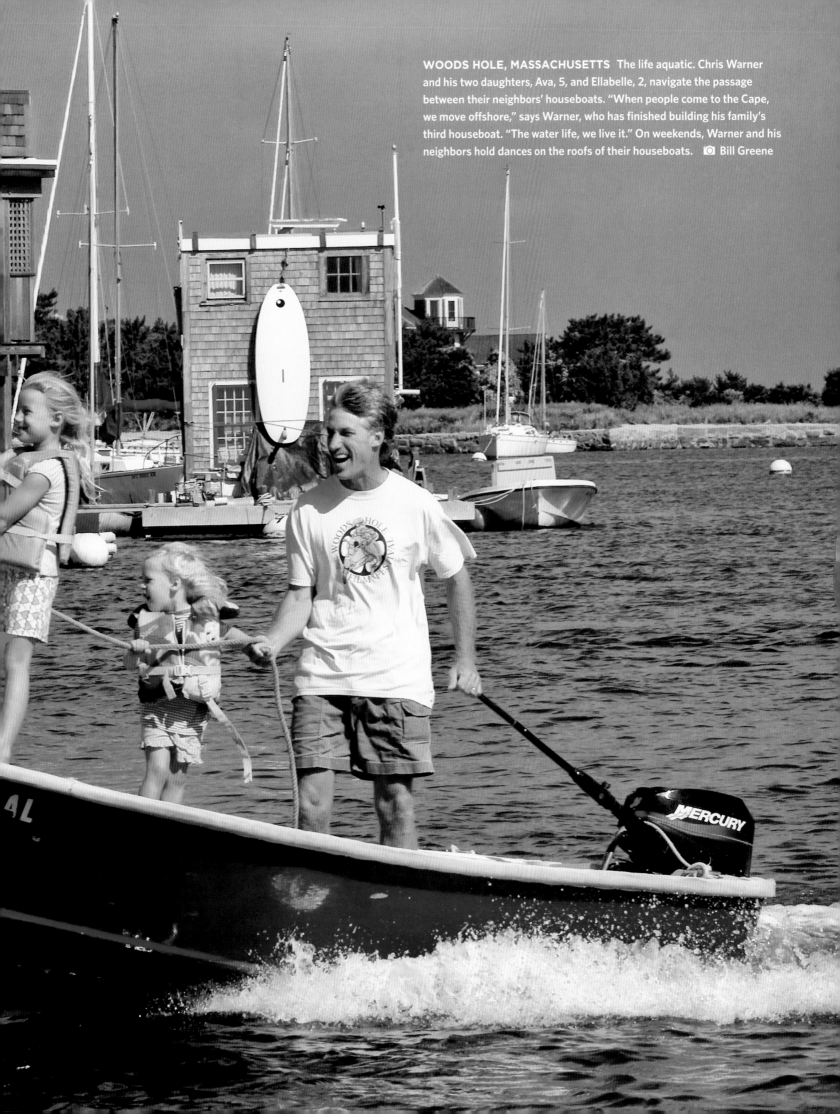

WOODS HOLE, MASSACHUSETTS The life aquatic. Chris Warner and his two daughters, Ava, 5, and Ellabelle, 2, navigate the passage between their neighbors' houseboats. "When people come to the Cape, we move offshore," says Warner, who has finished building his family's third houseboat. "The water life, we live it." On weekends, Warner and his neighbors hold dances on the roofs of their houseboats. 📷 Bill Greene

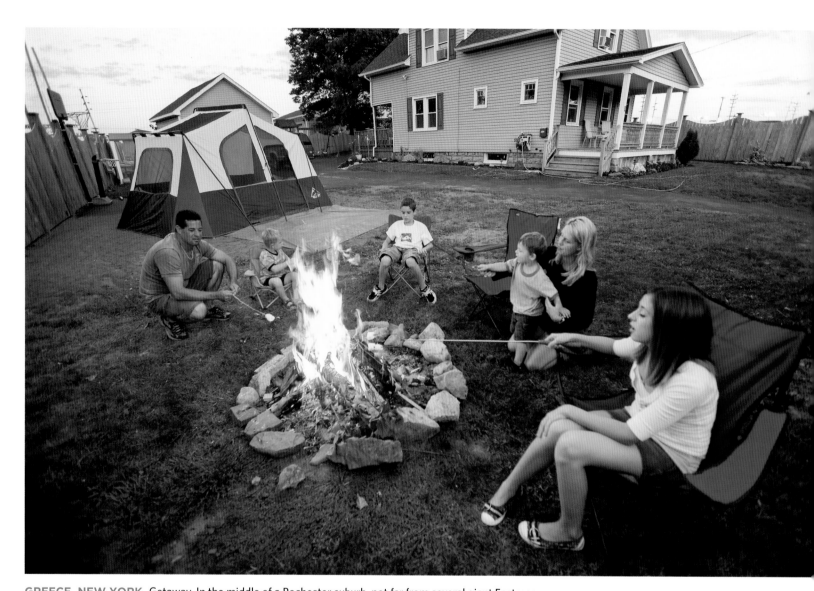

GREECE, NEW YORK Getaway. In the middle of a Rochester suburb, not far from several giant Eastman Kodak plants, the Tudisco family enjoys a weekly camping trip to an exotic location: their own backyard. The entire family—father Anthony, 40; Gavin, 5; Jacob, 9; Anthony Jr., 2; mother Keri, 34; and Chelsea, 13—enjoys a marshmallow roast at "Camp Tudisco." "With such a gap between the ages of our children," says Keri, "Anthony and I wanted to pass on our favorite pastime, which is camping," but Anthony Jr. was too young to trek into the wilderness. So they opted to set up a tent and build a fire in their fenced yard on a dead-end street. 📷 Carlos Ortiz

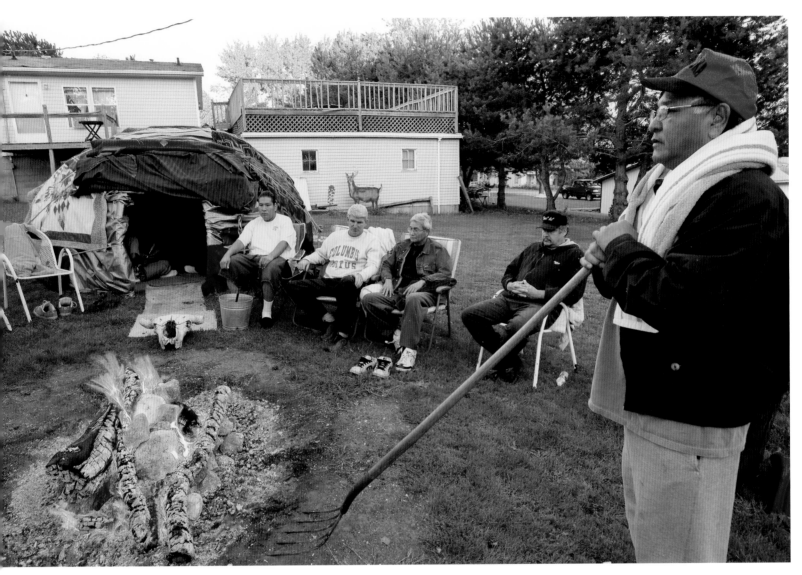

ROSALIE, NEBRASKA Rekindling tradition. Nate Merrick, an Omaha Indian, tends the coals around rocks that will soon heat the nearby sweat lodge. He will be joined by his nephew Bear, his father, Dave Korth, and two of his brothers inside the traditional lodge, where they will sing, pray, and smoke a sacred tobacco pipe. Many Native Americans have found that a return to traditional ways has helped them resist the temptation of drugs, alcohol, and other enticements of the modern world. Don Doll, S.J.

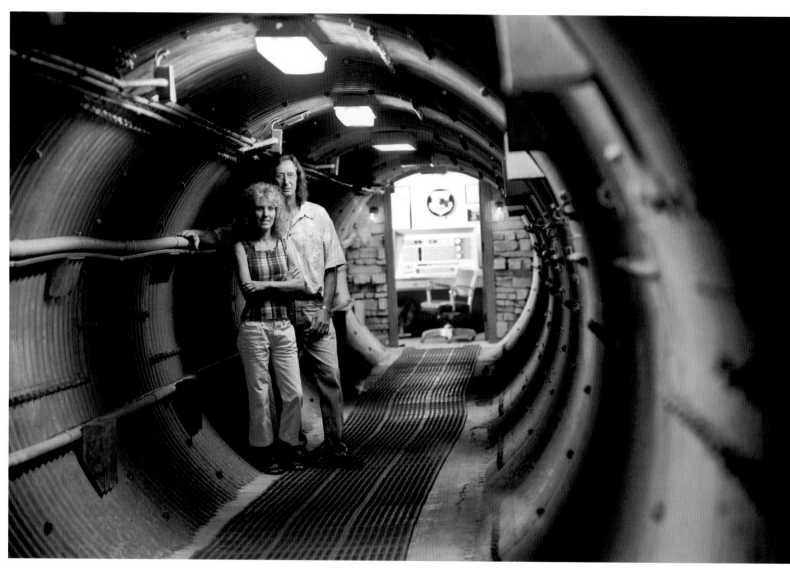

ESKRIDGE, KANSAS Home sweet Armaggedon. Ed Peden and his wife, Dianna Ricke-Peden, stand inside a 120-foot tunnel that connects their living quarters to a former Atlas E missile silo near Eskridge, Kansas, 30 miles southwest of Topeka. Their home, affectionately called "SubTerra Castle, The House That Love Built," was an active underground missile silo from 1961 to 1965, when it contained a four-megaton hydrogen bomb. The Pedens have converted the former steel and concrete bunker facility into an 18,000-square-foot underground home and have lived there for 13 years. Mike Yoder

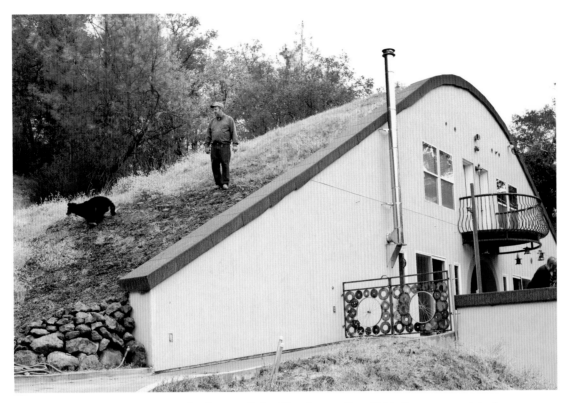

GRASS VALLEY, CALIFORNIA Rooftop stroll. Brad Peceimer walks with his Bernese mountain dog, Amelia, atop their earth-sheltered house in the Sierra Nevada foothills. Fed up with soaring utility bills, Peceimer built a new energy-efficient home that uses only 21 gallons of propane per year. He runs a family business from the house, handcrafting Tibetan prayer wheels with an antique lathe that was passed down in the family. ◎ Deanne Fitzmaurice

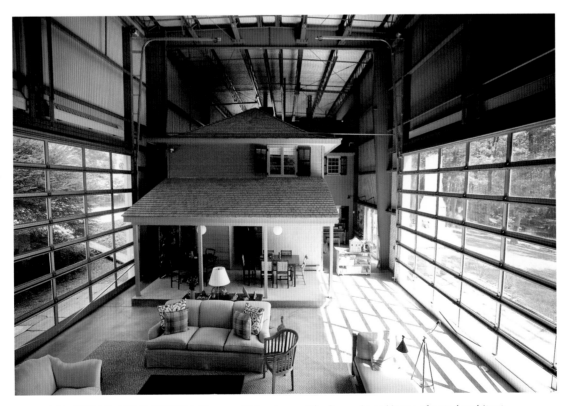

BERNARDSVILLE, NEW JERSEY House within a home. The Bunny Lane House of noted architect Adam Kalkin is an old aircraft hangar that encloses and extends Kalkin's original family home. The home's front porch is now in the dining room—and the living room stands where the front yard once did. Wrote one critic about Kalkin, "His art is characterized by an inventive, low-tech, mechanized absurdity, informed by a handful of obsessions." ◎ George Steinmetz

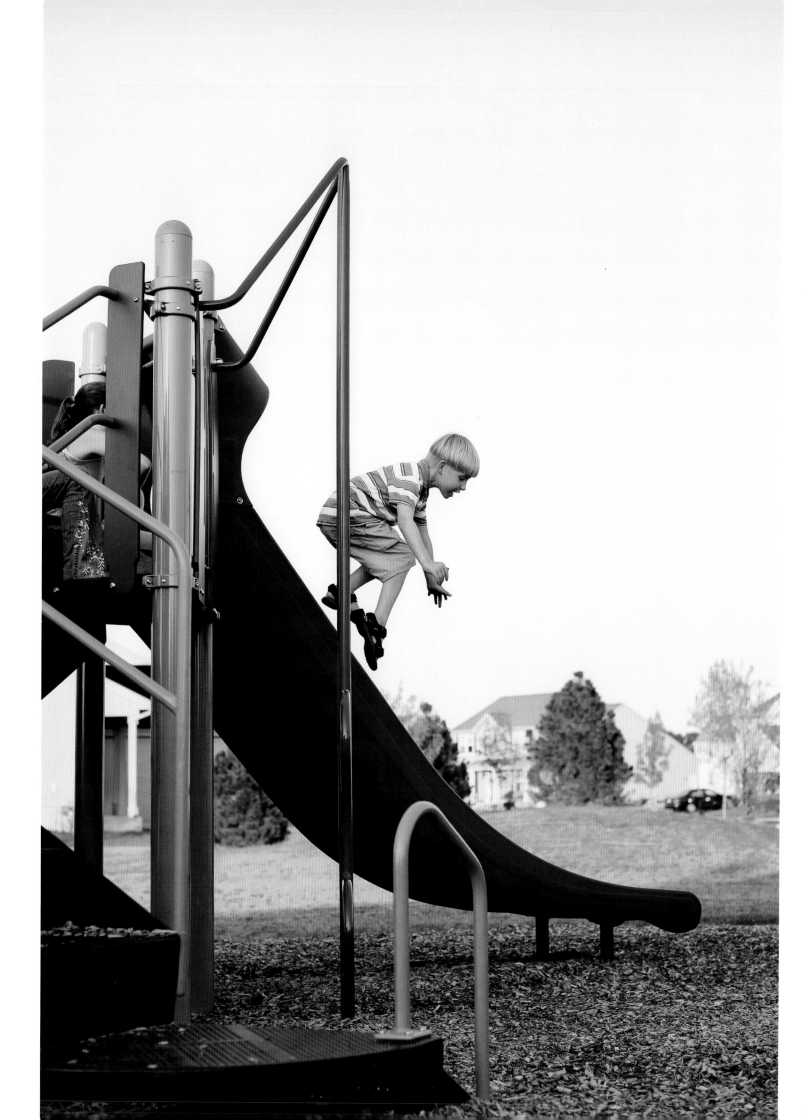

[Despite the fact that Americans spent more than 22 billion on health clubs and
fitness equipment this year, 83 percent don't do any exercise of any kind.]

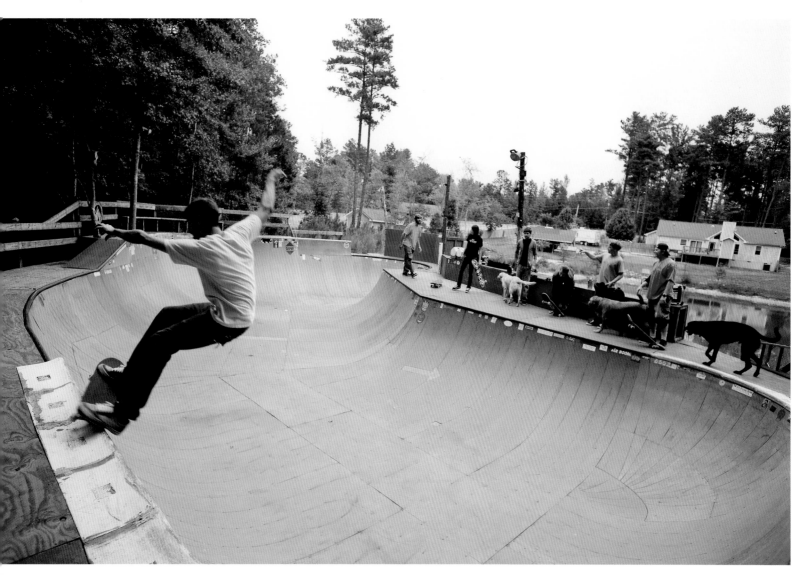

PITTSBORO, NORTH CAROLINA Sticking it. Lucky Pittsboro teens risk life and limb at Tony Sabbagh's custom-made backyard skateboard park. Here, Frank Gullo exits a frontside 5-0 grind on a six-foot wall. Friends Sabbagh and Gullo spent four years building the park, and now invite others over every week to skate and hang out. These facilities aren't cheap: one 13-foot ramp at the 2007 X Games cost $60,000 and took 394 hours to build. Jeremy M. Lange

YORKVILLE, ILLINOIS Landing zone. Kyle Berg, 6, jumps from the slide of the jungle gym at the Whispering Meadows community park on a quiet Sunday afternoon. While Kyle is active and loves sports, one-third of American children—25 million kids—don't spend enough time exercising and are estimated to be overweight. Experts blame TV, video games, sodas, and sugared foods for the 100 percent increase in weight problems in children and teens over the past two decades. Tim Klein

PHILADELPHIA, PENNSYLVANIA Psychedelic toast. Isaiah Zagar's life work, as he explains it, "is making the city of Philadelphia PA USA into a labyrinthine mosaic museum." The result is a half century of murals, walls, and interiors around the city featuring designs made from colored cement, glass and tile. Here Zagar shares a meal at his home—itself part of his vast art museum—with his wife, Julia. and and son, Ezekiel. 📷 April Saul

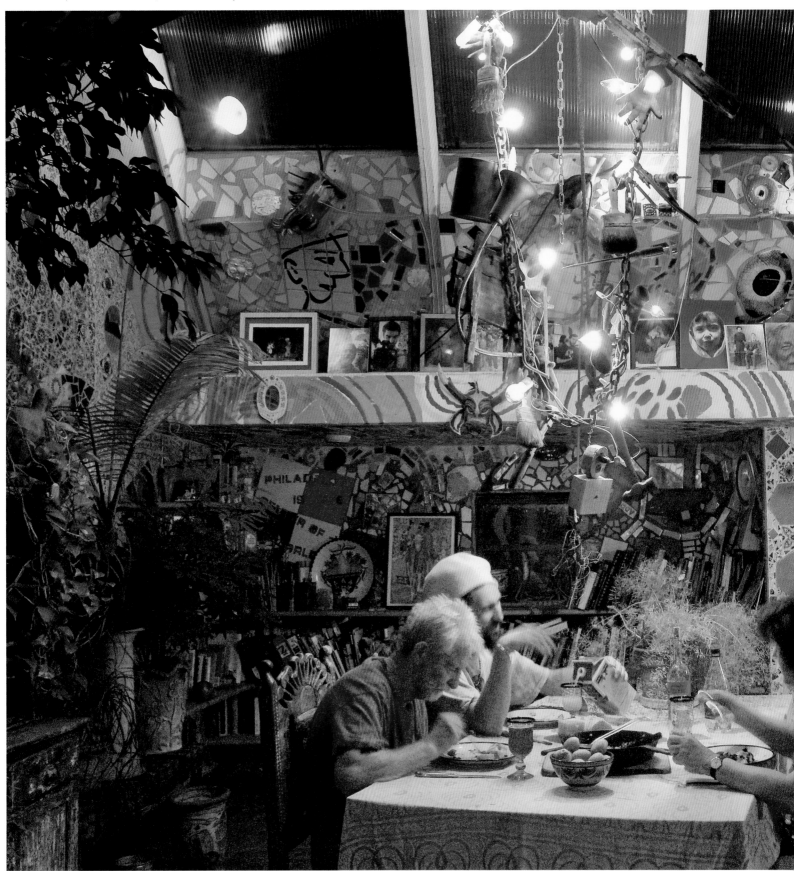

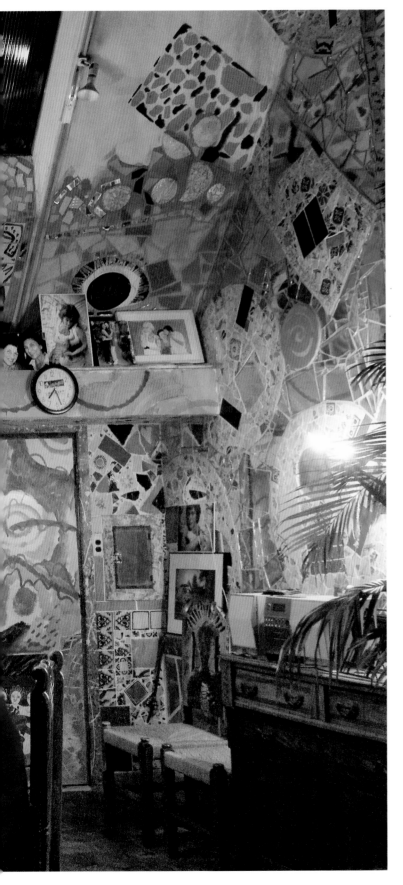

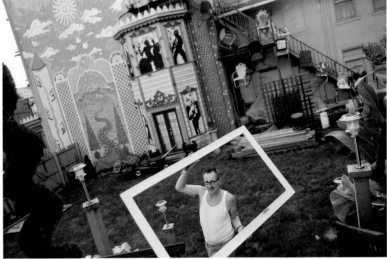

PITTSBURGH, PENNSYLVANIA Painted ladies. Ten years ago, waiter Randy Gilson bought a century-old house on his credit card for $11,300. He then bought five gallons of paint for $10—and hasn't stopped painting since. He now owns two adjoining houses in the Mexican War Streets neighborhood. He calls the wildly decorated homes "Randyland" and says his neighbors regard his artwork as "visual vitamins." ◎ Annie O'Neill

GRAND MARAIS, MINNESOTA Great expectations. Julie Keane lives in a tiny shack on the property of her ex-husband near the Canadian border. It's her workshop (for basket weaving) and residence while she constructs an octagon-shaped log cabin nearby. With her ex's help, Keane hopes to finish in time for her and their two daughters, Meadow and Cedar Adams, 13 and 11, to move in for Christmas. ◎ Judy Griesedieck

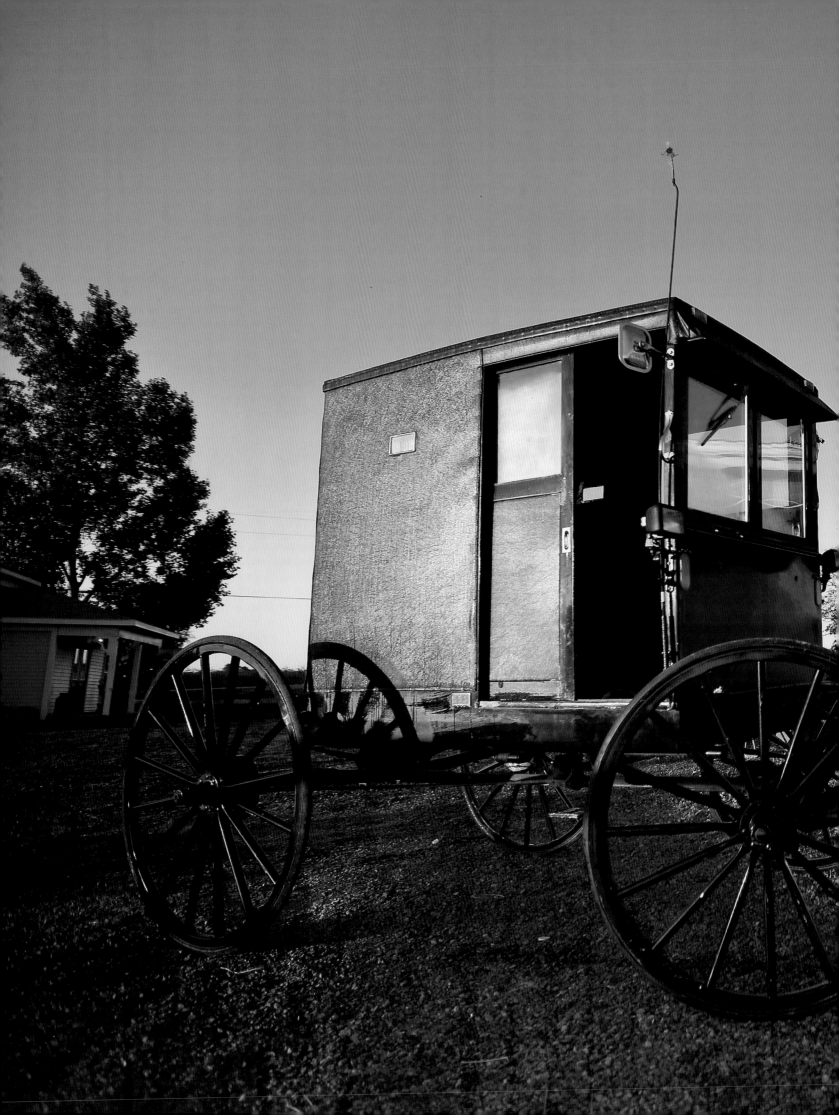

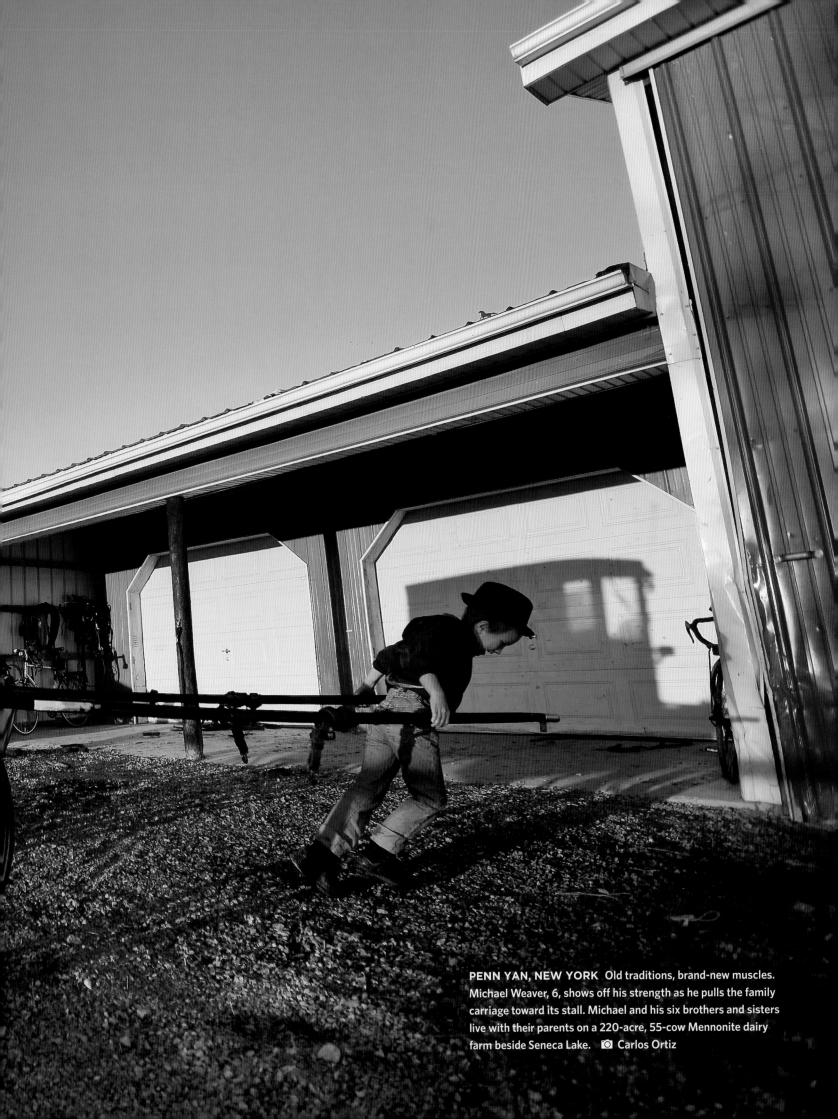

PENN YAN, NEW YORK Old traditions, brand-new muscles. Michael Weaver, 6, shows off his strength as he pulls the family carriage toward its stall. Michael and his six brothers and sisters live with their parents on a 220-acre, 55-cow Mennonite dairy farm beside Seneca Lake. 📷 Carlos Ortiz

LOUISVILLE, KENTUCKY Entry notes. Percussionist Gregory Acker plays the flute in the doorway of the Smoketown district home he shares with his wife, artist Brenda Wirth. The house has no closets, so Acker's handmade instruments and Wirth's artistic creations are stored out in the open. 📷 Dan Dry

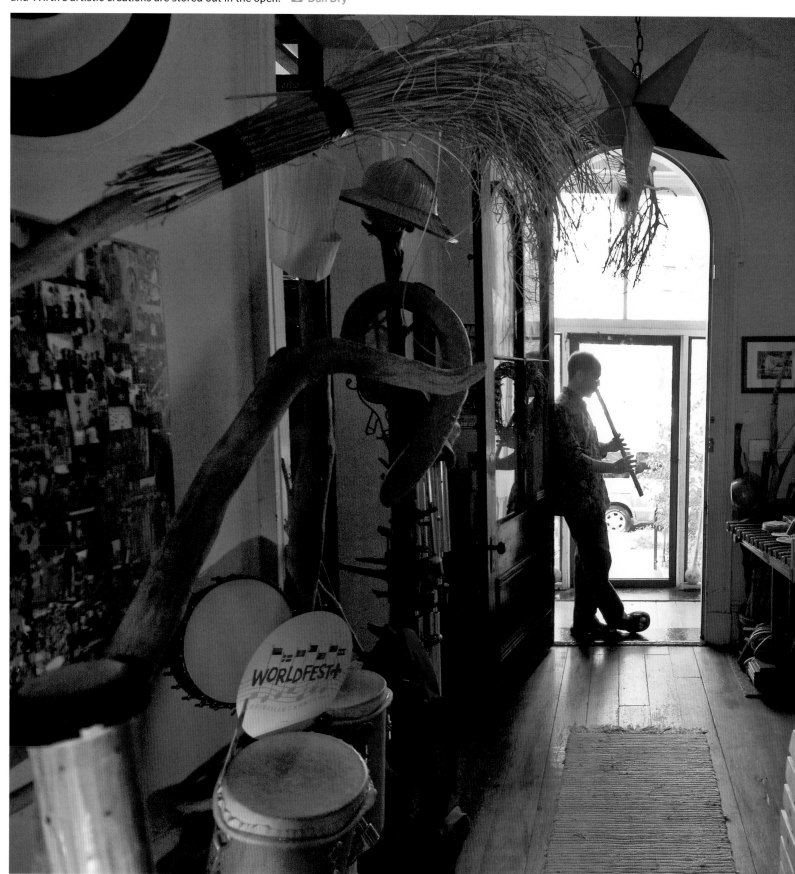

[The majority of Americans live their lives
within fifty miles of the place they grew up.]

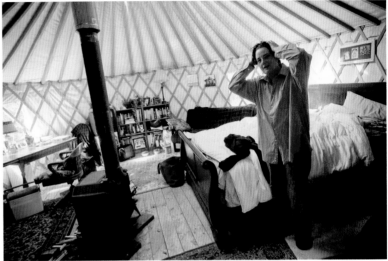

GRAND MARAIS, MINNESOTA Padded room. Second-grade teacher Toni Mason lives with her dog in a Mongolian yurt. In the rustic community of Grand Marais, diversity in lifestyle and living quarters is the norm—and Mason's single room is positively elegant compared to the domiciles of many of her neighbors. Originally from Mongolia, where they have been popular for centuries as a portable yet warm home, yurts are used in the United States today as low-impact guest houses in numerous state and national parks. 📷 Judy Griesedieck

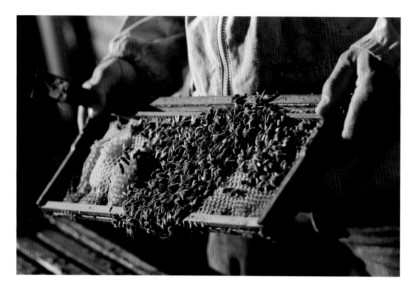

NEW YORK, NEW YORK Honey be mine. Beekeeper David Graves manages one of the most popular stalls at a weekend open-air market on New York City's Upper West Side. The big attraction? Fresh honey from 15 beehives he has placed around the city. "Bees," Graves explains, "fly about two to three miles each day in search of nectar and then return to the hive. In New York they favor the nectar of gingko, sumac, and linden trees, which give the honey a unique flavor." The most honey Graves has ever extracted in a single season was 140 pounds, from a hive on the Upper West Side. 📷 Michael Appleton

The buzz of city life. Graves tends to his hive 20 stories above Manhattan's East 15th Street. For the last seven years, Graves has made his home at hotels three nights per week to harvest the numerous hives he has placed atop buildings around the city. 📷 Michael Appleton

[During the 2007 MLB season, the average fan attendance per game was 32,785.
The home TV audience for the fourth and final game in the World Series was 20.9 million.]

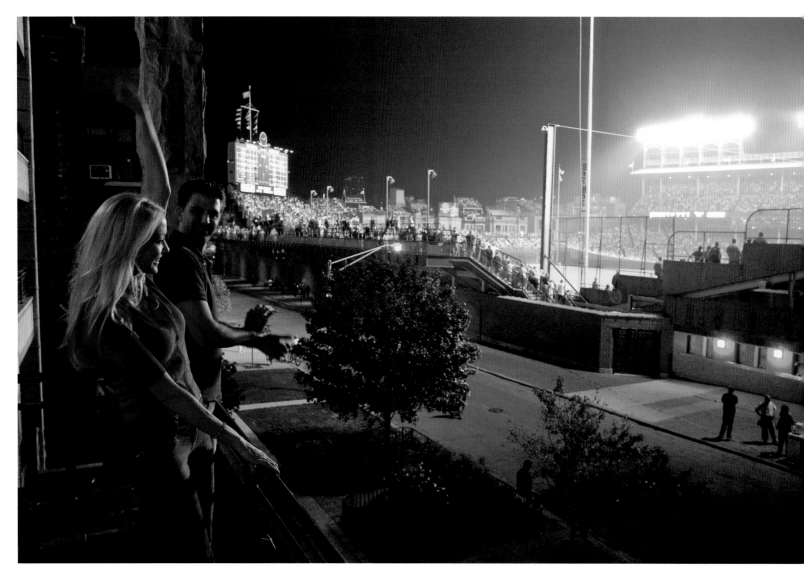

CHICAGO, ILLINOIS Cheap seats. Daniel Kiernan, who has lived across the street from Wrigley Field for the last three years, catches a late-season game with his girlfriend, Kristi Carpenter, a hardcore Cubs fan. He is a second-year resident at the University of Chicago Hospitals; she's a third-year nursing student. 📷 Mike Hettwer

Bleacher bums. Virtually every house on Waveland Avenue across from Wrigley Field sports some kind of seating so that fans (and their friends can catch a view of their beloved Cubs. On this night the Cubs were mounting a late-season playoff drive—but, as the fatalistic fans had come to expect, the team lost 5-2. 📷 Mike Hettwer

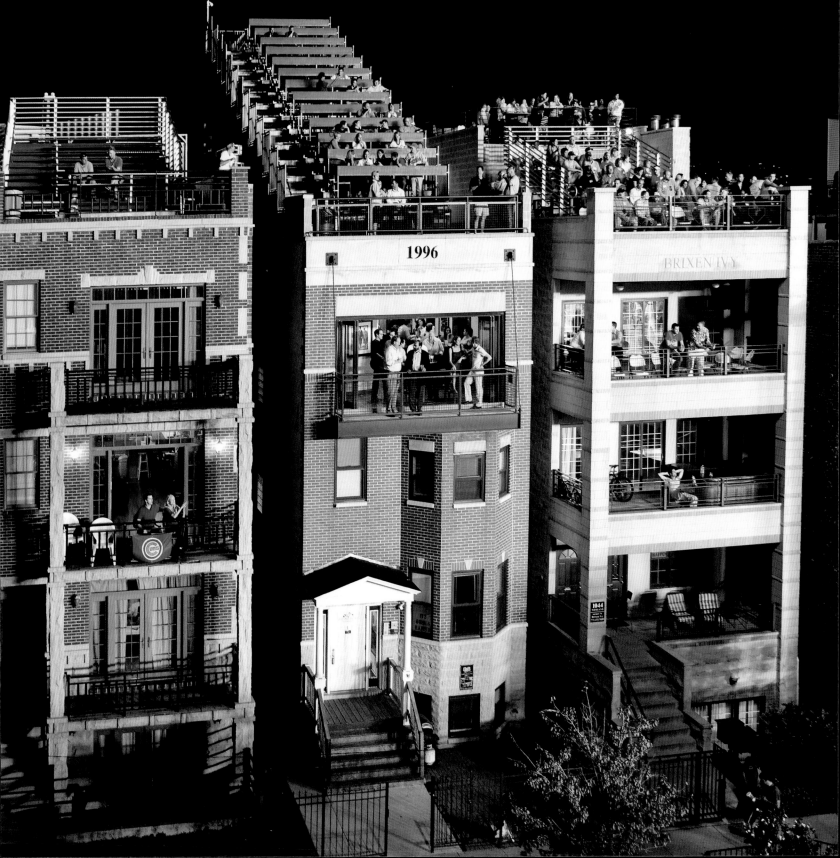

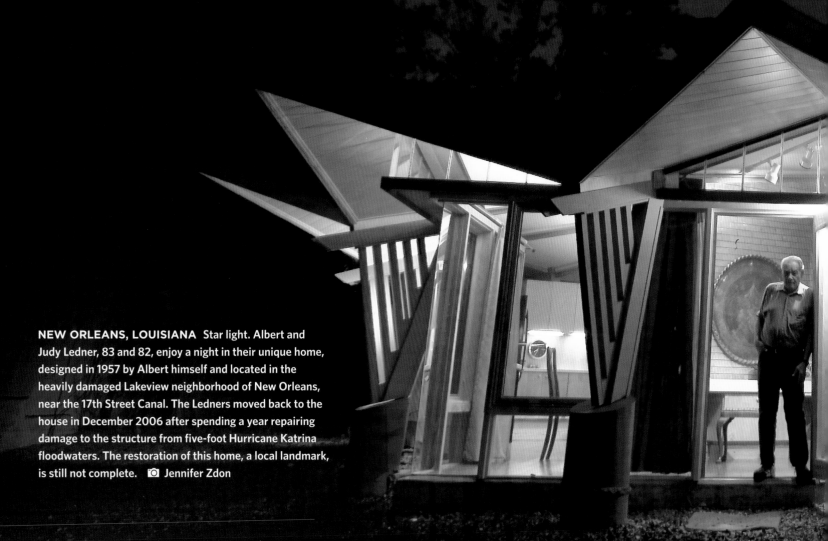

DAVID POGUE

HOME AS YOUR
WORKPLACE

MAN, THEY SURE ASKED THE RIGHT GUY to write the "Home as Workplace" essay for this book; I haven't worked a 9-to-5 day in my life. The cubicle culture is so alien to me, some of the jokes in *Dilbert* go sailing right over my head.

My commute to work is 13 stairs to the attic.

I work at home because I'm a writer and a musician. Like most creative types—painters, sculptors, photographers, writers, musicians, independent filmmakers—my office is at home. But there as many other good reasons to work at home as there are professions.

Sometimes, home is where the work is. That would explain the farmers, the home restorers, the piano teachers, and the home day-care operators.

Sometimes, the home *goes* where the work is. That accounts for the houseboat skippers, the trailer parks, and the RV fans.

NEW ORLEANS, LOUISIANA Star light. Albert and Judy Ledner, 83 and 82, enjoy a night in their unique home, designed in 1957 by Albert himself and located in the heavily damaged Lakeview neighborhood of New Orleans, near the 17th Street Canal. The Ledners moved back to the house in December 2006 after spending a year repairing damage to the structure from five-foot Hurricane Katrina floodwaters. The restoration of this home, a local landmark, is still not complete. 📷 Jennifer Zdon

But more and more, home is only an extension of a more traditional office. That's the way it goes for the telecommuters, the working moms, the freelancers, and the sales staff. Why waste time, fuel, and money hauling yourself to the office when you've got a perfectly good phone and laptop at home?

I have a neighbor who drags himself to and from the big city every single day—2.5 hours each way, right through the worst of both rush hours. He gets up too early to have breakfast with his kids in the morning, and arrives home too late to tuck them in at night. And on the great scale of commuter misery, that's not even an especially bad commute.

And you know how the oldsters always cluck about how fast kids grow up? "Next thing you know, they'll be off to college," they always say. But not if you work at home. I come down those 13 stairs every time I hear my kids screaming with laughter or wailing with pain. I'm home all the time they are. They're not *allowed* to grow up behind my back.

Working at home is good news for the environment; the telecommuting trend has saved billions of tons of greenhouse gases from choking the planet's air. Telecommuting is also good news for productivity and quality of life. If you can avoid spending two hours a day sitting on a bus or in a car, you gain 21 entire 24-hour days' worth of family time, work time, and "me" time every year.

And speaking of gaining time: working at home means escaping the massive American time drain known as *meetings*.

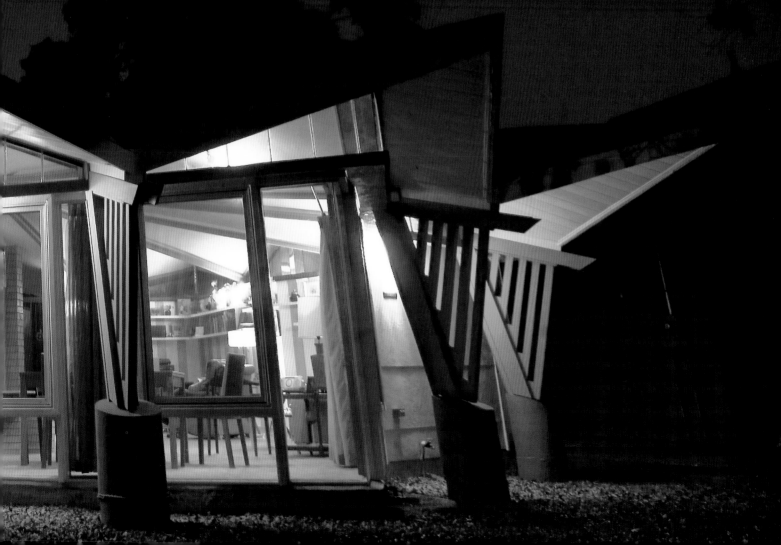

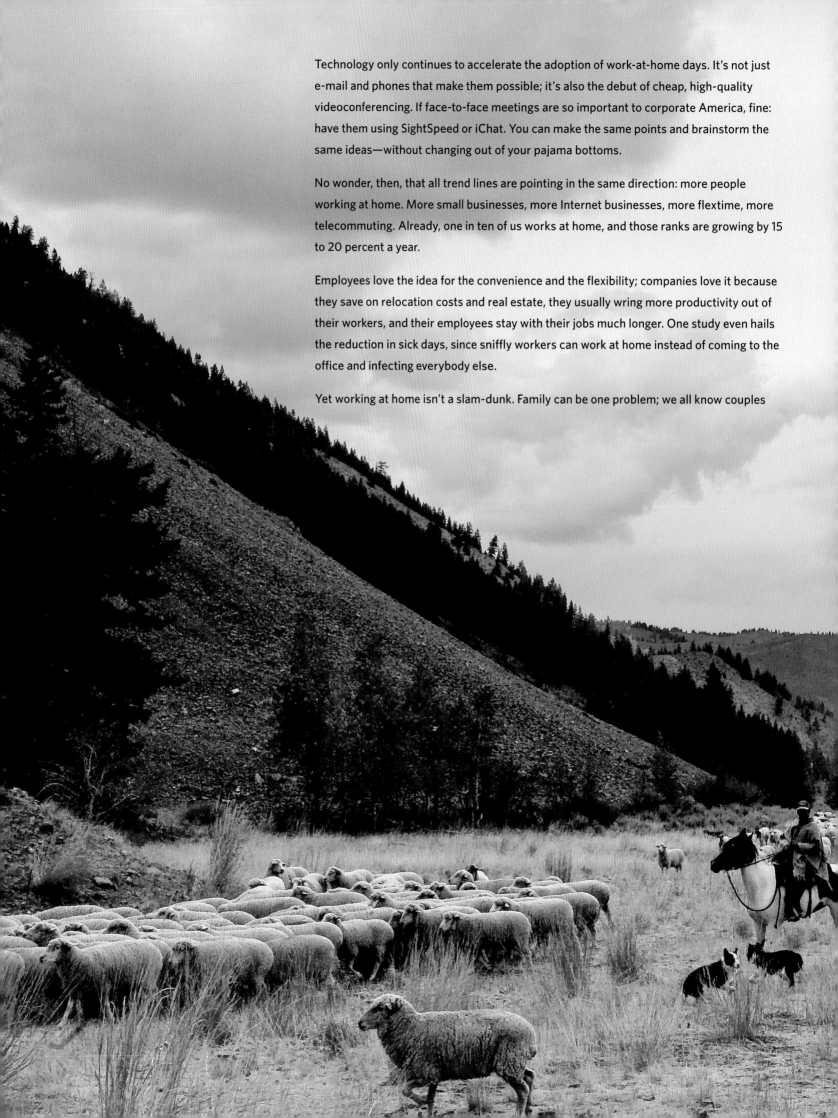

Technology only continues to accelerate the adoption of work-at-home days. It's not just e-mail and phones that make them possible; it's also the debut of cheap, high-quality videoconferencing. If face-to-face meetings are so important to corporate America, fine: have them using SightSpeed or iChat. You can make the same points and brainstorm the same ideas—without changing out of your pajama bottoms.

No wonder, then, that all trend lines are pointing in the same direction: more people working at home. More small businesses, more Internet businesses, more flextime, more telecommuting. Already, one in ten of us works at home, and those ranks are growing by 15 to 20 percent a year.

Employees love the idea for the convenience and the flexibility; companies love it because they save on relocation costs and real estate, they usually wring more productivity out of their workers, and their employees stay with their jobs much longer. One study even hails the reduction in sick days, since sniffly workers can work at home instead of coming to the office and infecting everybody else.

Yet working at home isn't a slam-dunk. Family can be one problem; we all know couples

whose marriages would collapse if they spent 24 hours under the same roof. And children around the house aren't always conducive to productivity, either; they can distract you, deliberately or not, and they sometimes generate unwelcome ambient sound when you're on the phone with someone important.

Then there's the isolation factor. I gather from *Dilbert* and *The Office* that the traditional corporate workplace has its share of idiots and jerks, people who procrastinate, backstab, and frustrate. But I also know that they make up a community, a forum of familiar faces. Going somewhere to work means having a circle of workplace buddies, and that can lead to good things—romance, chatter, new opportunities, or at least annual picnics. When you work at home, you have to try a lot harder to maintain a social life.

And suppose the telecommuting trends continue. Fast-forward 50 years. More isolation, more Internet hours, less human contact. Are we losing something essential along the way? Is there magic in the handshake deal, the face-to-face boardroom pitch, that you can't reproduce through a Webcam? Are we technologizing ourselves into a sci-fi future in which everybody sits at home in their own little PC bubbles? Will corporate headquarters eventually shrink and dissipate until General Motors is nothing more than a brass plaque on a server somewhere?

Nah. Managing our work and home lives has always been about balance, and it always will be. Social interaction is a fundamental need; the more we lose face time with colleagues at work, the more we'll compensate by spending time with people we actually *choose* to hang out with. Whatever time we save on commuting, we can now spend helping out at our kids' schools, attending classes ourselves, volunteering, or just being better parents or grandparents.

That's my guess, anyway. I'd mull it over some more, but I've got to get going. I hear traffic on the attic stairway is murder.

David Pogue is the personal-technology columnist for The New York Times and one of the world's best-selling how-to authors, with over 3 million books in print.

HAILEY, IDAHO Wool-gathering. Chilean herder Pedro Abarzua's wife and two children still live in Chile, but for nine often lonely months of the year, Abarzua lives in a tiny hut on wheels in the mountains of Idaho, tending sheep for Faulkner Ranches. His only other human contact comes from fellow herder Aliro Osorio and occasional visits from the ranch foreman. 📷 Stormi Greener

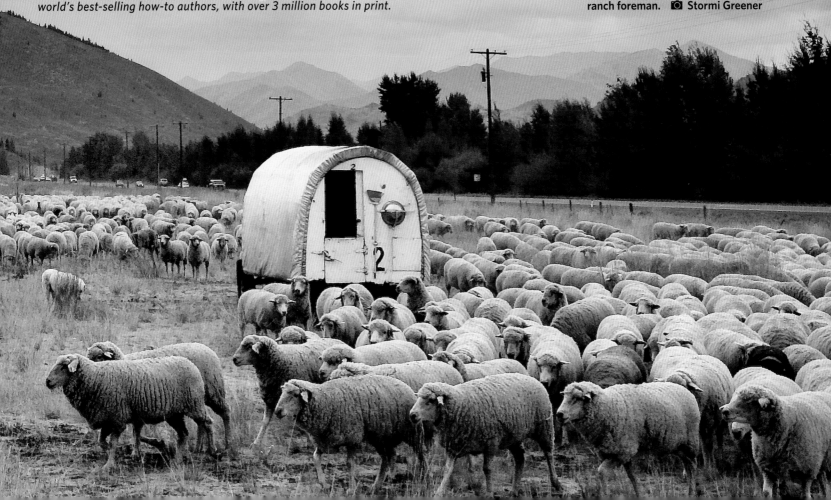

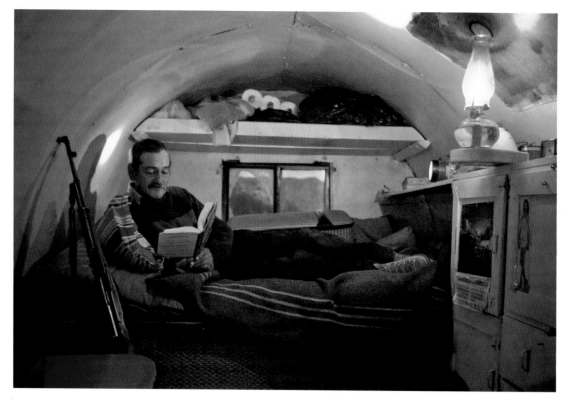

HAILEY, IDAHO A few last words. Abarzua takes a short rest with a book before relieving the second herder, Aliro Osorio, who is watching the flock of 1,500 sheep bedded in a grassy meadow at the base of the mountains. Abarzua and Osorio will take turns all night long with the dogs, tending the sheep and protecting them from wolves, which poach more than a third of the herd each year. 📷 Stormi Greener

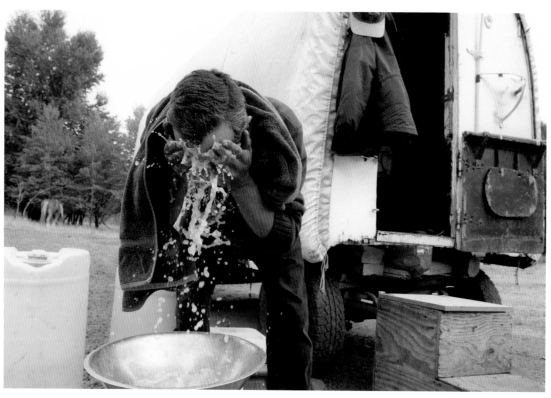

HAILEY, IDAHO Cold start. Abarzua washes his face in a pail of water carried up from a nearby stream. His standing-room-only wagon home contains only the basics: a flashlight, a gas stove for cooking, a kerosene lantern, and a small cupboard for food and dishes. 📷 Stormi Greener

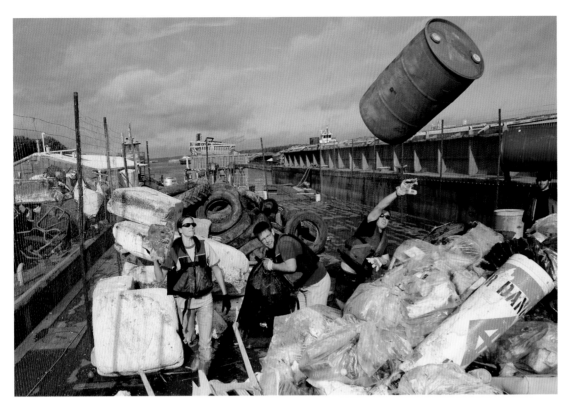

BUFFALO, IOWA Barrel toss. Chad Pregracke and friends spend most of their time living on a houseboat perched on a barge. Here, Pregracke throws a rusted barrel atop the growing pile of debris collected along the Mississippi River by Living Lands and Waters, a nonprofit he founded in 1998. Also helping are Tammy Becker and Tony Borreson. The group has enlisted thousands of volunteers to help America's rivers, inspiring cleanups in river towns such as the Quad Cities, Burlington, Keokuk, and Hannibal. 📷 David Peterson

BUFFALO, IOWA Galley laugh. Crew members from Living Lands and Waters spend time in the galley of their houseboat on the Mississippi River near Buffalo, Iowa. From left are Mike Coyne-Logan, Shanon Reineke, and founder Chad Pregracke. The crew live on the barge, once the headquarters of a barge company, as they journey up and down riverways in towns and cities from St. Louis to Guttenberg, Ohio. 📷 David Peterson

[The average American spends more hours a day
working than sleeping.]

JACKSONVILLE, ILLINOIS Art attack. Dutch-born Annie Brahler prepares for an upcoming business
trip to Paris in the dining room of her historic home on State Street. While her husband, Richard, is at
work and her three kids are at school, she runs an international business and Web site selling secondhand
treasures from her trips to the Netherlands, Belgium, and France. Her stately home serves as a showroom
for the items she scavenges on her trips. After fixing them up, she sells them to home designers across
America. 📷 Steve Warmowski

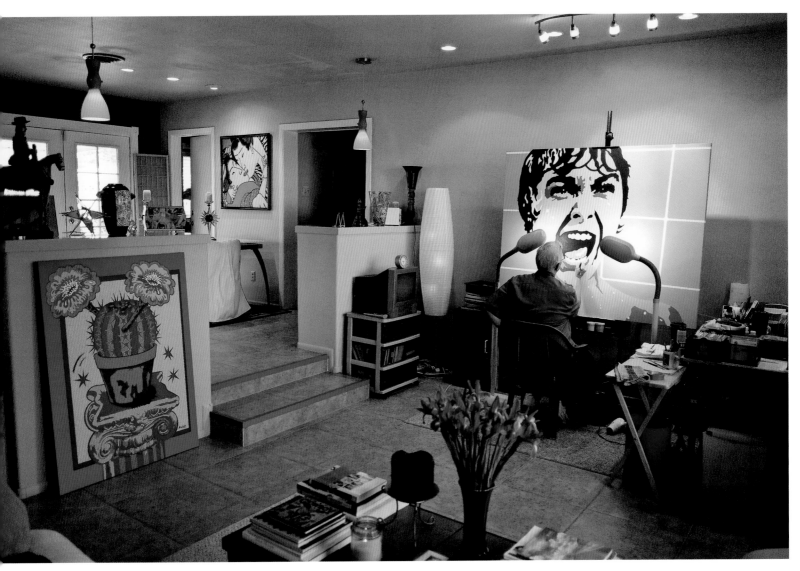

LAS VEGAS, NEVADA Work is a scream. Las Vegas artist Martin Kreloff puts the finishing touches on his painting of actress Janet Leigh in Alfred Hitchcock's *Psycho*. Kreloff's paintings are acrylic on canvas, and he has outfitted his living room as a full artist's studio. Kreloff also has a commission to paint images for a series of banners in Las Vegas's "cultural corridor." 📷 Brad Zucroff

Family management. Angel Boldt plans to homeschool all seven of her children, and six are already enrolled. Using the dining room table as a study area, Boldt keeps everyone on track during the day—while juggling two-month-old William on her lap. Families with more than three children are twice as likely to homeschool as those with fewer children. 📷 Alex Garcia

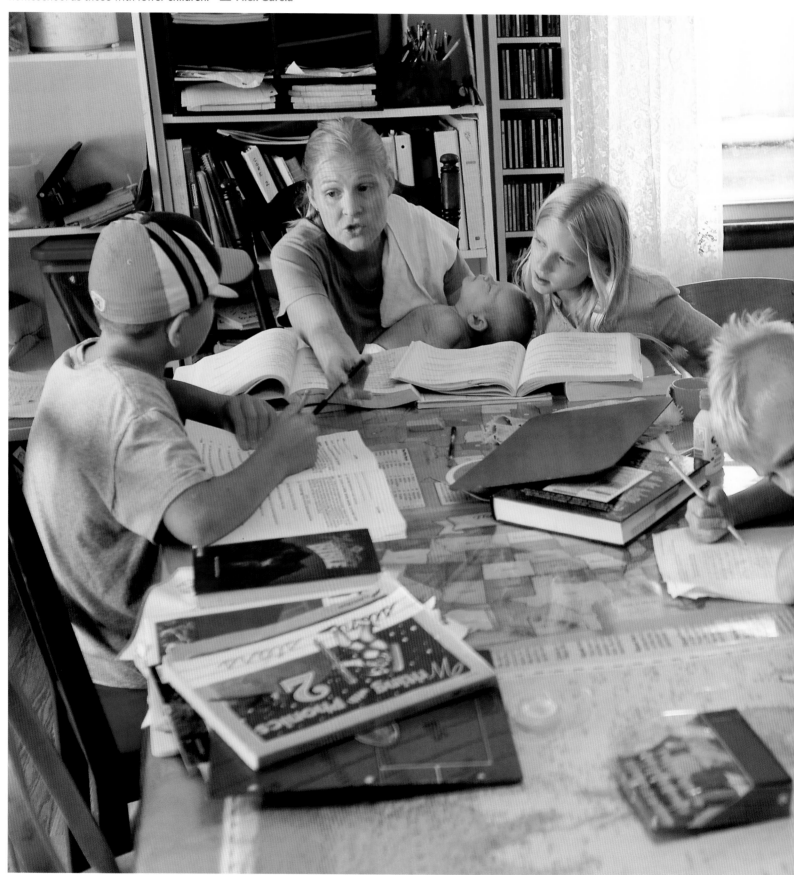

[Today's parents spend considerably more time with
their children than parents did in 1965.]

OGDEN, UTAH Flight plans. Sitting in an airplane they constructed from cardboard, Avalon, 5, Adelaide, 2, and Boston, 7, listen to their mother, Ronna Marker, as she maps their flight route to India—today's homeschool lesson. Marker, who teaches the children while husband Travis is at work, has been homeschooling since Boston was a preschooler. A fourth Marker child, still a toddler, will soon join the class. 📷 Ramin Rahimian

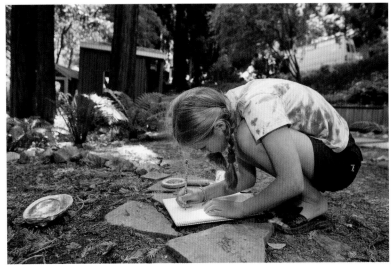

LOS GATOS, CALIFORNIA Nature study. As part of a science lesson, homeschooler Claire Bruder, 9, looks for round objects in nature to draw in the backyard of her home in Los Gatos, California. Today she and her sister worked on math and sentence structure, read books, and went outside to explore the natural world. Claire also found a spider. 📷 Jim Gensheimer

DUBUQUE, IOWA Happy birthday. The Trappist nuns of Our Lady of the Mississippi Abbey share a light moment while finishing off popcorn in the break room of their candy factory. Though the nuns are dedicated to prayer, silence, order, and discipline, that doesn't stop Sisters Kathleen O'Neill and Carol Dvorak from celebrating the 50th birthday of Sister Ciaran Shields, right. Catholics make up one quarter of the U.S. population. David Peterson

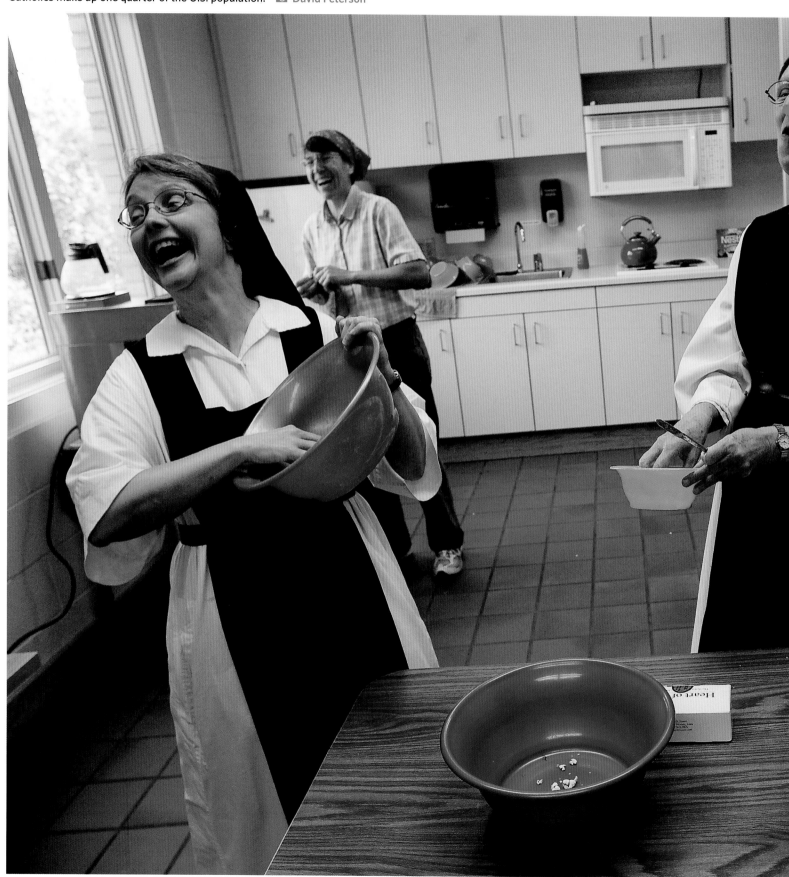

[Clergy rank themselves as the happiest people, by job, in America.]

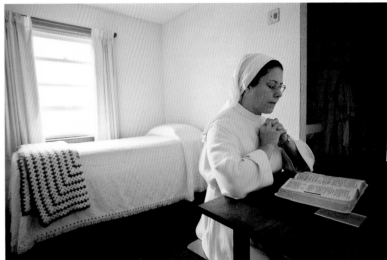

DUBUQUE, IOWA Home is a Habit. Sister Michele Armstrong shares a life of prayer, silence, simplicity, and daily work at Our Lady of the Mississippi Abbey, a monastery of 22 Trappist nuns that sits high on a bluff overlooking the Mississippi River. 📷 David Peterson

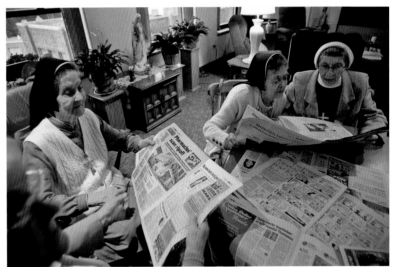

CHICAGO, ILLINOIS Current events. Sisters Paul Marie Pietroczynski, Helen Marie Dobrydnia, Mary Anisia Ciemiega, and Mary Paschalita Glista discuss the news in the community room of the Felician Sisters Mother of Good Counsel Province. Founded in Poland in 1855, the order ministers largely to Polish Americans. The home is divided between spartan bedrooms and lively common areas where the sisters talk, read, and even lift weights. 📷 Alex Garcia

SEATAC, WASHINGTON Clay time. Bruce Bickford, 60, became a cult figure in the 1970s for the disturbing animations he created for Frank Zappa. These days he performs his self-taught Claymation magic from his house, almost every room of which is a studio. Here he works in the garage, where he creates sets and does his filming. 📷 Steve Ringman

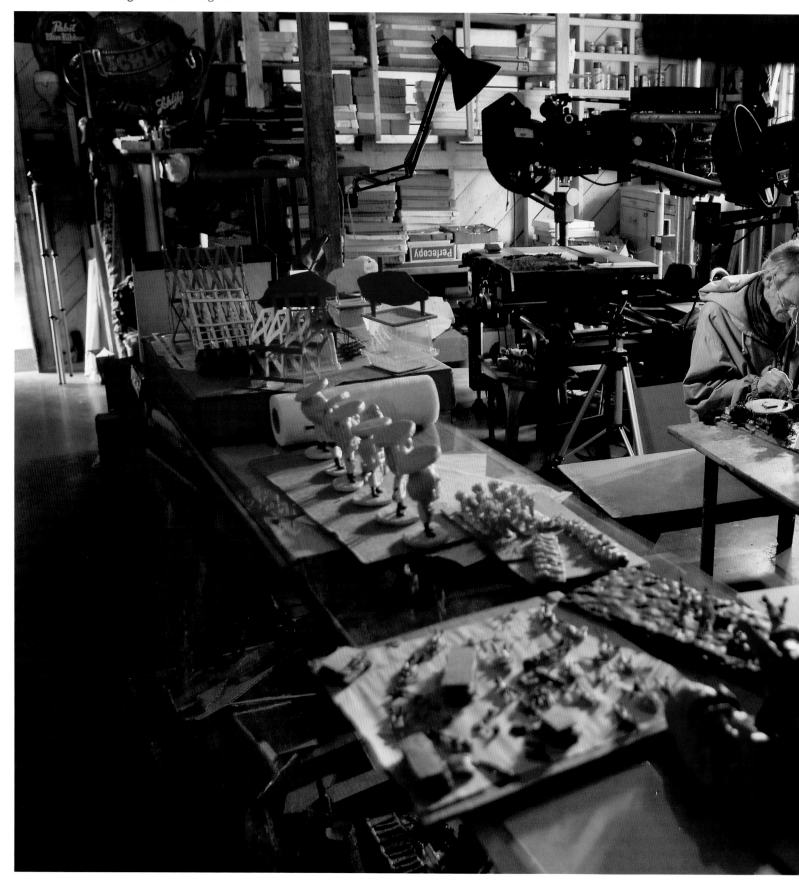

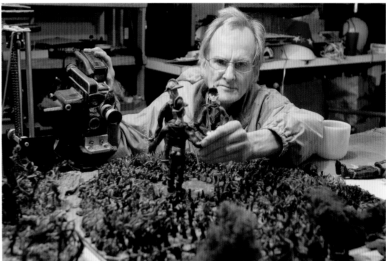

Making his moves. Working in his basement studio, Bickford positions figures for a scene from *Cas'l*—a new production featuring his Descendants of the Rogue Conquistadores figurines. It will take days of repositioning and shooting to create a few seconds of final film. Bickford's life and work were featured in the 2004 documentary *Monster Road*. 📷 Steve Ringman

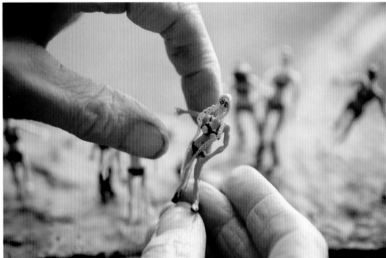

Thumbnail stretch. Bickford makes multiple versions in different sizes for all of the figures in his films, keeping a large inventory of extra arms and legs in his garage. These figures are the smaller version of characters he will use in a mystical forest scene in his newest movie project. Bickford's work is famous for its surreal environments and sinuous transformations of human figures into odd and eerie creatures. 📷 Steve Ringman

GREENSBURG, PENNSYLVANIA Adored avatar. As her husband watches, Kim Robben sings for a cancer benefit from her bedroom, aka "Circe Broom's Sunset Lounge Club," in Second Life, a multiplayer online virtual world. Her online alter ego, an avatar called "Kim Seifert," has more than 600 paying fans online—enough to enable this grandmother to quit her paralegal job in this world. Using their avatars, Second Life members can explore, meet other residents, socialize, participate in individual and group activities, and create and trade items and services with one another. More than 18 million people around the globe spend time in alternative online worlds. 📷 Annie O'Neill

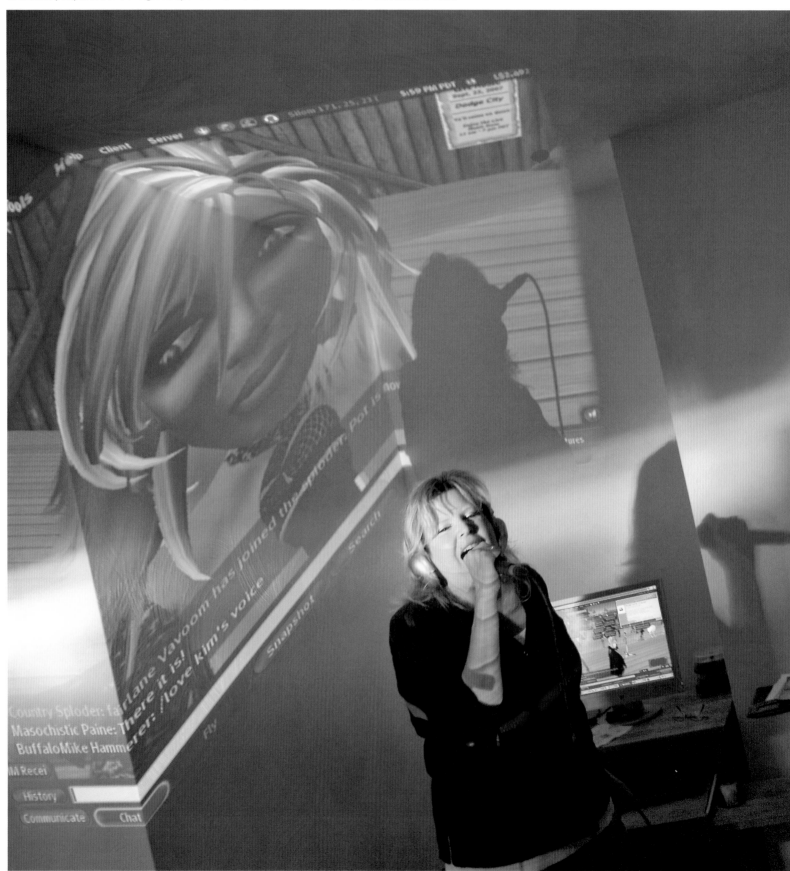

90 percent of Americans now regularly access the Internet from their homes and young adults
spend more time online and watch an hour less prime-time television than the average American household.]

OLATHE, KANSAS Power seller. Shonna Walker and her son, Tyler, 18, have filled their garage and basement with items from garage sales, which they then sell on eBay. Their living room is often filled with vintage cowboy boots waiting to be polished and sold. "If it's not a kid or a dog, it's for sale," says Shonna. Founded just ten years ago, eBay currently helps its 233 million users sell $52 billion worth of goods each year. More than $1,839 worth of goods are traded worldwide on the site every second of every day. 📷 Kyle Gerstner

Bloodline. Seven generations of Bruntons have run this family dairy since 1832, and two more generations are already in training. Brothers James, Ed, and Alan Brunton are the current bosses, but most of their wives and children work there as well. It takes every one of them, plus outside help, to run the 200-acre farm. 📷 Melissa Farlow

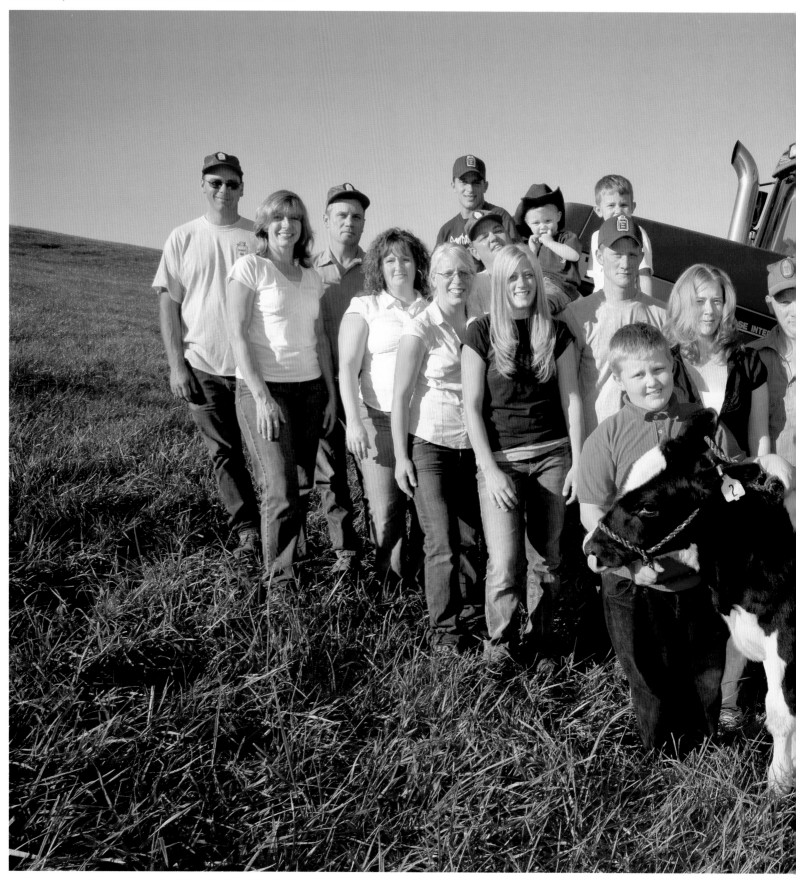

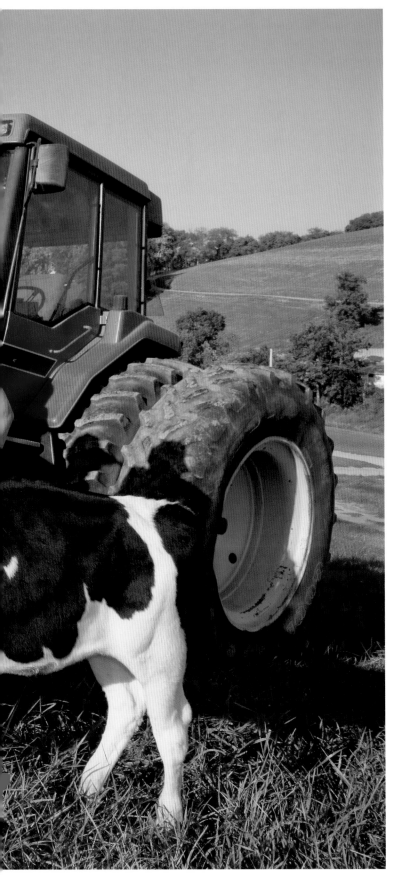

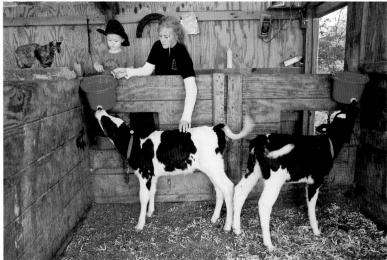

Little ones. At Brunton Dairy, the day begins at 4 am and ends at 8 at night. The 104 cows are milked twice each day, at 4 am and 5 pm, seven days per week. Here, veteran Rachel Brunton instructs her young cousin Cole on the care and feeding of the new calves. All 14 members of the Brunton clan work full- or part-time at the dairy. 📷 Melissa Farlow

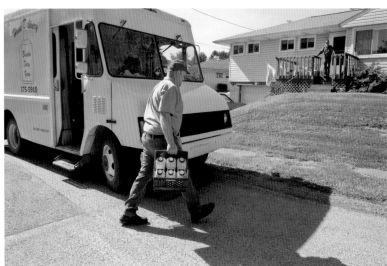

Another stop. Alan Brunton, the youngest of the three brothers who run Brunton Dairy, is in charge of bottling, making premium butterfat ice cream, and delivering products to customers (like William Gartley, here). Home delivery has dropped to less than 1 percent of the milk business—though lately the trend has begun growing again. 📷 Melissa Farlow

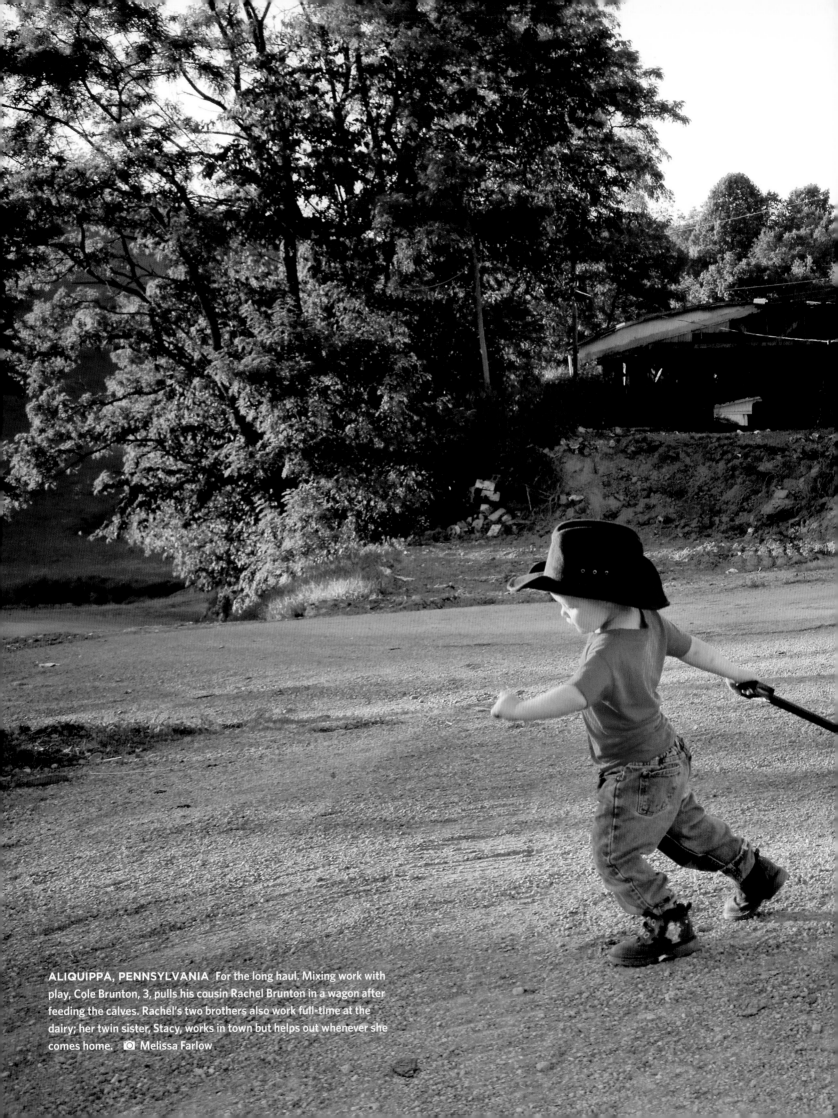

ALIQUIPPA, PENNSYLVANIA For the long haul. Mixing work with play, Cole Brunton, 3, pulls his cousin Rachel Brunton in a wagon after feeding the calves. Rachel's two brothers also work full-time at the dairy; her twin sister, Stacy, works in town but helps out whenever she comes home. 📷 Melissa Farlow

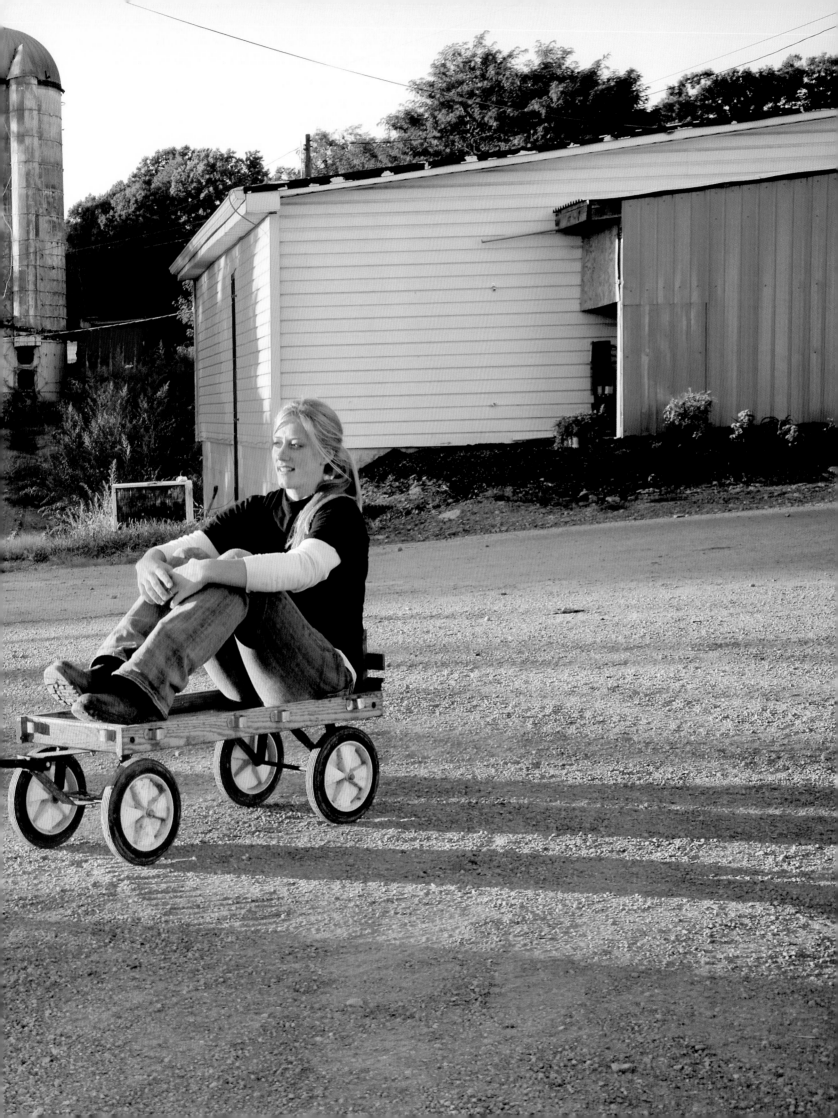

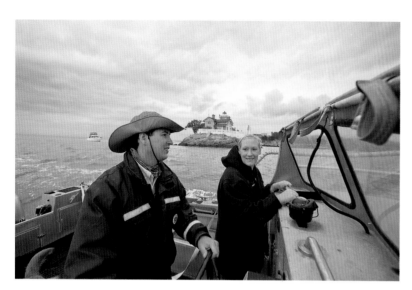

Traffic-free commute. Before taking over the lighthouse, Katy and Elan Stewart spent 10 months on a 30-foot sailboat traveling down the coast of California to central Mexico and over to Hawaii. They say working at the island inn feels like an extension of that lifestyle. 📷 Kim Komenich

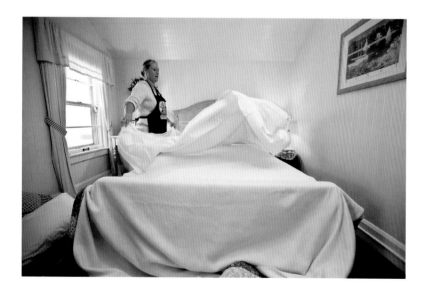

A light cleaning. Katy Stewart gets a bed ready for guests at the nonprofit East Brother Light Station. Katy and her husband, Elan, maintain the bed-and-breakfast and take turns readying the five rooms, each named after its distinctive view. 📷 Kim Komenich

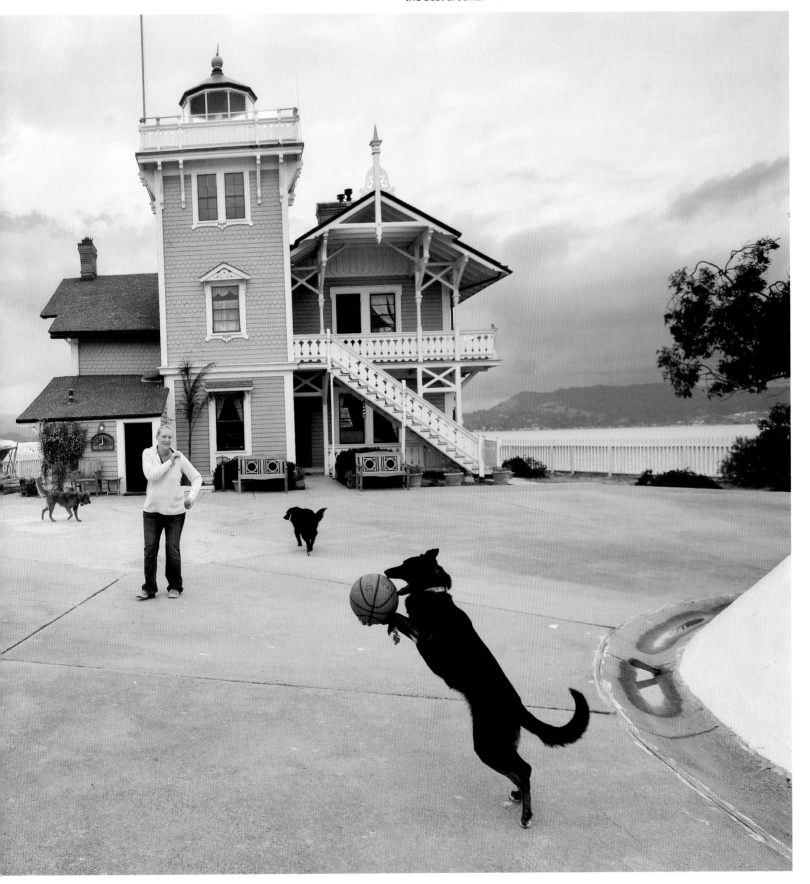

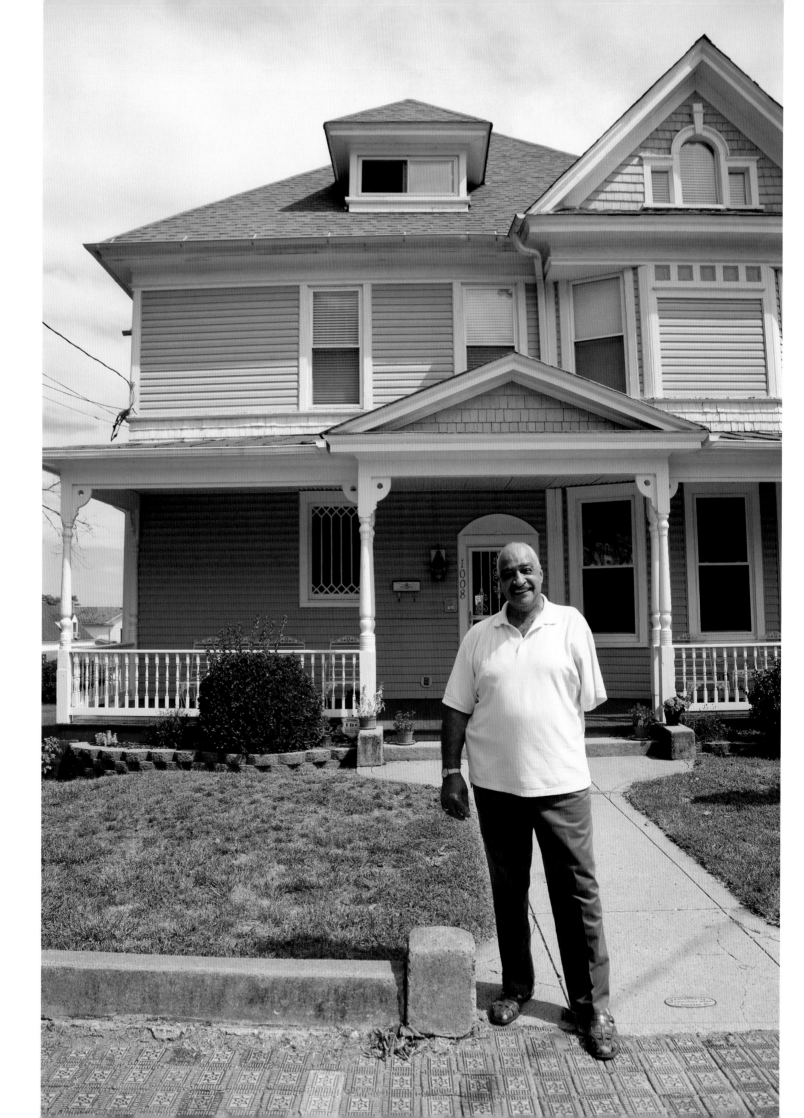

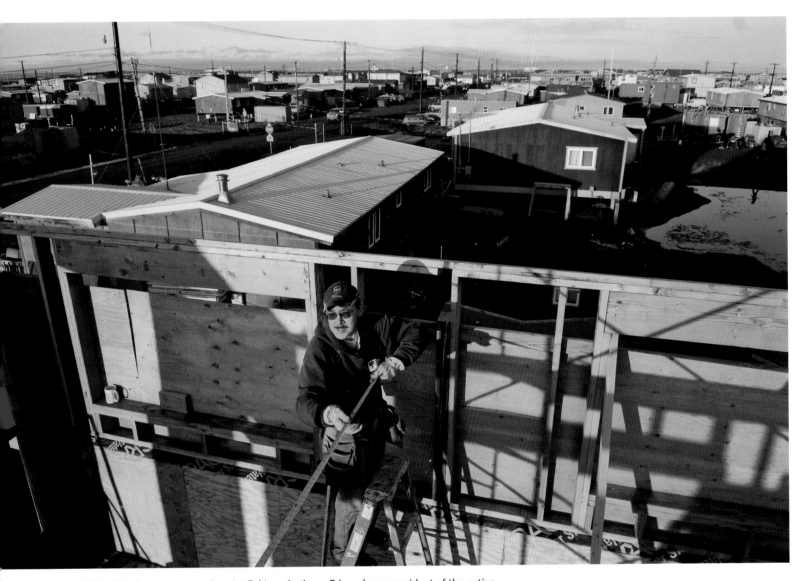

BARROW, ALASKA Northern exposure. Inupiat Eskimo Anthony Edwardsen, president of the native corporation UIC, works on his home in America's northernmost city. Though Alaska hasn't been immune to the real estate slump, rising oil prices have led to a booming economy on the North Slope. Edwardsen starts his work alone, but within minutes is joined by nephews, cousins, siblings, his wife, daughter, and granddaughters. Together they work until it is too dark to see. 📷 Luciana Whitaker

LYNCHBURG, VIRGINIA Board by board. Dabney McCain, 67, stands in front of the house he bought for just $1 in 1999 and completely restored by hand. McCain lost an arm in 1981 in an industrial accident—but that didn't keep him from constructing the roof and doing most of the extensive renovations by himself. "I used a lot of clamps," he laughs. 📷 Stephen Voss

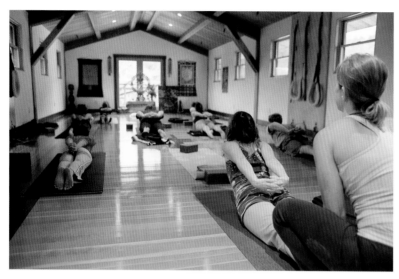

BOULDER CREEK, CALIFORNIA A flexible approach. Samantha Brown, right, teaches yoga in her home. The classes, mostly made up of employees of Brown's vineyard, meet three times per week. "Yoga has been a part of my life since I was 12-years-old," says Brown. "Twenty years later, I am still enthusiastically on the path." Yoga is a $3 billion industry in the United States, with 16.5 million adult practitioners. 📷 Maggie Hallahan

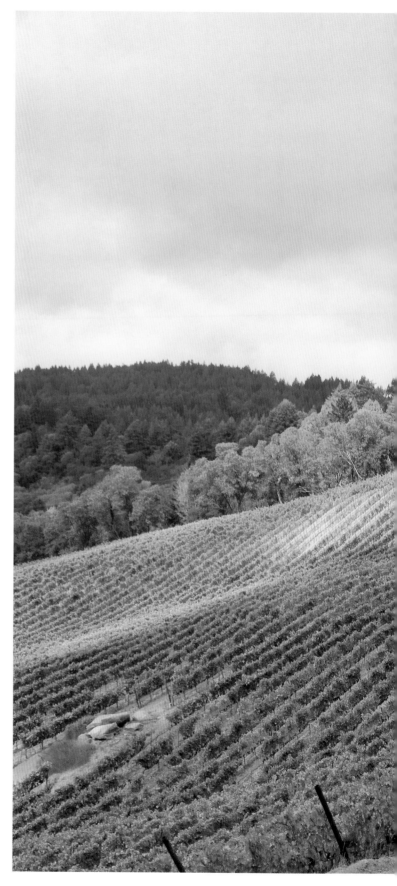

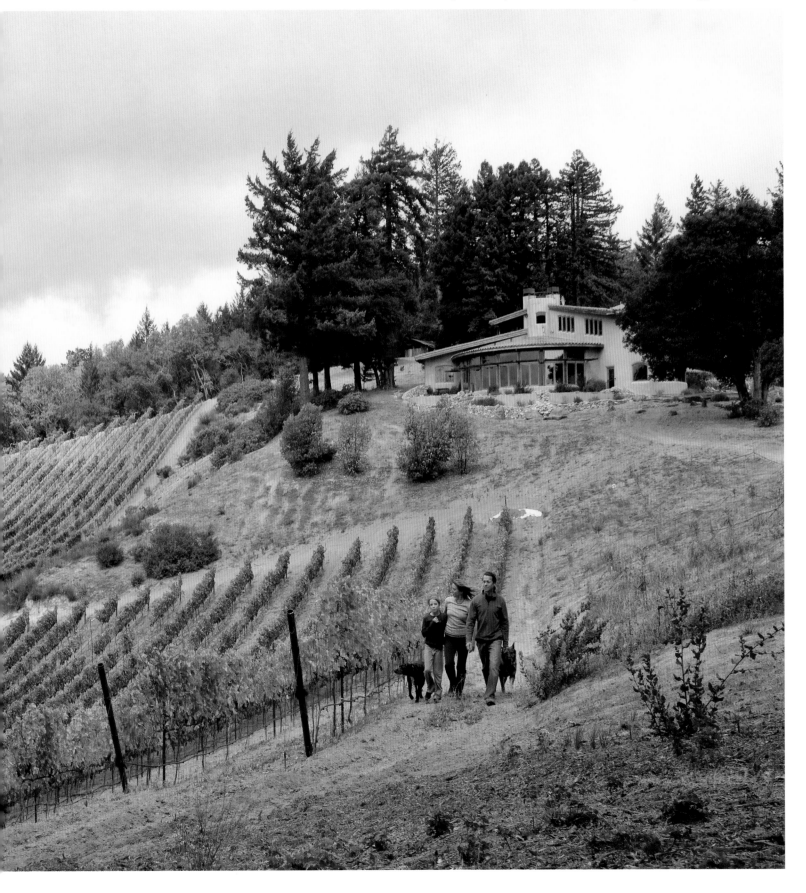

BOULDER CREEK, CALIFORNIA Under cultivation. A family strolls the vineyards of a winery in the Santa Cruz Mountains. Once the home of hippies and religious communes, these mountains, just a few miles from the fast pace of Silicon Valley, have become a close-by getaway for electronics tycoons and computer professionals, who often mix entrepreneurship with counterculture lifestyles. 📷 Maggie Hallahan

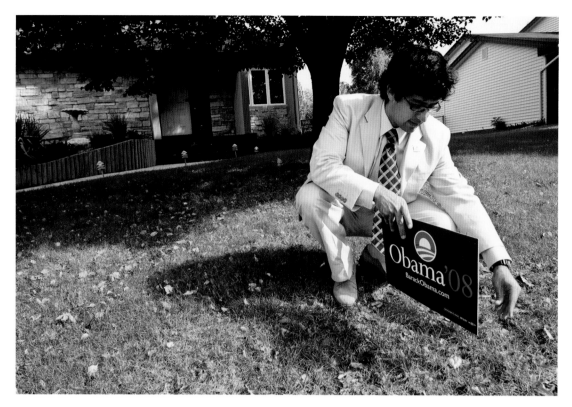

CLIVE, IOWA Commitment. Nathanael Blake, a member of Democratic presidential candidate Barack Obama's campaign staff, plants a sign in Karla Hansen's front yard in preparation for a caucus-style meeting at her home later that day. Since 1976, Iowa has had a major influence on presidential campaigns as the first political test of the election year. ◉ David Peterson

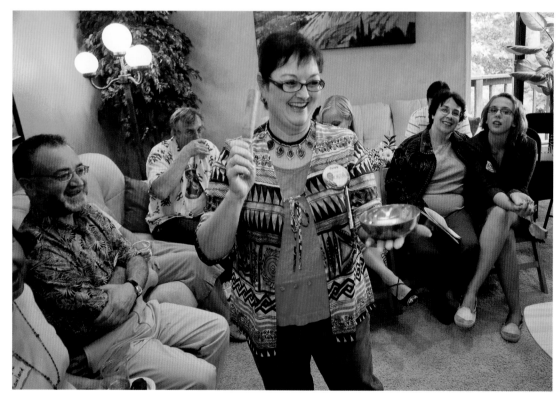

CLIVE, IOWA Convened. Karla Hansen, a longtime political activist, hosts a house party where concerned citizens have a chance to question members of presidential candidate Barack Obama's staff. Here she rings a Tibetan singing bowl to quiet the room and officially kick off the gathering. ◉ David Peterson

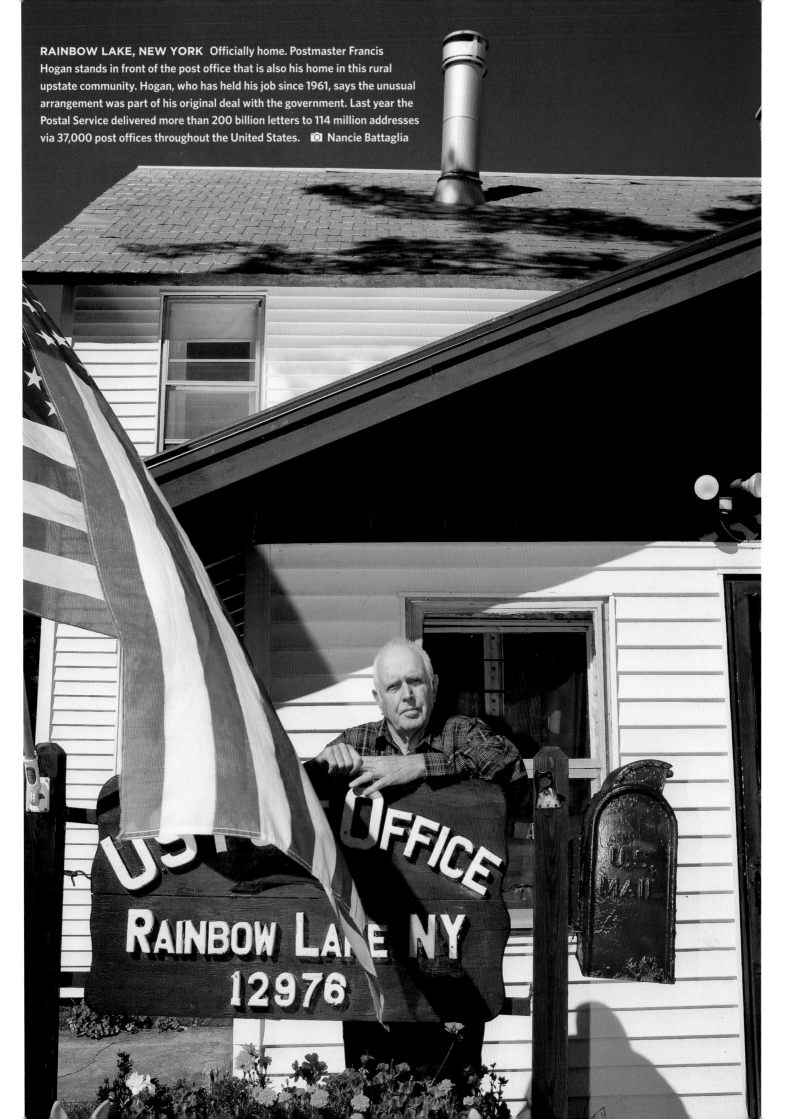

RAINBOW LAKE, NEW YORK Officially home. Postmaster Francis Hogan stands in front of the post office that is also his home in this rural upstate community. Hogan, who has held his job since 1961, says the unusual arrangement was part of his original deal with the government. Last year the Postal Service delivered more than 200 billion letters to 114 million addresses via 37,000 post offices throughout the United States. 📷 Nancie Battaglia

USPS OFFICE
RAINBOW LAKE NY
12976

U.S. MAIL

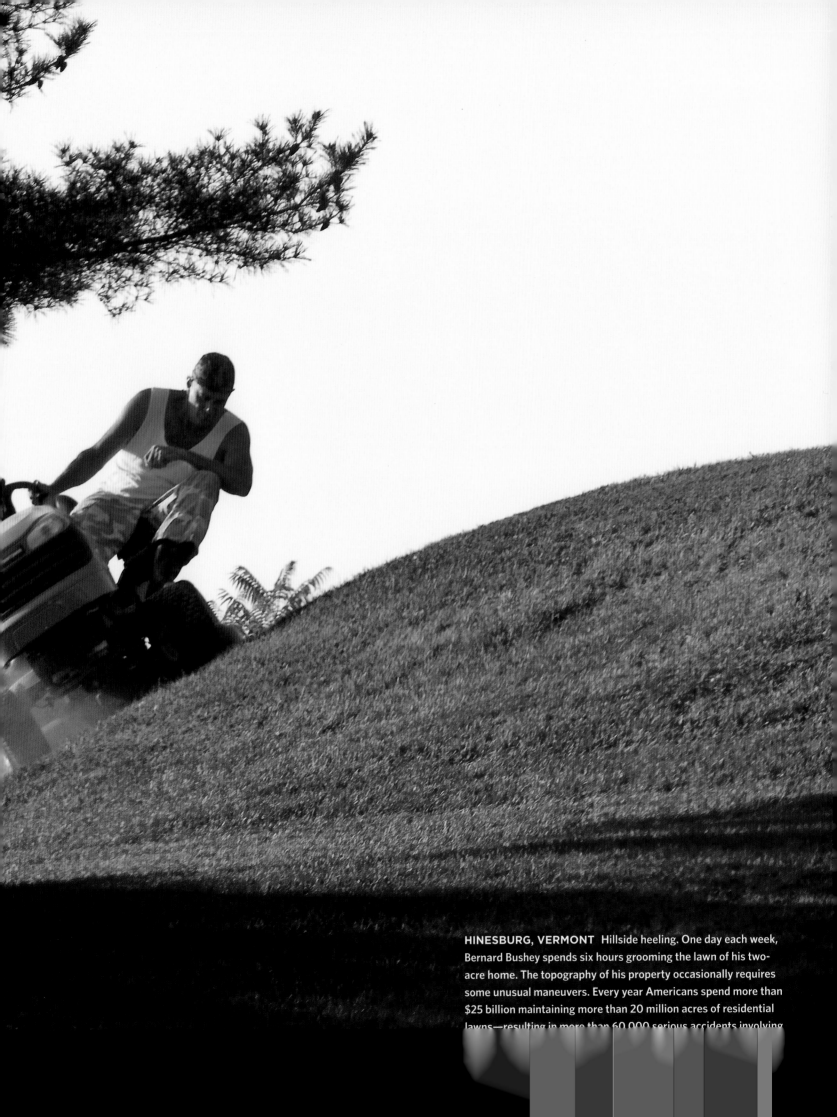

HINESBURG, VERMONT Hillside heeling. One day each week, Bernard Bushey spends six hours grooming the lawn of his two-acre home. The topography of his property occasionally requires some unusual maneuvers. Every year Americans spend more than $25 billion maintaining more than 20 million acres of residential lawns—resulting in more than 60,000 serious accidents involving

AMATEURS

The *America at Home* project invited talented amateurs to capture all the special moments that define home life and to submit them for possible inclusion in this book. Think of it as audience participation. More than 150,000 amateurs came to the project Web site and a selecti of their images, depicting American home life in all its glory, are included on the following pages and interspersed throughout this book.

MADISON, MISSISSIPPI The Harrison family loves their Saturday afternoon naps. Mother Sally took this shot just before climbing back in between her husband and their twins, Hayden and Hank. 📷 Sally Harrison

ALHAMBRA, CALIFORNIA Sleepy time. An exhausted Noah Rocha takes a nap with his pacifier, "Binky," following his second-birthday party. Noah has always slept in this unusual kneeling position. 📷 Micky Xin

YORKTOWN, VIRGINIA Time to bond. Ken Kerwin, 71, naps with 11-month-old Brianna in the family sunroom. Before his recent heart transplant, Kerwin never thought he'd get to meet his granddaughter. Now the two spend as much time together as possible. 📷 Barbara Kerwin

NEW BERN, NORTH CAROLINA After a long day as an active-duty Marine, Phillip Wisniewski went to get his clothes ready for the morning—and decided to close his eyes for five minutes. His wife, Becky, found him like this an hour later. The dog was not pleased. 📷 Becky Wisniewski

ARTHASVILLE, MISSOURI Airborne. Mary Kramme says her son, Theodore, 4, thinks he's Superman. Forever attempting flight, here he catapults f a tree stump into her boyfriend Scott Beste's arms. 📷 Mary Kramme

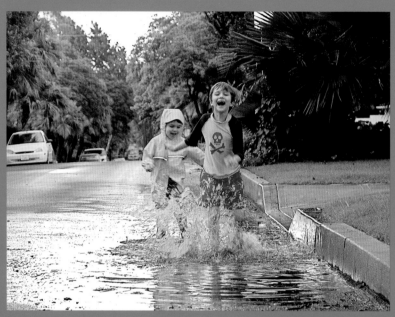

PALOS VERDES ESTATES, CALIFORNIA It doesn't often rain in Los Angeles, so Connor and Ryan Ramsdell, 3 and 7, took full advantage of the short-lived pool in front of their house. 📷 Heather Ramsdell

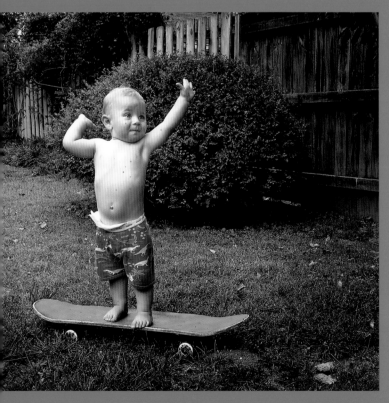

ASHVILLE, TENNESSEE The next Tony Hawk. While playing the backyard, 14-month-old Harrison Skinner decides to go kateboarding. The good news is that the wheels were safely stuck in the wn. 📷 Jennifer H. Skinner

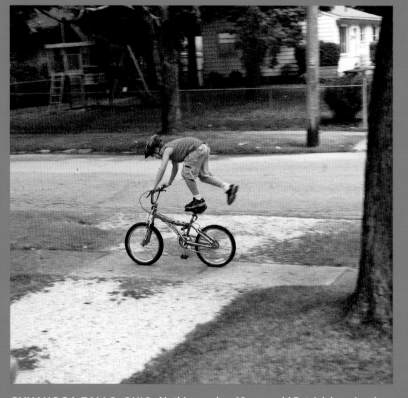

CUYAHOGA FALLS, OHIO Nothing makes 10-year-old Patrick happier than improvising a new daredevil trick on his bike. His mother, Deatra McEuen, takes consolation in the fact that at least he wears his helmet. 📷 Deatra McEuen

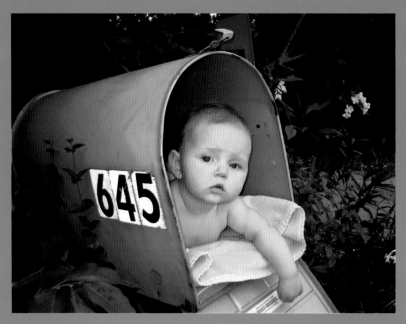

MERRITT ISLAND, FLORIDA You've got mail. Jordan Boggs, 7-months, takes up less room in the family mailbox than catalogs and junk mail do some days. 📷 Trish Boggs

SHERWOOD, OREGON Rub-a-dub-dub. The three Hubka kids—Ella, 2, Cole, 3, and Macy, 1—play in empty drink buckets left out after a family barbecue earlier that day. 📷 Ryan Hubka

HINGHAM, MASSACHUSETTS Bye-bye birdie? Oliver Ledwidge, 2, is searching for baby birds in the birdhouse of his grandmother, Mary McGrain. 📷 Mary McGrain

METAIRIE, LOUISIANA Cute crawfish. Gunnar Smith, five-months, loves to play peek-a-boo, creating an ideal moment for Mom to take the quintessential Bayou baby picture, complete with 40 pounds of steamed crawfish and locally brewed Anita beer. 📷 Stacey Smith

SUFFOLK, VIRGINIA Make way. At the Sharrar house, everyone is too hungry in the morning to wait for Grandma to prepare breakfast. 📷 Alison Worret

MANTI, UTAH Window watcher. While playing in their yard, the three Nordell children—Javed, Jaycie, and Shayliese—spot their baby brother, Roston, observing them and run over to say hello. 📷 Bonnie Lee Nordell

OAK PARK, ILLINOIS Mateo Garcia, 2, looks up at his sister, Gracie, 4, as they pause before heading to a party at a neighbors' house. 📷 Laura Husar Garcia

OAK PARK, ILLINOIS Mateo Garcia, 2, takes an early evening walk with his blue blanket, a constant companion. 📷 Laura Husar Garcia

LOVELL, MAINE Abby Garcia and Arianna Breene, both 8, wanted to play beauty parlor, so Abby's mother obliged. Neither girl knew what the cucumbers were for, but they tried them anyway. 📷 Kendra Lee Garcia

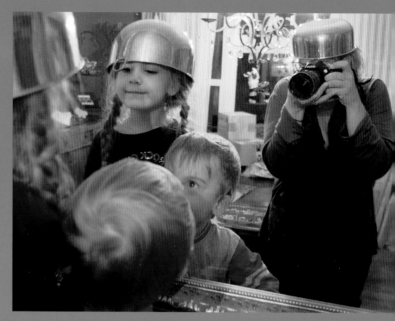

OAK PARK, ILLINOIS Laura Husar Garcia photographs Gracie, 4, and Mateo, 2. A stay-at-home mom, Garcia often joins her kids in wearing pots as hats, donning fairy wings, or wearing face paint. 📷 Laura Husar Garcia

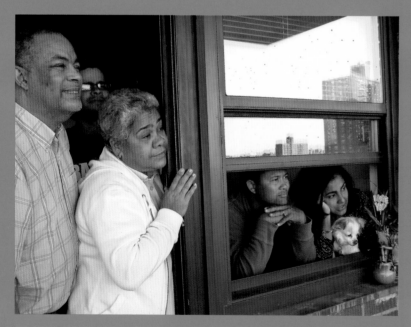

BRONX, NEW YORK The Pereyra family used to live in a basement apartment with no windows, but they recently moved to a ninth-floor apartment with a spectacular view. Even the dog loves it. 📷 Herendyra Pereyra

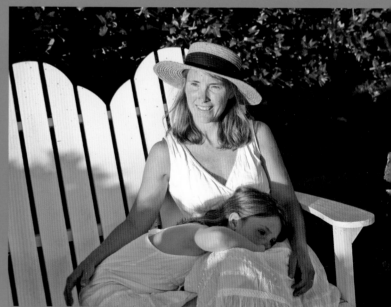

HILTON HEAD ISLAND, SOUTH CAROLINA Wearing their coolest dresses, Laura van Assendelft and her daughter Emily, 6, relax in the late afternoon sun after a family portrait on the beach. 📷 Diederik van Assendelf

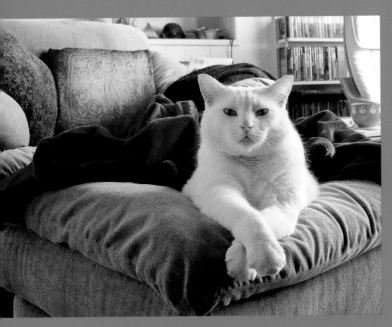

SACRAMENTO, CALIFORNIA King of the castle. At the Robinson house, Pete the cat rules his kingdom with an imperious gaze. Thirty-four percent of American households own at least one cat. 📷 Wendy Robinson

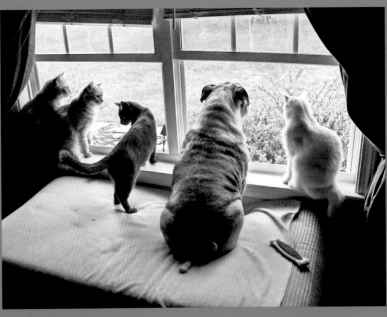

MOUNT HOLLY, NORTH CAROLINA Cookie was raised with cats, and the Flynns suspect she thinks she is one. She likes to perch on the couch and stare out the window with her fellow felines. 📷 Somer Flynn

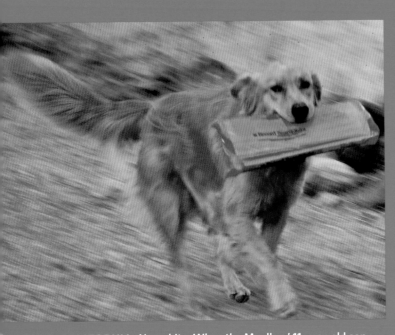

REDDING, CALIFORNIA News bite. When the Muellers' 11-year-old son, Micah, got tired of walking down their long driveway each morning to get the newspaper, he was inspired to teach Moxi, the family's golden retriever, to do the job instead. Unlike her young master, Moxi loves every second of it. 📷 Roxi Mueller

BRIMFIELD, ILLINOIS Hurry, hurry. Maggie May, a Vizsla, waits by the window every weekday for her mistresses, Alexis and Riley Baker, to step off the school bus and walk through the front door. 📷 Denise Baker

AMY TAN

HOME AND YOUR
COMPANIONS

MY HUSBAND RISES EARLY EACH MORNING and goes downstairs to read the newspaper. I scrunch deeper under the comforter, squeezing out more dreams. Until a few months ago, my three-pound boy dog would dance on my face to waken me. Now his two-pound sister, who is also bereft, lies quietly on my chest. If I don't stir, she licks my nostrils as gentle reveille.

We live in a hundred-year-old house overlooking the harbor, the straits, and the bay. From the bedroom window, I see an island of ghosts. It is a peaked mountain shaped like a peasant's conical hat. A hundred years ago, the island was the quarantine station for Chinese immigrants, some detained so long they wrote poems about loneliness. No one lives on the island anymore. At night, it is a purple shadow. Sometimes I think about the young woman whose father built her this house a hundred years ago. She must have seen lanterns blaze on the island at night.

Every morning, the water looks different, glassy or choppy, sapphire-colored or muddy gray. One day, we saw a glinting spot of water as long as a rich man's yacht. My husband and I asked, What's that? A school of golden fish? It was the sun angled just so. The next time we saw it, we forgot and said, What's that? Egrets, pelicans, and scrub jays fly by, turkey vultures too. In the fall, cyclones of geese and ducks circle the harbor. In the summer, hummingbirds sidle up to the windowpane.

Every morning I hear the grinding of coffee. Its scent rises as my husband climbs the stairs. He hands me my morning mug, and we do our ritual. "What do you say?" he asks. "Thank you," I answer, and he receives his kiss. There have been days when I awake confused because it is quiet and the smell of the house is of unstirred air. And then I remember that my husband is away on a trip. To miss someone is to also miss what is supposed to be the same in the house.

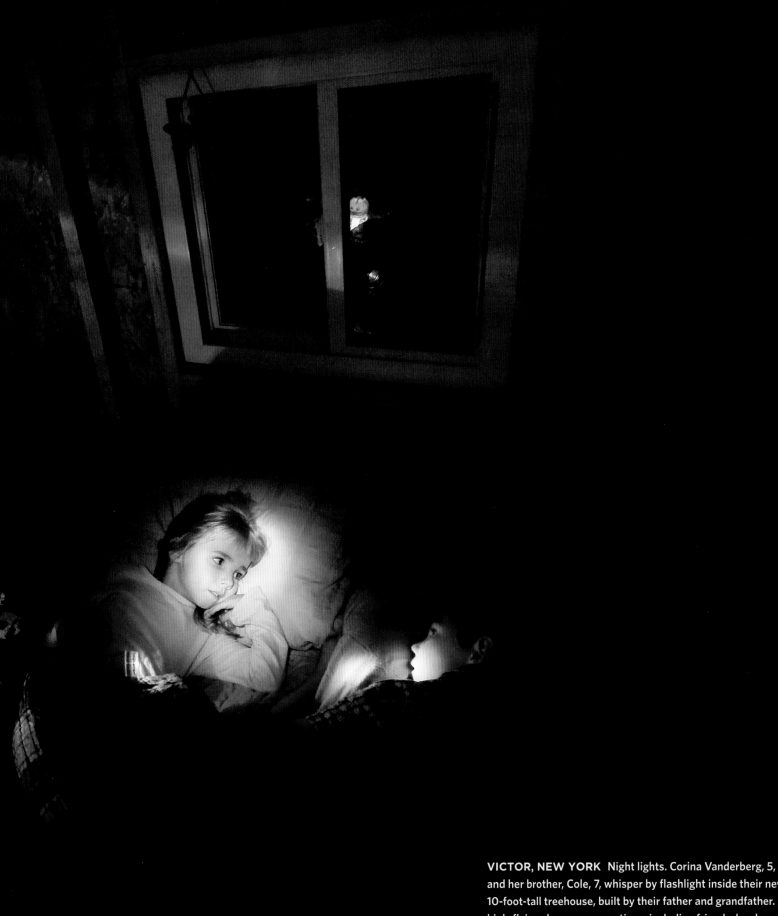

VICTOR, NEW YORK Night lights. Corina Vanderberg, 5, and her brother, Cole, 7, whisper by flashlight inside their new 10-foot-tall treehouse, built by their father and grandfather. A high-flying sleepover, sometimes including friends, has become the newest family ritual. Corina and Cole's parents take turns sleeping in the treehouse with them—while the other parent prepares breakfast in the morning. And sometimes, while the kids sleep inside, their parents sneak out to the treehouse with a bottle of wine and a baby monitor. 📷 Carlos Ortiz

Not so long ago, the little dogs raced together down the stairs, then flew out the door and onto the porch. The boy barked at the world and the girl nipped his heels. They ran to the lawn and peed on the same patch. The little boy galloped like a pony in tall grass. The little girl followed him to the pond. The boy chased off blackbirds. The girl barked as if she had helped. After the little boy died of old age, the little girl sat for many weeks at the top of the stairs facing the front door. That was where she and the boy had waited together whenever my husband and I had left the house without them. In the garden, next to the pond that the boy dog loved, I will plant a dwarf crab apple tree. It will flower in the spring.

Every morning the newspapers are waiting for me on the breakfast table. The crossword puzzle is filled in, and my husband is upstairs in his office. I take the papers and my second mug of coffee to the living room. The little girl dog lies in a spotlight on the rug. At ten o'clock, I go upstairs to my study, a former sunporch with nine windows and never enough bookshelves.

Once or twice a month, there is an excuse for a party. My editor is here for her daughter's wedding. My friend the art collector wants to meet my friend the art curator. My mother's birthday is today and we should make pot stickers to remember that she made them better. Take-out Chinese food arrives along with the first guest. The rooms fill slowly, then suddenly. The air grows warm with words. On cold nights, the partygoers borrow sweaters and wraps to stand outside on the deck. In autumn, they watch the moon rise and the island glow. Then someone is the first to leave. By midnight, the house is quiet, as if no one had ever come. But wait, there is leftover Chinese food. Evidence.

Every night, before sleep, I admire the water, the indigo island against an India ink sky. In a hundred years someone else will stand before this window. She will notice how the water looks different every day, how it is also the same. She will wonder if anyone ever lived on the island. She will write the answer in poetry.

Amy Tan is the author of The Joy Luck Club, The Kitchen God's Wife, The Hundred Secret Senses, The Bonesetter's Daughter, The Moon Lady, and The Chinese Siamese Cat.

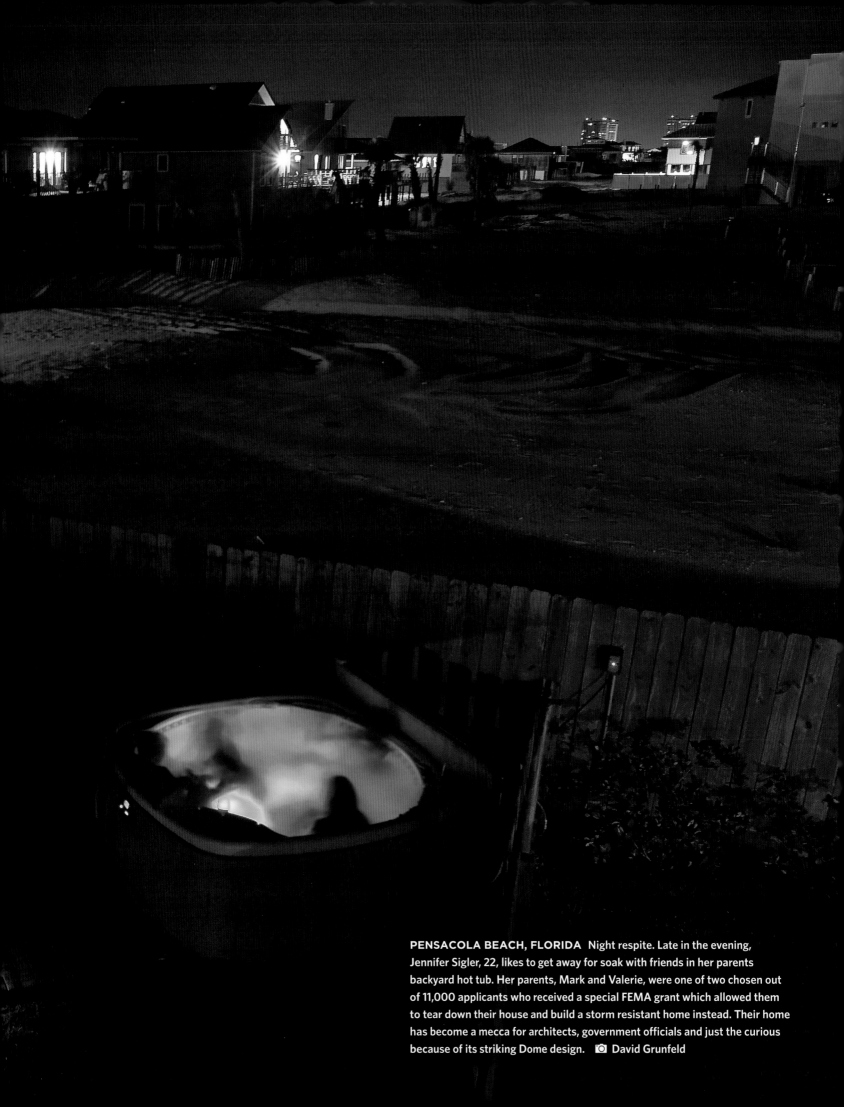

PENSACOLA BEACH, FLORIDA Night respite. Late in the evening, Jennifer Sigler, 22, likes to get away for soak with friends in her parents backyard hot tub. Her parents, Mark and Valerie, were one of two chosen out of 11,000 applicants who received a special FEMA grant which allowed them to tear down their house and build a storm resistant home instead. Their home has become a mecca for architects, government officials and just the curious because of its striking Dome design. 📷 David Grunfeld

EUGENE, OREGON Precious things. Reflected in an old mirror, Ray and Chris Scofield join other portraits on the wall of their eclectic, object-filled Oregon home. Inspired by programs like *Antiques Roadshow*, Americans now spend about $10 billion each year on antiques. 📷 Brian Lanker

80 percent of married men say they would marry the same woman if they took a time machine back to the day they got married. Only 50 percent of married women would do the same.]

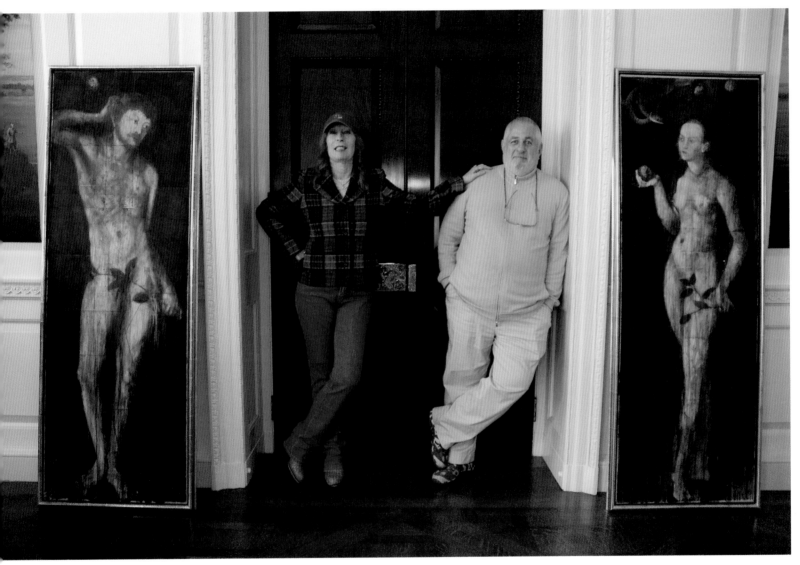

NEWPORT, RHODE ISLAND Adam and Eve. Gloria Nagy and husband Richard Saul Wurman join the very first couple in the living room of their Rhode Island home. The original paintings are by Blake Summers. Nagy is an author and lyricist who has published ten novels. Wurman, a pioneer in the practice of making information understandable, has written and designed more than 80 books; he also created the celebrated TED conferences and coined the phrase "information architect." 📷 C.M. Glover

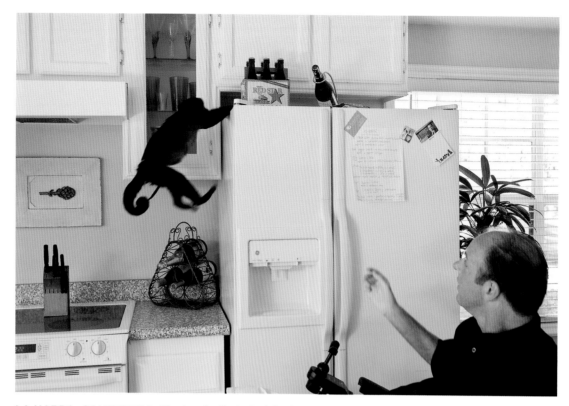

LA HABRA, CALIFORNIA Monkey do. Craig Cook broke his neck in a car accident 11 years ago and was left a paraplegic. Getting through the day was difficult until three years ago, when the Boston-based organization Monkey Helpers for the Disabled introduced him to Minnie, a companion and helper monkey who responds to voice commands, bringing Cook whatever he needs. 📷 Misha Erwitt

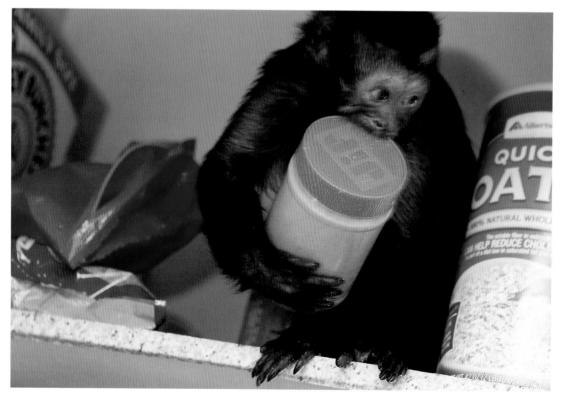

Sandwich time. Trained monkeys are not only intelligent but strong. Here, Minnie climbs into the pantry to get peanut butter for Cook's lunch. She can also pick up objects and turn light switches on and off. Needless to say, the pair have become close friends. On his mantel, Cook keeps a photo of Minnie, captioned "Daddy's Little Princess." It began as a joke, Cook explains, but now it's becoming true. 📷 Misha Erwitt

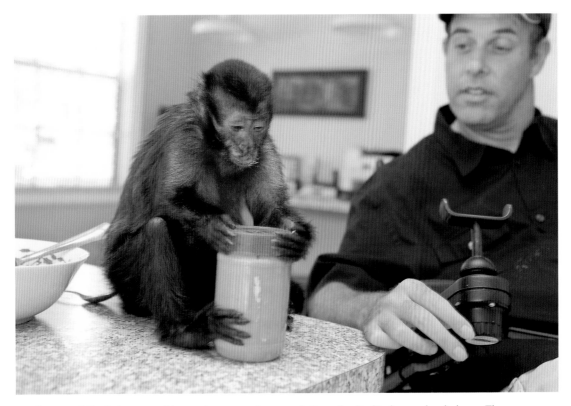

Do the twist. Minnie is a capuchin monkey, a species especially well suited to be monkey helpers. They are natural tool users and are endlessly curious. Today there are only 104 monkey helpers nationwide—at a training cost of $30,000 each—available for the 11 million disabled Americans who need assistance with daily living. Minnie is the first monkey helper to be placed in California. 📷 Misha Erwitt

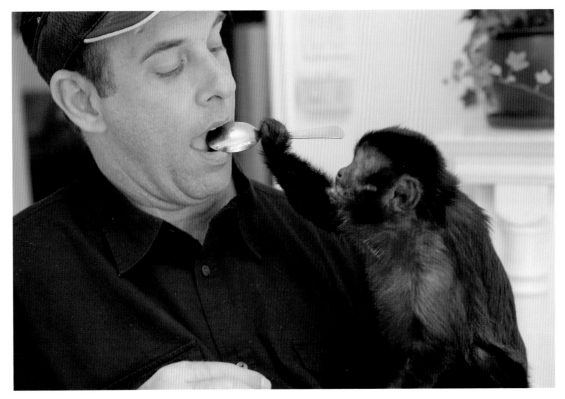

One last bite. Minnie helps Cook finish lunch. Besides helping with food preparation, Minnie has a 30-word command vocabulary, and can turn on the computer and load CDs. Her favorite command: give me a high-five. "Isn't it cool?" says Cook proudly. As a way of saying thanks, Cook has become a spokesman for the Helping Hands foundation. 📷 Misha Erwitt

[Americans spent more than 41 billion dollars on their pets this year,

almost double the 23 billion spent ten years ago.]

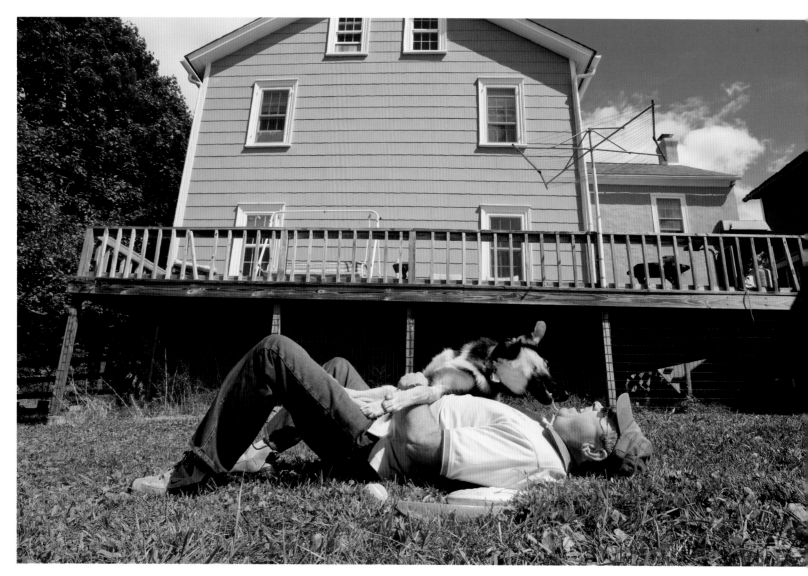

PERKASIE, PENNSYLVANIA Perpetual puppies. Since 1997 Rich Jones and his wife, Debbie Hahn, have raised puppies for Seeing Eye, an organization that trains dogs for the blind. The puppies are raised and socialized until they reach 17 months, at which point those that pass muster receive training as seeing eye dogs. The couple are now on their ninth puppy, doing their part to help America's 1.6 million blind people. Says Hahn, "It's the touching thank-you letters we receive from blind owners that enable us to give up our little charges." 📷 Michael Bryant

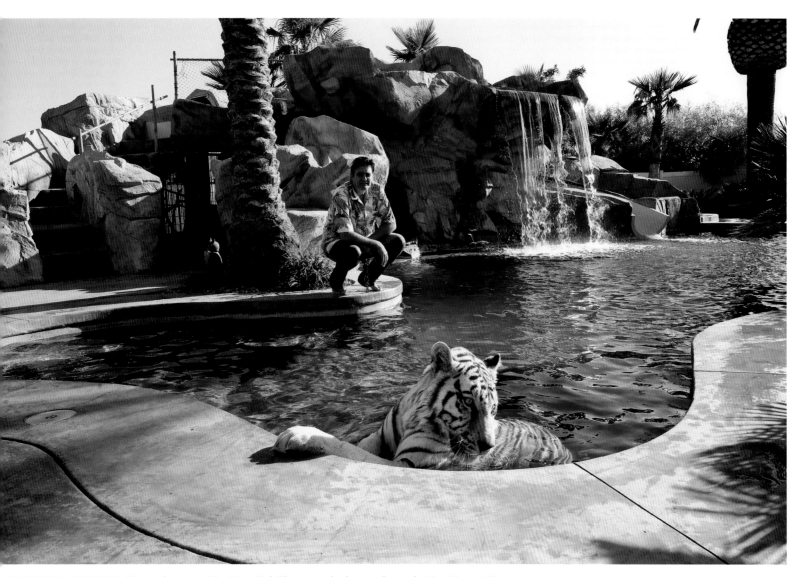

LAS VEGAS, NEVADA Star and stripes. Magician Rick Thomas, who has performed at Las Vegas's Tropicana, Stardust, and Orleans hotels over the last 25 years, shares his backyard habitat with seven performing tigers, including Samson, a white Bengal. Though none of his tigers has ever injured anyone, Samson is still considered dangerous. The U.S. Department of Agriculture has special regulations for such priceless creatures, requiring that performers use them to educate the public. "It's a privilege to work with them," says Thomas. "They aren't just pets. I want to help save this endangered species." 📷 Brad Zucroff

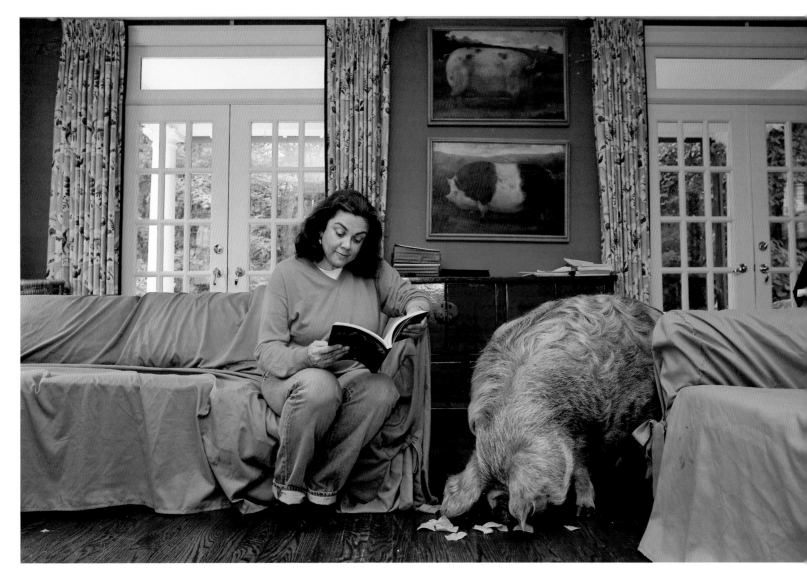

LAKE FOREST, ILLINOIS Hog heaven. Estelle Walgreen enjoys the company of Cooper, a 2-year-old Kune
Kune pig, in the living room of her mansion. Cooper usually roams the grounds of the estate with Estelle's other
pot-bellied pigs, Pinky and Piggy. As much as Walgreen loves them, her neighbors do not. More than 250 people
have filed a petition to force her to give them up. A judge has upheld her right to keep them, but Walgreen has
decided to move to the country anyway. 📷 Alex Garcia

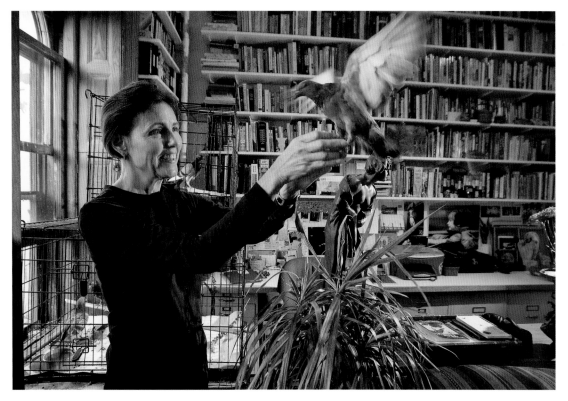

NEW YORK, NEW YORK Flutter. Rita McMahon does volunteer work for Animal General Hospital, a bird rescue organization, helping to nurse injured birds back to health. Before releasing baby birds back into the wild, she uses her Upper West Side apartment as a training ground to teach them to fly. 📷 Jennifer S. Altman

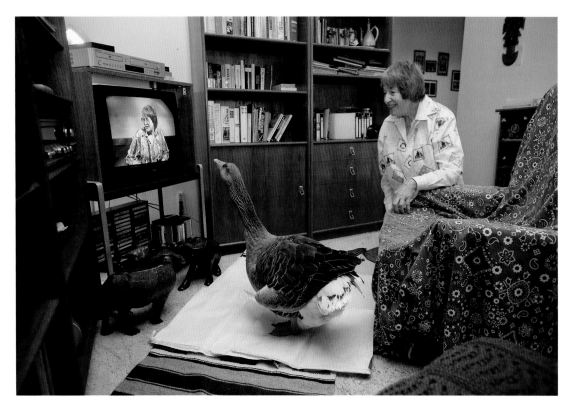

MILL VALLEY, CALIFORNIA Honk if you like geese. Sigrid Boehm, 71, is known as the Mother Goose of Mill Valley—her license plate even reads GOOSEMOM. Boehm shares her small condo with two geese, including the arthritic Mario, who honks with delight while watching her frequent television appearances. She also rehabilitates "problem" geese and relocates them to refuges and aviaries. 📷 Kim Komenich

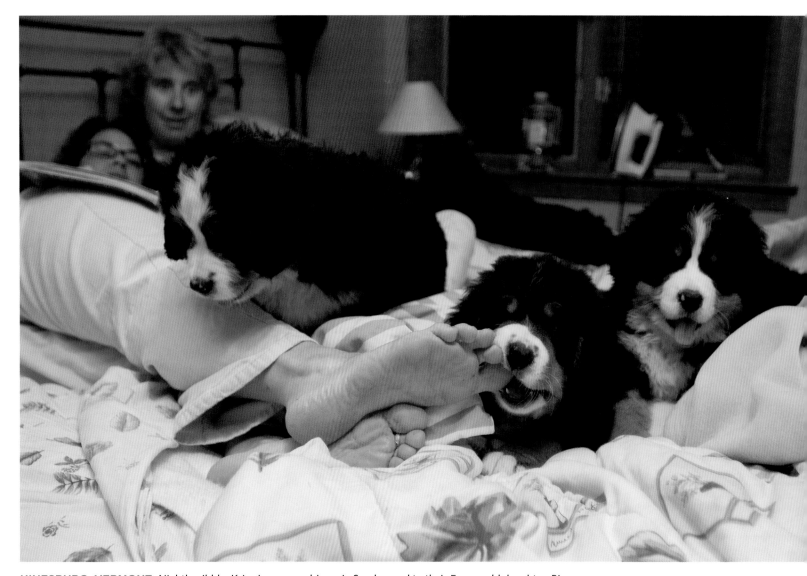

HINESBURG, VERMONT Nightly nibble. Kriss Lococo and Jacquie Snyder read to their 5-year-old daughter, Bianca, before tucking her into bed. Meanwhile, the newest additions to the household, six Bernese mountain dog puppies, find ways to amuse themselves. Four of the puppies will eventually be given up for adoption. 📷 Karen Pike

[Nearly 70 percent of all Americans share their beds with partners or pets.]

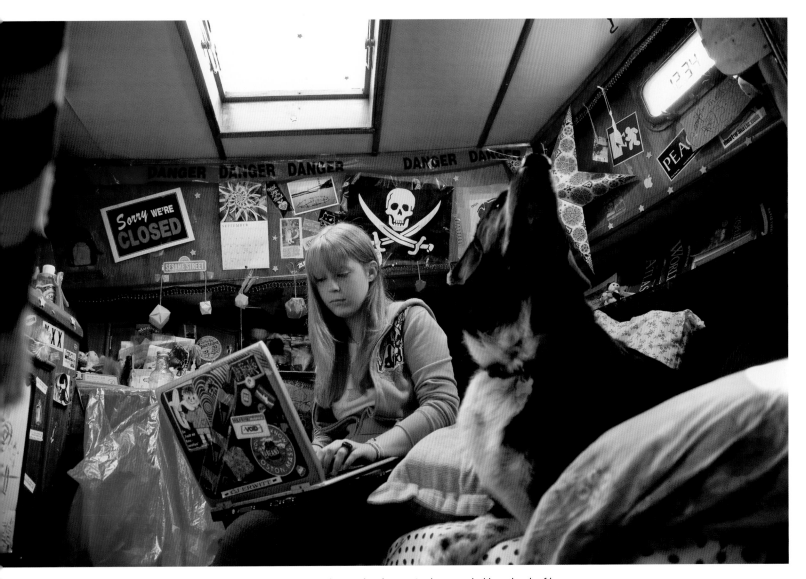

FRIDAY HARBOR, WASHINGTON All aboard. CJ Erwitt, 16, studies on her laptop in the crowded bow bunk of her family's 45-foot live-aboard cruiser, *Goldfinger*—all under the watchful protection of 100-pound Wilson. CJ has lived most of her life aboard small boats like this because her father, David, works as a marine mechanic. Their current location, in Friday Harbor in the San Juan Islands (population 1,900), represents CJ's seventh move since she was born. 📷 Elliott Erwitt

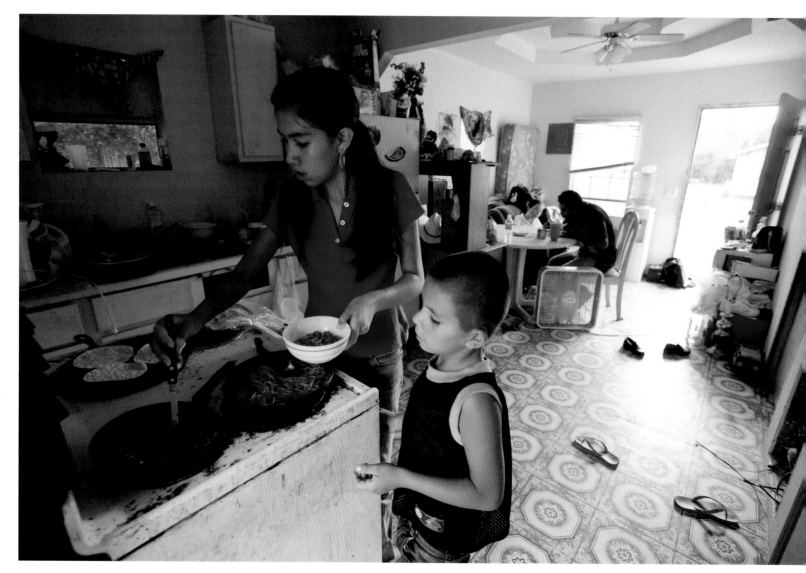

LA GRULLA, TEXAS Another helping. Marta Veronica Lopez, 13, serves dinner to her brother, Jose Manuel, 9, as one of her two sisters, Mayra Magali, 11, and father, Juan, eat at the table in their small rental house in La Grulla, Texas. As he raises his four children alone, Lopez is building a 1,400-square-foot home for his family in his spare time. In 2006, nearly one-quarter (23 percent) of American children lived with only their mothers, 5 percent with only their fathers, and 5 percent with neither of their parents. ◻ Michael Stravato

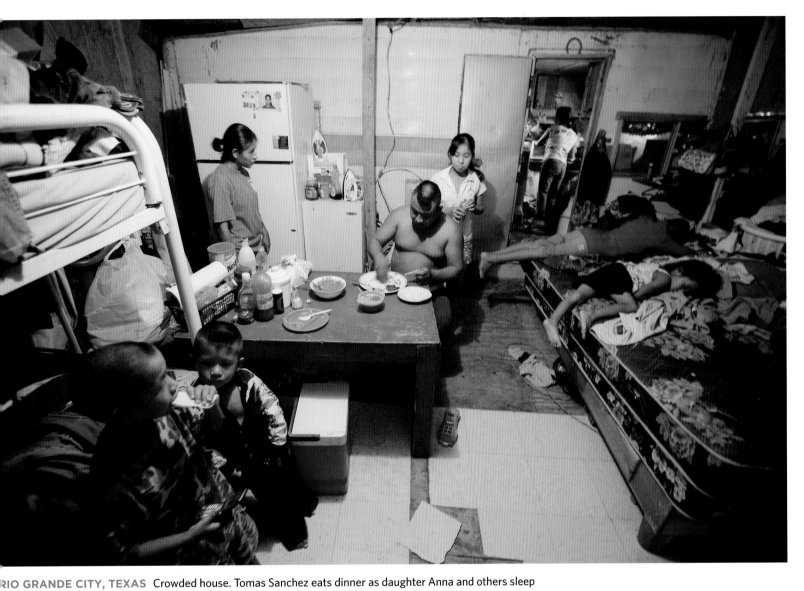

RIO GRANDE CITY, TEXAS Crowded house. Tomas Sanchez eats dinner as daughter Anna and others sleep nearby. Their home, in the Las Lomas *colonia*, is built from a trailer and various makeshift walls. They have no plumbing: the Sanchezes and their six children use an outhouse and get their water from a neighbor's garden hose. The percentage of the U.S. population living in poverty is 12.5 percent and growing. 📷 Michael Stravato

CLEAR LAKE, MINNESOTA Come on in. Shirley and Henry Groth, 64 and 66, quit their cubicle jobs, sold their home of 32 years, and bought a 32-foot Airstream trailer. "I wanted to get out and see the country," says Shirley. They've been on the road for five years, visiting 30 states in the first year alone. Seven percent of Americans are mobile home owners or renters, 44 percent of them aged 50 or older. Many now receive their Social Security checks at their next RV campground—of which there are 16,000 around the country. 📷 Ben Garvin

CHAPEL HILL, NORTH CAROLINA Home sweet home. Walter Atwater and his wife, Anne, live in the home where Walter was born in 1925. His father built the house ten years before that. Retired from IBM, Walter still farms the land, just as his father did nearly a century ago. 📷 Juli Leonard

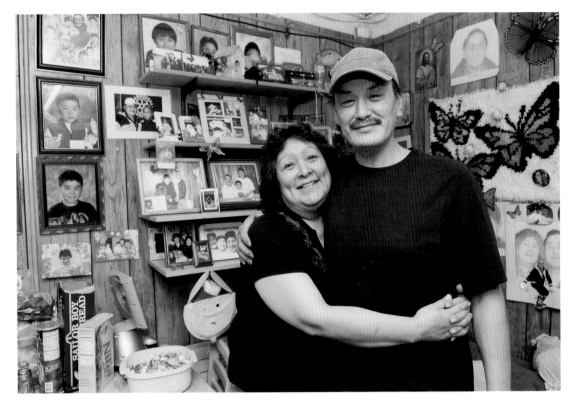

BARROW, ALASKA Here to stay. Elsie Pikok, Jerry Ahyakak, and Pikok's 7-year-old son, Qiugaaluk Ahyakak (whose portraits cover the wall), live in the house where Pikok was born and lived with her parents and 11 siblings. Pikok wants her son to be raised as she was, the Inupiat way, including learning the language, hunting caribou, harpooning whales (Ahyakak's profession), and sponge bathing in a house without water. 📷 Luciana Whitaker

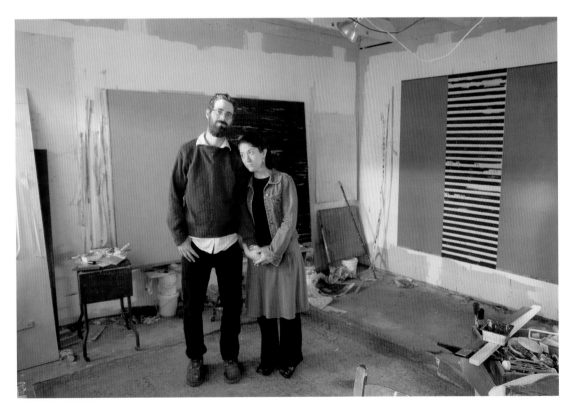

PROVIDENCE, RHODE ISLAND Paint job. In 2001, Cristina DiChiera and Neal Walsh found their dream home: an abandoned two-family house on Providence's West Side. With help from the Providence Preservation Society Revolving Fund, they brought it back to life. In 2003 they converted the garage behind the property into an art studio. Here, they pause among Walsh's paintings and the ongoing renovations. 📷 Anne Day

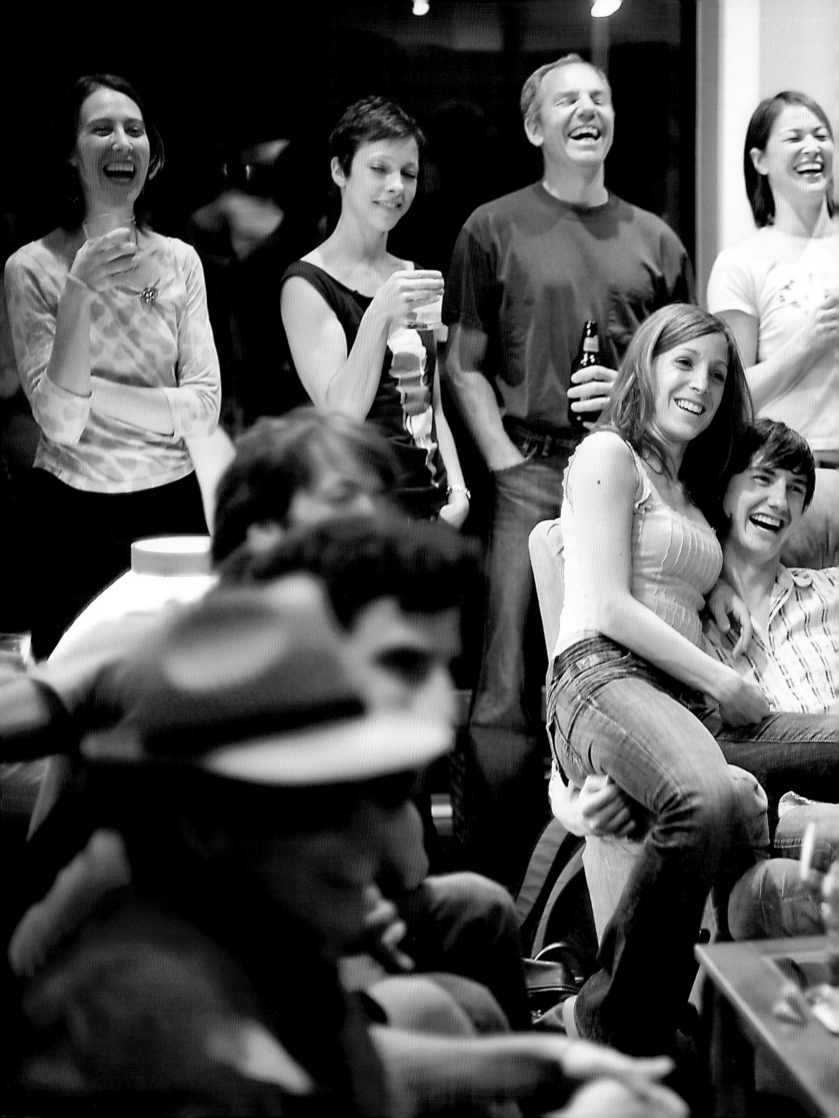

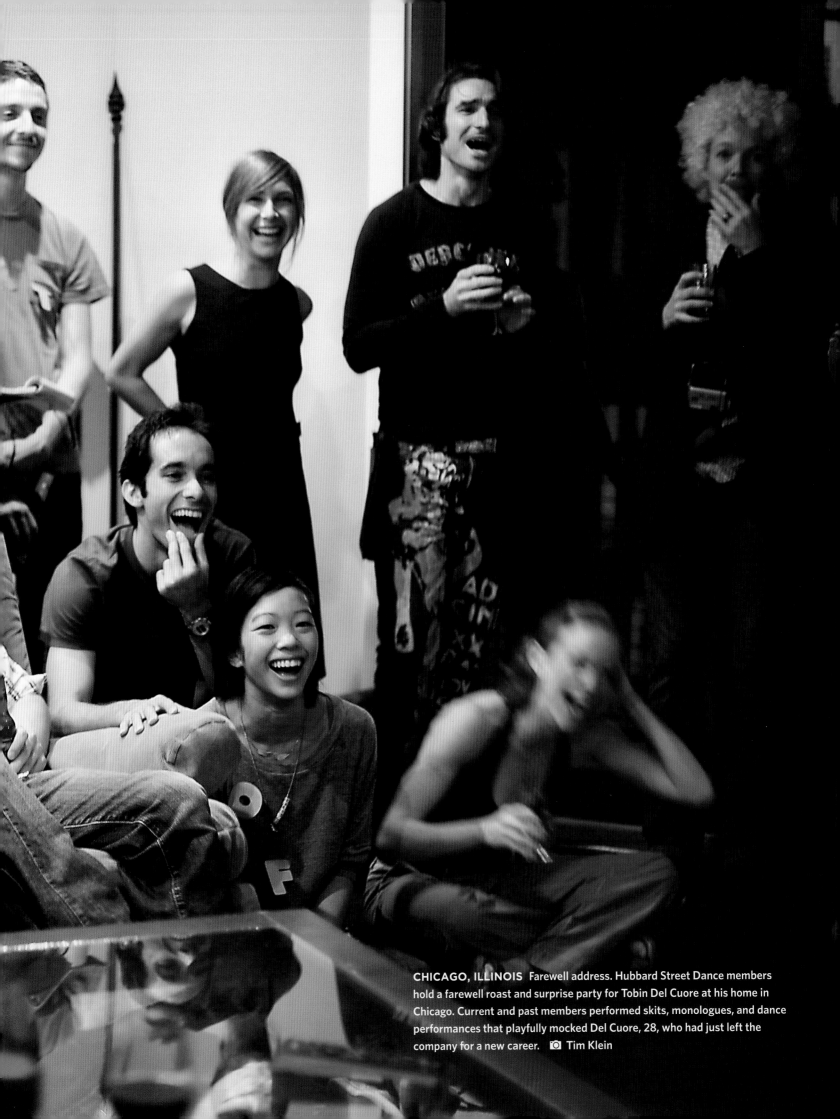

CHICAGO, ILLINOIS Farewell address. Hubbard Street Dance members hold a farewell roast and surprise party for Tobin Del Cuore at his home in Chicago. Current and past members performed skits, monologues, and dance performances that playfully mocked Del Cuore, 28, who had just left the company for a new career. 📷 Tim Klein

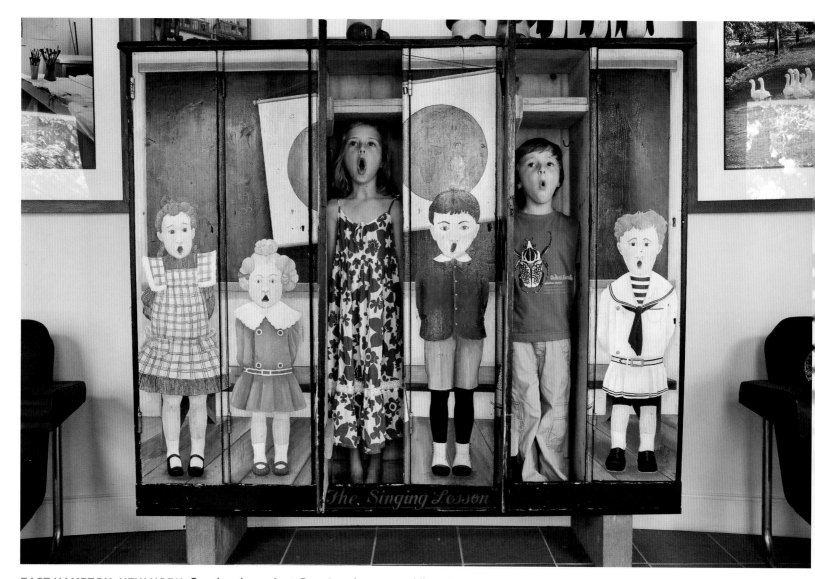

EAST HAMPTON, NEW YORK Grandpop knows best. Ever since they were toddlers, the first thing that Phoebe and Jesse Smolan, 7 and 5, do when they arrive at their grandfather's Long Island home is to climb into the painted school lockers to see how much they've grown since their last visit. A scrapbook kept by Grandpop Elliott Erwitt, a renowned photographer whose images appear on the walls of museums around the world, lets them chart their growth. 📷 Rick Smolan

The world's population—currently at 6.4 billion—has quadrupled over the past century. The United States, with a population of nearly 300 million people, is the only industrialized country that is still experiencing strong population growth.

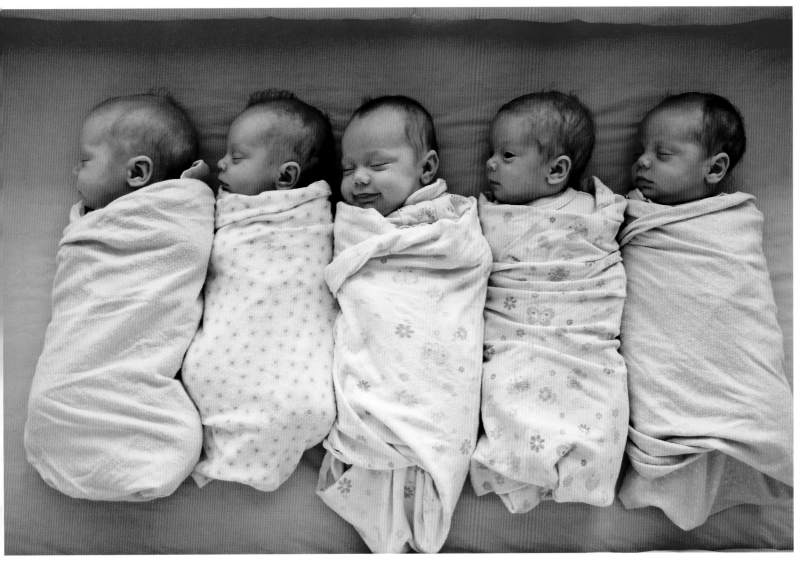

CEDAR PARK, TEXAS Secret smile. Only seven weeks old, the five newest Wilkinsons—Kassidy, Kaydence, Rustin, Kyndall, and Ryder—are swaddled in flannel wraps after their morning baths. With two older children, Kaiya, 4, and Riley, 7, their parents, Riley and Rachelle, would be overwhelmed without the help of local volunteers, who come in pairs every two hours. Michael O'Brien

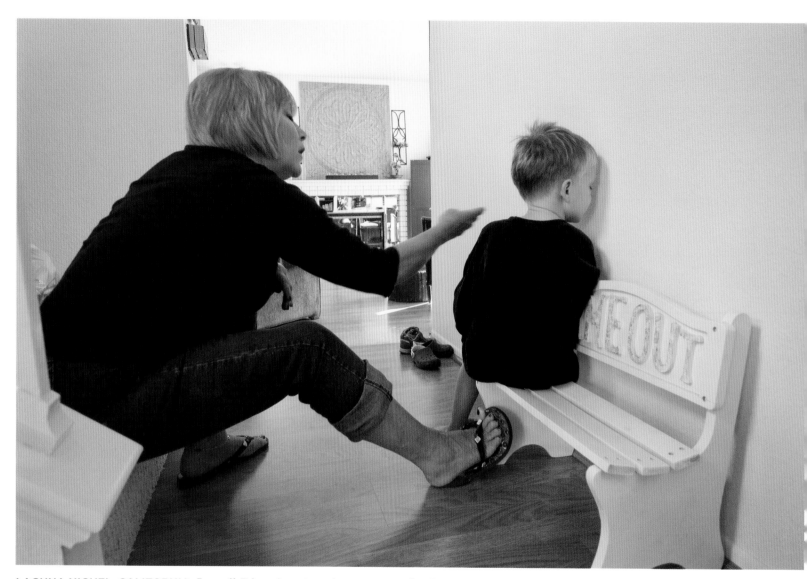

LAGUNA NIGUEL, CALIFORNIA Face-off. Tyler refuses to make eye contact when his grandmother, Schelia Evans, tells him he's just earned five minutes on the time-out bench. Evans, a practiced hand who looks after her three grandchildren while her daughter is at work, does her best to make the day fun, while still using the bench to discipline misbehavior. About 2.4 million American grandparents act as caregivers to one or more grandchildren. 📷 Rick Rickman

[Close to 1 percent of all American homes include members of three generations, where a grandparent is part of a household that includes their grandchildren.]

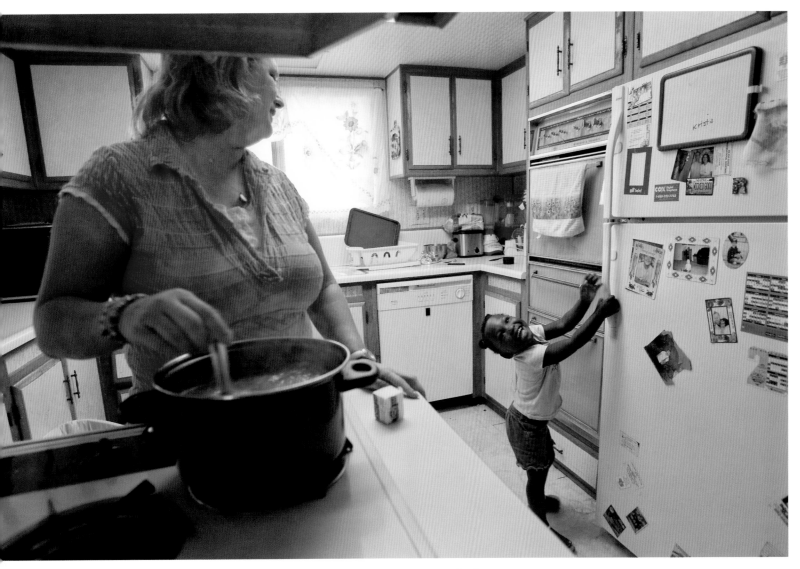

SAN DIEGO, CALIFORNIA Destiny. In addition to caring for her teenage birth child, high school nurse Colleen Dixon has adopted three disabled children: Zoey, 3, shown here; Trevor, 6; and Rico, 7. Zoey and Rico had drug-addicted birth mothers, and Trevor has Down syndrome. Says Dixon, "These are the children I was meant to have." A single parent, Dixon is carrying on a family tradition: she has 42 brothers and sisters, many of them adopted, mentally challenged, or disabled. 📷 Peggy Peattie

MANHATTAN, KANSAS A distant voice. Emily Cummings, 8, reads a letter from her father, Major Brent Cummings, who is in Iraq serving a 15-month tour with the 216th Infantry. He will return in May 2008. Until then, Emily has only letters, a voice on the phone, and her Flat Daddy photo. 📷 Mike Yoder

TOLEDO, OHIO Perspective. Graphic artist Ryan Straube cuts a roll of Flat Daddies (and Mommies) into individual images at SFC Graphics in Toledo, Ohio. The century-old company prints about 70 life-size pictures of soldiers each week and charges only shipping fees to send the pictures to military families with children. 📷 David Ahntholz

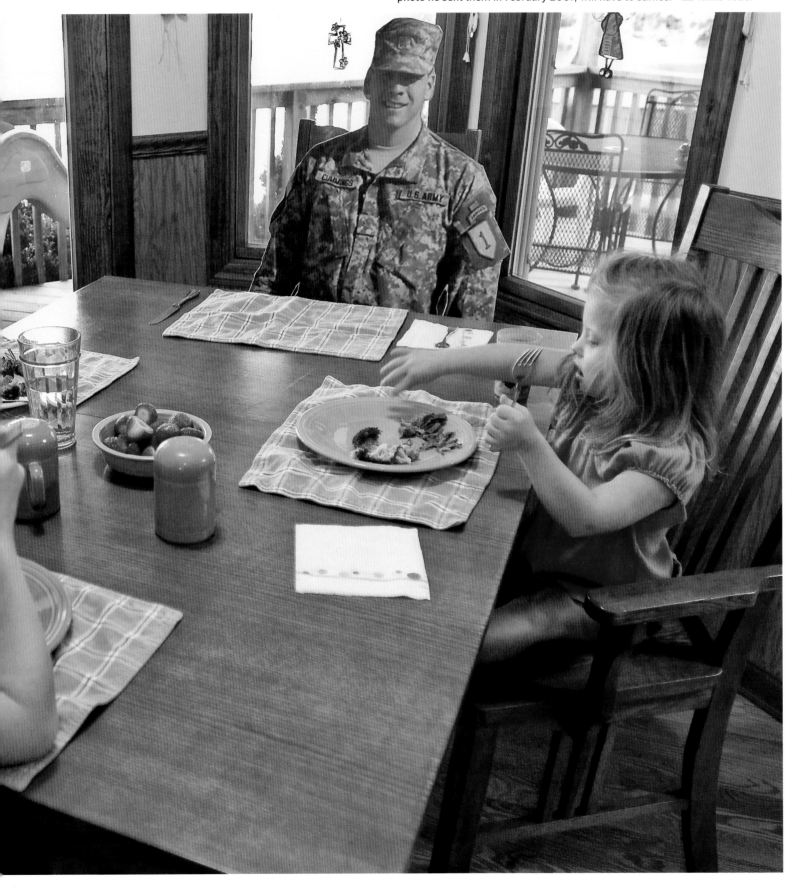

MANHATTAN, KANSAS Daddy, can you hear me? Laura Cummings and her two daughters—Emily, 8, left, and Meredith, 4, right—sit down to dinner with an enlarged photo cutout of husband and father Major Brent Cummings. Until he returns from his 15-month tour in Iraq, this Flat Daddy image, made from a photo he sent them in February 2007, will have to suffice. 📷 Mike Yoder

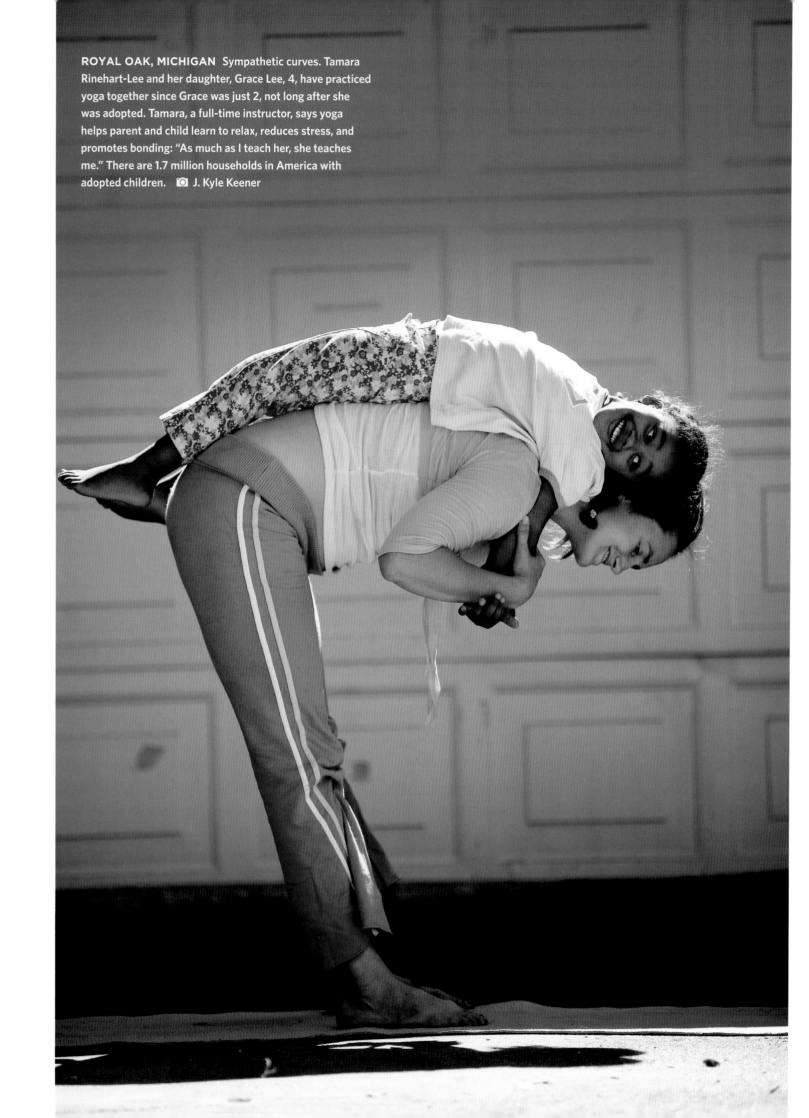

ROYAL OAK, MICHIGAN Sympathetic curves. Tamara Rinehart-Lee and her daughter, Grace Lee, 4, have practiced yoga together since Grace was just 2, not long after she was adopted. Tamara, a full-time instructor, says yoga helps parent and child learn to relax, reduces stress, and promotes bonding: "As much as I teach her, she teaches me." There are 1.7 million households in America with adopted children. 📷 J. Kyle Keener

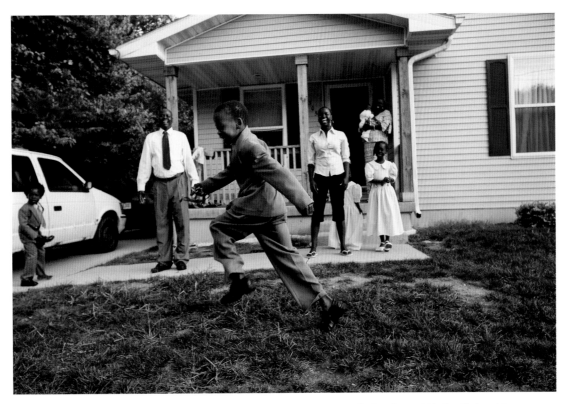

DES MOINES, IOWA Stepping out. Kolmut Mai burns excess energy before he and his family head to church. Since the summer of 1992, Sudanese refugees have been immigrating to Des Moines through Lutheran Immigration and Refugee Services. The Mai family arrived in 1998, seeking freedom from war and religious persecution. For them, home is not just the four walls of a house, but America itself. ◎ David Peterson

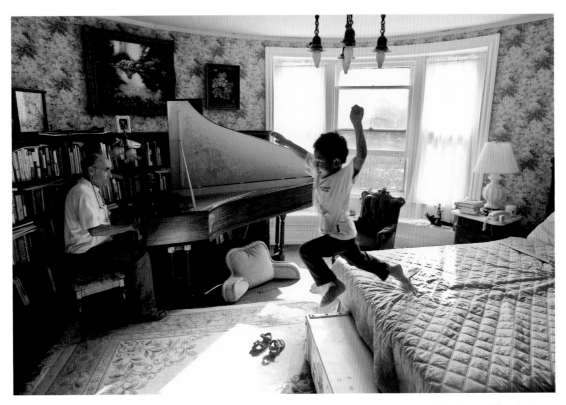

SWARTHMORE, PENNSYLVANIA High note. Seventy-year-old Dr. John Brodsky builds a harpsichord. A master craftsman of musical instruments, Brodsky plans to build one for each of his children and grandchildren. Here he is assisted by Eric Thanh Brodsky, his adopted son from Vietnam. Eric wants to grow up to be just like his father. ◎ Michael Bryant

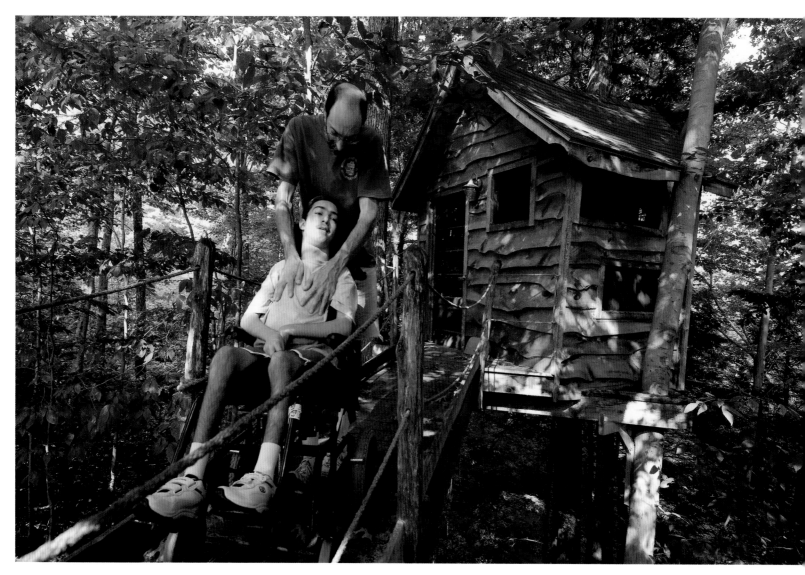

MILTON, VERMONT My father, my son. Special education teacher Paul Erena spends the afternoon with his son, James, who was born with a neurological disorder that severely limits his ability to move and speak. James's treehouse was built by Forever Young Treehouses and funded by the Make-a-Wish Foundation, which has awarded grants to more than 150,000 disabled and terminally ill children. 📷 Jeb Wallace-Brodeur

[Some 10.7 million disabled people need daily personal assistance,
and 1.8 million people work as full-time in-home health aides.]

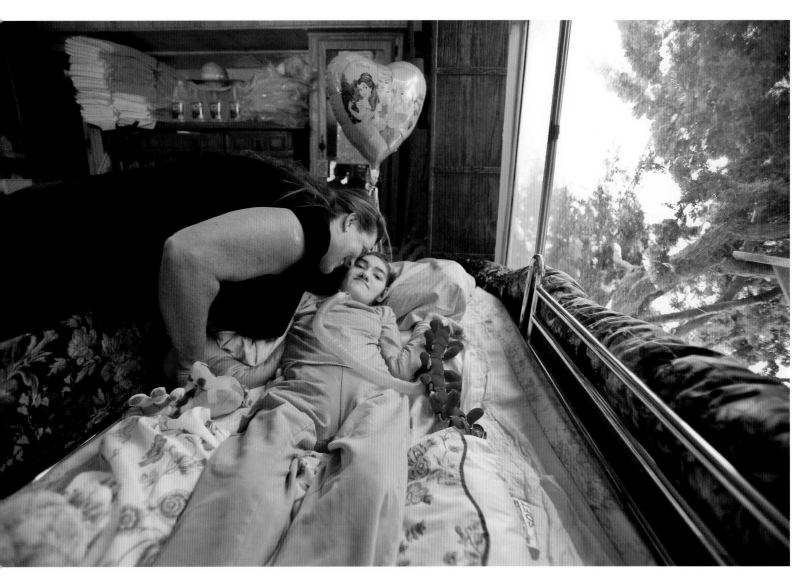

WESTLAKE VILLAGE, CALIFORNIA My mother, my daughter. Twenty-seven-year-old Summer Howlett, who has cerebral palsy, is greeted each morning by a sunny view outside her window, a wake-up kiss from her mother, Helen, and balloons that make her smile. Summer has permanent feeding and breathing tubes, and a nurse tends her during the day, while Helen takes the night shift. When Summer was a child, the doctor wanted to put her in an assisted living center, but her mother refused. 📷 Dana Fineman

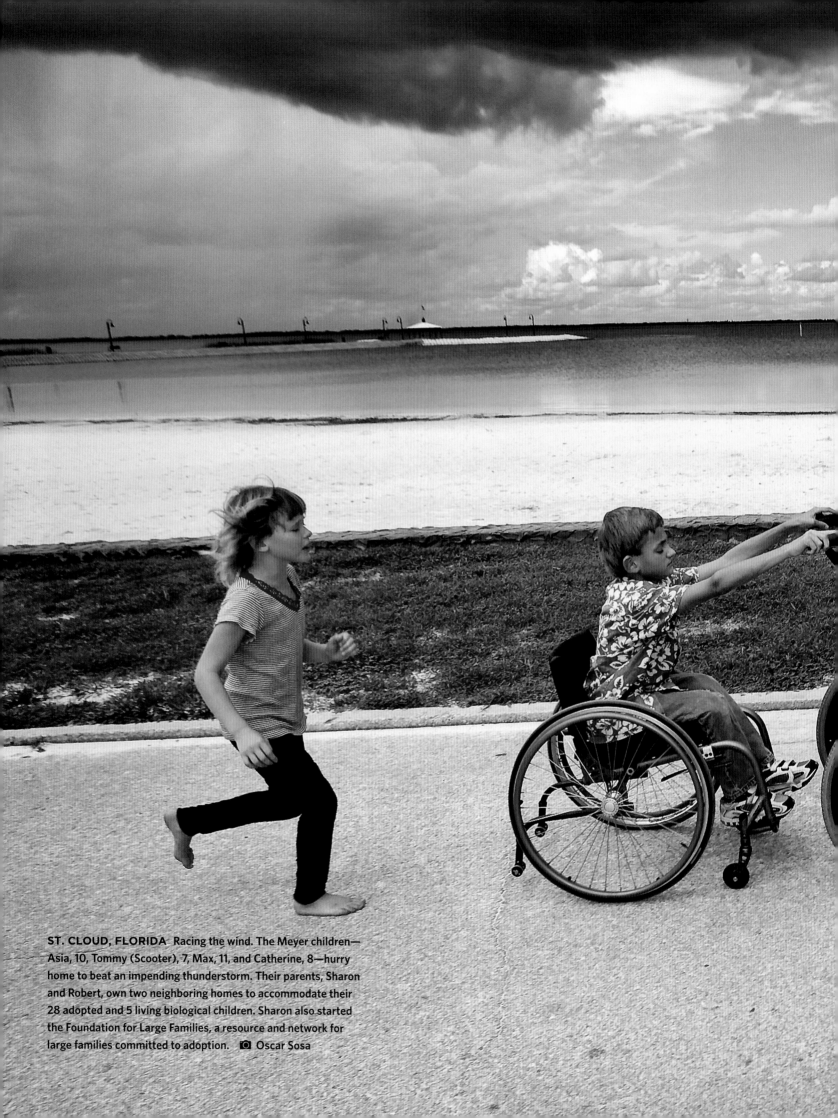

ST. CLOUD, FLORIDA Racing the wind. The Meyer children—
Asia, 10, Tommy (Scooter), 7, Max, 11, and Catherine, 8—hurry
home to beat an impending thunderstorm. Their parents, Sharon
and Robert, own two neighboring homes to accommodate their
28 adopted and 5 living biological children. Sharon also started
the Foundation for Large Families, a resource and network for
large families committed to adoption. ◉ Oscar Sosa

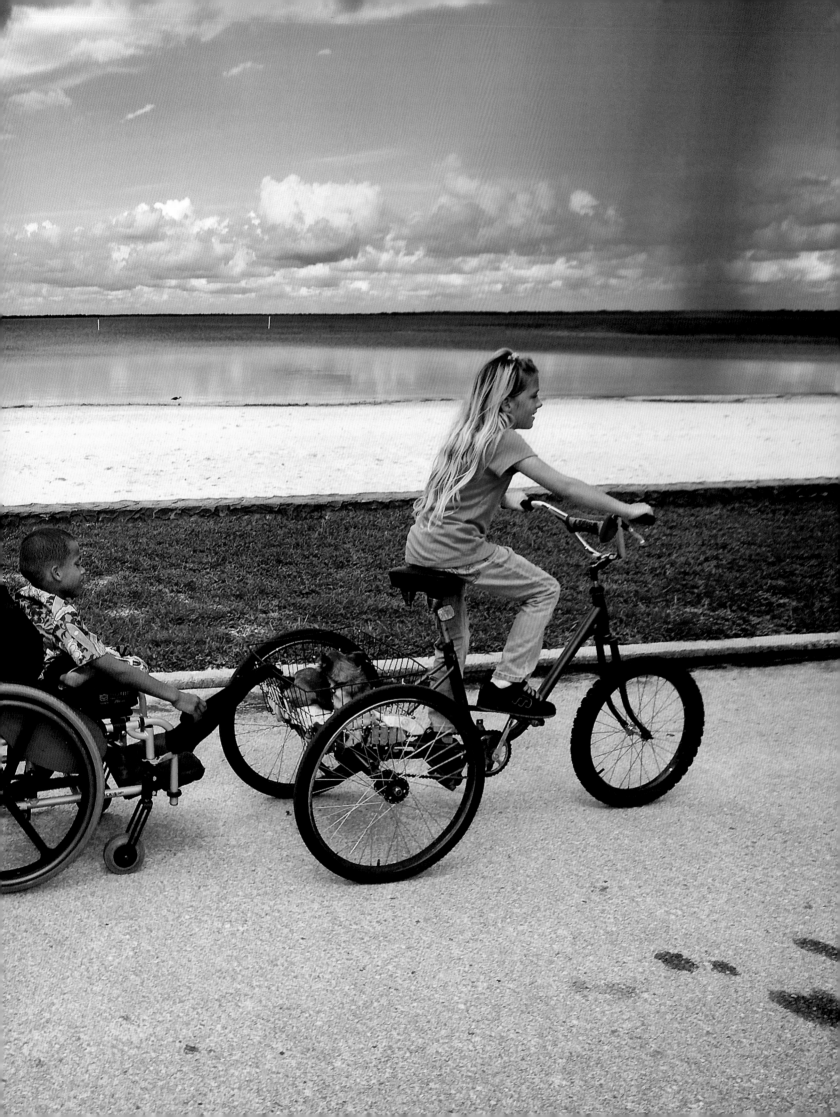

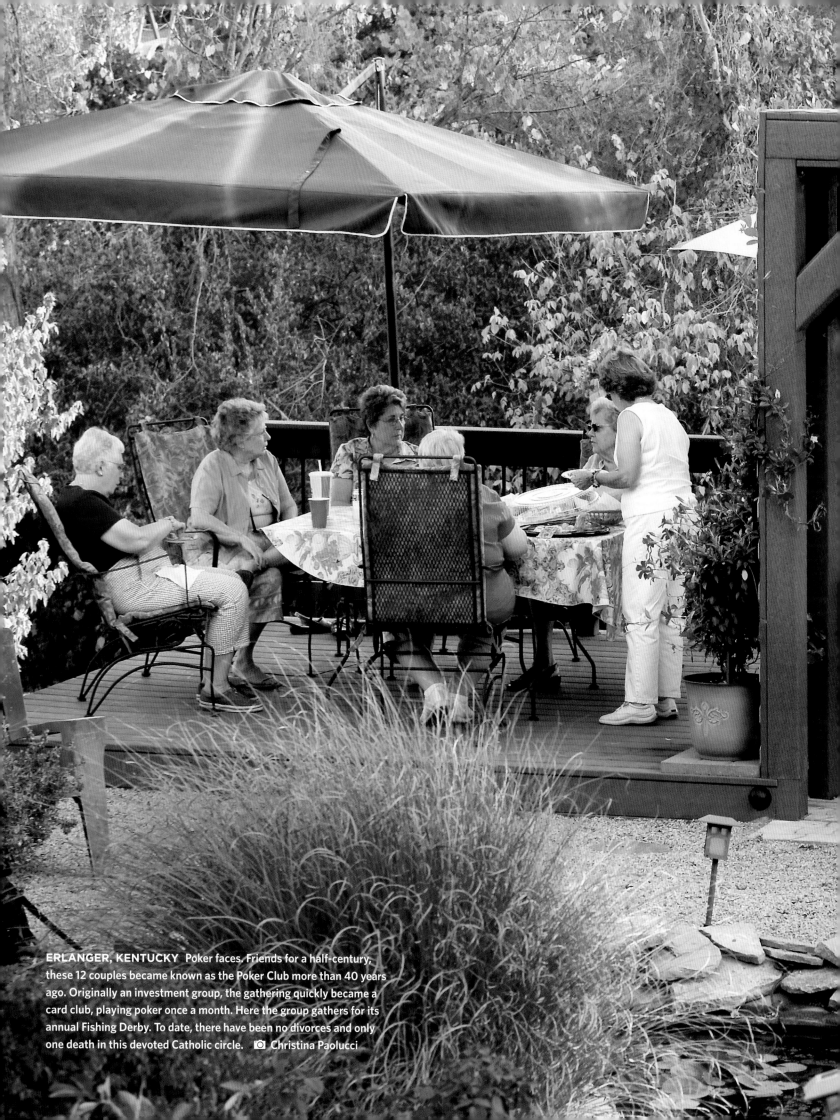

ERLANGER, KENTUCKY Poker faces. Friends for a half-century, these 12 couples became known as the Poker Club more than 40 years ago. Originally an investment group, the gathering quickly became a card club, playing poker once a month. Here the group gathers for its annual Fishing Derby. To date, there have been no divorces and only one death in this devoted Catholic circle. 📷 Christina Paolucci

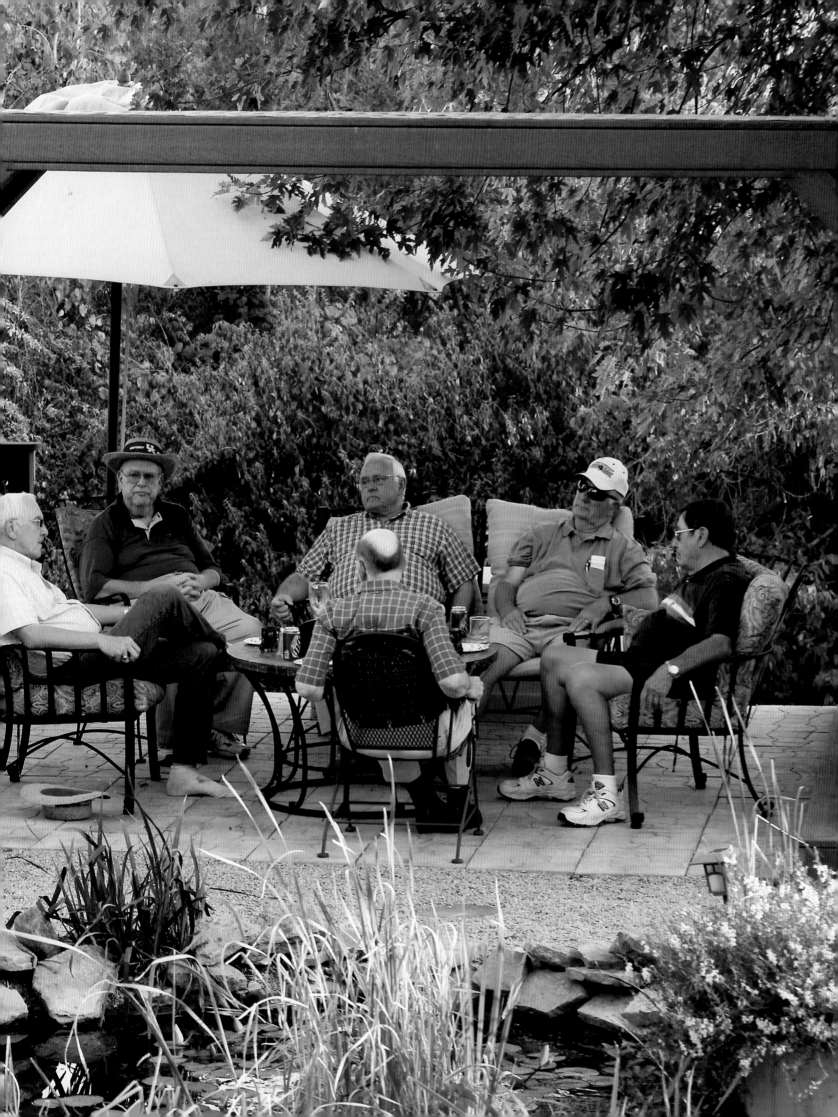

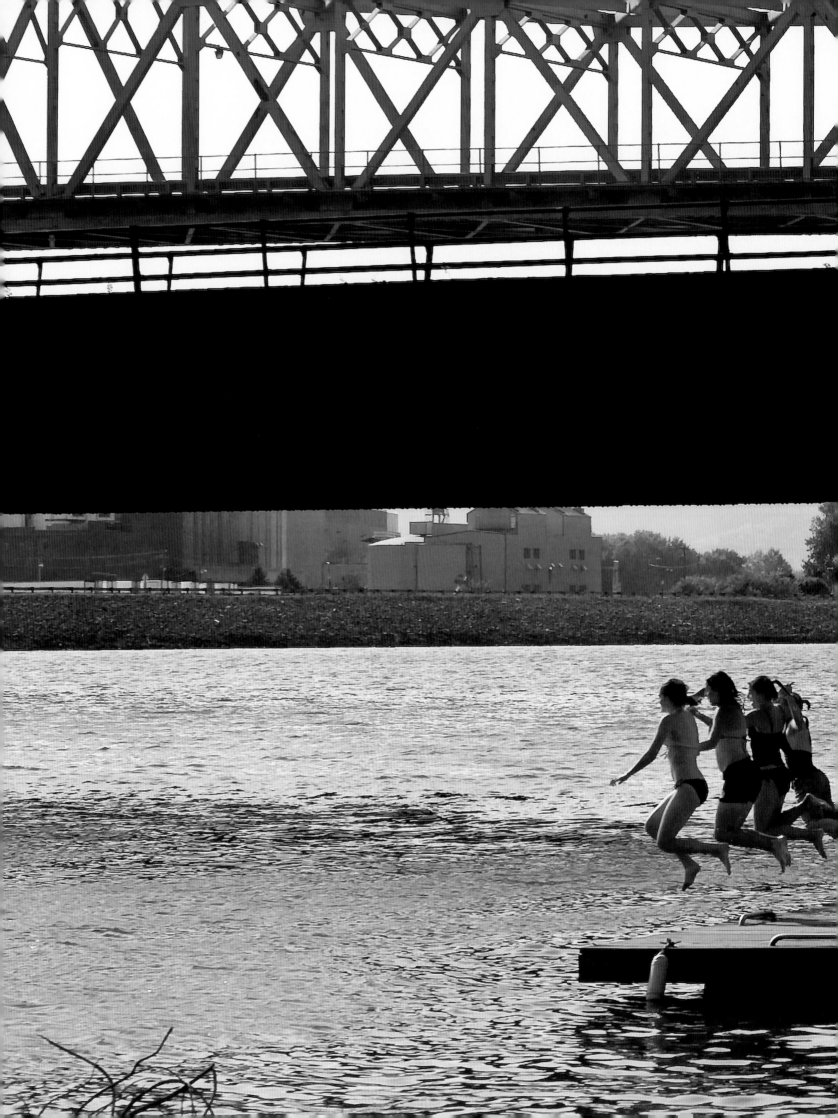

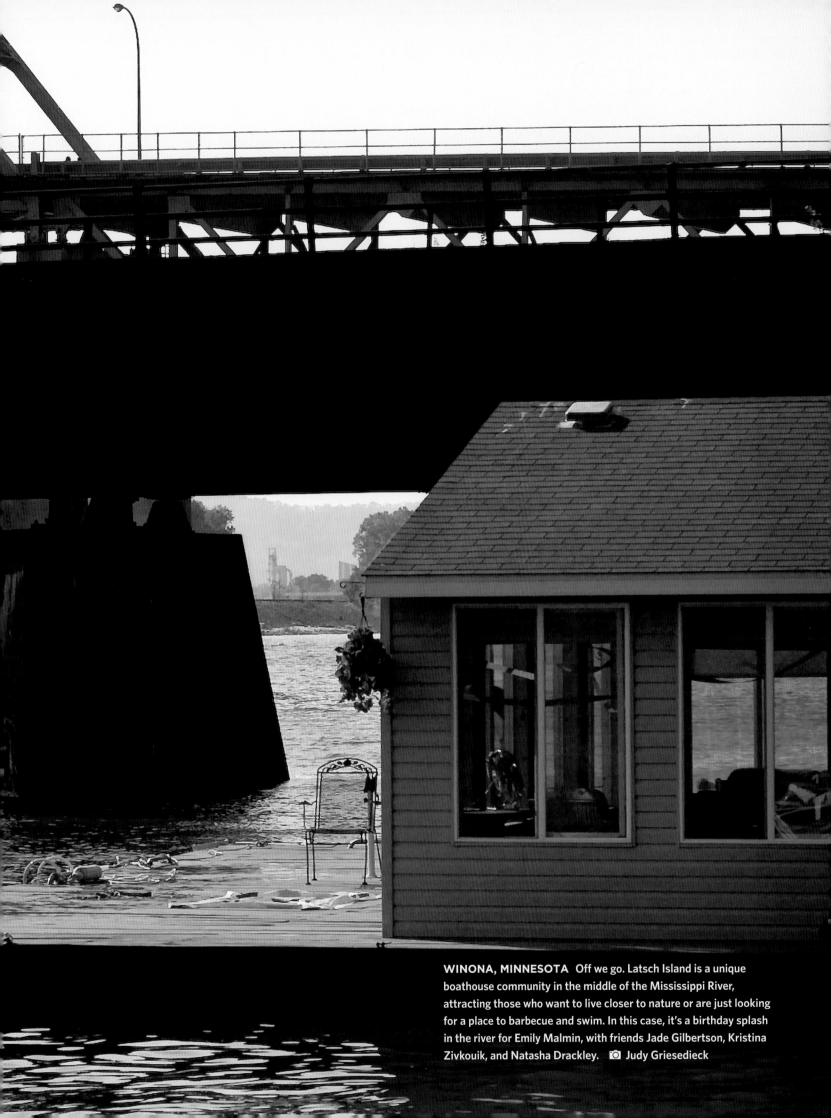

WINONA, MINNESOTA Off we go. Latsch Island is a unique boathouse community in the middle of the Mississippi River, attracting those who want to live closer to nature or are just looking for a place to barbecue and swim. In this case, it's a birthday splash in the river for Emily Malmin, with friends Jade Gilbertson, Kristina Zivkouik, and Natasha Drackley. 📷 Judy Griesedieck

JONESBORO, GEORGIA Pussycat, pussycat, I love you. Jerri King and her husband, Marshal, open their home to as many as 20 wayward cats at a time. Jerri is a member of RescueCats, an animal rescue organization that sets up tables at area pet stores to seek foster families for the felines. Of the more than 150 million dogs and cats in the United States, only about 15 percent have been adopted from shelters. 📷 Erik S. Lesser

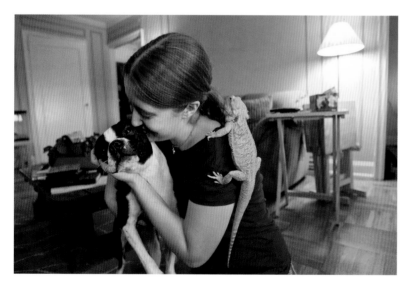

PHILADELPHIA, PENNSYLVANIA To the rescue! Pennsylvania veterinary student Sara Sprowls gives her Boston terrier, Dexter, a big kiss. Sprowls loves to rescue displaced pets, especially exotic ones. Sara also owns the Australian bearded dragon lizard seen on her back, and Roland, a corn snake. All the animals happily coexist in her one-bedroom apartment. 📷 Michael Bryant

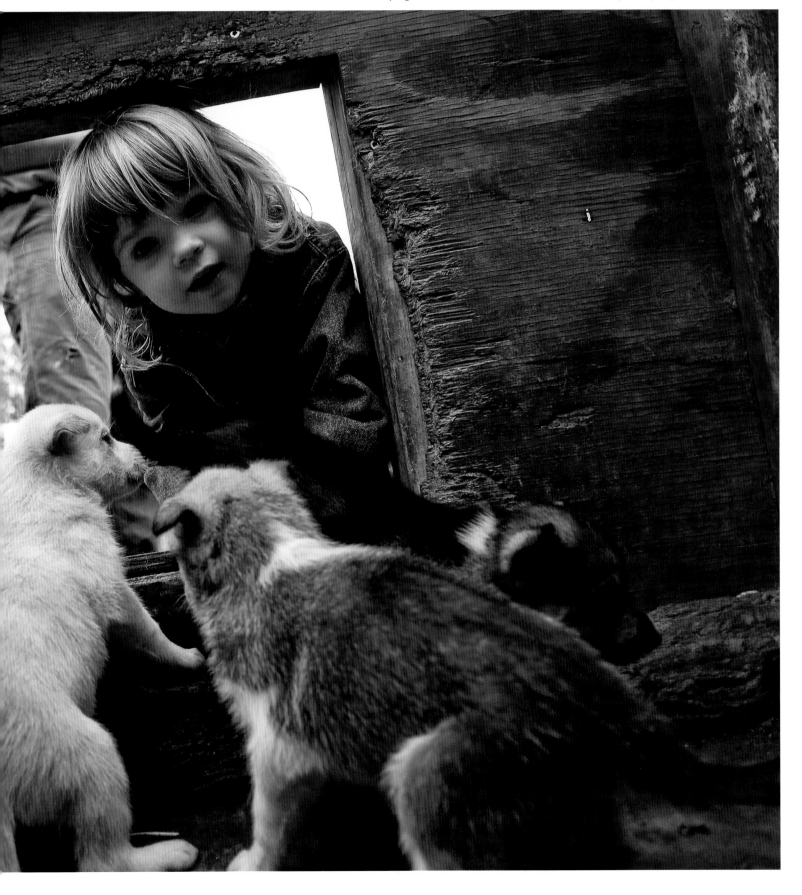

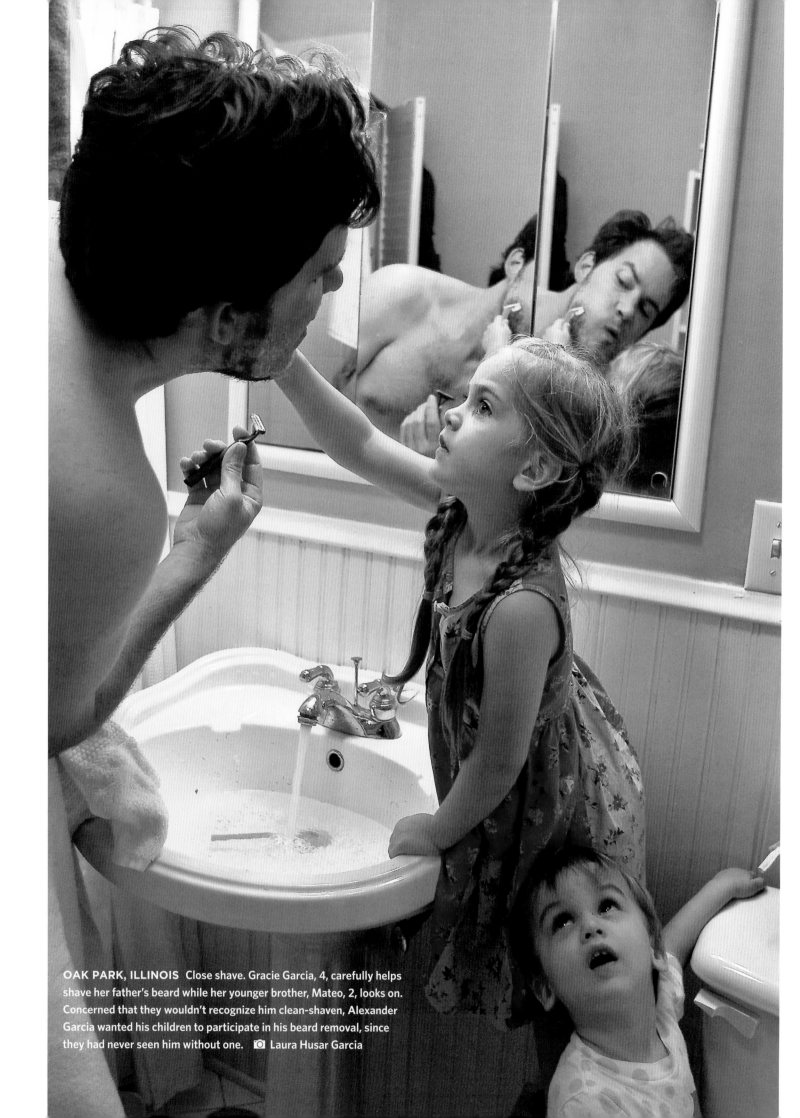

OAK PARK, ILLINOIS Close shave. Gracie Garcia, 4, carefully helps shave her father's beard while her younger brother, Mateo, 2, looks on. Concerned that they wouldn't recognize him clean-shaven, Alexander Garcia wanted his children to participate in his beard removal, since they had never seen him without one. 📷 Laura Husar Garcia

ALBANY, GEORGIA Mirror image. As part of their morning quality time, Josh, 3, and his dad, Chad, like to shave together. Unlike his southpaw father, Josh uses a razor that's only plastic. It's an enduring tradition: though challenged for nearly a century by electric razors, wet shaving with a blade is still a $6 billion industry. Kelly Mullins

PORTLAND, OREGON Concentration. Ruby Zelinsky, 3, carefully gives her dad, Ben, a shave at their home. Armed with a rechargeable electric razor, Ruby makes sure to get every last whisker. Brian Lanker

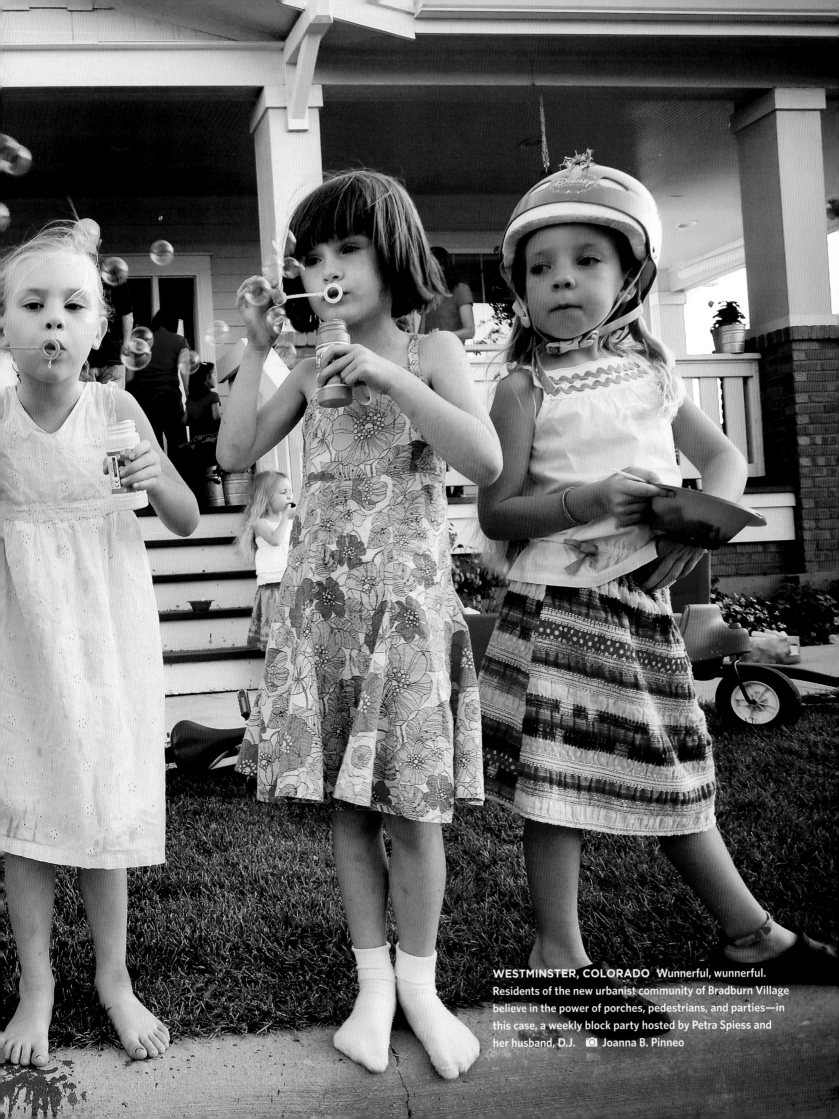

WESTMINSTER, COLORADO Wunnerful, wunnerful. Residents of the new urbanist community of Bradburn Village believe in the power of porches, pedestrians, and parties—in this case, a weekly block party hosted by Petra Spiess and her husband, D.J. Joanna B. Pinneo

[Fathers today devote more than 150 percent
more time to child care than they did in 1965.]

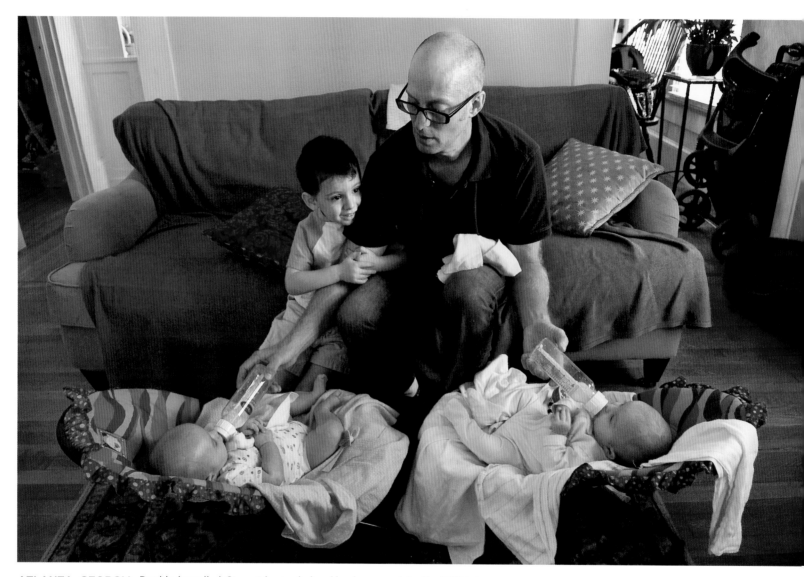

ATLANTA, GEORGIA Double-barrelled. Stay-at-home dad and landscape painter Paul Hill takes care
of his three-month-old twins, Quinn and Norah, as well as son Liam. It pays to be ambidextrous when
both twins are hungry at the same time. Thirty-two out of every 1,000 births in the United States result
in twins. Over the last 20 years, multiple births in this country have jumped nearly 60 percent, largely
due to fertility drugs. 📷 Erik S. Lesser

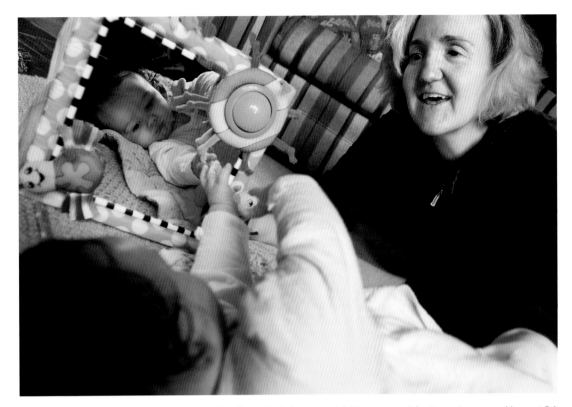

BOZEMAN, MONTANA Point of view. Stephanie Cain lost her sight in a car accident as a teenager. Now, at 34, her first child, Vivian, is the light of her life. Stephanie says she doesn't need sight to give Vivian all the love she needs. "Mothering is intuitive for me," Cain says. As for chasing a toddler around, she says, "Vivian makes plenty of baby noise, giggling and gurgling around the house—so I can track her and keep her safe." 📷 Anne Sherwood

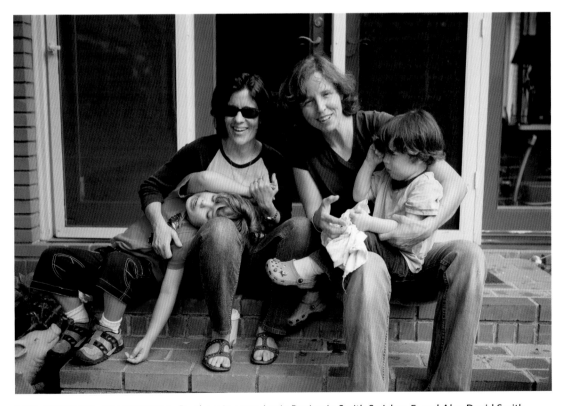

LOS ANGELES, CALIFORNIA Brothers in arms. Louie Benjamin Smith Swisher, 5, and Alex David Smith Swisher, 2, are half-brothers, sons of the same anonymous father/donor to partners Kara Swisher, a journalist, and Megan Smith, a high-tech executive. After the boys were born—Louie to Swisher, and Alex to Megan—the two women cross-adopted them to complete the family. Here, the San Franciscans pose for a weary group photo at the Los Angeles home of Bernie Cummings and Ernie Johnston. 📷 Ian Logan

KUALAPUU, HAWAII Planting bed. When deer began to invade their vegetable garden, Rick and Bronwyn Cooke rigged up a bed in the tomato house and took turns sleeping there to keep the trespassers out. It's also proven popular with Bronwyn and the family dog, Tigerlilly, for after-gardening naps. 📷 Richard A. Cooke III

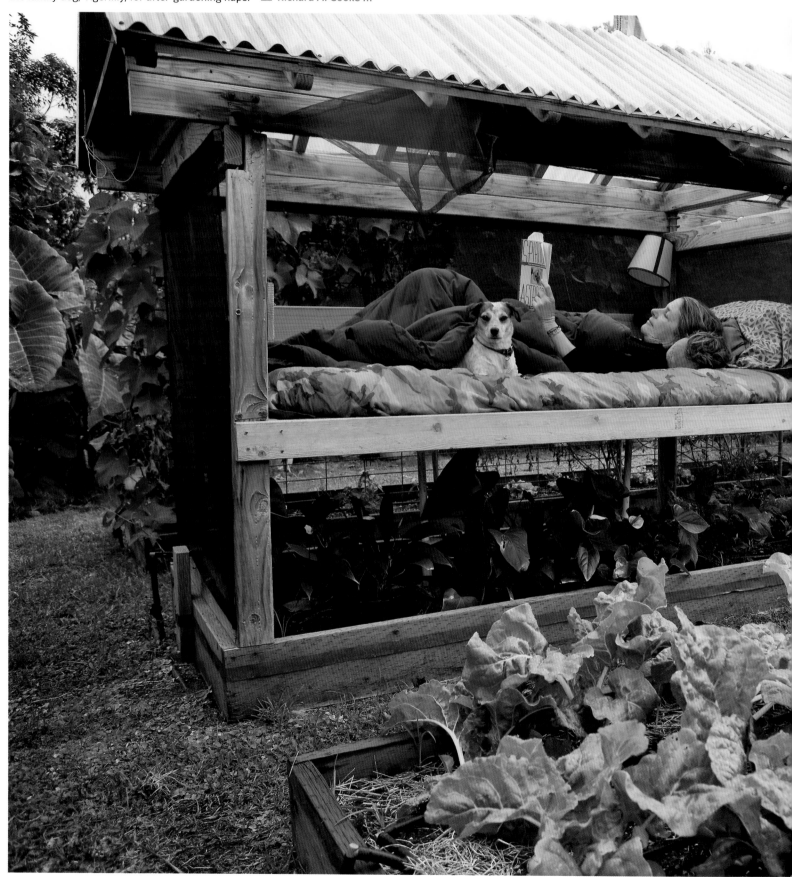

Even though only 1 percent of Americans live on a farm today (down from 30 percent in 1920), 41 percent of American households have flower gardens, 25 percent raise vegetables and 13 percent grow fruit trees.]

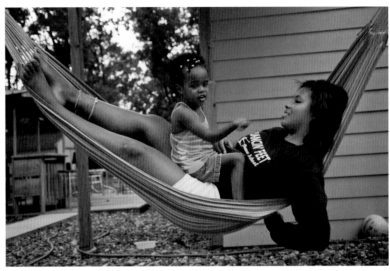

HAM LAKE, MINNESOTA Swing time. Megan Couwenhoven rocks on a hammock with her 3-year-old sister, Anna, in their backyard. Both girls were adopted and represent two of the ten children in Ann and Russ Couwenhoven's family, half of whom were from Ethiopia. 📷 Ben Garvin

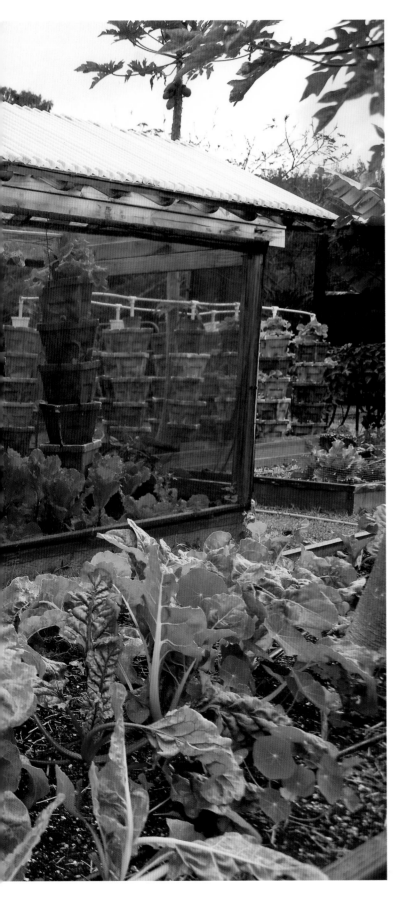

[Americans own an estimated 243 million cars—averaging nearly two per household.
Suburbanites spend an average of 100 hours per year commuting.]

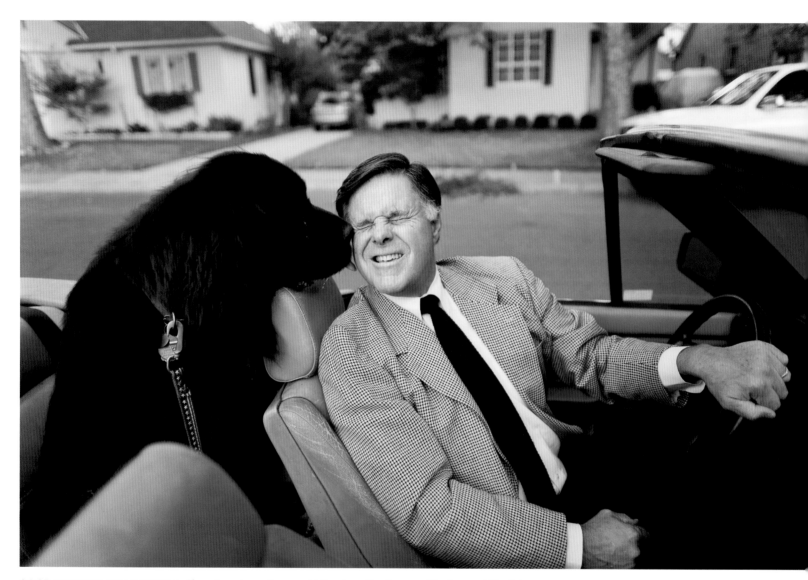

SACRAMENTO, CALIFORNIA Slurp. Lourdes, a 5-year-old Newfoundland rescued by Jeanne Winnick Brennan, likes to jump into the car as her husband Bill, 63, and their children drive off to sporting events or friends' houses. 📷 Renée C. Byer

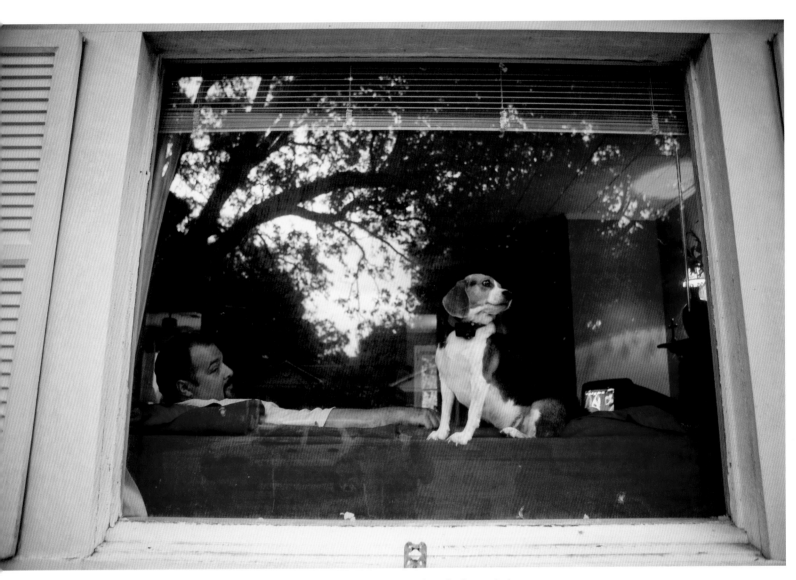

LAFAYETTE, LOUISIANA A familiar view. Roxie the beagle likes to stand atop a couch in the front window of her home to watch for friends or trespassers. Meanwhile, owner Doug Granger, a delivery driver who grew up in the neighborhood—his childhood best friend still lives across the street—watches a Louisiana State football game. When the game is over, Roxie will join Granger outside for a postgame barbecue. 📷 Chris Granger

[American families, on average, spend more money eating meals in restaurants than they do on purchasing groceries.]

SAN FRANCISCO, CALIFORNIA In preparation. Doug Steele isn't afraid to take risks: he quit his job and moved in with his girlfriend, Caitlin Fager, on the very same day. Their first date was at the Uptown, a bar in the city's Mission District, and it was love at first sight. These days, Steele has his own architecture practice—and, after two years of living together, the couple is making preparations to be married in Lake Tahoe. More than 5.5 million American couples now live together without being married, up from 3.2 million in 1990. 📷 Heidi Schumann

MONTPELIER, VERMONT The pot luck club. The potluck dinner has become an American tradition. To this one, Renee Affolter and Jason Gingold brought chicken satay; Ken Jones and Janel Johnson, apple pie; Sarah and Greg Guyette, spring rolls; Ken and Patty Valentine, bok choy salad; and Sally and Terry Thompson, Asian coleslaw. 📷 Jeb Wallace-Brodeur

[On average, Americans have nine close friends and the average American is within five years of their best friends age.]

STILLMORE, GEORGIA Gossip girls. Behind her house in rural eastern Georgia, Jane Purcell runs a popular three-seat hair salon. Regular customers Frances Creech, Mary Davis, and Jacqueline Hopkins, all from surrounding towns, come to get their hair done, gossip, and, in the case of Creech, make pointed comments on the newest fashion trends (and skinny models) while she awaits her appointment. 📷 Michael Hanson

FAIRFAX, CALIFORNIA Poser. Every Wednesday night, Lucienne Matthews opens her home to as many as ten of her friends, aged 30 to 80. They chat, watch *Jeopardy*, offer mutual support, and knit late into the evening. Nora the dog occasionally stands in as model. 📷 Kim Komenich

CLYDE PARK, MONTANA Stern observer. At Crazy Woman Farm, the playmates for Jack and Hazen Marshall, 6 and 3, are pigs, chickens, cats, dogs, and pair of watchful horses. A farm childhood, once the norm in America, is now a rarity—there are only 2 million farms in the United States today, compared with nearly 7 million a century ago. 📷 Anne Sherwood

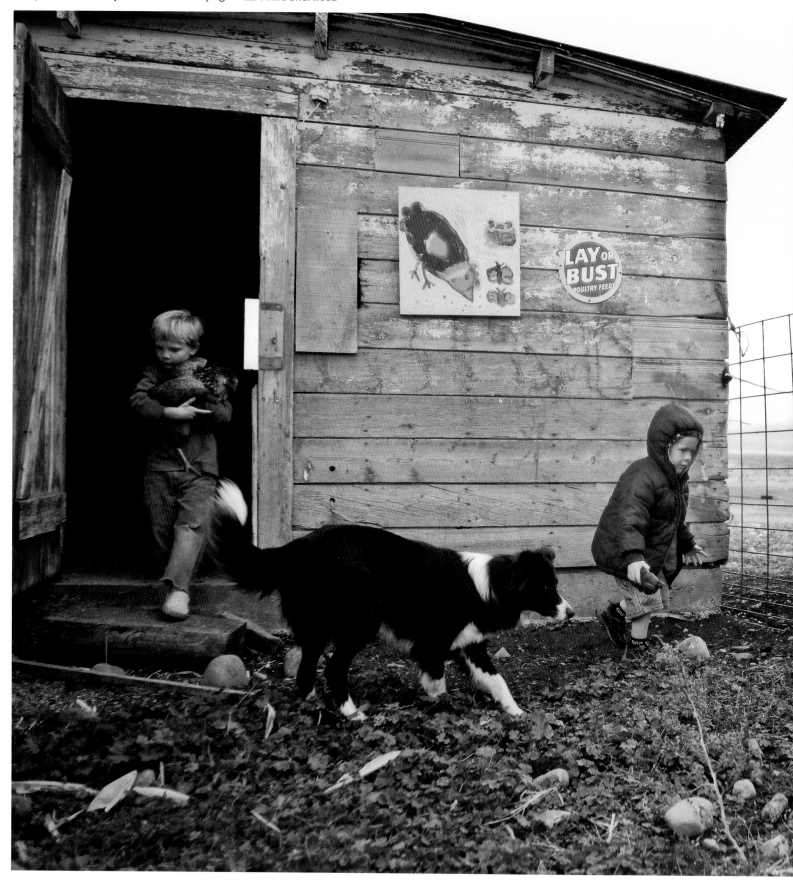

LOS GATOS, CALIFORNIA Chicken tender. Homeschooling mom Jody McCalmont always sets aside time amid math and language lessons so her daughters, Yelena, 5 (above), and Claire, 9, can hug their pet chickens. Today's homework includes counting trees and making mud ink. 📷 Jim Gensheimer

CLYDE PARK, MONTANA Old Macdonald had some cats. On Crazy Woman Farm, Hazen, 3, and Jack, 6, play with the barn cats while their parents, Jim and Barb Marshall, look after the lambs and tend the organic garlic. While the cats may have grown accustomed to being lugged around, that doesn't mean they like it. 📷 Anne Sherwood

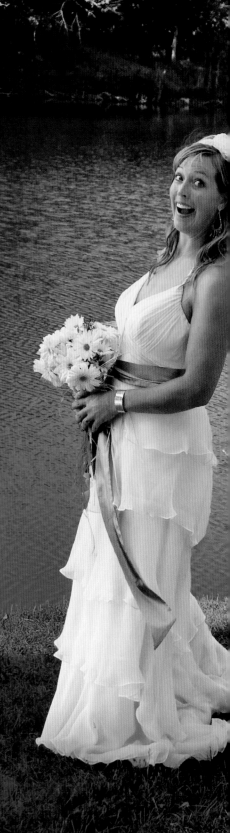

RICHARD RODRIGUEZ

HOME AND
CELEBRATIONS

It is always my father up first. I hear the sound of my father filling the coffeepot with cold water. It is dark outside. I, too, am awake.

Every family manages enforced intimacy with repeated behaviors—little things. Memory elevates such little things to sacraments.

In my earliest home there is one bathroom. Who gets in first and for how long is never discussed. The younger takes the more tepid shower.

There are family towels, well worn, fringes of thread at the edges. There are thick, plush towels on the rack next to the window. These are reserved for visitors who don't come. When visitors do eventually come, they are too polite to use the fancy towels. There is a spider lurking in the folds of one of them.

Every family has secrets.

I am sorry I am not as innocent as the rest of them. I don't really belong here. But I know where the sugar bowl is. I know which windows are stuck, and which rattle. I know where to find Scotch tape and pliers and postage stamps and glue. There is money in an envelope in the second drawer of my parents' bureau, beneath my father's underwear. They never miss the ones, but they would miss the twenties. I know my mother sleeps with her hands outside the blankets; she can't sleep otherwise. On weekends my father sings a lyric in Spanish that has no conclusion. It is about a woman.

My mother removes the cover from the birdcage. From the perspective of Pretty Boy, my mother is the sun.

And three-legged Fifi the dog is scratching at the kitchen door to be reunited with nature. It must be 6:45.

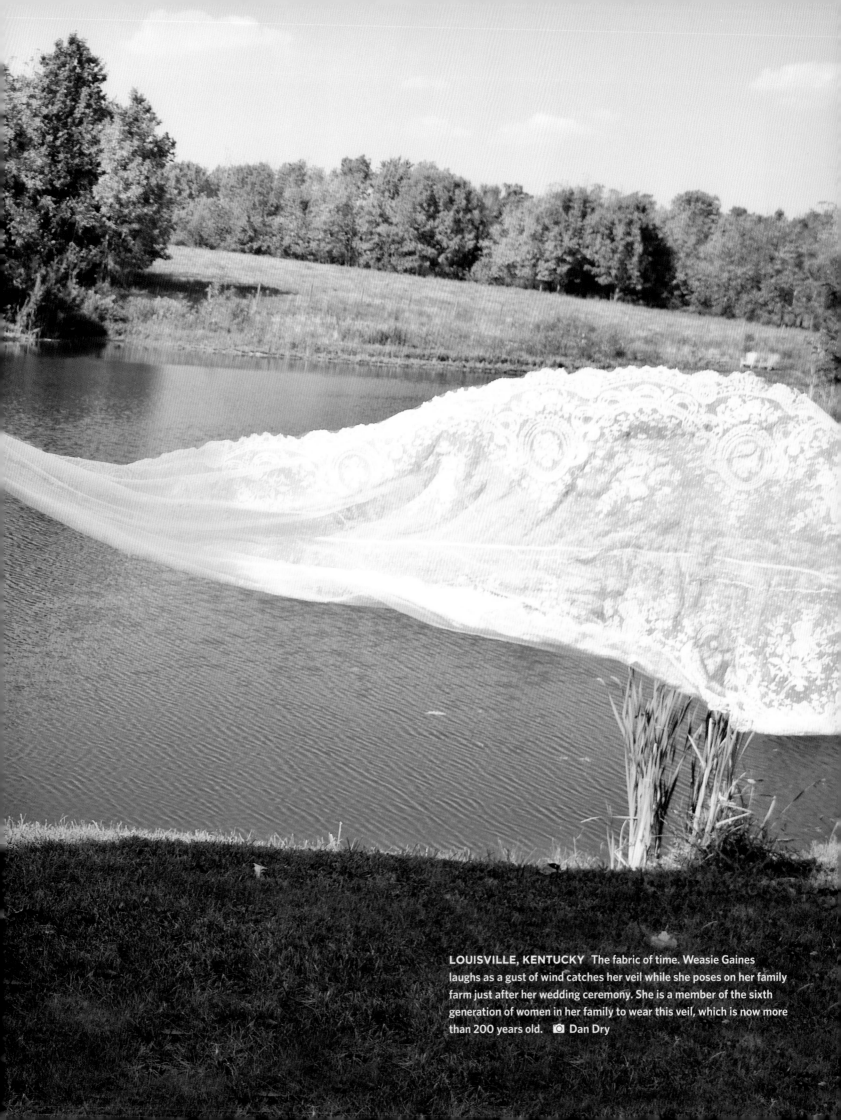

LOUISVILLE, KENTUCKY The fabric of time. Weasie Gaines laughs as a gust of wind catches her veil while she poses on her family farm just after her wedding ceremony. She is a member of the sixth generation of women in her family to wear this veil, which is now more than 200 years old. 📷 Dan Dry

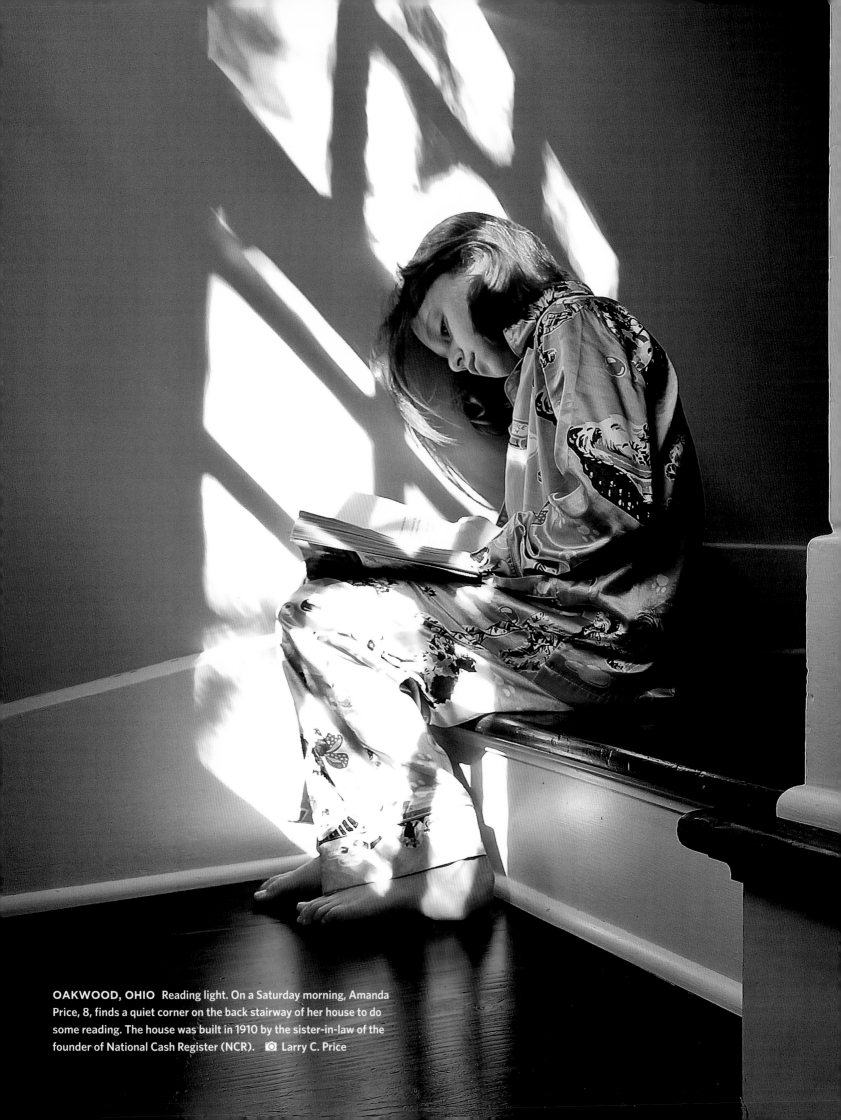

OAKWOOD, OHIO Reading light. On a Saturday morning, Amanda Price, 8, finds a quiet corner on the back stairway of her house to do some reading. The house was built in 1910 by the sister-in-law of the founder of National Cash Register (NCR). 📷 Larry C. Price

For more than ten years, I use a yellow bowl for my breakfast. Everyone in the family knows the bowl is mine.

I meet many people who say they hate turkey. They hate church. They hate marriage. They hate Christmas. August. School. Sports. Subtitles. Family reunions. Musicals. Funerals.

You will have noticed how many children, even how many fathers, do not own a suit or a tie anymore. Often there is nothing formal to wear at a funeral but a short-sleeved white shirt or a bright sweater. Often, there is no funeral.

By the time I am in high school, I sleep in my dead grandmother's bedroom. She didn't die in the room. She died at my aunt's house, miles away. Nevertheless, everyone calls the room by her name. I paint the blue walls green and her ghost seems to go with the blue.

A friend's family has a death room. The little boy's bedroom is kept as it was. A stuffed tiger leans tipsily against the boy's pillow. The door remains closed. A rectangle of sunlight slides down the wall.

No place is off-limits in our house, no shoebox, no drawer, no suitcase, no mirror. There are things you cannot mention. Subjects. My parents sometimes make love late at night. The names of some relatives—people my mother cannot abide.

My family prays before dinner (in Spanish, if there is no company). We used to say family prayers before sleeping. But now we children are too old to pray with our parents. They grow old reciting the Rosary in their bedroom.

Seven years of good luck for Fifi: she laps up the milk when my careless elbow juts off the edge of the table, when my yellow cereal bowl finally crashes to the floor.

Americans raise children to leave home. It is the most radical of our habits. Huck Finn is in Vietnam, I hear. My younger sister becomes the first girl to go away to college.

And then come the family reunions—happy, obligatory, inconvenient. No one prefers turkey, but everyone eats it. The recipes are magics and prayers. Scents and flavors are summoned from the realms of the dead. No shortcuts. It has to be done properly, or the Three Kings will become confused in the desert, the Pilgrims will sail back to England, the Virgin of Guadalupe will become the Virgin of Somewhere Else.

My parents died. Their last house was put up for sale. The money was divided among us. Pure sunlight on the garage wall. A red camellia.

As a wise little boy, I thought Resurrection Day would find us all together. But now we have families of our own. And the broken yellow bowl is the only thing that brings us together again. Coffee. Chirping bird. A forgotten Latin grammar. The back door slamming.

Richard Rodriguez is the author of Brown: The Last Discovery of America, Hunger of Memory, and Days of Obligation: An Argument with My Mexican Father.

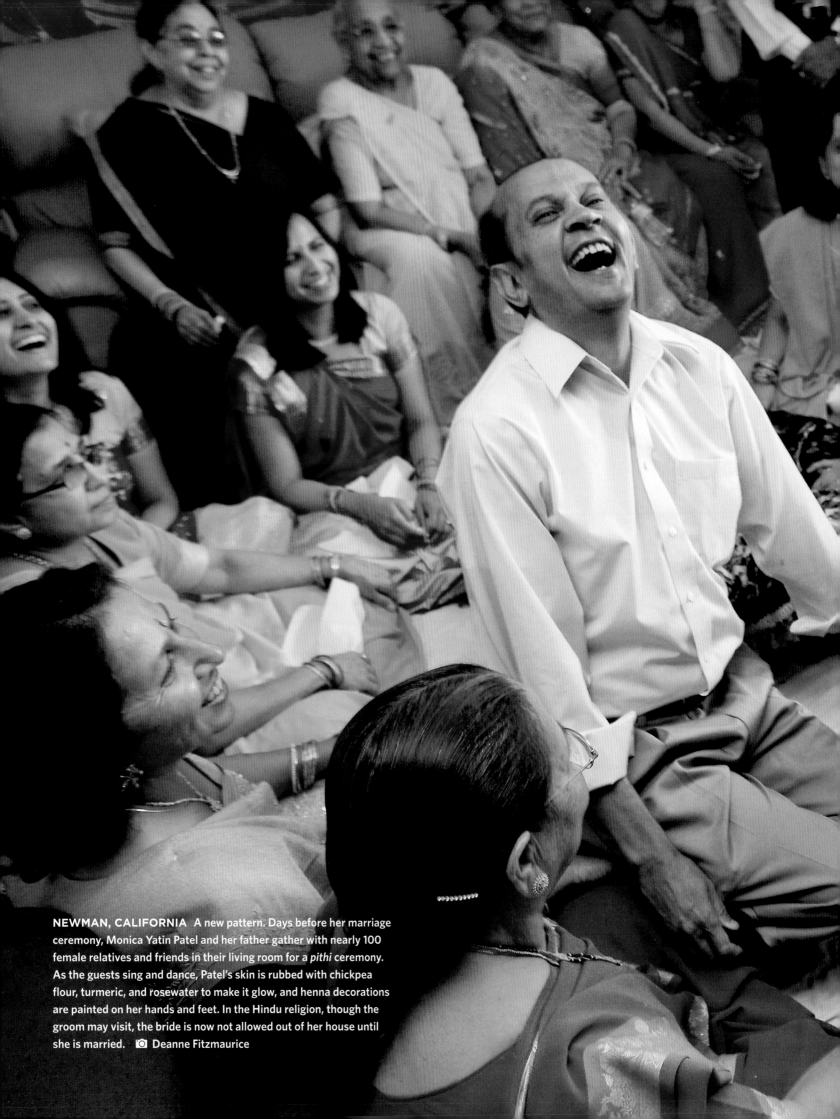

NEWMAN, CALIFORNIA A new pattern. Days before her marriage ceremony, Monica Yatin Patel and her father gather with nearly 100 female relatives and friends in their living room for a *pithi* ceremony. As the guests sing and dance, Patel's skin is rubbed with chickpea flour, turmeric, and rosewater to make it glow, and henna decorations are painted on her hands and feet. In the Hindu religion, though the groom may visit, the bride is now not allowed out of her house until she is married. 📷 Deanne Fitzmaurice

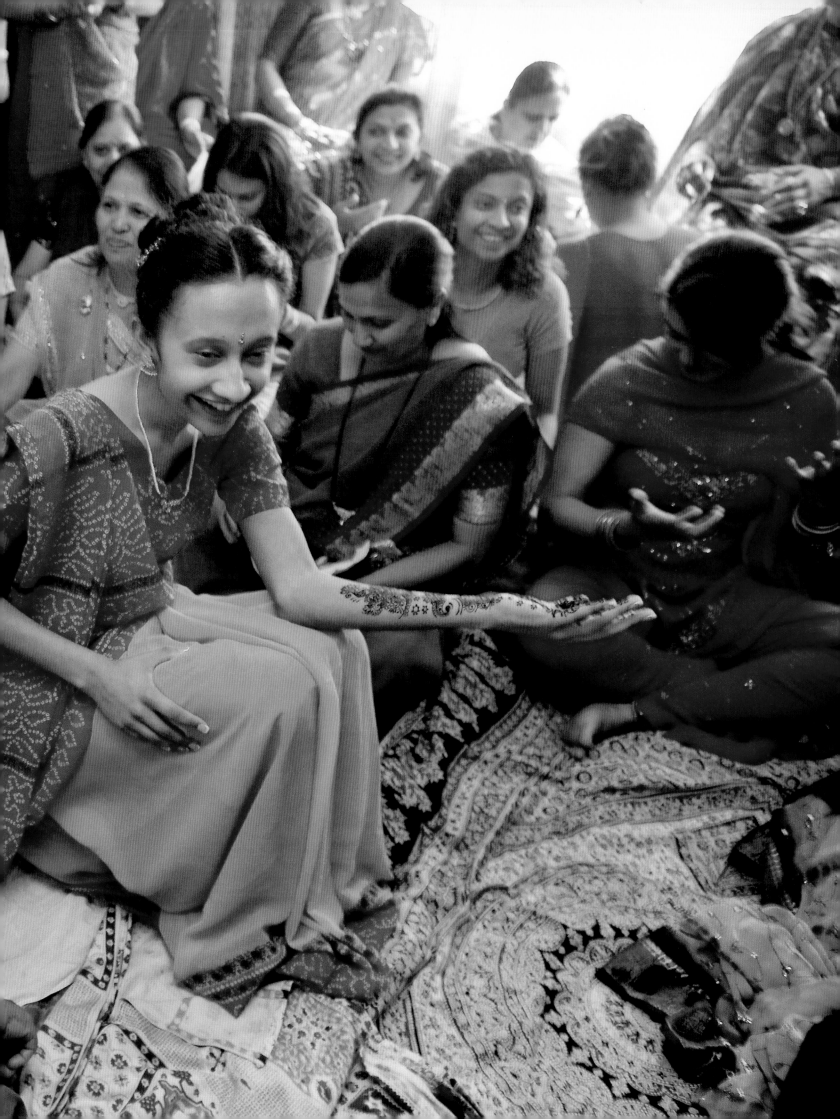

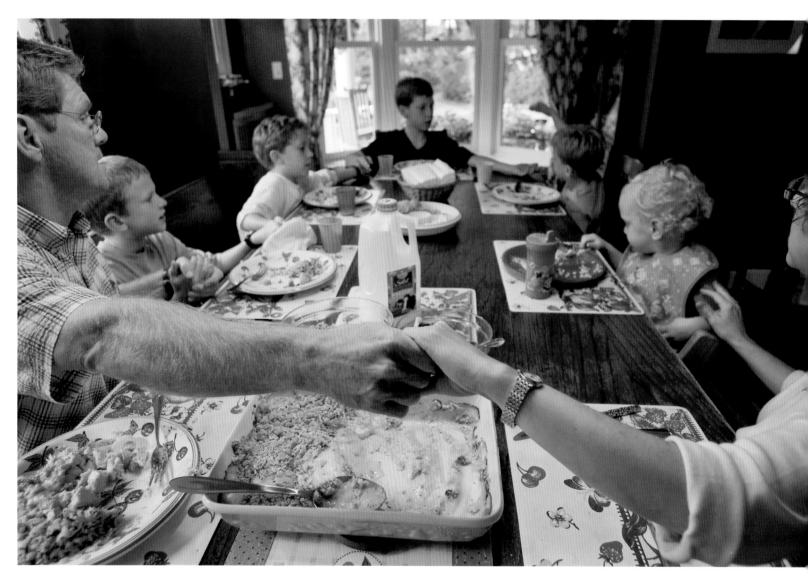

MINNEAPOLIS, MINNESOTA Family circle. At the end of each day, Jackie and Robert Harvey and their five boisterous boys gather around the dinner table to read from the Bible and hold hands in a quiet prayer. During their 15 years of marriage, after having met through the church, the Harveys have been music ministers at Our Lady of Grace church in Edina, Minnesota. But this year they plan to take a sabbatical to focus their time and energy on their family. ◉ Judy Griesedieck

[More than 82 percent of American families believe in God, 33 percent say
they pray several times a day, and 66 percent pray at least once a day.]

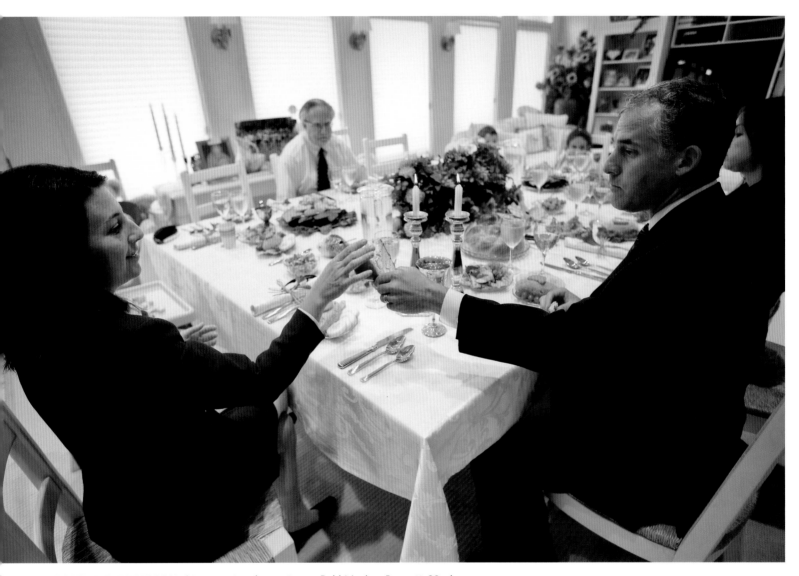

WEST BLOOMFIELD, MICHIGAN Atonement and repentance. Rabbi Joshua Bennett, 39, shares
challah bread with his wife, Meg, 37, during the Jewish New Year—Yom Kippur—dinner at the home of
a fellow rabbi's parents. Rabbi Bennett is a leader of West Bloomfield's Temple Israel, the largest reform
congregation in the world. 📷 J. Kyle Keener

[America's population is expected to grow by 100 million people over the next 37 years. More than 50 percent of that growth will come from immigrants or their children.]

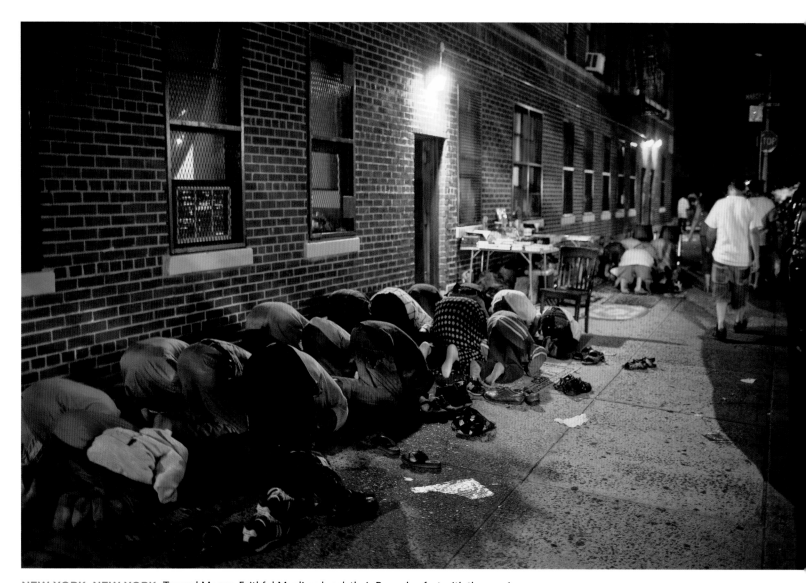

NEW YORK, NEW YORK Toward Mecca. Faithful Muslims break their Ramadan fast with the evening Maghrib prayer and meal at Makky Masjid, a small mosque in the lobby of an apartment building in Morrisania, a diverse neighborhood of West Africans and Dominicans in the South Bronx. Constrained by the limited space, the overflow crowd of Ramadan observers spills out onto the sidewalk with their prayer mats. 📷 Yoni Brook

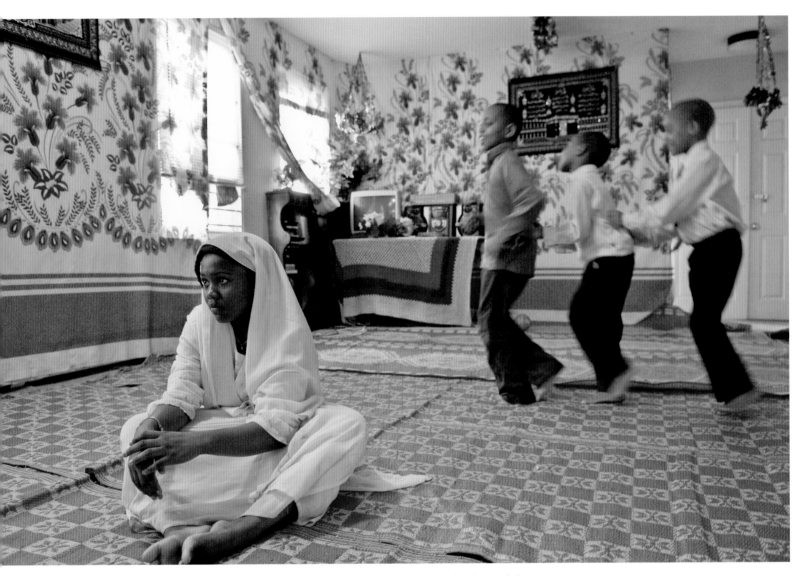

HARTFORD, CONNECTICUT Memories of home. Somalis Rukia Hassan, 15, and her three brothers, Abdi, Abdikadir, and Abdirzak, are among the 30,000 African political and religious refugees allowed into the United States each year. Though often living in some of the poorest neighborhoods in the country, most are happy to be here and keep their memories of home alive by decorating their floors and walls to reflect their native traditions. Like other immigrants before them, many Somalis will lift themselves out of poverty by the time their grandchildren are born. ◎ Bradley E. Clift

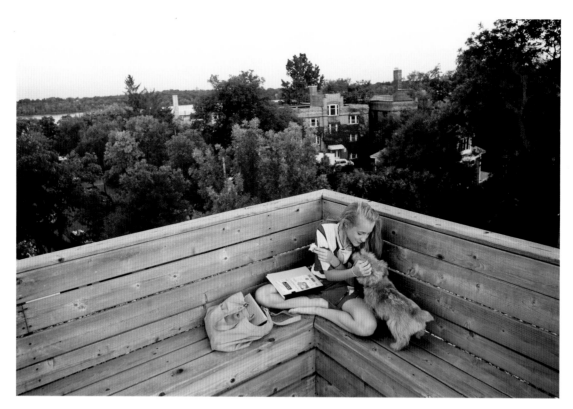

MINNEAPOLIS, MINNESOTA Apex. Still in uniform from an earlier soccer game, Taylor Healy, 14, plays with her Norwich terrier, Oliver, and does her homework on the rooftop deck of her family's new condo in Minneapolis. Having recently moved from a home in Connecticut where her family had a large yard, Healy has made the condo roof deck her new outdoor sanctuary. 📷 Judy Griesedieck

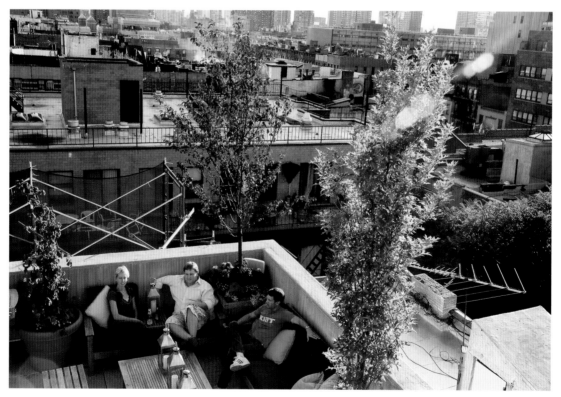

NEW YORK, NEW YORK Hell's aerie. Amber Freda, Campbell Kidd, and Nathan Koach chill after work in Koach's rooftop garden overlooking Manhattan's Hell's Kitchen neighborhood. With young professionals looking for bargains and proximity to work, urban gentrification is a common feature of many major American cities. 📷 C.M. Glover

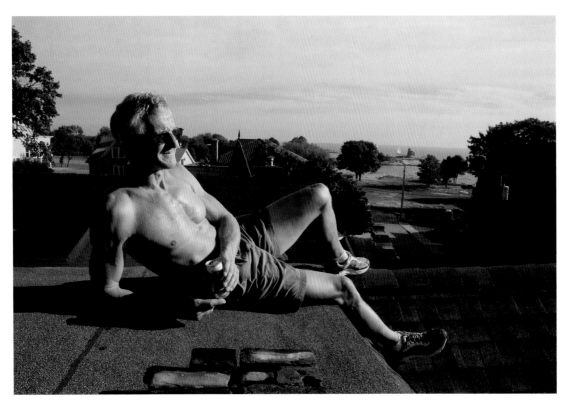

GROTON, CONNECTICUT Rooftop brew. When Michael Boucher gets home from his job at Pfizer, he likes to grab a beer, climb through the hatch in his attic, and watch the sunset from his rooftop perch. 📷 C.M. Glover

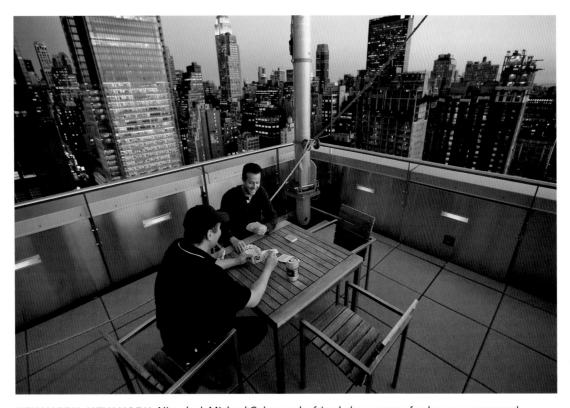

NEW YORK, NEW YORK Nice deal. Michael Cohen and a friend play a game of poker on a communal deck of the Orion building 30 stories above Times Square. The Orion, a condo community, soars 60 stories above 42nd Street, offering residents everything from a full-time concierge to a free morning breakfast. 📷 Michael Appleton

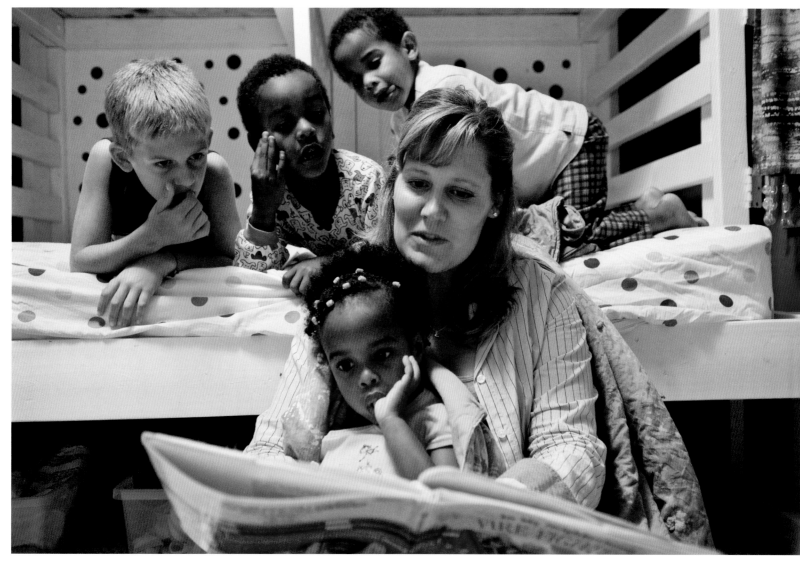

HAM LAKE, MINNESOTA Riveting tale. Anna Couwenhoven, 3, sits in her mother Ann's lap as they read a book together. Looking on are Noah, 8; Micah, 6; and Phillip, 3. Five of Ann and husband Russ's ten children were adopted, some from the United States, some from Ethiopia. Says Ann, "After our first adoption we felt like we had been trained. So we started seeking more children. God was telling us to adopt older kids." God also had a surprise waiting, Ann says. "While filing paperwork for our last adoption, I found out I was pregnant." 📷 Ben Garvin

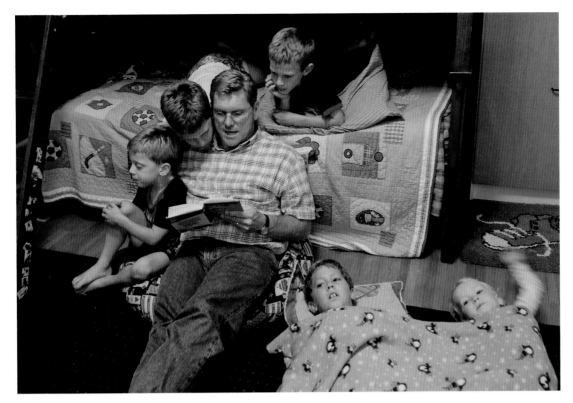

MINNEAPOLIS, MINNESOTA Winding down. Robert Harvey reads his five sons to sleep. Seamus, 7, and Liam, 2, are already down, and Danny, 6, is fading, but the two oldest, John, 11, and Joseph, 9, are still following the story. 📷 Judy Griesedieck

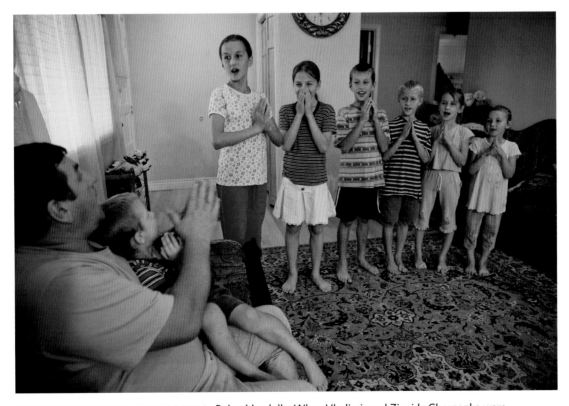

RANCHO CORDOVA, CALIFORNIA Babushka dolls. When Vladimir and Zinaida Chernenko were newlyweds in Ukraine, they spent six months trying to get pregnant and feared they never would; now they have 17 biological children. Having emigrated eight years ago to escape religious persecution, the family now spends evenings after homework singing Christian songs in Russian. Neither Vladimir nor Zinaida speaks English. 📷 Renée C. Byer

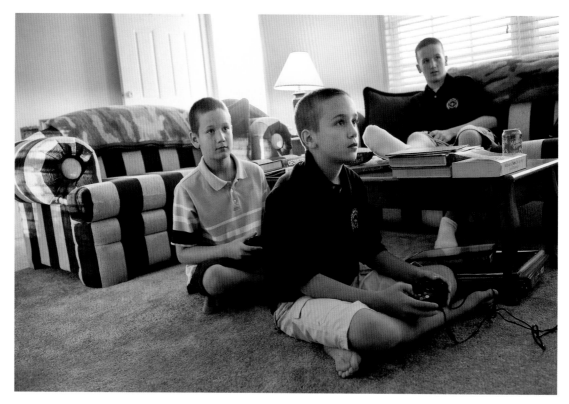

CHATHAM, VIRGINIA Virtual combat. Logan, Brandon, and Christian Mitchell play video games in their living room. Their mother, Kelly Mitchell, moved to this house on her ex-husband's farm to be closer to the boys as they attend Hargrave Military Academy. 📷 Stephen Voss

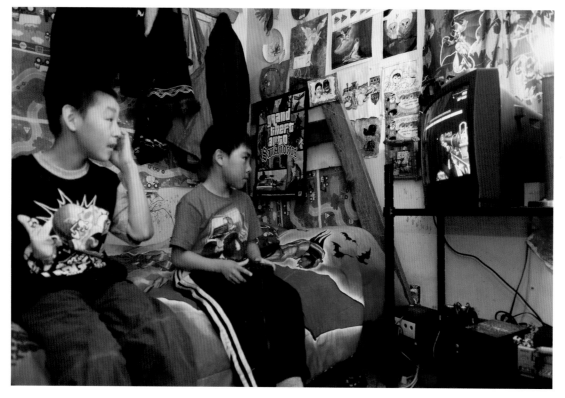

BARROW, ALASKA Vroom. Their historic Inupiat house on the shore of the Arctic Ocean may have no running water, but the good news for 7-year-old Qiugaaluk Ahyakak and his buddy, Niuqsiq, is that his house does have electricity. And a GameCube. And Grand Theft Auto. Computer games are now a $7.4 billion industry (larger than the movie industry), having tripled over the last decade. 📷 Luciana Whitaker

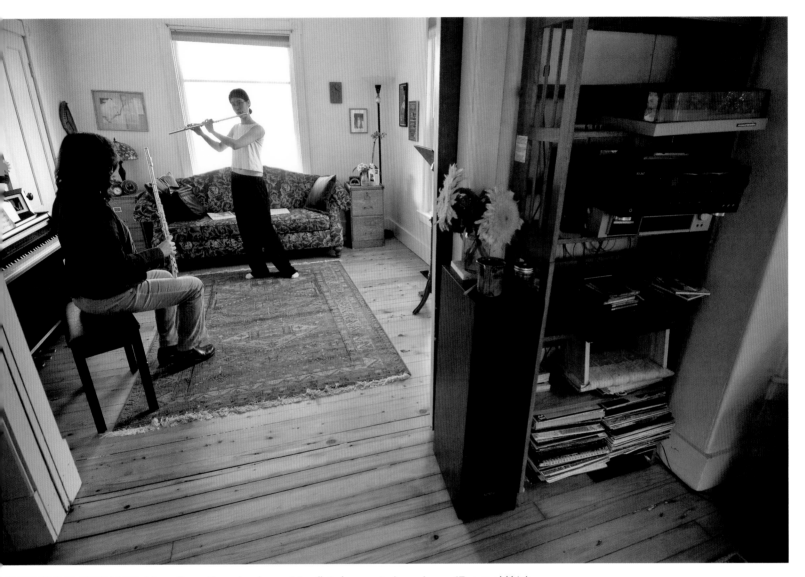

MONTPELIER, VERMONT Muse. Karen Kevra has been giving flute lessons to Jenny Law, a 17-year-old high school student, in the parlor of Kevra's home for the last seven years. Law took up the flute in the fifth grade and currently plays with her high school orchestra and a local youth orchestra, the Green Mountain Symphony. She plans to play music "for fun" in college—possibly a prudent choice: there are only about 250,000 working musicians in the United States—and 40 percent of those are part-timers. 📷 Jeb Wallace-Brodeur

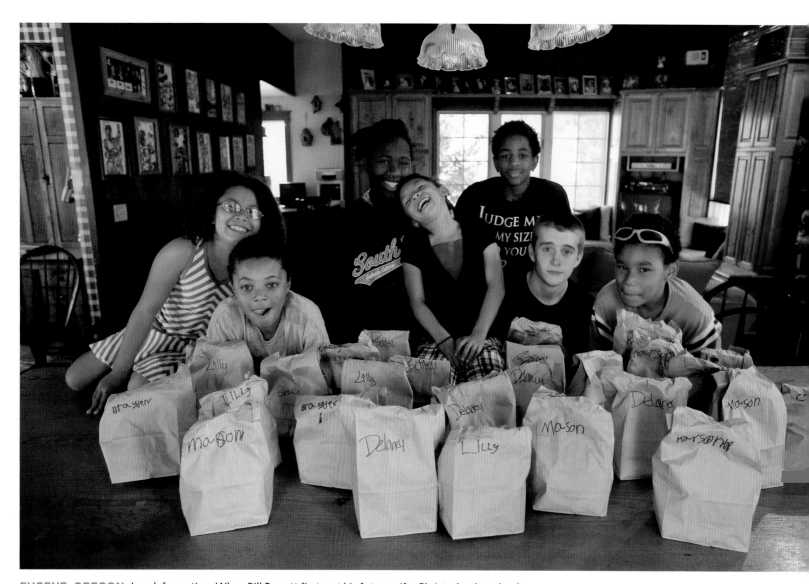

EUGENE, OREGON Lunch formation. When Bill Barrett first met his future wife, Christy, he thought she was kidding when she said she wanted 12 children. Now, after the couple has had 4 children of their own and adopted 12 more, Bill finally understands Christy's mission: finding families for needy kids. When she isn't looking after her own brood, she works with local social services to speed up the adoption process by having professional photographers shoot evocative portraits of children. These elegant photos replace the traditional mugshots and give prospective parents a sense of each child's personality. The images can be viewed at Christy's "Heart Gallery." 📷 Thomas Boyd

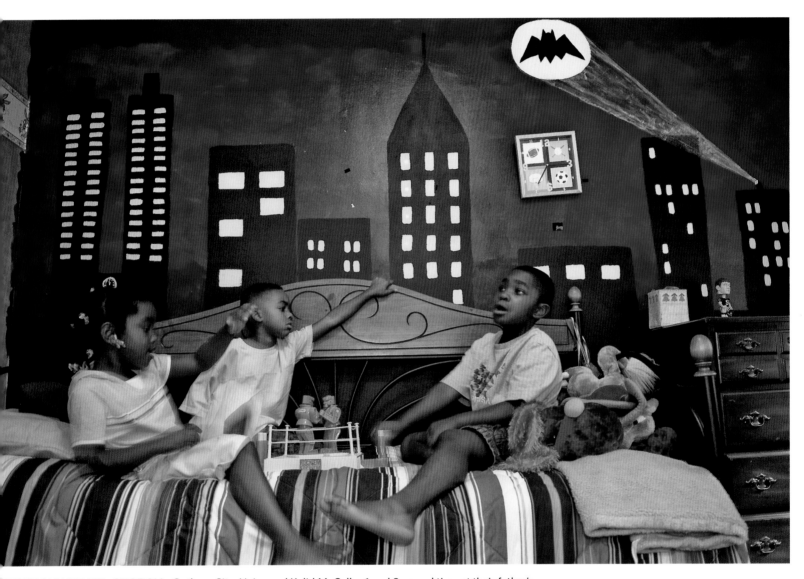

STONE MOUNTAIN, GEORGIA Gotham City. Naiya and Kalid McCalla, 6 and 8, spend time at their father's
house with stepbrother John Jones, 6. The children of divorced parents, the McCallas call themselves "two-
bedroom kids" because they have a bedroom at each parent's home. One-third of the nation's 73.7 million
children live with divorced parents today, compared with just 5 percent in 1960. Erik S. Lesser

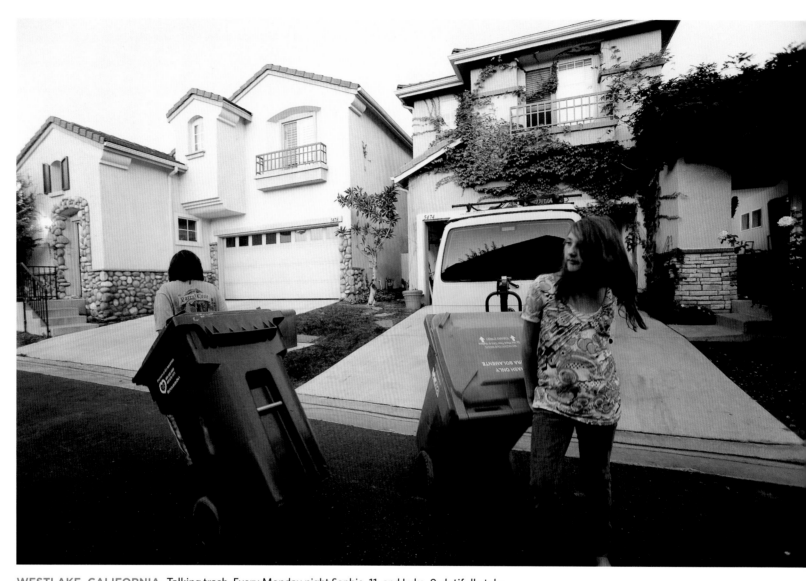

WESTLAKE, CALIFORNIA Talking trash. Every Monday night Sophie, 11, and Luke, 9, dutifully take out the trash and recycling as part of their weekly chores at the Appel household. Their recycling efforts are helping to reduce the nearly 4.5 pounds of waste per person finding its way to landfills throughout the United States each day. 📷 Dana Fineman

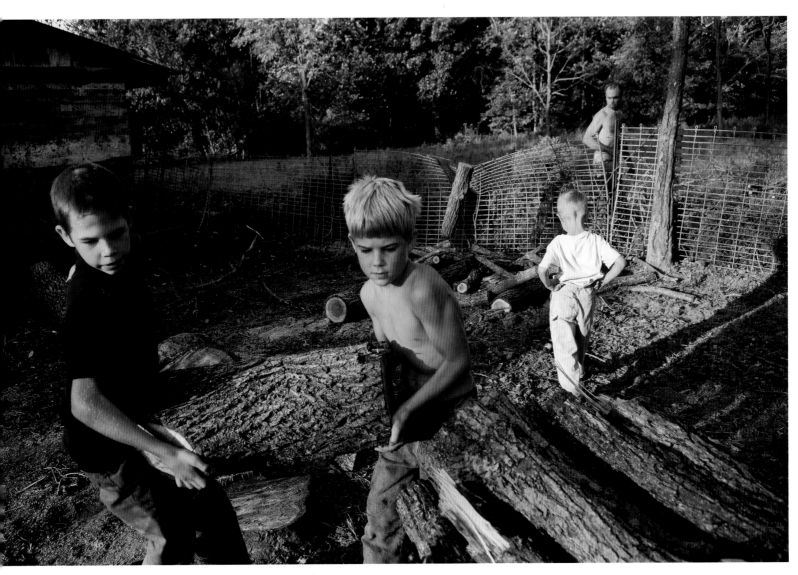

SMITHFIELD, ILLINOIS Off the grid. Sam, 9, Caleb, 11, and Matthew, 4, stack logs from a dead tree they chopped up for firewood. Their mother died a year ago, and their father, Tim Howerter, a minister and rural homesteader who is raising his five children with Christian values, believes in self-reliance. In fact, Howerter has donated the family's farm to his church. 📷 Fred Zwicky

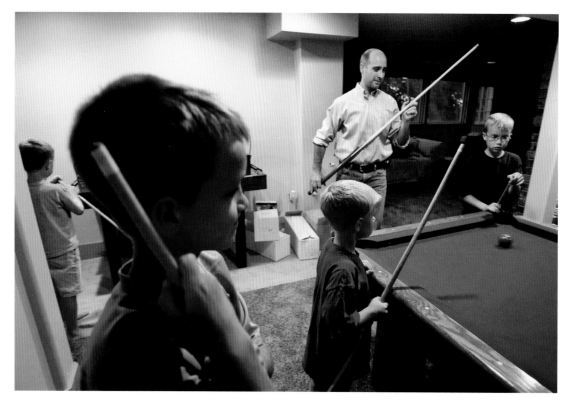

OGDEN, UTAH Corner pocket. The Burtons, a Mormon family of nine, take part in the church's "family home evening," emphasizing dinner, religious lessons, prayer, and play. Here Ken, a lawyer, shoots pool with sons Jackson, 9, Ken William, 12, Brigham, 7, and Isaac, 10. One of the world's fastest-growing faiths, the Mormon Church has more than 13 million members. Ramin Rahimian

ALPHARETTA, GEORGIA Easy riders. Nancy and David Salter went from a carefree couple to a hectic family of five literally overnight. Their triplets, Matthew, Patrick, and Joseph, are now four years old and rule the neighborhood. Gene Driskell

PEORIA, ILLINOIS Eye of the hurricane. On a warm evening, Rasheedan Jackson keeps track of her 1-year-old daughter, Aniya (foreground), as the little girl plays with sisters Jakima and Jakinia Roesbur, 2 and 4, and other young residents of Taft Homes public housing. About 1.3 million American households currently live in government-assisted housing. 📷 Fred Zwicky

OAKWOOD, OHIO Two square. Harrison and Benjamin Berke , 7 and 8, play a private game as their parents and neighbors gather for a late afternoon block party and cookout. 📷 Larry C. Price

[More than 93 percent of homeowners consider their neighborhood safe,

and 78 percent are not afraid to walk alone at night.]

WESTMINSTER, COLORADO Snack time. As parents gather and chat at the weekly porch party of Petra and D.J. Spiess in this new urbanist community, their children hold a picnic and Mom makes sure that everyone is served. New urbanism works to combine traditional values with modern urban planning. These communities feature regional architecture and universally accessible public spaces, and encourage walking to restaurants and shops, parks, and the homes of friends and neighbors. ◎ Joanna B. Pinneo

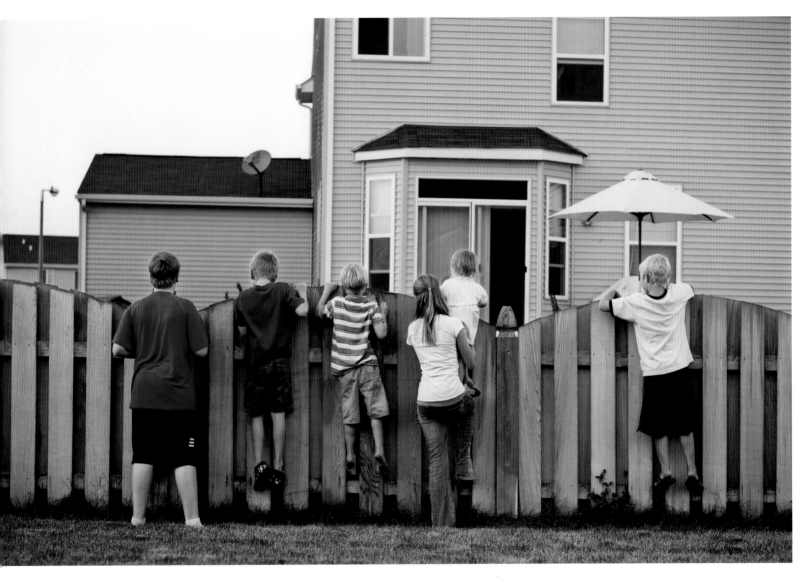

YORKVILLE, ILLINOIS Boosters. The Fahles host the Wallins and the Bergs in the backyard of their home to celebrate family birthdays in September. The three families are now related through remarriages between widowed grandparents. For mother Judy Fahle, this means her aunt is now her mother-in-law and her husband is also her cousin. The expanded family gets together several times each month—and when it gets too crowded they join in from the yard next door. 📷 Tim Klein

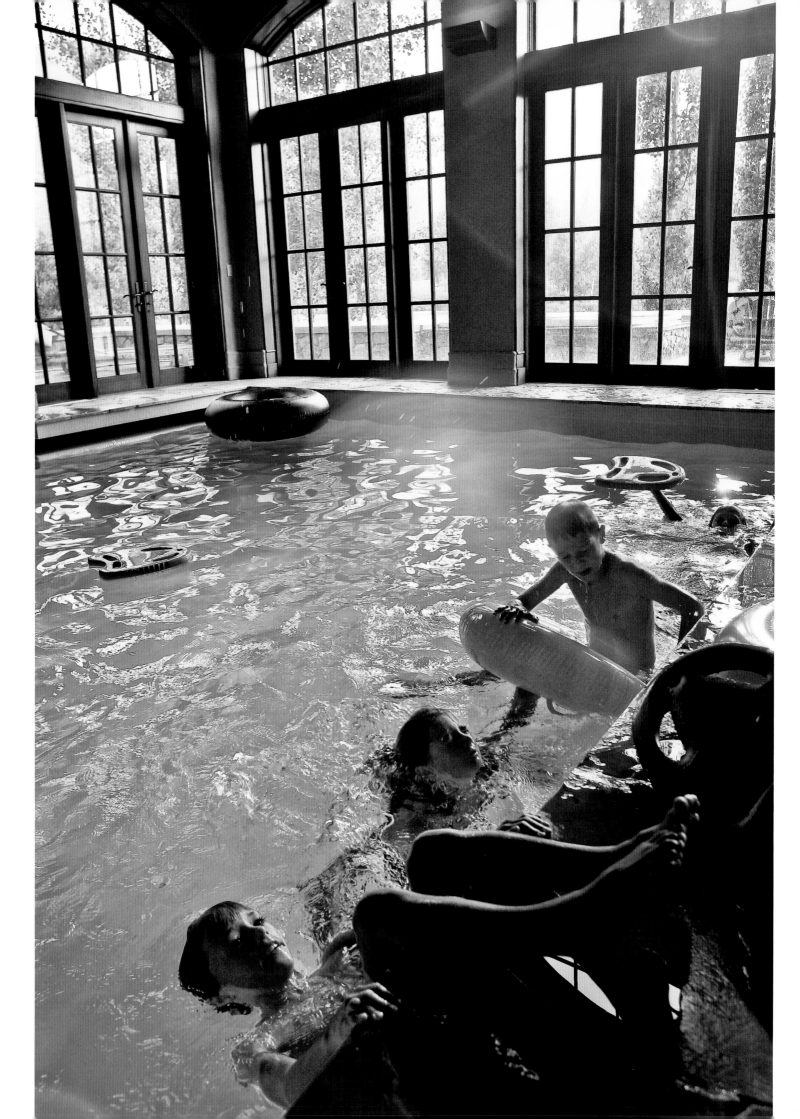

61 percent of American families believe money can't buy happiness. Relationships with children and friends ranked as the first and second most important contributor to a happy life.]

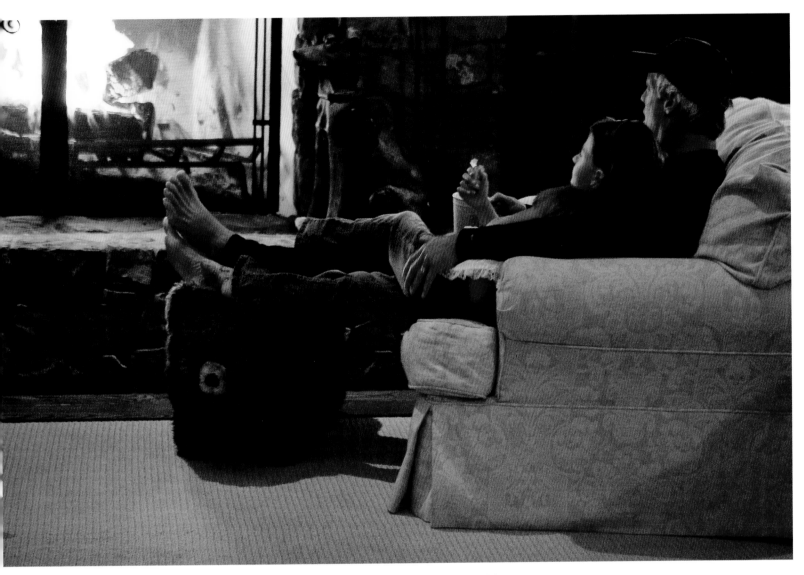

HAILEY, IDAHO Chasing the shadows away. Six-year-old Fallon, having woken up early from a bad dream, cuddles with her father, Tim Flaherty, in front of a warm fire. In a few moments she'll finish getting ready to hop on the bus for Hemingway Elementary School, where she is a first-grader. 📷 Stormi Greener

Wet weather. On a rainy day, four of the five Flaherty children take advantage of their family's indoor pool after completing dinner, cleanup, and homework. The fifth and oldest child, Jake, 12, is still inside doing schoolwork. Jokes their nanny, Brooke Bushnell, "The pool is great, plus on late nights it can serve as an instant bathtub for the kids." 📷 Stormi Greener

GREECE, NEW YORK Equipoised. Jesus Barberia, 46, spots his two daughters, Verónica, 13, and Andréa, 11, on a dock behind their home facing Lake Ontario. The sun has set and the tide has gone out, leaving the girls and their father suspended high above the sands. 📷 Carlos Ortiz

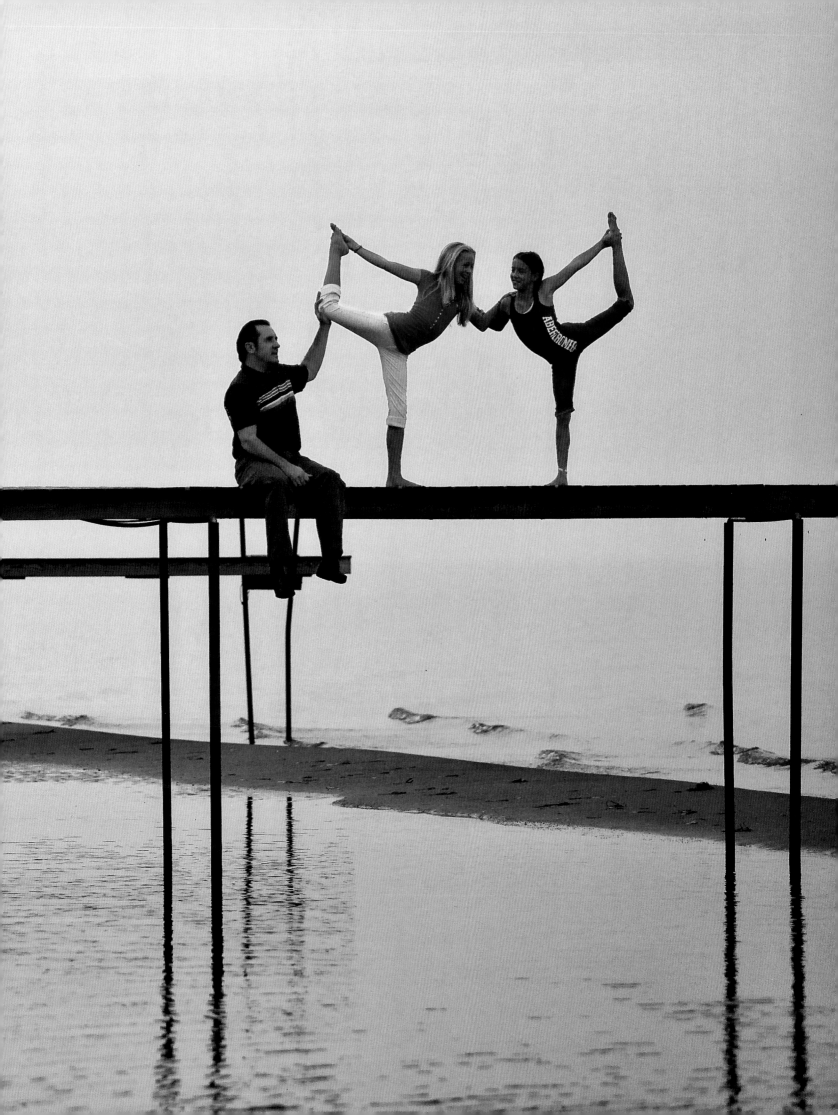

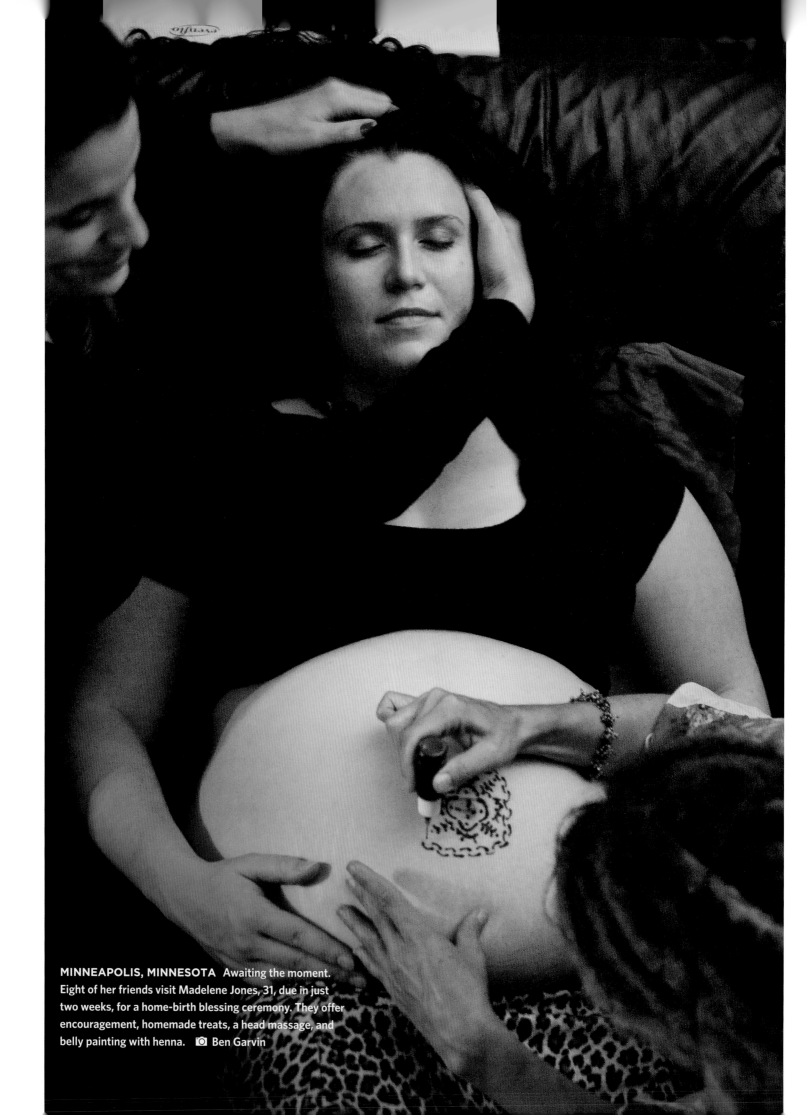

MINNEAPOLIS, MINNESOTA Awaiting the moment.
Eight of her friends visit Madelene Jones, 31, due in just
two weeks, for a home-birth blessing ceremony. They offer
encouragement, homemade treats, a head massage, and
belly painting with henna. 📷 Ben Garvin

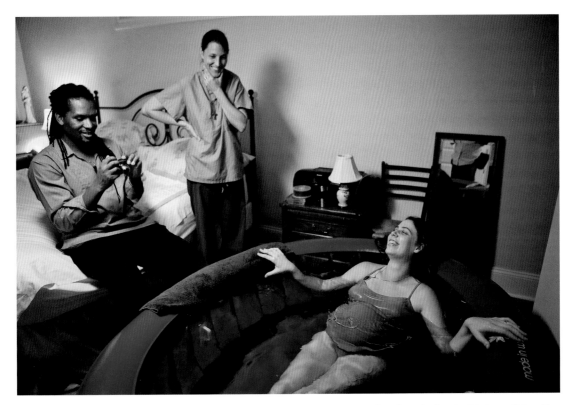

NEW ORLEANS, LOUISIANA Try this at home. Jean Montes inspects the photo he has just taken of his wife, Sarah, as she prepares for a home birth in a pool of water in their bedroom. Midwife Kami Dehler stands by to assist. Though water deliveries are relatively new in the United States, more than 90 countries around the world currently offer them in hospitals and birthing clinics. 📷 Chris Granger

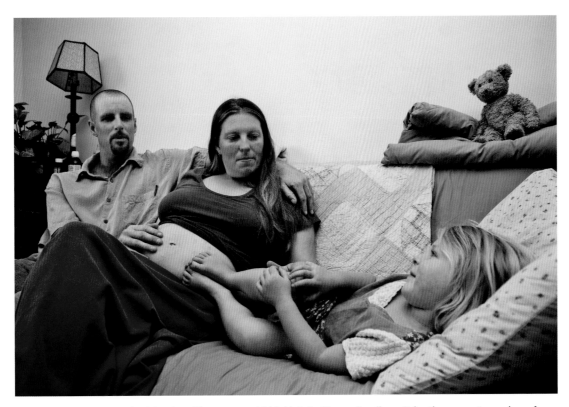

CABOT, VERMONT Anticipation. Three-year-old Mekiah Smith can hardly wait for the newest member of the family to arrive. Her parents, organic vegetable farmers Christina Aucoin and Shane Smith, plan to have the baby at home with the help of a midwife. In 2003, approximately 8 percent of American births were attended by midwives, more than doubling since 1990. 📷 Karen Pike

NORTHAMPTON, MASSACHUSETTS Make a wish. Family-style dinners and weekly teas to help students transition into their new lives are a tradition at 130-year-old, all-female Smith College. Uzuri Sims, 17, presents a 19th-birthday cake, complete with candles, to Katherine Oberwager—while other students, holding a "study party" in the house lounge, look on. 📷 Nancy Palmieri

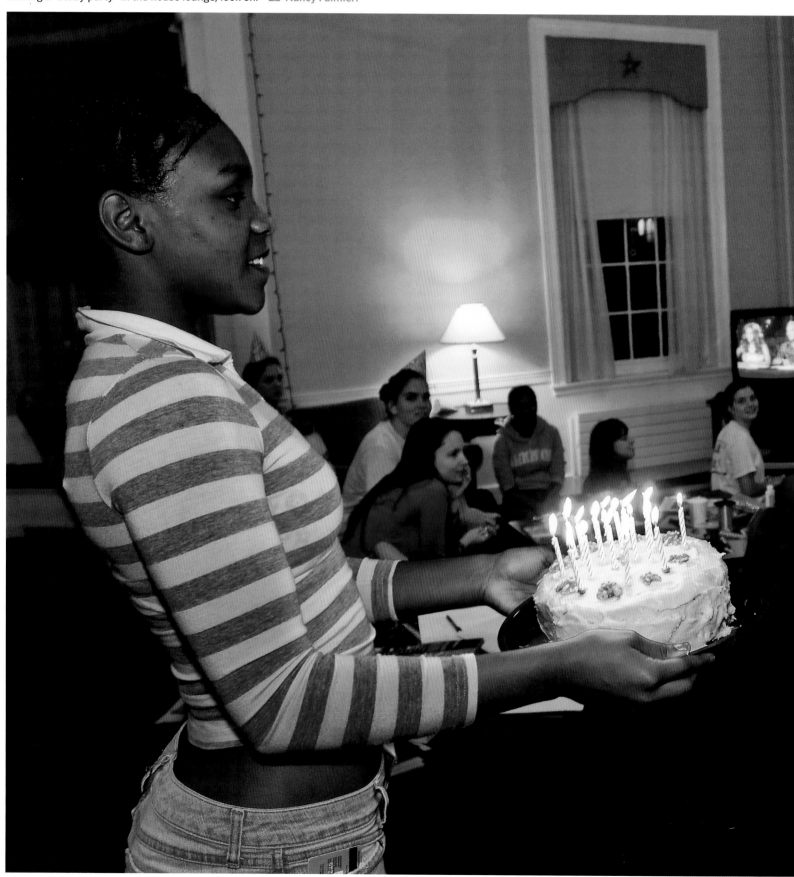

Approximately 700,000 Americans celebrate birthdays each day. Over the course of a year we exchange more than 1.1 billion birthday cards and spend more than 10 billion on birthday gifts.]

GOODING, IDAHO 133 years young. Blowing out the candles on their shared birthday cake are John, 75; Kalie, 9; and Mike Faulkner, 49. Faulkner Ranches, a three-generation operation, raises sheep and cows and also grows farm crops and feed. Once the norm, multigenerational family living is increasingly rare in America today—a mere 4 percent of all households have more than three generations living under one roof. 📷 Stormi Greener

YORKVILLE, ILLINOIS Ready, set, blow. Three families gather to help the Fahles celebrate their four September birthdays. Twenty friends and family members attended the party, which included food, gifts, and a trip to Whispering Meadows park. 📷 Tim Klein

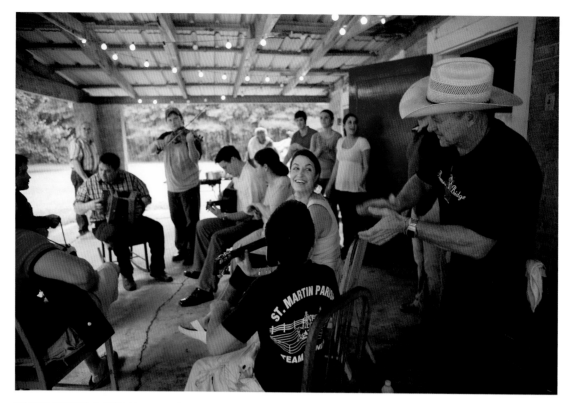

HENDERSON, LOUISIANA Bal de maison. At "Grandpa's Camp," named in memory of the Huvals' late grandfather, family get-togethers are a Cajun love affair. Jack Tally and Luck Huval prepare a family recipe for fried fish and chips while the others rotate in and out of an impromptu jam. All 14 members of the family play an instrument—even if it's only the spoons. ◎ Chris Granger

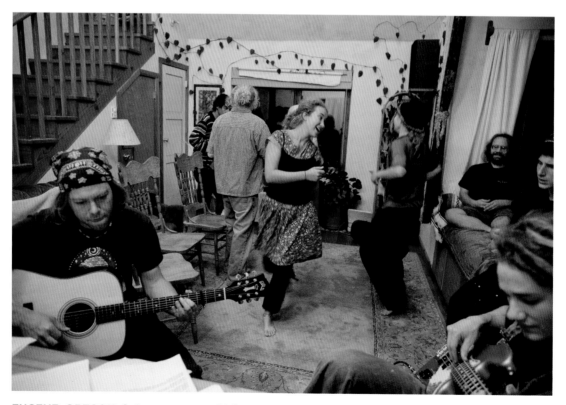

EUGENE, OREGON Swing your partner. Melanie Rios leads a play rehearsal at Maitreya Ecovillage, a small community of homes near downtown Eugene designed by its residents to be both green and sustainable. The play, to be performed locally by the residents, deals with attitudes towards global warming. Sixty-six percent of Americans now believe that global warming is a serious threat to the future of mankind, and many have changed their lifestyles to address these concerns. ◎ Thomas Boyd

[Only 7.3 percent of American adults have played a
musical instrument in the past 12 months.]

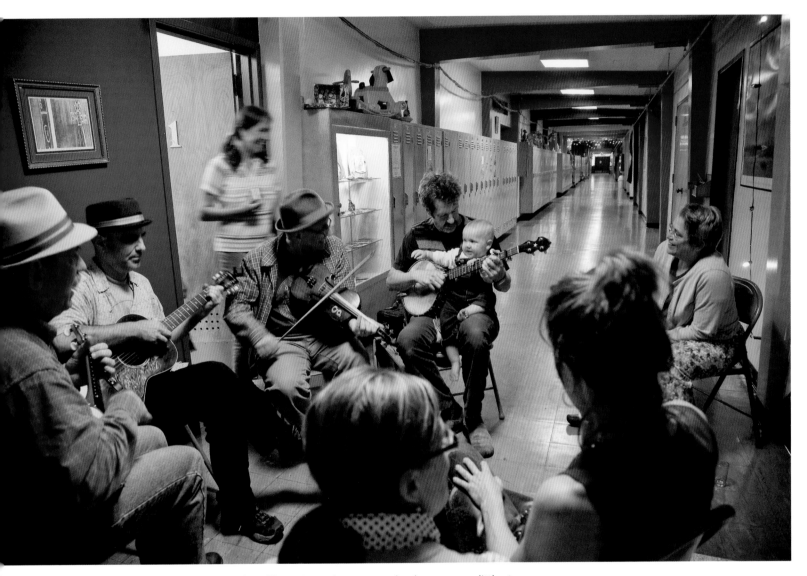

SEATTLE, WASHINGTON Master class. The idea of living in an elementary school may seem a little strange to some, but the laidback atmosphere of Cedar Park Elementary attracts all types of aspiring artists. Rents are low for the nine converted classrooms-turned-apartments, which still feature blackboards, lockers, child-height sinks ... and communal bathrooms. Here, residents gather to celebrate Fenton Cooper's first birthday with a little homemade music. 📷 Zak Powers

PORT CHESTER, NEW YORK Memory markers. The YAI group home encourages its mentally disabled adult residents to accomplish as many domestic tasks as they can. Here, Mildred Raff rests in her room beside a end table that encapsulates the memories of a busy lifetime before age took its toll. The largest photo is of Raff's daughter and son-in-law. For many older Americans, the items scattered across their night tables capture a life well lived and memories well preserved. 📷 Andrew Lichtenstein

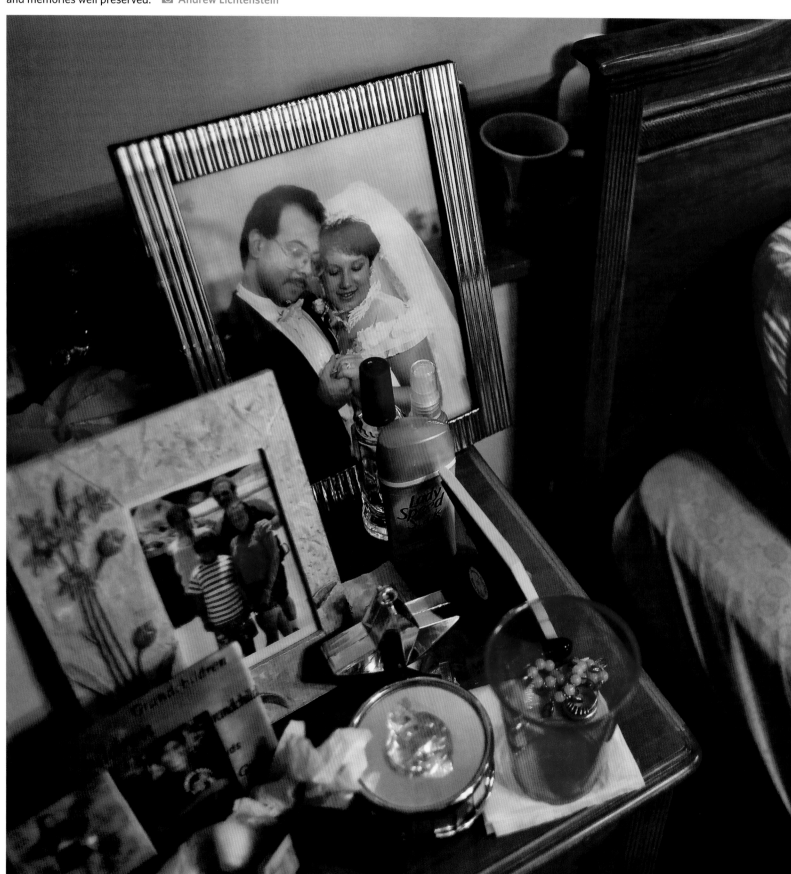

There are an estimated 67,473 centenarians (people aged 100 or older) in America.
By 2037 this number is expected to increase to more than 500,000.

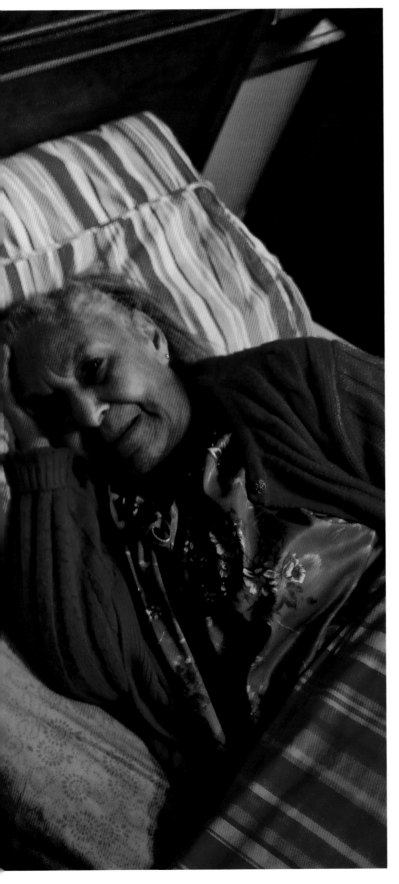

CHAUTAUQUA, NEW YORK Autumn almanac. Joan Smith clips newspaper articles in her sunroom. A year-round resident of Chautauqua, Smith acts as historian for a number of local groups. More than 60 million Americans (27 percent of the population) volunteer for a nonprofit organization at least once per year. 📷 Nancie Battaglia

BURLINGTON, VERMONT Mother-and-child reunion. Harriet Duffy, 99, makes her way to the living room after dinner in the house she shares with her daughter, Dorothy Burns, 82, and a Japanese caregiver, Ryoko Ando, 62, a teacher studying at a local college who speaks little English. They are part of Homeshare Vermont, a program founded in 1983 that teams the elderly with people needing a place to live. 📷 Karen Pike

[More than one-quarter of Americans say they left their
child's room "as is" after their child left home.]

BATON ROUGE, LOUISIANA In their sights. Dressed as hunters and prey, 200 sisters from Delta Gamma sorority at Lousiana State University head for their weekly off-campus social event with the Lambda Chi Alpha fraternity. Tonight's theme is "On the Prowl." Reflecting the need for young people to have a home away from home, Greek houses, which faded in the 1960s, have returned with a vengeance. Jennifer Zdon

MALIBU, CALIFORNIA Wishing it would never end. The childhood dream of an endless summer draws Sophie Appel, 11, Ava Felman, 10, and Luke Appel, 9, to hang out in Ava's pool on a late September day—long after school has started and the leaves have started to turn. 📷 Dana Fineman

MALIBU, CALIFORNIA A polish between pals. Best friends Sophie Appel and Madeleine Jacobus, both 11, give each other manicures and pedicures during a sleepover at Jacobus's home in the hills of Malibu, California. 📷 Dana Fineman

ARABI, LOUISIANA Living-room rink. Caitlyn Anglin, 9, saw her house destroyed by Hurricane Katrina two years ago. Today, with few places to play, Caitlyn uses the floor of another destroyed home as a place to skate (her sneakers have built-in rollers). An estimated 44 percent of New Orleans's residents—a quarter-million former residents—have still not returned to the homes they lived in before the 2005 hurricane. ◉ Chris Granger

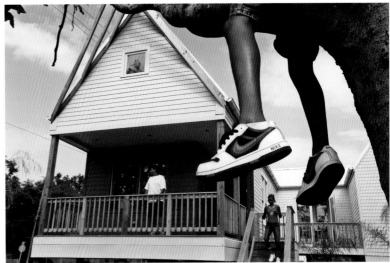

BILOXI, MISSISSIPPI Bird's-eye view. Zaccari Parker, 10, climbs a tree while his mother, Karen, and sister, Courtnee, 17, tour their new home, built and donated by Architecture for Humanity. The Parkers lost their previous home to Hurricane Katrina. The work required to repair Katrina's damage on the Gulf Coast is immense—for example, 2 million cubic yards of debris have been incinerated just for mold and other health reasons. 📷 Lee Celano

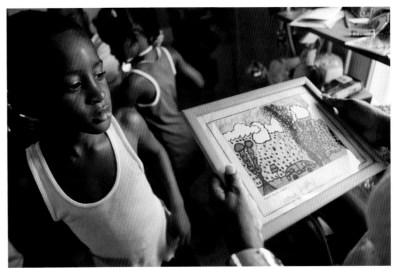

BILOXI, MISSISSIPPI Safely in the frame. Roderick Murphy, Jr., 9, watches his mother, Chelsea Bradley, as she studies his drawing of a hurricane. The family currently lives in a FEMA trailer, one of 86,000 families along the Gulf Coast still doing so more than two years after Hurricane Katrina. 📷 Chris Granger

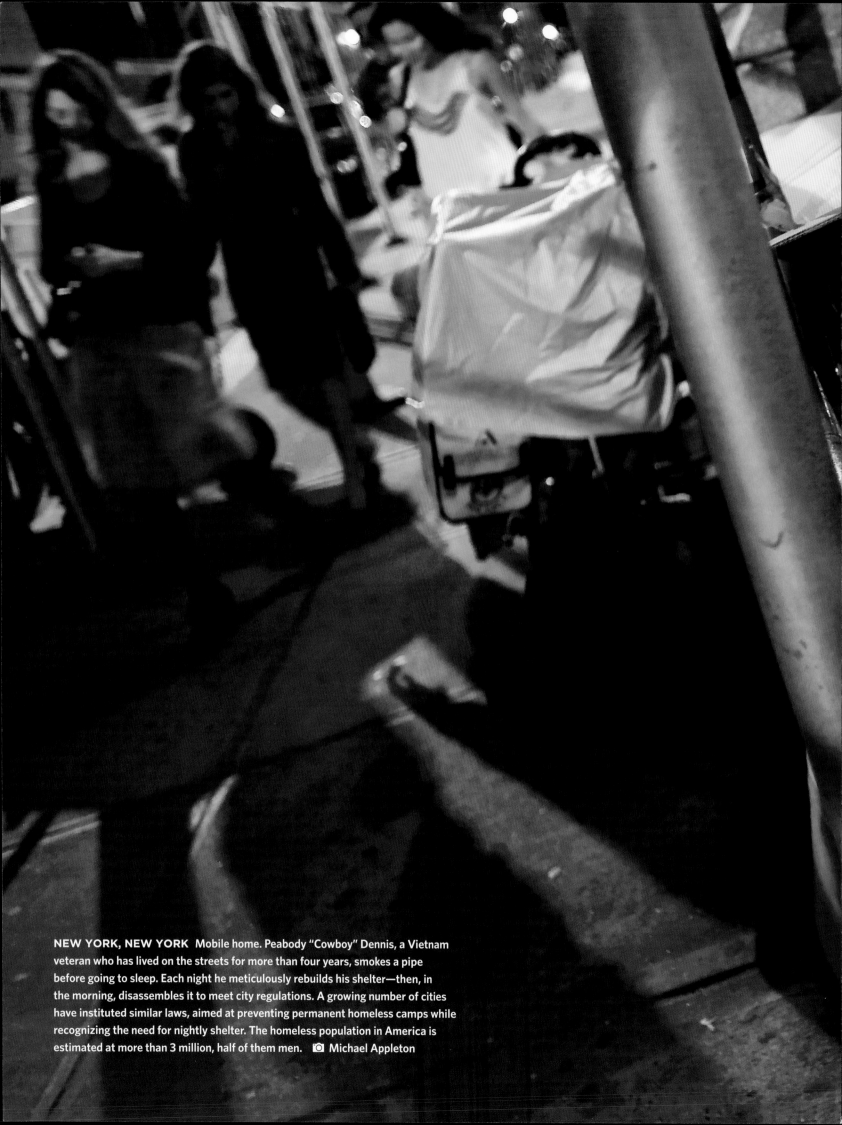

NEW YORK, NEW YORK Mobile home. Peabody "Cowboy" Dennis, a Vietnam veteran who has lived on the streets for more than four years, smokes a pipe before going to sleep. Each night he meticulously rebuilds his shelter—then, in the morning, disassembles it to meet city regulations. A growing number of cities have instituted similar laws, aimed at preventing permanent homeless camps while recognizing the need for nightly shelter. The homeless population in America is estimated at more than 3 million, half of them men. 📷 Michael Appleton

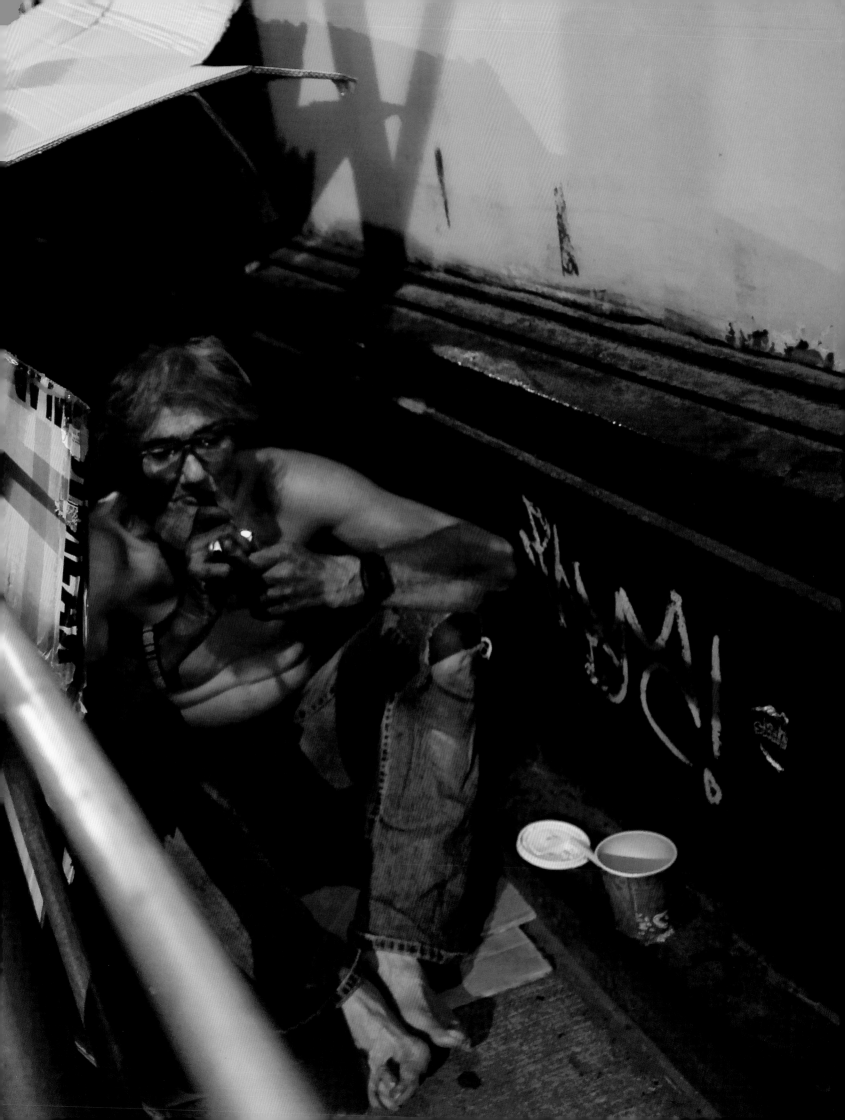

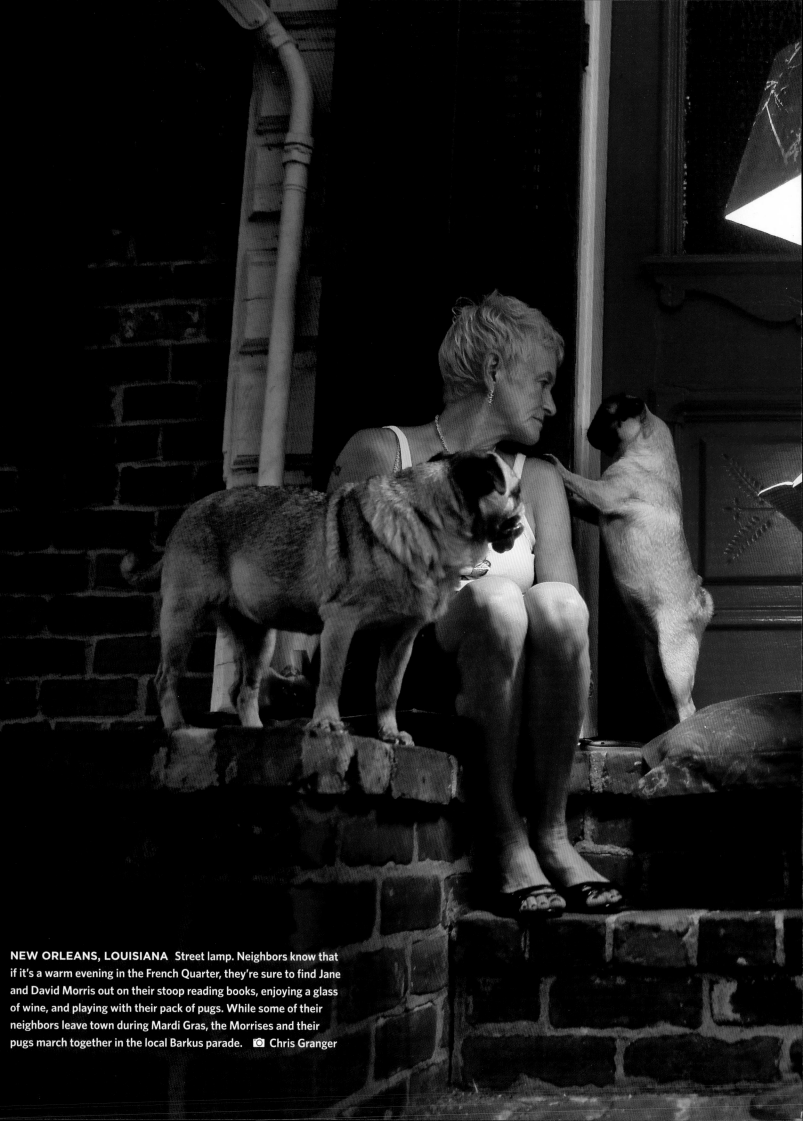

NEW ORLEANS, LOUISIANA Street lamp. Neighbors know that if it's a warm evening in the French Quarter, they're sure to find Jane and David Morris out on their stoop reading books, enjoying a glass of wine, and playing with their pack of pugs. While some of their neighbors leave town during Mardi Gras, the Morrises and their pugs march together in the local Barkus parade. 📷 Chris Granger

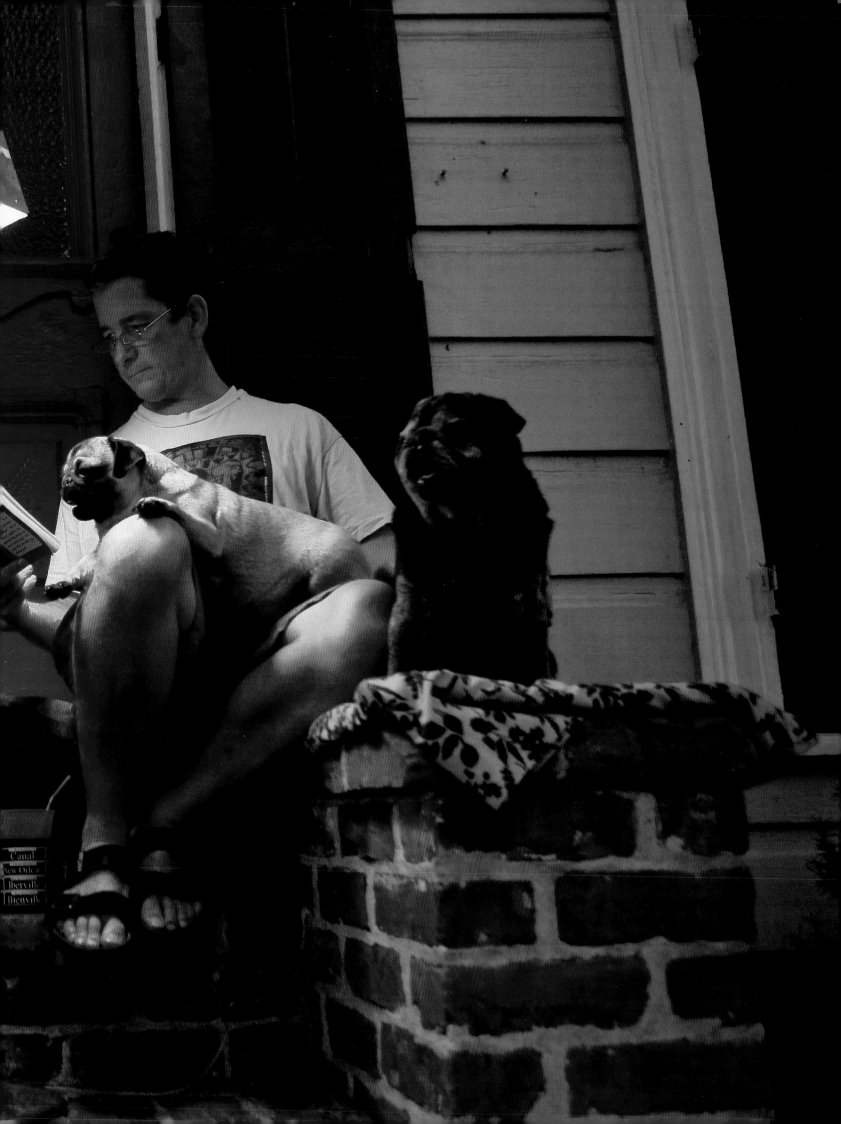

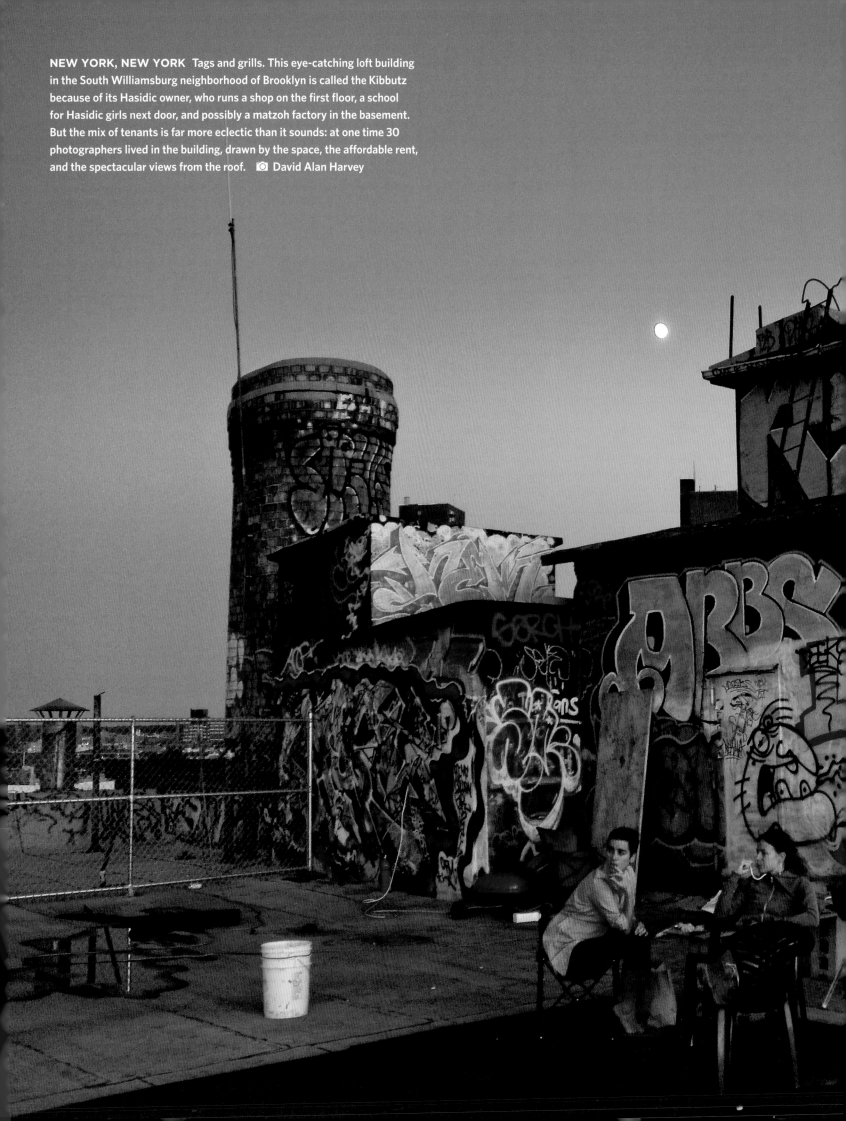

NEW YORK, NEW YORK Tags and grills. This eye-catching loft building in the South Williamsburg neighborhood of Brooklyn is called the Kibbutz because of its Hasidic owner, who runs a shop on the first floor, a school for Hasidic girls next door, and possibly a matzoh factory in the basement. But the mix of tenants is far more eclectic than it sounds: at one time 30 photographers lived in the building, drawn by the space, the affordable rent, and the spectacular views from the roof. 📷 David Alan Harvey

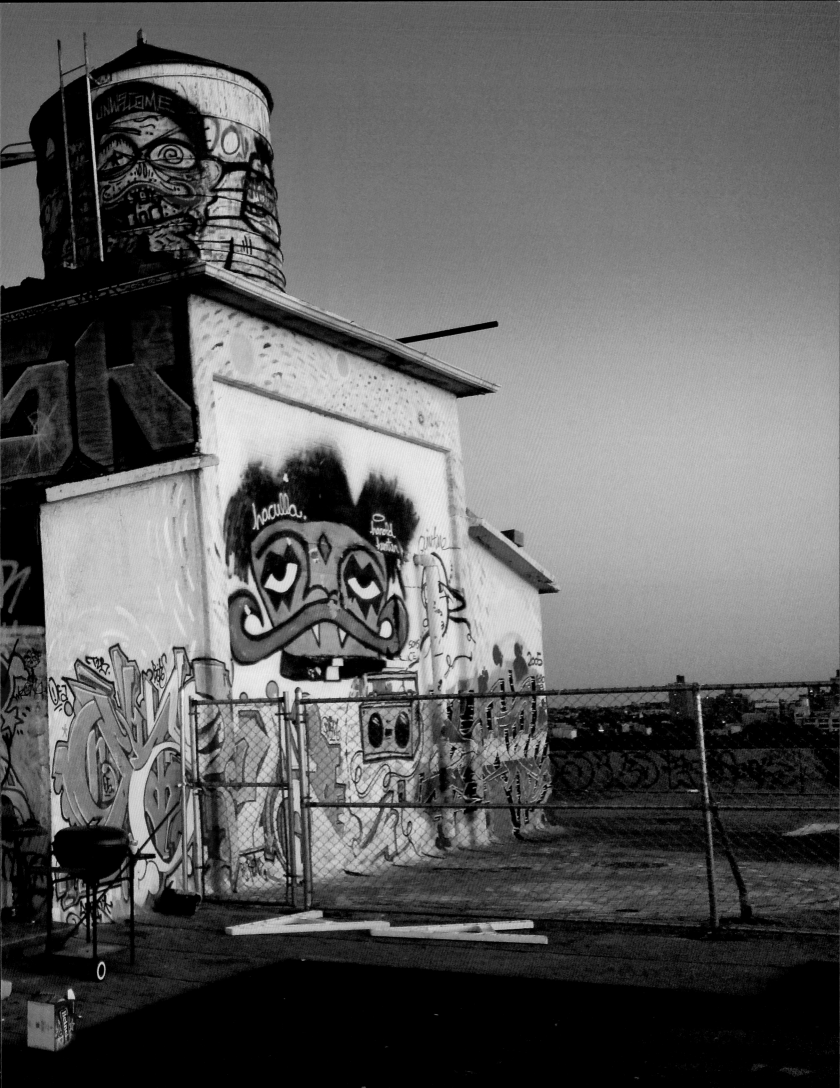

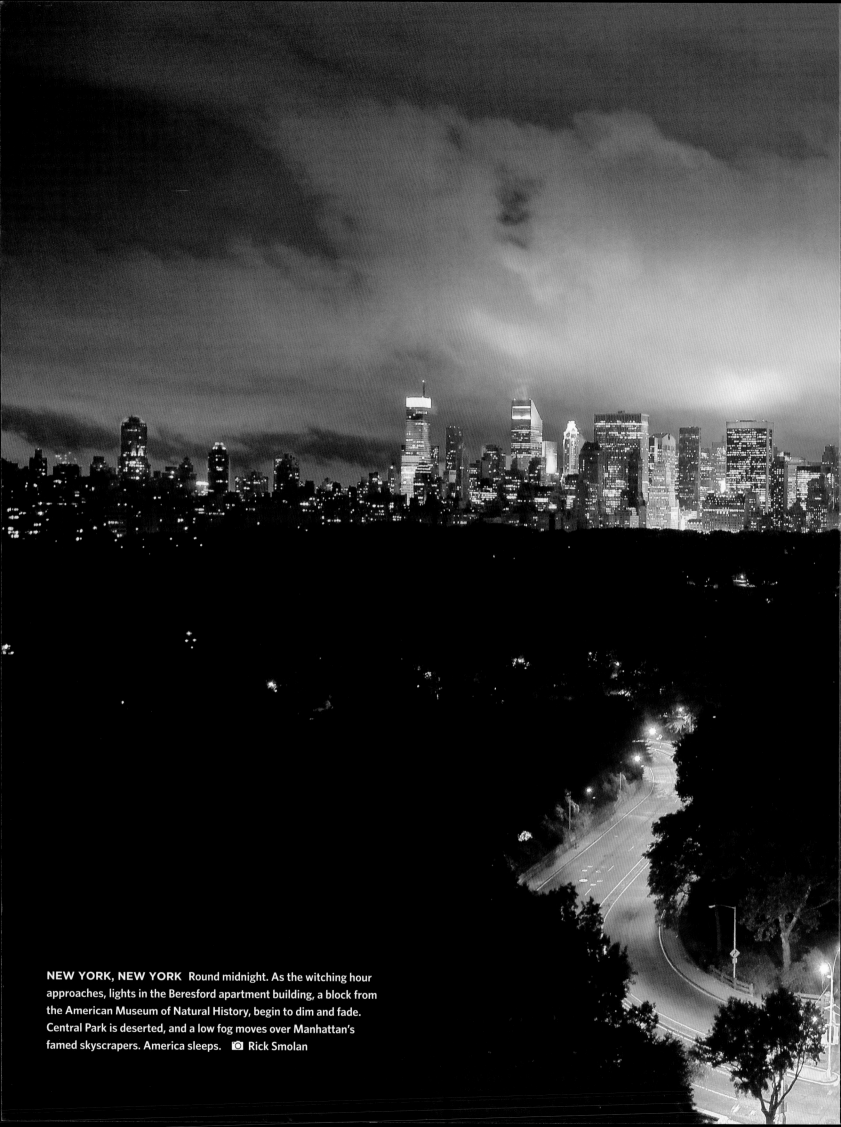

NEW YORK, NEW YORK Round midnight. As the witching hour approaches, lights in the Beresford apartment building, a block from the American Museum of Natural History, begin to dim and fade. Central Park is deserted, and a low fog moves over Manhattan's famed skyscrapers. America sleeps. 📷 Rick Smolan

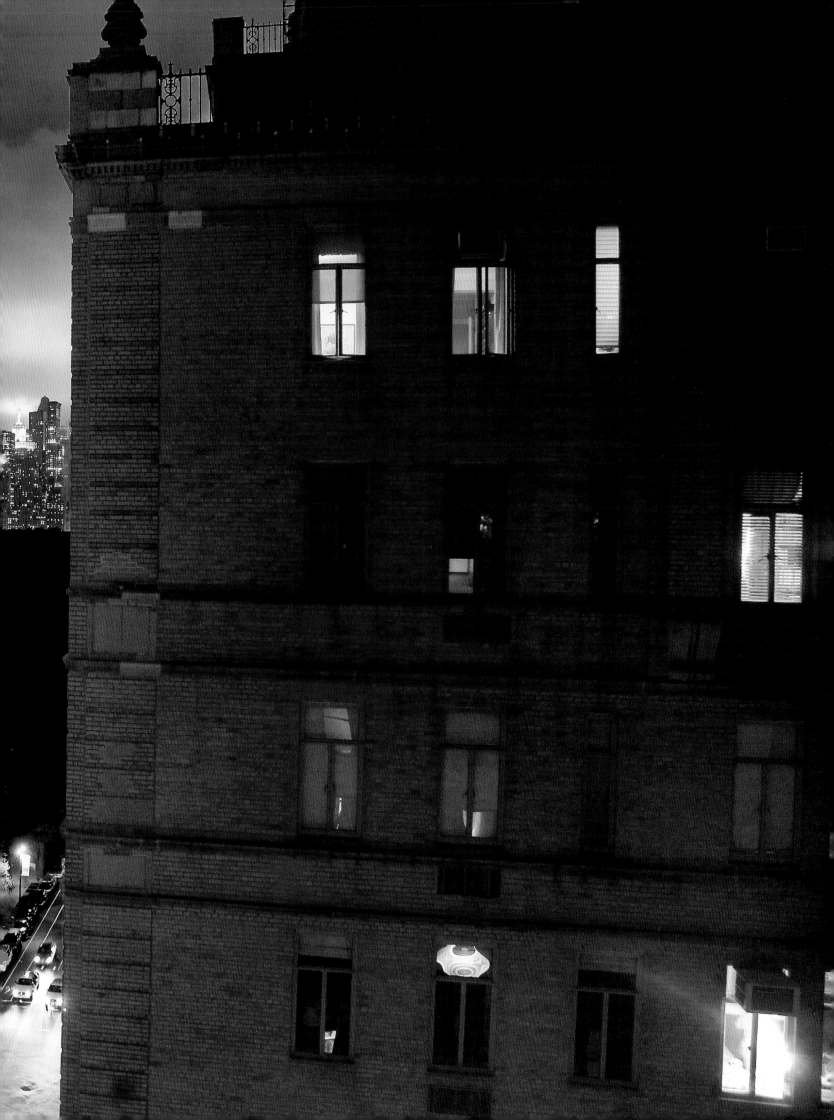

IKEA

IKEA is proud to have served as the sponsor of the *America at Home* project.
At IKEA we believe that home is the most important place in the world, and this
book, and the larger citizen photography event that surrounded it, makes that point
vividly. As these images teach us again and again, a home is not the walls, floors, or
even the furnishings; it's the people who live in it and the experiences they share.

The photographs in *America at Home* are also a reminder that every family is different
in its composition, in its dreams, in what it values, and in its vision of itself. IKEA too
is a diverse family. Our dream is to improve the daily life of the most people possible;
and our contribution is providing a wide range of well-designed, high-quality, and
functional home furnishings at prices so low that almost any family can afford them.
When we design products, we envision the price tag first and then challenge our
designers, product developers, technicians, and purchasers to reach that goal.

This was the vision of IKEA when it was founded in 1943 by Ingvar Kamprad. It is
not surprising, then, that when Kamprad named the company, he chose the place he
knew as home: **I**ngvar **K**amprad, from the farm **E**lmtaryd, in the village of **A**gunnaryd
in the rural province of Småland, Sweden. Today, IKEA has more than 115,000
co-workers in 231 IKEA stores, and trading offices and distribution centers in 40
countries around the world, yet we still retain that original vision, first formed in
that little farmhouse. IKEA is still about family, about those things we cherish most,
and, most of all, about home.

GOOGLE

Google's mission is to organize the world's information and make it universally accessible and useful. We were drawn to the *America at Home* project because of its focus on capturing the range of experiences and emotions associated with home and family life. We are pleased that our products were used to share the photographs from this project with a broad audience. The *America at Home* photographers and writers have created a story that celebrates the human experience, and we are glad to have played a part in bringing this to you.

HP SNAPFISH

Named the Best Overall Photo Sharing Site by *Good Housekeeping*, Snapfish has more than 45 million members and two billion unique photos stored online. Share, store, and edit your photos for free in a secure, password-protected account. Get professionally developed prints for as little as 10¢ each—they've been called "the best prints for the least money" by *PC* magazine! Plus, Snapfish offers over 100 customizable photo products, from photo books and greeting cards to mousepads, calendars, and collage posters. Create your free account today!

BABYCENTER

BabyCenter® knows that nothing makes a house a home more than children. The *America at Home* project is an ideal outlet to depict both the harmonies and challenges of home life with children, and thousands of our users submitted their photos for consideration in this project. BabyCenter is the number-one online destination for new and expectant parents in the United States, with global reach in 12 markets and more than 6 million monthly users worldwide.

CAMERABITS & PHOTO MECHANIC

Founded in 1996 by Dennis Walker, Camera Bits is the developer of Photo Mechanic, the standard workflow software for digital photojournalists around the world. **www.camerabits.com**

DRIVESAVERS DATA RECOVERY

With the highest success rate in the data recovery industry, DriveSavers Data Recovery proves to its business, government, academic, and individual customers all over the world that data loss is only temporary. **www.drivesavers.com**

FACEBOOK

Facebook is a social utility that connects people with friends and others who work, study, and live around them. People use Facebook to keep up with friends, upload an unlimited number of photos, share links and videos, and learn more about the people they meet. **www.facebook.com**

FILEMAKER

Millions of customers, from individuals to large organizations, rely on FileMaker's award-winning database software, which includes the legendary FileMaker Pro product line for Windows, Mac, and the web, to manage, analyze, and share information. FileMaker, Inc. is a subsidiary of Apple Inc. **www.filemaker.com**

FOTONATION.NET

FotoNation.net provides Internet imaging products and services for the digital photography market and has deep expertise in the development of both wireless connectivity and Internet imaging services. The company's most recent offering is powering Nikon's new my Picturetown imaging service. **www.fotonation.net**

HEWLETT-PACKARD

HP focuses on simplifying technology experiences for all of its customers, from individual consumers to the largest businesses, with a portfolio that spans printing, personal computing, software, services, and IT infrastructure. **www.hp.com**

LACIE

LaCie's external storage solutions and color monitors feature original designs and leading-edge technology to help people easily manage their digital lives. **www.lacie.com**

NIKON

With over 100 photographers using the COOLPIX S51c to shoot and send thousands of photographs to its my Picturetown photo sharing service, Nikon is excited to see the resulting collection of images that define America at home. **www.nikonusa.com**

O'REILLY'S DIGITAL MEDIA

O'Reilly's Digital Media connects people to the experts through books and online resources from highly respected working professionals who are masters of tools and technologies focused on the rapidly changing world of creative media. **http://digitalmedia.oreilly.com**

PANTONE

Pantone, Inc. is the world–renowned provider of color systems and leading technology for the selection and accurate communication of color across a variety of industries. **www.pantone.com**

POWER ON SOFTWARE

Now Software is the developer of the Eddy Award–winning Now Up-to-Date and Contact, the number-one calendar and contact management software for business and power users. **www.nowsoftware.com**

TRAVELMUSE

TravelMuse provides content, community, and planning tools to empower consumers to make better online travel decisions. **www.travelmuse.com**

RICK SMOLAN
Project Director

JENNIFER ERWITT
Project Director

KATYA ABLE
Chief Operating Officer

PHOTOGRAPHY AND ASSIGNMENTS

ERIC MESKAUSKAS
Photography Director

KAREN MULLARKEY
Assignment Director

WILLIAM NABERS
Senior Assignment Editor

MADDY MILLER
Senior Assignment Editor

M. WESLEY HAM
Photographer Liaison

ASSIGNMENT EDITORS

Donna Acedo
Lisa Maria Cabrera
Lee Cerre
Denise Mangen
Bethany Obrecht
Jennifer Ollman
Jon O'Hara
Tamara Rosenblum

DESIGN AND PRODUCTION

BRAD ZUCROFF
Creative Director

DIANE DEMPSEY MURRAY
Art Director

PETER TRUSKIER
Automation & Color Management

HEIDI MADISON
Project Manager

CAROLINE CORTIZO
Image Production Artist

ANN JOYCE
Production Designer

HULDA NELSON
Production Designer

JOAN OLSON
Production Designer

MICHAEL RYLANDER
Creative Consultant

EDITORIAL

MICHAEL MALONE
Contributing Editor and Caption Writer

MATTHEW REED BRUEMMER
Researcher

SHERRI SCHULTZ
Copy Editor

ANNA MANTZARIS
Proofreader

PICTURE EDITORS

Eric Meskauskas
Formerly *New York Daily News*

Michele Stephenson
Formerly *Time*

Elliane Laffont
Hachette Filipacchi Media

Jean-Pierre Laffont
Hachette Filipacchi Media

Karen Mullarkey
Formerly *Newsweek*

Maddy Miller
Formerly *People*

Brad Zucroff
Formerly *National Geographic Traveler*

Nadja Masri
GEO Magazine

TECHNOLOGY

CHUCK GATHARD
Technology Director

TOPHER WHITE
Systems Architect

WEBSITE

MICHAEL RYLANDER
Creative Director

HEATH CARLISLE
Programmer

MATTHEW REED BRUEMMER
Content Coordinator

PUBLICITY AND OUTREACH

DAPHNE KIS
Communications Director

KIM SHANNON
Communications Manager

AVENUE MARKETING & COMMUNICATIONS
Mike Hettwer
Daniel Bodde

CONNORS COMMUNICATIONS
Connie Connors
David Moore
Chris Granger
Maya Duncan

GOLDBERG MCDUFFIE COMMUNICATIONS
Grace McQuade

OFFICE ADMINISTRATION

ALLY MERKLEY
Office Manager

PARISA MORID
Office Manager

BRETT MESKAUSKAS
Office Coordinator

NANCY MERKLEY
Office Coordinator

SENIOR BUSINESS ADVISOR

BARRY REDER

LITERARY AGENT

CAROL MANN
The Carol Mann Agency

DOCUMENTARY

MIKE CERRE
Executive Producer

Lee Cerre
Mike Elwell
Chuck Clifton
Michele Clifton
Hugh Scott
Mark Holzman
Terry Schilling

LEGAL COUNSEL

NATE GARHART
Coblentz, Patch, Duffy & Bass, LLP

JONATHAN HART
Dow, Lohnes & Albertson, PLLC

DAVID WITTENSTEIN
Dow, Lohnes & Albertson, PLLC

ACCOUNTING & FINANCE

EUGENE BLUMBERG
Blumberg & Associates

ARTHUR LANGHAUS
KLS Associates

JOE CALLAWAY
KLS Associates

ROBERT POWERS
Calegari & Morris Certified Public Accountants

HEIDI LINK
Calegari & Morris Certified Public Accountants

LINDA SEABRIGHT
Bookkeeper

RUNNING PRESS

Jon Anderson
Lisa Clancy
Craig Herman
Bill Jones
Joanne Cassetti
Daniel Clipner
Carolyn Savarese

PRE-PRESS & PRINTING

GARY HAWKEY
iocolor

ANDREW CLARKE
Asia Pacific Offset

FERRARI COLOR

Dan Spangenberg
Jill Adri
David Gurr

SENIOR ADVISORS

Marvin and Gloria Smolan
Phillip Moffitt
James Able

SPECIAL THANKS

Monica Almeida
Jane Anderson
Chris Anderson
Bob Angus
Dave Armon
The Bakst Family
Simon Barnett
Sunny Bates
Keith Bellows
Lisa Bernstein
David Bohrman
Jessica Brackman
Russell Brown
Tess Canlas
Bruce Chizen
David E. Cohen
Joyce Deep
Gene and Gayle Driskell
Dan Dubno
The Durham Family
Amy Erwitt
David Erwitt
Ellen Erwitt
Erik Erwitt
Sasha Erwitt
Harlan Felt
Kevin Foong
Pia Frankenberg
Peter Friess
Mary Anne Golon
Roz Hamar
Greg Harper
Michael Hawley
Kathleen Hazelton-Leech
Jerry Held
Chandi Hemapala
James Higa
Sam and Kate Holmes
George Jardine
James and Zem Joaquin
Steve Jobs
Jon Kamen
Paul Kent
Matt Kursh
The Lester Family
Andrea Lovitt
Davis Masten
Lucienne Matthews
Richard Matthews
Michele McNally
Charles Melcher
Doug and Tereza Menuez
Matthew H. Murray
Dean and Anne Ornish
Rick Pappas
Paula Parrish
Gabe Perle
Gabriella Piccioni
Gina Privitere
Natasha and Jeff Pruss
Pamela Reed
Steven Riggio
Peter Rockland
Diane Rylander
Sheri Sarver
Terry Schaefer
Duane Schultz
Richard Sergay
Kim Small
Rodney Smith
Leslie Smolan
Sandy Smolan
Brian Storm
Derrick Story
Kara Swisher
Anne Wojcicki
Claudia Zamorano

SPONSOR

IKEA
Pernille Lopez
Bill Agee
Magnus Gustafsson
Michael Hay
Tracey Kelly
Mona Liss
Mary Buyno Mann
Gina Raiser
Raymond Simanavicius

ADDITIONAL SUPPORT

GOOGLE
Sergey Brin
Marissa Mayer
Michaela Prescott
Megan Smith
Anita Rajeswaren
Beth Martin
R.J. Pittman
Kenneth Dauber

SNAPFISH
Ben Nelson
Nicola Anderson
Geoff Ayres
Sinyen Be
Heather Calvosa
Julian Carlisle
Cass Carrigan
Deanna Dawson
Matt Domenici
Kevin Frisch
Ramana Murthy Garugu
Vijay Gatadi
Tina Hui
Hema Kannan
Sumant Manda
Murali Nallana
Ben Nelson
Rand Newman
Adina Nystrom
Dennis Prince
Shankar Ramamoorthy
David Saxton
Jay Shek
Lisa Sterling
Rolf Wilkinson

BABYCENTER
Colleen Hancock
Nissa Anklesaria
Cynthia Maller

CAMERA BITS & PHOTO MECHANIC
Dennis Walker

DRIVESAVERS DATA RECOVERY
Scott Gaidano
Chris Lyons
John Christopher

FACEBOOK
Katie Geminder

FILEMAKER
Kevin Mallon

FOTONATION.NET
Eric Zarakov
Yury Prilutsky

LACIE
Martha Humphrey
Barry Katcher

NIKON
Bill Giordano
Chuck Deluca
Lisa Baxt

POWER ON SOFTWARE

Donn Hobson
Sean Boiarski

TRAVELMUSE

Kevin Fliess
Eric Wood
Cyril Bouteille
Donna Airoldi
Michael Kwatinetz

FACT SOURCES

Centers for Disease Control and Prevention
Entertainment Software Association
Environmental Protection Agency
ESPN
Habitat for Humanity
Helping Hands: Monkey Helpers for the Disabled
IKEA HOME Survey, conducted by MarketTool Research
Kevin O'Keefe, *The Average American: The Extraordinary Search for the Nation's Most Ordinary Citizen*
Make-A-Wish Foundation
Major League Baseball
National Academy for State Policy
National Association of Professional Organizers
National Home Education Research Institute
National Model Railroad Association
NCAA
Neighborhood Housing Services of Greater Cleveland
The New York Times
Rand Gulf States Policy Institute
Time Inc.
US Census Bureau
US Department of Agriculture
US Department of Education
US Department of Justice
US Dept of Labor
US Department of Transportation
US Green Building Council
US Geological Survey

JUNIOR ADVISORS

Phoebe Smolan
Jesse Smolan
Alexandra Able
Zachary Able
Sophia Able
Reed Smolan
Lily Smolan
Savannah Smith
Sydney Pruss
Evan Pruss
Mason Rylander
Annabelle Rylander
CJ Erwitt
Sam Worrin
Max Worrin
Violet O'Hara
Jack Robert Boyt
Zoe Dubno
Teddy Dubno

MORALE OFFICER

Ally the Dog